T0158279

FILM AND THE AMERICAN MORAL VISION OF NATURE

FILM AND THE AMERICAN MORAL VISION OF NATURE

Theodore Roosevelt to Walt Disney

Ronald B. Tobias

Michigan State University Press
East Lansing

Copyright © 2011 by Ronald B. Tobias

☺ The paper used in this publication meets the minimum requirements of ANSI/NISO Z39.48-1992 (R 1997) (Permanence of Paper).

 Michigan State University Press
East Lansing, Michigan 48823-5245

Printed and bound in the United States of America.

17 16 15 14 13 12 11 1 2 3 4 5 6 7 8 9 10

LIBRARY OF CONGRESS CATALOGING-IN-PUBLICATION DATA

Tobias, Ron.
 Film and the American moral vision of nature : Theodore Roosevelt to Walt Disney / Ronald B. Tobias.
 p. cm.
 Includes bibliographical references and index.
 ISBN 978-1-61186-001-6 (cloth : alk. paper) 1. Nature in motion pictures. 2. Motion pictures—Moral and ethical aspects—United States. 3. Motion pictures—Social aspects—United States. 4. Philosophy of nature—United States—History—19th century. 5. Philosophy of nature—United States— History—20th century. I. Title.

 PN1995.9.N38T53 2011
 791.43'636–dc22 2010052292

Cover design by Erin Kirk New

Book design by Scribe Inc. (www.scribenet.com).

green press INITIATIVE Michigan State University Press is a member of the Green Press Initiative and is committed to developing and encouraging ecologically responsible publishing practices. For more information about the Green Press Initiative and the use of recycled paper in book publishing, please visit www.greenpressinitiative.org.

Visit Michigan State University Press on the World Wide Web at:
www.msupress.msu.edu

I sometimes think the day will come when all modern nations will adore a sort of American god, a god who will have been someone who lived as a human being and about whom much will have been written in the popular press: images of this god will be set up in the churches, not as the imagination of each individual painter may fancy him . . . but fixed once and for all by photography. Yes, I foresee a photographed god, wearing spectacles.

EDMOND AND JULES DE GONCOURT, JOURNAL, NOVEMBER 15, 1861,
TWO WEEKS AFTER THEODORE ROOSEVELT'S THIRD BIRTHDAY

Contents

Acknowledgments ix

Introduction xi

1 Tales of Dominion 1

2 The Plow and the Gun 19

3 Picturing the West, 1883–1893 29

4 American Idol, 1898 49

5 The End of Nature, 1903 65

6 African Romance 83

7 The Dark Continent 103

8 When Cowboys Go to Heaven 115

9 Transplanting Africa 129

10 Of Ape-Men, Sex, and Cannibal Kings 145

11 Adventures in Monkeyland 157

12 *Nature*, the Film 173

13 The World Scrubbed Clean 181

Notes 197

Bibliography 231

Index 245

Acknowledgments

For those who had the patience, the goodwill, and the enthusiasm—however guarded—I am indebted. To David Quammen for going to bat for me; to Bob Rydell for giving me support when I really wasn't sure that what I was doing was on track; to the archivalists at the American Museum of Natural History for sharing their playground with me; to the Field Museum just for being the Field; to Julie Loehr, the wonderfully user-friendly editor at the Michigan State University Press; to Jessica Hann and Sean Solowiej for their invaluable support; to Montana State University for giving me the time to write the book; and, to my students, who enjoy challenging my convictions.

Introduction

RAYMOND WILLIAMS CONCEDES IN *KEYWORDS* THAT THE WORD "NATURE" IS "PERHAPS the most complex word in the language."[1] For good reason. The word has gone to the core of much of Western philosophy and religion over the past two thousand years. And though the word pretends a certain naïveté, it is, in fact, burdened with complex histories. Every day we invoke the powers inherent in nature, and every day we employ it to serve a variety of ideological interests.

Since the earliest of recorded days, humankind has sought guidance from nature regarding what is normal and proper. Augustine of Hippo, a church father and an influence on the church's fundamental understanding of moral law, believed that original sin stymied humanity's access to natural law; therefore, the only viable path to salvation was through divine (that is, biblical) law.

A thousand years later, Thomas Aquinas disagreed. He interpreted nature as the mind of God. Through right reason, he argued, one could glimpse elements of eternal law but never truly apprehend it. Yet, said Aquinas, natural law provided humanity with an indisputable understanding of right and wrong. In other words, nature was a message from God in his own word.

Pioneer anthropologists George Boas and Arthur Lovejoy observed wryly in *Primitivism and Related Ideas in Antiquity* (1935) that nature often provided an "immediate certificate of legitimacy (whose) credentials need not be further scrutinized" when it came to determining an independent source for social mores. According to Aquinas, natural law instructs us how to make up the rules and regulations that govern people. It also teaches us how to live a righteous life. But Boas and Lovejoy noticed in their studies of people that natural law was not conveyed from the mouth of God directly to the ear of humankind. It came secondhand. "To identify the objective ethical normal with those rules of conduct which are valid 'by' or 'according to' nature," they noted curiously, "gave no logical answer to any concrete moral question; it was merely another way of saying that whatever is objectively right is objectively right, or that what is normal is normal."[2] One didn't discover the truth by looking under the right leaf; rather, one had to reason meaning. But what was a moral certainty in one village could just as easily be taboo in another. The *meaning* of God, the meaning of nature, the meaning of society—even the meaning of language itself—had to be interpreted. Thoreau's man in the woods seeks both *logos* and *lex* in nature.

Aquinas calculated four types of law: eternal law, divine law, natural law, and human law. Each law finds points of connection with the others. But these bridges aren't just trivial interstitials; they're permeable boundaries—crossroads—that allow the divine to enter nature or man, or allow man to venture into nature or the divine.

The intersection between natural and human law inevitably connected nature to politics. In 1901, the German philosopher and geographer Friedrich Ratzel suggested that states were akin to biological organisms that grew, matured, and died. "Without war," General Friedrich von

Bernhardi commented, affirming Ratzel's inchoate expansionism, "inferior or decaying races would easily choke the growth of healthy budding elements, and a universal decadence would follow."[3] The imperatives of growth outweighed stagnancy; the strong should rule the weak.

Since the earliest of days, humankind looked to nature to provide models of proper behavior. The goal of this book, however, is not to sort out the myriad ways in which societies have used nature to authorize morality, but to explore the crossroads between natural and human law. Human understandings of the role and purpose of nature often shape the ways in which people understand their role in nature both as citizens of the natural world and as citizens of the social and political world, a sentiment captured by C. S. Lewis when he claimed that natural law was "conceived as an absolute moral standard against which the laws of all nations must be judged and to which they ought to conform."[4]

Such transactions between natural and social came easily. For example, in spite of the furor it caused upon its publication, Darwin's theory of evolution quickly begot social theories that grafted racial and political theory onto natural selection. Within five years of the publication of *On the Origin of Species* (1859), Francis Galton, Darwin's cousin, launched a modest proposal in favor of the selective breeding of humans in an essay he later elaborated into a book, *Hereditary Genius* (1869). "It is in the most unqualified manner that I object to pretensions of natural equality," he wrote. It would be more practical, he suggested, engineering "a highly gifted race of men by judicious marriages during several consecutive generations."[5] Galton, a statistician by preference, tried to demonstrate his proofs scientifically, in Alfred Russel Wallace's words, "to determine the general intellectual status of any nation" by estimating the ability of its "most eminent men." (Galton's argument so impressed Wallace that he declared Galton's work would surely "rank as an important and valuable addition to the science of human nature.")[6]

Somewhat paradoxically, Thomistic doctrine not only cemented the convergence between natural and human law, it also reaffirmed human dominion "over every creeping thing that creepeth upon the earth." God intended for man to reflect the natural in his own social and political institutions, and yet, in the translation that has dominated scriptural cathexis for millennia, nature "to you shall be for meat."[7] Aquinas denied that animals were objects of moral concern. "There is no sin in using a thing for the purpose for which it is," he asserted in the *Summa Theologica*. "Now the order of things is such that the imperfect are for the perfect . . . hence, all animals are for man."[8] The tension between custody and control occupies the core of contemporary dialogue about nature and the environment, but at the turn of the twentieth century, the Lord's warrant for America seemed much more certain.

The themes of exceptionalism and destiny for a "universal Yankee nation" evolved from the experience of conquering nature's continent. "We have it our power to build the world over again," dreamed Thomas Paine in 1776. "A situation, similar to the present, hath not happened since the days of Noah until now. The birthday of a new world is at hand, and a race of men."

OWNING NATURE

In 1898 the United States took Cuba, Guam, Puerto Rico, and the Philippines away from Spain by force. In January 1900, Albert J. Beveridge, the junior senator from Indiana, stood on the floor of the U.S. Senate and proclaimed that God "has made [Americans] the master

organizers of the world to establish system where chaos reigns" and that the Lord had chosen Americans to be the "trustees of the world's progress" so "that we may administer government among savages and senile peoples."[9] This righteousness found its sources in the way the American people imagined the role of environment in shaping the country's destiny. While Germany yearned to conquer the East ("*Drang nach Osten*"), the United States yearned to conquer the West. The frontier created tough men and women, quick to pick a fight or settle one. The gun, the knife, and the axe became new implements for building both character and nation. The frontiersmen, wrote Roderick Nash in *Wilderness and the American Mind*, "acutely sensed that they battled wild country not only for personal survival but in the name of nation, race and God."[10] Strong, defining personalities such as Buffalo Bill Cody, Frederic Remington, and Theodore Roosevelt shaped the interplay of ideas, discourse, and power that redefined America at the end of the nineteenth century by amalgamating the imperial and the environmental. When newspaper editor John L. O'Sullivan claimed in 1845 "the right of [American] manifest destiny to overspread and to possess the whole of the continent which Providence has given us for the development of the great experiment and federated self-government entrusted to us," he compounded nature with the imperial growth of the United States. As a naturally inherited right, manifest destiny depended upon an ideology of dominion that made conquering nature a precondition for conquering other nations. As Ella Shohat and Robert Stam write in *Unthinking Eurocentrism,* "the desire to expand the frontiers of science became inextricably linked to the desire to expand the frontiers of empire."[11] In other words, the nation that controls nature controls the world.

THE LIBERATION ECOLOGY OF THE AMERICAN WEST

In 1996, political ecologists Richard Peet and Michael Watts defined the concept of an environmental imaginary in *Liberation Ecologies* as a way for a society to imagine nature, "including visions of those forms of social and individual practice which are ethically proper and morally right with regard to nature." Rejecting the view that nature is a purely human construct, Peet and Watts try to "counterbalance the claim of a complete social construction of nature with a sense of the 'natural construction' of the social." An environmental imaginary is not entirely synthetic; rather, it is a "primary site of contestation" between nature and culture that sees "nature, environment, and place as *sources* of thinking, reasoning, and imagining: the social is, in this quite specific sense, naturally constructed."[12]

In 2003, Michael Watts reframed the key question of political ecology as "what passes for the environment and what form nature takes as an object of scrutiny," thus opening the door to humanistic inquiry into the role that culture plays in defining the meaning of nature.[13] If an aim of political ecology is to examine the political and social networks of money and power that have been imposed upon real landscapes, then so should we examine their effect on imagined landscapes. Imagined landscapes—and the narratives positioned within them—shape Americans' popular attitudes about nature: what it is, how we see it, and what it means. The American West became a site of contention "in which and through which memory, identity, social order and transformation [were] constructed, played out, re-invented, and changed."[14]

Two technical innovations promoted this American metamorphosis. During the 1890s, rapid advances in color lithography and rotogravure printing made it economically feasible to produce images for every citizen, literate or not. Pictures of the West proliferated in books,

illustrated newspapers, magazines, and on the covers of countless thousands of dime novels. They appeared painted on the drapes of the stage and in the earliest of movies. They were ubiquitous. In 1889, the W. S. Kimball & Company produced a series of tobacco cards called "Savage and Semi-Barbarous Chiefs and Rulers," and a year later Kickapoo Plug Tobacco launched its series of "American Indian Chiefs." They were more popular than baseball cards. And in 1898 Congress authorized the postcard, which, by 1900 visually chronicled everything from the exotic to the mundane. Images flooded the American consciousness.

As the printed image became accessible to everyone, so did the camera. In 1883, George Eastman produced the first rolled photographic film; five years later he introduced the first Kodak camera ("You push the button, we do the rest"). Grover Cleveland bought a Kodak, as did the Dalai Lama and anyone who could afford the spendy $25 price tag. By 1900, however, Eastman introduced the Kodak Brownie for $1, which brought the camera to Everyman.

Eastman also produced motion picture film, which Edison used in his 1891 invention, the Kinetoscope, a projection device housed in a four-foot-tall wooden cabinet that showed motion pictures through a peephole. These new image technologies quickly challenged the hegemony of the word.

"To see is to know," wrote the assistant secretary of the Smithsonian, George Brown Goode, in 1898 as he predicted the museum of the future. "In this busy, critical, and skeptical age each man is seeking to know all things, and life is too short for many words. The eye is used more and more, the ear less and less, and in the use of the eye, descriptive writing is set aside for pictures."[15] By the turn of the century, the proliferation of still and motion pictures threatened to supplant the word as a primary source of historical evidence. The romantic poetry of Wordsworth, Shelley, and Keats, the essays by Emerson and Goethe, and the journals of Muir and Thoreau, all of which rhapsodized on the sublime within nature, found *new* expression in the realistic images of the still and motion picture camera. "The art of the past no longer exists as it once did," writes English critic John Berger. "Its authority is lost. In its place is a language of images. What matters now is who uses that language for what purpose."[16]

The motion picture camera became the dominant medium for disseminating national ideology at the turn of the century. The narratives within film, write Shohat and Stam, did not simply reflect the historical processes they recorded; they provided "the experiential grid, or templates through which history can be written and national identity figured."[17] When Frederick Jackson Turner penned his elegy for the American frontier in 1893, those committed to expansionism started to look abroad for their next field of conquest. And they brought their guns and cameras with them.

THE HEROIC RISE OF PICTURE MAN

The strong, defining image of Theodore Roosevelt is woven into the warp and woof of the American cultural tapestry. At five feet ten, his squared-off, bulldoggish stature, his rimless glasses perched on the end of his nose, offset by the unique Rooseveltian smile—part grimace, part snarl—and his larger-than-life gestures that expressed fearlessness made him exceptionally photogenic. To this day he remains one of the most recognizable presidents, elevated to the iconic status of Washington, Jefferson, and Lincoln as the fourth member of the quartet of faces chiseled into granite at Mount Rushmore. His madcap dash up San Juan Hill, his bloody

safari into darkest Africa, and his agonized journey down an unchartered river in the Amazon are etched into the popular imagination. "He was his own limelight," wrote his friend, the novelist Owen Wister. "He could not help it."[18]

Roosevelt's arrival at a critical juncture in American history "was one of those utterly unthinkable coincidences," remarked William Allen White. "[That] a man of Roosevelt's enormous energy should come to the Presidency of exactly that country which at exactly at that time was going through a transitional period—critical, dangerous, and but for him terrible."[19] A man of immense physical, intellectual, and theatrical presence, he was an amalgam of the churning social, political, and economic forces that were agitating for social change at the end of the nineteenth century. He presented himself as an American Hercules, certain, confident, and strong. And he sensed the role the motion picture camera would play in creating his persona as a man of action.

The motion picture camera, barely fledged, discovered Roosevelt in the spring of 1897 as he stepped onto the national stage as the assistant secretary of the navy under President McKinley. Thirteen months later, he would resign his post to become a lieutenant colonel in the First U.S. Volunteer Cavalry Regiment—the Rough Riders—as they embarked for action in Cuba. Three years to the day after the Rough Riders mustered out of service on September 15, 1898, Theodore Roosevelt, at the age of forty-two, went from a retired lieutenant colonel to the twenty-sixth president of the United States. "I rose like a rocket," he famously said of himself.

The love affair between Roosevelt and the camera was mutual. He relied on emerging visual platforms to design and project himself and his personal philosophy to the nation. During his lifetime he wrote thirty-eight books (many of which contained pictures of him); he appeared in over a hundred documentary films, thousands of editorial cartoons, dozens of motion picture cartoons, and countless still images. "He is more than a picture personality," wrote a columnist in *Motion Picture World* in 1910. "He is a PICTURE MAN."

> His is such an overmastering personality that we go the length of expressing the hope that moving pictures of him may be preserved in safe custody for future reference. What would the public of this country give today to see Abraham Lincoln or George Washington in their habits as they lived, in moving picture form? . . . Don't you think the student, the historian, the biographer, the patriot would be glad to see moving pictures of these great man? Surely so. It is the same with Mr. Roosevelt.[20]

Using his own physical metamorphosis from a frail, asthmatic "Teedy" of childhood into the muscular, boisterous "Teddy" of adulthood may smack of overcompensation, but it was that very overexertion of personality that made him so appealing to the public and the camera. As a sturdy self-made frontiersman whom nature had tested by pushing him to his limit, he helped create a way of looking at the American West as a way for the nation to look at itself.

This book focuses on the dialectical role the motion picture camera played in explicating the relationships between society and nature, and how that ideology provided the moral authority to support the country's imperialist agenda abroad, particularly in Cuba during the Cuban War for Independence (more commonly known as the Spanish-American War of 1898), and in Africa between 1909 and 1910, the year Roosevelt went on safari on behalf of the Smithsonian. The institutional representation of these events appeared in 1936, when the American Museum of Natural History in New York opened the doors to African Hall. I examine how the dioramas of African Hall function in terms of the relationship between Americans

and nature, and how they meld both imperial and environmental imaginaries through the use of the dramatic narratives that were emerging from early cinema. Further, I explore how these dioramas create a visual and ideological template for what is today known as the natural history film.

The flood of images at the turn of the century argued forcibly one commonality: the forests and inland seas, the vast rolling plains and immeasurably deep canyons carved the intaglio of American character.

In the following thirteen chapters, I survey the histories of the men and women whose ideologies shaped the public image of nature. Chapter 1, "Tales of Dominion," traces the ideology of dominion from its theological, philosophical, and political roots. Drawing on diverse thinkers such as St. Augustine, Francis Bacon, Thomas Hobbes, and Adam Smith, the chapter traces the history of the secularization of nature from the fifteenth century to the present, and then concludes with a discussion of the role the motion picture camera played in the earliest days of cinematography to play out the philosophy of dominion.

Chapter 2, "The Plow and the Gun," contrasts two men who held similar beliefs: Frederick Jackson Turner and Theodore Roosevelt. In 1890, the superintendent of the eleventh national census declared the lack of "a frontier line" in the unsettled areas of the United States. Three years later, the historian Frederick Jackson Turner stood in front of his colleagues at a meeting of the American Historical Society in Chicago and announced "the closing of a great historic movement" in American history. "The true point of view in the history of this nation," Turner argued, "is not the Atlantic coast, it is the Great West."

That same year, another historian, who was writing the third volume of *The Winning of the West,* thanked Turner for having "put into shape a good deal of thought that has been floating around rather loosely." Theodore Roosevelt, who'd already authored ten books on American history, advanced himself as an authority on the American West (even though he had actually spent less than a year ranching and hunting there). Although he embraced many of Turner's ideas, he found them timid. Rather, he promoted the aggressive dominance of the land, including the abrogation of all treaties and rights that had been made with Native peoples on it. Roosevelt wrote about his personal conquests in the Dakotas and Montana, and proposed his own theory about the role nature played in the building of national character and identity.

In 1883, Roosevelt went west to find himself, and in the course of his search, he found a theory of a nation as well. He pointed westward and said it was there that, as a nation, "we shall ultimately work out our highest destiny." Chapter 3, "Picturing the West, 1883–1893," chronicles Roosevelt's worldview, which included a belief in the prerogative of the white race to assume responsibility for and command nature.

Chapter 4, "American Idol, 1898," follows Theodore Roosevelt's meteoric rise to political power and the role of the motion picture camera in his ascent. The American incursion into Cuba in 1898 marked the shift from an environmental imaginary into an imperial imaginary. Roosevelt and his "great big, goodhearted, homicidal children" known as the Rough Riders became America's polestar, and photographic and cinematic images of them flooded the culture, creating an "American idol."

Until the end of his life, Roosevelt could not reconcile his understanding of the political need to protect nature with his personal urge to kill it. As one of the great conservationists of his time, he was also one of the great hunters of his time, a passion that often placed him

in the crosshairs of controversy once he became a world leader. Chapter 5, "The End of Nature, 1903," traces the hunting controversies that surrounded Roosevelt during his tenure as vice president and president, and how the visual depiction of him as a "game butcher" created tension between Roosevelt the creator (of American natural resources) and Roosevelt the destroyer, the hunter who preferred to plunge a knife into the heart of a mountain lion than to shoot it.

During his presidency, Roosevelt struggled to restore the "balance of nature" in Yellowstone National Park according to his preconceptions about what nature ought to be. Yellowstone, as a landscape of consumption, altered the terms of the environmental imaginary of the nineteenth century by reconfiguring nature in terms of resource management.

At the end of this second term, Roosevelt agreed to leave Washington so as not to distract the public during Taft's succession. He chose to go on safari to Africa for a year (1909–1910) in order to collect specimens of mammals for the Smithsonian. Chapter 6, "African Romance," examines Roosevelt in Africa as the head of the Smithsonian's African Expedition.

His appointment as the chief agent of the expedition wasn't a pretense; indeed, being appointed the chief agent of the National Museum of Natural History was a validation of his vision of himself as a world-ranked faunal naturalist-explorer. Africa also became a stage for Roosevelt to act out his personal ambition as the Grand Hunter. In all, Roosevelt and his son Kermit collected a staggering array of over 21,650 specimens of animal and plant life, including 12,000 mammals, birds, and reptiles. And yet Roosevelt declared his restraint: "We did not kill a tenth or a hundredth part of what we might have killed had we been willing."

More importantly, Roosevelt brought a motion picture cameraman with him to Africa at a time when Americans had never seen any photographic or cinematic images of the animals or people who lived on the "Dark Continent." Starting with *Roosevelt in Africa* (1909), Roosevelt's filmic depiction of Africa, the United States played out its imperial fantasies in Africa on the movie screen both on location with great white hunters and in Hollywood.

Chapter 7, "The Dark Continent," explores the roles that nation, race, gender, and class played in the American construction of the Dark Continent. Africa was the blank canvas upon which Americans projected their political and social agendas and ambitions. These narratives are captured in stark contrast in the stories of *Roosevelt in Africa* and of Ota Benga, a Pygmy who first appeared on exhibit in the St. Louis Exposition of 1903 and then was put into the monkey house at the Bronx Zoo in New York.

Even before Roosevelt returned from Africa, cowboy imperialists such as Charles Jesse "Buffalo" Jones and Paul Rainey were already planning their own film expeditions to Africa. Chapter 8, "When Cowboys Go to Heaven," follows the narratives of men like "Buffalo" Jones, who promoted himself as an original frontiersman, which he proved by roping and tying, "often single-handed, every kind of wild animal of consequence to the found in our western country." Jones was a self-styled "lord of the beasts" who embodied the same ambivalence toward nature as Theodore Roosevelt. He believed in the wildness of nature and that it was essential to developing the unique character of the American, and yet, at the same time, he devoted himself to humbling nature in order to prove the superiority of men over the land and the beasts that dwelled upon it.

A year later Paul Rainey arrived in Africa with his Mississippi bear-hounds and made *Paul Rainey's African Hunt.* The spectacle of Rainey's hounds fatally swarming a cheetah reflected an American political discourse about the exercise of power on foreign soil and the dream of an emerging American political and military hegemony in the world. Unlike the restrained

violence in Jones's film, the violence in Rainey's film is literally and figuratively unleashed. Rainey's hounds embodied American aggressiveness, and their unflinching readiness to fight to the death with the king of beasts spoke of their determination, their fearlessness, and the need for cooperation to defeat a superior foe.

The natural history museum of the early twentieth century sought to capture and suspend the natural world in dramatic tableaux vivants—"living pictures"—that suspended time during a moment of ideological perfection. Major institutions such as the Field Museum, the Smithsonian, the American Museum of Natural History, and the Oakland Natural History Museum actively sponsored expeditions to Africa during this period to collect specimens for public display. Recent advances in taxidermy that combined technical expertise with artistic temperament stimulated curators to think about a more dynamic presentation of their specimens. Chapter 9, "Transplanting Africa," deconstructs the ideological content in the natural history dioramas in African Hall at the American Museum of Natural History, and Theodore Roosevelt acts as a metalogue—the overarching political narrative of the American experience—that physically and figuratively surrounds and shapes the museum and therefore the social representation of nature. This new model of nature not only withdrew the imperial agent—the hunter—but also created a rift between human beings and nature that would evolve to become the hegemonic representation of nature in the future.

Outside African Hall, images of nature had undergone its own revolution through American cinema, which employed a radically divergent dogma as the men who zealously promoted the ideology of knowledge and power within cultural institutions such as the natural history museum. Outside African Hall, the cinema produced its own revelations about the relationships of Americans to foreign landscapes. The jungle melodrama (often conflated with the Western) played out American imperial fantasies and fears about class and power (Tarzan), and sex and race (apes that kidnap white women and cannibals). Chapters 10 and 11 ("Of Ape-Men, Sex, and Cannibal Kings" and "Adventures in Monkeyland") explore the interracial abduction fantasy about apes (and the black men who acted as their surrogates) that had been simmering in Western society since the mid-nineteenth century, when a minor explorer from Louisiana by the name Paul du Chaillu showed up in London in 1861 with some gorillas skins and skulls that he had collected in western equatorial Africa.

Martin and Osa Johnson, supposed prototypes for the characters of Carl Denham and Ann Darrow in *King Kong,* made "documentary" films about Africa during the twenties and thirties that combined the dramatic narratives of Hollywood with documentary footage. Chapter 11 explores the lives of the Johnsons, and how entertainment and education fused as a model for storytelling that combined both fiction and nonfiction.

Chapter 12, "*Nature,* the Film," explores the relationship between the natural history dioramas of the AMNH and contemporary natural history film, and how this shared discourse produces narrative structures that invest nature with morality. In 1973, Hayden White published *Metahistory,* a systematic study of a nexus of aesthetic constructs that underpin the historiographical text. White contends that the historian, conditioned by preconceptual layers of historical consciousness, selects and organizes "data from the unprocessed record" of the historical field into a "process of happening" with a beginning, middle, and an end "in the interest of rendering that record more comprehensible to an audience." In other words, the historian, either consciously or unconsciously, unifies disparate elements within the historical field to create a rhetorically constructed prose narrative. These *modes of explanation,* he ventures, "are embodied in the narrative techniques, the formal argumentation, and the ethical

position developed in the historiographical discourse." By conducting an archaeology of these modes of explanation, we can inquire how a historically situated set of social, technological, and visual practices constructed landscapes and the people and animals that lived within them.

Six months after the American Museum of Natural History opened the doors to African Hall in 1936, Walt Disney began work on his second animated feature, *Bambi. Bambi* combined natural realism and animation—an idea that seemed oxymoronic at the time—and created a realistic portrayal of life in the forest as a reflection of the perfect social order. In 1948, Disney released the first episode of *True-Life Adventures,* a series of natural history films that used the studio model created for *Bambi.* Together, the *True-Life Adventures* (1948–1960) and *Bambi* served as the hegemonic template for virtually every natural history film made by Discovery, National Geographic, and the BBC since.

Chapter 13, "The World Scrubbed Clean," argues that Disney's moral view of nature embodies the same ideologies of race, class, and gender that Carl Akeley created for African Hall. Using a guise of realism, Disney's utopian image of nature was calculated, in the words of one of the engineers of Disneyland, "to program out all the negative, unwanted elements and program in the positive elements" in order to create the world not as it actually is but as "a world that is the way they think it should be." In other words, stories about nature became another way of saying *Once upon a time . . .*

Tales of Dominion

CHRISTIAN THEOLOGY UNDERSTOOD THE POWER INHERENT WITHIN NATURE AS THE divine ordinance of God. St. Augustine chided the inquisitive who searched for knowledge about nature as violators the Lord's sanctity. "This is the disease of curiosity," he warned. "It is this which drives us to try and discover the secrets of nature, those secrets which are beyond our understanding, which can avail us nothing, and which man should not wish to learn."[1] In other words, the righteous need only know that God was the Cause and nature was the Effect; further inquiry constituted heresy. But as science and technology made it possible to peek at the inner workings of physical nature in the seventeenth century, the philosophers of the Enlightenment ventured an idea that would radically shift the base of power between humans, God, and nature.

What if, several French and English philosophers speculated during the early 1600s, *nature wasn't the active manifestation of God but a material thing*—what the Comte de Buffon would later call "the external throne of divine magnificence"—*elegantly crafted by the Creator but left to operate on its own by a set of discoverable principles?* If that were true, Descartes suggested in 1637, then we might "render ourselves the masters and possessors of nature."[2]

By the end of the seventeenth century, material nature no longer reflected the attentive presence of God so much as it confirmed his absenteeism. Nature was not ipso facto God, as Aquinas had suggested, but evidence—the fingerprint—of God. "To know Nature was to know God," Raymond Williams writes in *Problems in Materialism and Culture,* "although there was radical controversy about the means of knowing: whether by faith, by speculation, by right reason, or by physical inquiry and experiment."[3]

During the Renaissance, knowledge about nature routinely combined objective with subjective content. For example, people shared practical knowledge about secular (or biological) foxes, such as their appetite for chickens, for example, or how to snare them. Foxes also hosted subjective content, including oral folklore such as proverbs, adages, and fables that reflected human strengths and foibles rather than biological attributes. The fox was, in a sense, an almanac that combined practical knowledge with hearsay, folklore, and fancy. Until the seventeenth century, comments contemporary French historian and philosopher Michel Foucault, "to write a history of a plant or animal was as much a matter of describing its elements or organs as describing the resemblances that could be found in it, the virtues that it was thought to possess, the legends and stories with which it had been involved, its place in heraldry, the medicaments that were concocted from its substance, the foods it provided, what the ancients thought of it, and what travelers might have said of it."[4]

This imposition of meaning made the fox a repository for metaphysical as well as empirical

knowledge. As a staple figure in the literary fabulist traditions of culturally and temporally divergent writers such as Aesop, Vishnu Sarma, Bidpai, Phaedrus, Marie de France, and Jean de la Fontaine, the fox ranged over a broad field of signification. Aesop's fox, for example, is an antihero. Unlike the imperial lion, who lords over his kingdom by virtue of his incontestable strength, the trickster fox learns to live off the radar of his oppressors by using his wits. Read this way, craft and cunning in Aesop's *Fables* provided disenfranchised peasants with an existential role model and a handbook for survival in a world in which they were powerless.

Christian medieval bestiaries, on the other hand, depicted the fox as a cohort of the devil. Morally bankrupt, he was glib, devious, and charismatic—chief attributes of the heretic—and his frequent appearance on the margins of medieval manuscripts dressed in the robes of a clergyman as he preaches to a flock of birds warns readers of the mortal danger of being astray by false preaching.[5]

The fox developed as a major allegorical figure in the folk and religious canons of Western literature over the course of two thousand years. The trickster antihero of *Reynard the Fox* (*Le Roman de Renart*) first appeared in twelfth-century France and then spread gradually throughout the Old and then the New World, where he remains embedded in a wide variety of American cultural incarnations that range from the character of Br'er Fox in Joel Chandler Harris's Uncle Remus stories to the nameless man character in Ralph Ellison's *Invisible Man* (1953) to Walt Disney's *Song of the South* (1946) and *Robin Hood* (1973).

The biophysical animal began shedding its metaphysical dimensions in the middle of the sixteenth century. In 1551, the Swiss naturalist Conrad Gesner published *Historia animalium,* a visual compendium of the animal kingdom that reflected a growing interest in the extrinsic animal. Often cited as the first modern zoological work, the *Historia animalium* not only draws on the Old Testament, Aristotle, and medieval bestiaries, but also Gesner's personal observations of animals to create a synthesis of ancient, medieval, and modern science. Hand-colored plates accompany a curious alloy of objective and subjective content about each species, including fables, proverbs, adages, and facts about the animal's life history, a description of its anatomy, and its geographic distribution.

The animals in Gesner's bestiary range from the literal to the figurative. The cow, the horse, the goat, and the dog share pages with the unicorn, the satyr, and the manticore, a fabulous beast with the body of a lion, the head of man, and the sting of a scorpion. Gesner's renditions of domestic animals are precise—the result of personal observation—whereas his renditions of exotic animals such as the baboon and the porcupine are secondhand. His work departs from earlier (and later) natural histories that reflect a fascination for

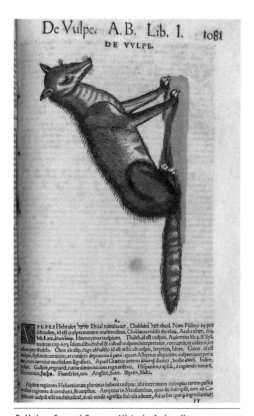

DeVulpe, Conrad Gesner, *Historia Animalium*, 1551

the real and imagined grotesqueries of terra incognita as he shifted his interest increasingly away from imagination toward investigation, from the unknown to the known, and from the unique to the mundane. His depictions of the cow and the horse, for example, concern themselves with the correctness of proportion rather than the rampant metaphysical speculations that intrigued many of his contemporaries.

Gesner's fox straddles the medieval and the modern. At first his portrait seems more whimsical than biologically representative. The fox's excessively angular features reinforce it as vulpine, shifty, and untrustworthy. Its intense gaze assesses the viewer, but indirectly, from an extreme angle. Gesner's fox is agile, smart, and contemplative—still gorged with subjective content.

Yet Gesner's fox is as much index as icon. The text that accompanies his engraving supplies observational data about the animal's range, habits, and diet. Although he mixes zoological and etymological information with adages and proverbs, Gesner's inchoate empiricism nonetheless prefigures modern science. His work presages the fork in the road that would separate subject from object, culture from nature, past from present, and poetry from science.[6] By the end of the century, others began to publish meticulous anatomical studies such as Carlo Ruini's *Anatomy of a Horse: Diseases and Treatment* (1598), arguably the first comprehensive and serious scientific study of the horse. His detailed drawings of the musculature and blood circulation of the horse were a precursor to veterinary science. Nature became increasingly depicted as material substance scrubbed of spiritual content.

THE GREAT CHAIN OF BEING

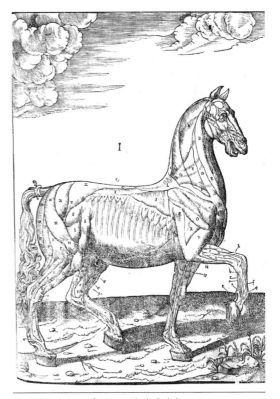

In the thirteenth century, Thomas Aquinas proposed a moral hierarchy of existence called the Great Chain of Being (*Scala naturae),* an organizational metaphor based upon the "goodness of things." Its basic premise is that every rock, plant, animal, human, and angel has a designated place in a divinely created hierarchy that extends from the lowest (that which is completely material) to the highest (that which is completely spiritual). Where one ended up in this pecking order depended upon the degree of Spirit with which one had been endowed. The peak of perfection was God, who sat on his throne as the Divine Hierarch. Immediately beneath him served a host of angels, followed by man ("a little lower than the angels").[7] Following man, which Aquinas ranked from monarchs and popes to thieves and pirates (with Gypsies occupying the lowest rung of humanity) came animals, birds, worms,

The Musculature of a Horse, Carlo Ruini, 1598

plants, and finally rocks, which were devoid of Spirit. The Great Chain of Being was, in Stephen J. Gould's words, a "static ordering of unchanging, created entities . . . placed by God in fixed positions of an ascending hierarchy."[8]

Aquinas' discrete divisions that separated humans from animals served as a theological (and social) model that gradually evolved as a biological model. But other men of science of the sixteenth and seventeenth centuries preferred instead to speculate on the variety of grotesque beings that cohabited the human and the animal world, creatures that did not fit neatly into theology's clear-cut scheme of things.

Once the lines between the celestial, the human, and the bestial had been drawn, it became important to enforce their separation. For example, the sanctions for having sex with animals were severe in the Old Testament. Leviticus condemns bestiality as morally reprehensible and prescribes death for both for beast and "whosoever lieth with a beast." The severity of the punishment reflected a belief in the catastrophic consequences of those illicit unions. Leviticus 18:23–24 reads, "Neither shall thou lie with any beast to defile thyself therewith; neither shall any woman stand before a beast to lie down thereto: *it is confusion*" (emphasis added). The confusion that resulted from the physical commingling of animal and human consisted of a startling array of monsters that blurred what it meant to be either animal or human. One Jewish scholar rejected the idea of miscegenation between the human and animal based upon the Judaic belief that God had created "an unbridgeable abyss between the Creator and the creature," and exhorted Jews to remain "oblivious of these unions (contrary to nature) that result in the births of divine or monstrous beings, which in other traditions, blur the dividing line between man and the animals."[9]

The presence of such beasts was more than just speculative. In 1573, Ambroise Paré, an accomplished anatomist often referred to as the "father of surgery," published a visual compendium of interspecifics that resulted from the unnatural union of beast and human. *De Monstres et Prodiges* chronicled the "Blending and Mixture of Seed" that resulted in human-animal hybrids such as a frog-headed boy, a pig that has the hands and feet of a man, and a man who is half pony.[10] In 1642, Ulisse Aldrovandi, (whom the Comte Buffon would call the "Father of Natural Science") published *Monstrorum historia* (*The History of Monsters*), followed in 1665 by the Italian scientist Fortunio Liceti, who published *De monstris* (*On Monsters*), which mixed the grotesque, the monstrous, with the fabulous.[11] Liceti's pig has the head of a gentleman wearing a powdered wig. One of his cats has six legs; four of them feline and two, which extrude from its pelvis, are human. There is a man with the head of a fish, and a fish with the head of a man. Those more beast than human remained naked and wild; others, more human than beast, range in dress from royals to tradesmen to paupers. Liceti's man with the head of an elephant and Aldrovandi's man with the head of a swan (*cynocephalus)* have evolved as citizens, whereas the satyrs and the mermen and sea women (*Mare donna*) remain brutes.

Nature's world was also a laboratory for radical evolution: fish sprout legs or wings and dogs walk upright. Rather than moving toward a world of orderly segregation between species, nature seemed more interested in creating a pan-species that blurred animal and human into a single continuum of life. As in Aquinas, the more human an animal, the higher its place in the hierarchy of life, but the divisions between self and animal Other remained uncertain. Nonetheless, the human incorporated—literally and figuratively—the animal as effortlessly as the animal incorporated the human. The fabulous beasts of Gesner or Aldrovandi are more than just medieval marginalia or fetishes of morbid anatomy; they also act as visual interrogatories

that try to map the borderlands between the bestial and the celestial, the human and the animal, and the self and the Other. They overcome the ecclesiastical denunciation of trespass and flirt with miscegenation.

But the need for coherency in nature made the imposition of order paramount. In 1603, Francis Bacon wrote an essay entitled *The Masculine Birth of Time,* in which he categorically imputes to nature the purpose of serving humanity: "I am come in very truth leading Nature to you, with all her children, to bind her to your service and to make her your slave. . . . So May I succeed in my only earthly wish, namely to stretch the deplorably narrow limits of man's dominion over the universe to their promised bounds."[12] When in the late sixteenth century Galileo proposed that the universe, while numinous, was not ineffable, people were starting to regard nature as a text that could be translated verbatim provided one could learn the language it was written in. That language, Galileo declared, was mathematics.

Galileo's work in astronomy, mechanics, and mathematics produced a method that others would test and elaborate. It was from Galileo that Thomas Hobbes (1588–1679) developed his concept of the world as a mechanical system.[13] "The universe, that is, the whole mass of all things that are, is corporeal," Hobbes wrote in *Leviathan.*[14] In other words, all that was real in the universe was material and therefore knowable, and if it wasn't material, then it wasn't real. Hobbes, a devout determinist, went so far as to reject the idea of free will. Everything, including that which was human, he declared, could be explained by the mathematics of motion. His declaration of independence, free of the tyrannical restraints of theology, resulted in his own version of the prime law of nature, which, "thus conceived, is self-preservation and self-aggrandizement, pursued by whatever trickeries or cruelties may prove to be advisable."[15]

From that point in history forward, the control of nature depended upon the ability to predict it accurately. There was no place for chance, randomness, or chaos in its orderly equations. Ultimately, the feeling developed that no mystery could remain inexplicable. By the time Isaac Newton published *Mathematical Principles of Natural Philosophy* in 1687, people had begun to think of nature as a logically ordered "world machine" that could be understood by carefully examining each of its constituent elements, much in the way a mechanic could dismantle an engine in order to understand the functional relationships between its parts.

"The decisive theoretical break came with Descartes," notes John Berger. Since God privileged only humans with souls, animals were reduced to the status of biological machines. "To the same degree as man has raised himself above the state of nature," Buffon lamented, "animals have fallen below it: conquered and turned into slaves, or treated as rebels and scattered by force, their societies have faded away, their industry has become unproductive, their tentative arts have disappeared. . . . What visions and plans can these soulless slaves have, these relics of the past without power?"[16]

Freed from the theological hobble of the ineffability of nature, the new project rapidly expanded its scope during the eighteenth century. Nature now required systems of order that explicated linear relationships between living things. The earlier attempts of naturalists such as Aldrovandi, Liceti, and Gesner to categorize creatures into groups quickly proved futile as the imperial fleets that scoured the world dumped untold biological wealth into their nations' coffers. The cloistered walls of Europe started to crumble as a flood of unknown plant and animal species into the Old World created an epistemological crisis. What were these things? How were they related to other things? How should they be categorized and what should they be called?

PEEPING INTO GOD'S CLOSET

In 1735 Carl Linnaeus, the son of a Swedish village clergyman, published an eleven-page systematized view of nature. The first edition of *Systema naturae* divided nature into three kingdoms: the kingdom of animals, the kingdom of plants, and the kingdom of stones. The kingdom of animals included a curious class of creatures Linnaeus called *Paradoxa,* which consisted of fabulous and chimerical monsters such as the hydra, the satyr, the phoenix, and the dragon. Although he took the bold step of including humans with primates, he also added two other species of borderlands humans in the same category as *Homo sapiens: Homo troglodytes,* a night creature that spoke in hisses, and *Homo caudatus,* a human with a pronounced tail.[17] The first edition is a curious blend of new and old, mythic and real, and subjective and objective.

By the time the second edition appeared five years later in 1740, Linnaeus had expunged *Paradoxa* from the biological record. "The first task of wisdom," Linnaeus had declared, "is to know the things themselves."

> This notion consists in having a true idea of the objects; objects are distinguished and known by classifying them methodically and giving them appropriate names. Therefore, classification and name-giving will be the foundation of our science.[18]

But Linnaeus believed that God had chosen him to reveal his divine plan in nature to humankind. "God has suffered him to peep into his secret cabinet," he wrote of himself in the third person. "God has endowed him with the greatest insight into natural knowledge, greater than any has ever gained . . . and has made of him a great name, as one of the great ones of the earth."[19] In spite of his claim to divine inspiration, Linnaeus believed his *System* fell woefully short of its objective, and he spent the rest of his life searching for the Holy Grail, God's *Logos* in nature.[20] The Holy Writ from God's mouth to Linnaeus's ear, *Logos* would be a revelation theology of the underlying order of the universe. It was Heidegger's revised definition of *phusis,* the thing itself, not its shadow. Linnaeus died forty years later, his divine task unfulfilled.

Born the same year as Linnaeus, Georges Louis Leclerc de Buffon embarked on a secular attempt to categorize the living world in his encyclopedic *Histoire Naturelle* (1749–1788). Buffon brought Gesner's epiphany from two hundred years ago to its logical conclusion: the privileging of science over history, religion, and literature. He believed that the mission of science was to collect data through empirical observation that was free of the distortions of emotion, religion, or opinion.

Emerging science had a harder time divesting itself of religion than it did of history or literature. Even though Buffon blazed a path for other secularists who would follow him (Cuvier, St. Hilaire, Lamarck, and Darwin, for example), most of his contemporaries maintained steadfastly that nature wasn't just the handiwork of God but the mind of God. Just two years before the publication of Darwin's *On the Origin of Species* in 1859, Harvard professor Louis Agassiz wrote, "The human mind is only translating into human language the Divine thoughts expressed in nature in living realities."[21] Accordingly, God and nature weren't two threads intertwined as one that science could unravel and separate at its leisure; rather, they were one inalienable thread. Science *was* theology, a justification that came from a reevaluation of God's intent for nature in Scripture.

REPAIRING THE WORLD

Before the Enlightenment, redemption theology had always counseled piety and patience. But a new view developed during the seventeenth century that the lot of man wasn't simply to await final judgment in death, but to accept God's mandate to preside "over the works of thy hands" (Hebrews 2:7, KJV) by claiming his God-given rights of dominion over nature. Historically, at the same time science started to reverse the polarity of power between nature and man, progressive theologians and philosophers justified its work on scriptural grounds. "Man by the Fall," Francis Bacon wrote in the early seventeenth century, "fell at the same time from his state of innocency and from his dominion over creation. Both of these losses however can even in this life be in some part repaired; the former by religion and faith, the latter by arts and science."[22]

The issue of repair, which is central to Bacon's argument, is rooted in Old and New Testament theology, which posits that the Lord delivered an imperfect world to humans and then left it to them to "repair the world in the Kingdom of God." In Judaism, the tenet of *tikkun olam*—which translates from the Hebrew as "repair the world"—derives from the Mishnah, the classic rabbinic teachings of the second century A.D. and to Lurian Kabbalist mysticism of the sixteenth century.[23] Two assumptions underlie the practice of *tikkun olam:* first, that the material world (nature) is flawed, and, second, that salvation—individual and collective, spiritual and material—depends upon humankind's willingness to restore it through contemplative action. The theological conclusion, therefore, is that God delivers nature to humankind, as evidenced in Genesis 1:26 (KJV): "And God said, Let us make man in our image, after our likeness: and let them have dominion over the fish of the sea, and over the fowl of the air, and over the cattle, and over all the earth, and over every creeping thing that creepeth upon the earth."

Few words in the Bible have had as much force in shaping humankind's relationship to nature as the Hebrew verb *radah,* which has been translated as *to have dominion over* but also as *to rule or reign over, to hold sway over,* and *to subdue.*[24] The word appears again two verses later in Genesis 1:28 (KJV) when God exhorts the wayward couple to go forth: "Be fruitful and multiply, and replenish the earth, and subdue it: and have dominion over the fish of the sea, And over the fowl of the air, and over every living thing that moveth upon the earth." Translator Robert Alter argues that *radah* "is not the normal Hebrew verb for 'rule' . . . and in most of the texts in which it occurs it seems to suggest an absolute or even fierce exercise of mastery."[25] A first reading of these verses concludes that the earth and all that exists upon it were meant for the discretionary use of humans for the intent of supplying the wants of humanity; however, a subtler reading suggests that the reason God delivers nature to humans is so they might repair it. Genesis 2:15 (KJV) reinforces the onus of responsibility that God attaches to the gift of nature: "And the LORD God took the man, and put him into the garden of Eden to dress it and keep it." This reading of Genesis concludes that God delivers dominion of nature to humankind for purpose of repairing (*dressing*) and maintaining (*keeping*) it. As time went on, however, the issue of repair became focused inwardly either on the individual or collective self. In Christianity the focus of repair increasingly became the salvation of the soul, and in Judaism, it became the rectification of social injustice.

The split between the inner self and the outer world occurred gradually as theologians and other commentators endlessly parsed scripture. In 1486, the Italian Renaissance philosopher Giovanni Pico della Mirandola wrote the *Oration on the Dignity of Man,* often referred to as

the "Manifesto of the Renaissance," in which "the Great Artisan" explains to Adam his place in the Great Chain of Being as a creature that is neither bestial or celestial, but, based upon his choice, has the capacity to be either. Pico's Adam floats in the purgatorial margin between the bestial and the celestial. He belongs to both worlds and yet to neither. He aspires to the God-head and yet succumbs to animal instinct. He embraces the animal and yet longs to escape it. In order to empower Adam's free will, however, God put nature at his disposal:

> According to your desires and judgment, you will have and possess whatever place to live, whatever form, and whatever functions you yourself choose. All other things have a limited and fixed nature prescribed and bounded by Our laws. You, with no limit or no bound, may choose for yourself the limits and bounds of your nature. *We have placed you at the world's center so that you may survey everything else in the world.*[26]

Over time, the obligation of dominion—to work on God's behalf to complete an imperfect world—gradually lost its cogency. In 1871, Robert Jamieson of the Church of Scotland concluded in his commentaries that humans were God's proxies, "clothed with authority and rule as a visible head and monarch of the world."[27] The British Methodist minister Adam Clarke (?1760—1832), considered by many to be one of the most influential preachers in the generation following John Wesley, wrote in his *Commentary* that God "prepared every thing for [man's] subsistence, convenience, and pleasure before he brought him into being; so that, comparing little with great things the house was built, furnished, and amply stored, by the time the destined tenant was ready to occupy it."[28] In Clarke's view, God provided the fruits of the earth for our personal "*convenience and pleasure.*" In other words, the purpose of nature was to serve as humanity's larder.

If dominion was a boon, however, it came at the cost of unremitting labor. The steady, purposeful hand of man "cuts down the thistle and the bramble, and . . . multiplies the vine and the rose," observed the Comte de Buffon.[29] Only labor could transform disorder into order and barrenness into fertility, and only tireless vigilance could keep the tended field from slipping back into its native unruliness. Labor consummated the telos of nature by turning wheat into bread, timber into lumber, ore into metals, and mud into brick, making it possible to "correct in some measure," Adam Smith wrote, "that distribution of things which she herself [nature] would otherwise have made," an idea Smith drew from John Locke's claim for the natural entitlement of man to use nature in any way he deemed "necessary or useful to his Being."[30]

In the New World, labor turned nature into spiritual and economic value. Echoing John Winthrop's exhortation to his fellow travelers in his sermon on the eve of the Puritans' exile from England in 1630, that "we must uphold a familiar Commerce together," so that the faithful might build a new Israel, John Locke sanctioned the right of men to seize and hold land through their labors.[31] "God gave the World to Men in Common," he wrote in *Two Treatises on Government* (1689), "but since he gave it to them for their benefit, and the greatest Conveniences of Life they were capable to draw from it, it cannot be supposed he meant it should always remain in common and uncultivated." Harking back to the theological principle of completing an unfinished world, Locke concluded that God had intended that the world belong to those who would, in Buffon's words, multiply the vine and the rose. "He gave it to the use of the Industrious and Rational (and *Labour* was to be *his Title* to it)," wrote Locke, "not to the Fancy or Covetousness of the Quarrelsome and Contentious."[32] Thus the seeds of the imperial imaginary rooted in the pliant soil of nature.

NATURE OPENS HER BROAD LAP

A study of the succession of environmental imaginaries of the American West reveals an accretion of native and nonnative histories that extend as far back as the arrival of human beings on the continent. Whereas the environmental narratives of indigenous people tended to be stable as a result of long-term cultural and environmental adaptation to the conditions of the West, the environmental narratives for nonnatives tended to be less stable as they struggled to cope with the variables of nature that were unique to them. Thus, the concept of the American frontier underwent a series of metaphorical transformations as successive generations of Euro-American explorers, adventurers, and settlers learned to adapt to and control their environments.

From the start, settlers expressed their experience of nature in America in the familiar terms of the trope of a lost land refound, the promise of Paradise Regained. In contrast to the dour Puritanical vision of nature as "a waste and howling wilderness / Where none inhabited / But hellish fiends, and brutish men / That Devils worshiped," other early writers about American surrendered themselves to a more effusive style when writing about nature.[33] Robert Beverly in *The History and Present State of Virginia* (1703) described a place "so agreeable, that Paradise it self seem'd to be there, in its first Native Lustre."[34] Beverly's hyperbole was not uncommon among early American writers, many of whom were enchanted by what seemed an unpossessed "virgin" continent in spite of the fact that there was ample evidence that the indigenous population had invested heavily in the maintenance of forests and grasslands for generations.

Other writers resorted to familiar metaphors of sexual conquest or what Anne McClintock calls "the erotics of ravishment."[35] In 1632, Thomas Morton likened vacant New England to a virgin whose "fruitfull wombe not being enjoyed, is like a glorious tombe."[36] And in 1782, J. Hector St. John de Crèvecoeur described America in *Letters from an American Farmer* as a place where "nature opens her broad lap to receive the perpetual accession of new comers and to supply them with food."[37]

The common thread to these authors was the belief in the rightful claim of dominion over nature and the mandate to convert wilderness into a "fruitful garden." The imperative of finishing the unfinished became the decisive cultural project over the next 250 years. By the time Jefferson published *Notes on Virginia* in 1785, the libidinous pastoralism of writers such as Beverly and Crèvecoeur took on a more practical, ideological hue. Jefferson's notion of the agrarian farmer embraced the land and shunned the excesses of "European luxury and dissipation."[38] Even though Jefferson admitted his vision was only "a theory which the servants of America are not at liberty to follow," the image took root in the American psyche and gradually ripened into a social icon, resurfacing in a rich variety of guises.[39] The American hero and heroic landscape become sui generis. He appeared in the political landscape of Jefferson's agrarian farmer and Andrew Jackson's "common man" in the artistic landscape of authors such as Cooper, Wister, Melville, Hemingway, and the poetry of Whitman, Sandburg, and Frost; on the palettes of Thomas Moran, Thomas Cole, Alfred Bierstadt, and Thomas Hart Benton; through the photographic lenses of William Henry Jackson, Ansel Adams, Robert Flaherty, and Pare Lorenz; and in the philosophical landscape of Emerson and Thoreau. The essence of the American experience for both Europeans (and Native Americans albeit in fundamentally different ways) has been rooted in a complex of verbal and visual images of nature that hosted their collective dreams, desires, and fears about themselves. These images—and the meanings attached to them—constitute a critical dimension of the dialectical relationship between nature and society. For better or worse, nature became forge in which the nation hammered out its national identity.

PICTURING AMERICA

Prior to the Civil War, images were largely a privilege of the elite. The paintings and pioneer photography that portrayed the majesty and awe of the American wilderness were unique objects that found their way into the parlors of the rich and eventually into museums. During the 1890s, however, improved printing technology started to make images accessible to everyone. Mass-produced images of endlessly rolling grasslands, fertile valleys, and forests teeming with wildlife reflected a rapidly changing discourse about the West.

The verbal and visual narratives provided by a culture that was keen on having its citizenry settle the West created expectations of minimized risk, open space, the opportunity for wealth, and social stability. As the known replaced the unknown, images of conquest and settlement replaced images of marauding savages scalping hapless settlers and an endless stream of tornadoes, prairie fires, droughts, and blizzards. The pioneer had cleared the way for a new hero, the settler family, whose plow broke the plains and whose axe turned the rough, unhewn forest into cabins, settlements, and towns. Reward outweighed risk, and trepidation turned into awe as people became fascinated with images of geysers that shot boiling water a hundred feet into the air and of blazing red desert canyons. From the cramped confines of their cities, people began to *see* unbridled opportunities of the West to grow families, wealth, and a nation.

Then, in 1895, less than two years after Frederick Jackson Turner famously declared the end of the American frontier, two Frenchmen, Auguste and Louis Lumière, premiered what is generally accepted to be the world's first public film screening in a darkened basement lounge of the Grand Café on the Boulevard des Capucines in Paris.[40] The debut of the motion picture camera—the *cinématographe* as the French called it—would not only chronicle the sights of a century in transition, it would also capture and reflect the zeitgeist of a time when the West wrestled with the heady imperatives of empire.

On the other side of the Atlantic, Thomas Edison's lab in West Orange, New Jersey, was developing its own version of the *cinématographe*, the Kinetograph. The camera was so unwieldy—it weighed more than half a ton—that it took up residence in its own building, which was itself mounted on a pivot so it could follow the sun in order to maximize the lighting through its open roof. Dubbed the "Black Maria" because of its resemblance to a London paddy wagon, Edison's camera could not "go out to examine the world; instead, items of the world were brought before it—to perform."[41]

The Lumière's camera, however, weighed less than twelve pounds. Rather than have the world come to it, the *cinématographe* went out into the world. By 1903, the Lumière catalogue contained over two thousand *actualités,* the term given for the documentary slices-of-life that chronicled everyday events around the world.[42] Audiences watched the pageantry of European royalty, from the coronation of Nicholas II in Russia (*Couronnement du Tzar,* 1896) to the funeral of King Oscar II; they watched a bullfight in Spain (*Arrivée des Toréadors,* 1896), gondolas in Venice (1897), elephants in Cambodia (*Promenades des Éléphants à Phnom-Penh,* 1901) and coolies in Vietnam (*Coolies à Saigon,* 1897). Footage poured in from every corner of the world: India, Australia, the Americas, Africa, Turkey, and Asia: the Lumières brought the world to the doorstep of Everyman.

Animals became a major staple of pioneer cinema because they were exotic and because they helped to play out Western fantasies of the human domination of nature. The camera, which was slow to venture into the jungles, swamps, or savannahs of the world, preferred instead to film the captive and domesticated animals that were easily available on farms or in circuses, menageries, and zoos. Bears, lions, elephants, and monkeys became token ambassadors of

nature. The hundreds of films shot between 1895 and 1903 that include animals as their primary subject reassured their audience that the beasts of the world, both domestic and wild, had submitted to the superior moral and physical authority of humans.

By the end of the nineteenth century, Americans started to believe for the first time that nature was more under their control than they were under its. The trappers, explorers, and adventurers who had ventured into the dark interior of the American continent were largely bereft of social, spiritual, and material support and so learned how to live in the hinterlands of nature. The wisdom to cope with the hostile elements frequently required that they watch and learn from other animals and from Native peoples. But as Euro-Americans moved in from the margins of the continent and settled the interior, they cut the forests and plowed the plains, they built towns and cities and the roads between them. Rather than embrace the commonalities between themselves and nature, they put as much distance as possible between the two by claiming the God-given right of dominion. And while people periodically suffered from the devastating effects of dust storms, tornadoes, droughts, fire, and flood, they began to feel confident that the forces of nature could no longer dislodge them. Nature, it seemed, had retreated to the no-man's-land of swamps, deserts, and glacial peaks, and had ceded the rest to man.

A STRONG HAND THAT SHALL BROOK NO RESISTANCE

In 1901, on the occasion of the 125th anniversary of the Battle of Trenton, Woodrow Wilson gave a speech called "The Ideals of America" that described a nation poised on the brink of realizing its capacities as a progressive power. American democracy, Wilson claimed, was not the outcome of a simple declaration of independence but the culmination of a process that took many decades to evolve. Wilson argued that America had matured from adolescence to adulthood over the past century and was now both capable and deserving of its responsibilities as a leader among nations. "The Battle of Trenton is as real to us as the battle of San Juan hill," Wilson commented, deftly connecting the American Revolution with the Spanish-American War as an enterprise of honorable necessity, as though the seizure of Cuba and the Philippines were a natural, if not an inevitable, outcome of history. Wilson proclaimed that the social, political, and moral anomie that had so recently eroded the resolve of a nation had been replaced with a clarity of vision and a commitment to action that was similar to the vision that had prompted the leaders of the colonies 125 years ago. "It was clear to us even then, in those first days when we were at the outset of our life, with what spirit and mission we had come into the world," Wilson exhorted. "Some men saw it then; all men see it now."

Like Theodore Roosevelt before him, Wilson pointed to the West as evidence of national destiny. "We stretched our hand forth again to the West, set forth with a new zest and energy upon the western rivers amid the rough trails that led across the mountains and down to the waters of the Mississippi. There lay a commitment to be possessed." That, Wilson concluded, was to be "the real making" of the nation:

> That increase, that endless accretion, that rolling, restless tide, incalculable in its strength, infinite in its variety, has made us what we are, has put the resources of a huge continent at our disposal; has provoked us to invention and given us mighty captains of industry. This great pressure of a people moving always to new frontiers, in search of new lands, new power, the full freedom of a virgin world, has ruled our course and formed our policies like a Fate.[43]

The Spanish-American War, Wilson argued, had transformed a loose confederacy of states into a tightly knit nation. But America had been blessed with a superior strain of men "of a certain initiative, to take the world into their own hands." Other nations with less vigorous people could not hope to realize democracy without the guidance and stern hand of those nations that had realized the full potential of democracy. "In brief, the fact is this," Wilson spoke bluntly, "that liberty is the privilege of maturity, of self-control, of self-mastery and a thoughtful care for righteous dealings,—that some peoples may have it, therefore, and others may not."

The people of Cuba and the Philippines were among those who required American assistance to realize a mature democracy, but those privileges came not as a gift but at a cost. "This is what we seek among our new subjects," Wilson insisted, "that they shall understand us, and after free conference shall trust us: that they shall perceive that we are not afraid of criticism, and that we are ready to explain and to take suggestions from all who are ready, when the conference is over, to obey." The orphaned people of the Philippines, like the Cubans and other less determined, less developed people around the world, lacked a commonality of history or spirit. They were, in the common phrase of the day, a grasshopper people, much like the grasshopper in the Aesop's tale that fritters away the day seeking his own immediate pleasures rather than preparing for the hardships that lie ahead. The international political arena was rapidly turning global, and only those nations that could flex their political muscles convincingly would have a seat at the table. The United States was ready to take its place among the powerful nations, and it was determined to show the rest of the world that it was a mature, muscular nation, ready for action and strong enough to prove a point.

This vigorous, immodest rhetoric sparked the imagination of every politician, factory worker, and housewife in America. The patriotic swell that had rolled out of Havana Harbor in 1898 washed across the nation. When once it meant more to be a Missourian or a New Yorker than it meant to be an American, the unifying appeal of Wilson's message helped reverse that polarity. The United States consolidated. And the camera—particularly the motion picture camera—became the primary vector for reinforcing these goals.

More than any other device or technique, the motion picture camera transformed nature from a material reality into a dream of something half-forgotten. It rendered three dimensions into two, and muted nature's voice, and glorified the human voice. It created a new vision of America based upon the image of the mythic frontiersman. Its virtues were boldness, fearlessness, and resolve, the same virtues that had created the determined generations before them who had fought for independence and the rights of men. These lessons repeated themselves in the nation's matinées, which pandered to the national mood. Notions of empire played out in the newsreels—*actualités* that reinforced a federal image—and in the countless nickelodeons and vaudeville stages of America. It was a time for new heroes.

The American motion picture camera normalized the social chain of being in America with the president of the United States at the top, followed by all the senators and governors, and the lawmen, followed by white male citizens, female white citizens, and finally outlaws, who themselves had greater status in the white world than black males or black females, who, in spite of occupying the lowest rung on the ladder of being in America, were frequently objects of forbidden desire to some of those above them. And the glue that held this social schemata together was dominionism, first over nature, and then over the earth.

Film offered awe for the exotic, but more importantly, these animal films became the nation's first motion picture fables as they argued the case for the American dominion over nature.

PROFESSOR HAGENBECK'S BICYCLING POLAR BEARS

The first generation of natural history films embodied naive and endearing narratives about taming the beast. Among the earliest *actualités* of the Lumières was *Feeding the Swans* (1895), which is arguably the world's first natural history film.[44] The film consists of a static shot of people feeding swans in a park. Edison followed a year later with *Feeding the Doves,* a twenty-five-second film showing a woman and a little girl feeding doves. Dozens of other feeding films followed. They included feeding everything from domesticated animals such as kittens, ducks, pigeons, geese, swans, dogs, and hogs to wild animals such as ostriches, otters, sea lions, bears, rhinoceros, elephants, hippopotami, and chameleons. In every case, a human feeds a dependent animal, often from the hand if not a child's hand, suggesting that all beasts humble themselves before them.

The point was made emphatically in films that featured small children playing in the company of wild animals. In 1902 one of Edison's competitors, the American Mutoscope and Biograph Company, listed *Children Playing with Lion Cubs* in its catalogue, which described the film as "a rather remarkable picture, taken in the Berlin Zoological Gardens showing two little children romping with a pair of lion cubs."[45] A few months later a similar film appeared in the S. Lubin Studio catalogue; in it yet another child "is seen playing and rolling around with six or eight lion cubs, the smallest of which is much larger than himself. The child shows no sign of fear and everyone will be surprised at the playfulness of these young but wild animals."[46]

The Lubin Studios also distributed *Small Boy and Bear, Hagenbeck's Circus* in 1903, which featured a child playing with "the largest black bear in captivity." Dozens of other similar films followed. These films represent a free rendering of Isaiah 11:6, in which the lion, led by a little child, lies down with the lamb. (It is actually a wolf, not a lion, which lies down with the lamb in Isaiah.) Only the tranquility presented in these films has little to do with an equitable peace between all creatures; rather, it has to do with symbolically affirming their submission to humans.

The animal performance film became very popular during this time. The fierce denizens of nature had been recast as a troupe of maudlin characters acting out scenarios of domesticity. By forcing animals that once threatened humans to engage in parodies of human social customs, society symbolically defanged nature. Some early films, for example, featured boxing animals, such as *Professor Welton's Boxing Cats* (1894), *Boxing Cats* (1898), *Boxing Dogs* (1899), *Boxing Horses, Luna Park* (1904), and one particularly egregious film, *The Boxing Horse* (1899), featured a horse that has been fitted with a pair of boxing gloves fighting a "powerful colored man." According to the film's summary, they "pummel each other all around the ring. The horse scores the only knockdown."[47]

Other films showed animals doing everything from jumping hurdles (*Bear Jumping Hurdles,* 1899) to riding bicycles (*The Monkey Bicyclist,* 1904) to a variety of animals such as dogs, bears, donkeys, elephants, and horses wrestling each other or humans. These acts had their roots in the circus midway where chickens played the piano or monkeys smoked cigarettes and played cards. A society that could make a polar bear ride a bicycle or could dress an elephant in a pink tutu and get it to stand up on its hind legs in mockery of a pirouette believed it could lay low the most wild and therefore the most threatening of beasts.

Hegel surmised that "An out-and-out Other simply did not exist for the mind."[48] By incorporating attributes of the alien into the more familiar properties of the self, society strives to negate the threat of power by the Other. Elephants that perform ballet or monkeys dressed

up as a bride and a groom that get "married" by another monkey dressed as clergy reflect our distal selves. Instead of acting as surrogates that illuminate humanity, animals in performance films act as ironic foils to it. The parade of animals that perform on film in the early part of the twentieth century were exercises of power disguised as gentleness. They reaffirmed society's dominion over nature by reassuring its citizens that *all* life depended upon it for something as basic as sustenance (as in the feeding films) and that even the fiercest of beasts—lions and bears, for example—had been humbled before it to the point that children could play with them fearlessly. More importantly, their performances indicate not simply subservience, but obedience.

By 1904, however, films about humbled animals had run their course. In 1903 Pathés Frère released *Hunting the White Bear,* a film that revised the role of the wild beast in the grand morality play on the cinematic stage.[49] *Feeding the Hippopotamus* (1903) became *Hunting the Hippopotamus* (1907) and *Feeding the Russian Bear* (1903) became *Bear Hunting in Russia* (1908). The same beasts that had so recently begged morsels of food from the open palms of women and children suddenly found themselves being stalked by rich, white men who were intent on aggressively reasserting their imperial claims to dominion with a .375-caliber Holland and Holland Royal Double Rifle.

By 1906 hunting films were a matter of regular fare.[50] The earliest of these films dealt with more domestic and therefore more stylized forms of hunting, such as fox, deer, boar, and duck, all of which were the province of the gentlemanly class. But as the camera ventured farther out into the imperial world, the nature of the quarry shifted to increasingly exotic and correspondingly dangerous animals such as bear, lion, crocodile, buffalo, wolf, hippo, elephant, and even whales. During the next four years, hunting films girdled the globe: *A Moose Hunt in Canada* (1906), *A Polar Bear Hunt* (1906), *Hunting Buffalo in Indo-China* (1908), *Elephant Hunting in Cambodge* [sic] (1909), *Panther Hunting on the Isle of Java* (1909), *Hunting Sea Lions in Tasmania* (1910), *Hunting Bats in Sumatra* (1910), *Bear Hunt in the Rockies* (1910), and many others.

These representations of nature in early American cinema reflect an increasingly aggressive assertion of dominion, coterminous with the national expansion of empire. From the passive aggressive *Feeding the Swans* (1895) to the aggressive *Bear Hunt in Russia* (1909) and *Lassoing Wild Animals in Africa* (1911), the public came to understand nature as increasingly subject to the rule and authority of its human masters. One by one, the presumptuous moral authority of the Western juggernaut humbled the great beasts of the world—and the countries they inhabited. Gradually the beast became an imposture for contended imperial places: one hunted *African* lions and *Indian* tigers and *Russian* bear. Where conquest was wanting, the wildest, fiercest emblem of place became the target of the white hunter, and so the hunt of the wild animal played out the hunt for imperial power.

Now and then, however, that rationalization went terribly awry.

DEATH IN THE PARK

The most grievous visually recorded example of an assertion of human dominance over the animal occurred in 1903, when Edwin S. Porter filmed the execution of a Coney Island elephant for alleged crimes against humanity (*Electrocuting an Elephant*).

By contemporary accounts Topsy was an unpredictable, ill-tempered animal that had already killed two people by the time she came to Luna Park, an elaborate amusement park that was under construction at Coney Island in late 1902. Elephants had always been a big attraction in American circuses and amusement parks. For years, the elephants Gyp and Judy carried as many as 9,000 people a week on their backs up and down the boardwalks of Luna Park without incident. But six months before the park was scheduled to open, a drunken handler fed Topsy a lit cigarette, whereupon she picked him up with her trunk and "dashed him to the ground, killing him instantly."[51]

Frederic Thompson and Elmer "Skip" Dundy, the developers and promoters of Luna Park, knew they had to do something to punish their "outlaw" elephant. They hit upon the scheme of performing a public execution, which they hoped would maximize what was left of Topsy's income potential. So they decided to hang the elephant in public.

When they announced the execution to the public, the American Society for the Protection of Cruelty to Animals denounced it as inhumane; after all, the ASPCA pointed out, even the state of New York had given up hanging men in 1888 in favor of a more humane method called electrocution.[52]

Instead of hanging Topsy, Thompson and Dundy decided to commission Thomas Edison to provide the technical expertise to build a device capable of delivering enough electricity to kill a three-ton elephant. Unknowingly, they stepped into the middle of a dogfight between two American titans of industry who were battling over nothing less than the future of electricity in America.

George Westinghouse and Thomas Edison were deadlocked in a struggle for control over which electrical system would prevail for delivering current to America. Westinghouse developed alternating current (AC) and Edison, direct current (DC). The economic stakes were enormous. Edison knew Westinghouse's alternating current could produce higher voltage and deliver it over longer distances than could his direct current, but he hoped he could sabotage Westinghouse by convincing people that alternating current was more dangerous than his direct current.

In 1887 Edison bought a 1,000-volt Westinghouse AC generator and invited the public to his lab to watch as he electrocuted dozens of stray cats and dogs (rounded by up neighborhood children for twenty-five cents each) so everyone could see how lethal Westinghouse's alternating current was. And when the governor of New York signed a bill allowing for the execution of criminals by electrocution, Edison lobbied that the electric chair use Westinghouse's version so people would associate the dangers of electrocution with alternating current.

Over the next eight months, Edison publicly electrocuted a series of large dogs and then finally, in a grisly cadenza, executed two calves and a 1,200-pound horse in order to convince the State of New York that AC was deadlier than DC. His smear campaign worked. Noted the *New York Times* after witnessing the agonizing deaths produced by Edison's experiments, "After January 1 (1889), the alternating current will undoubtedly drive the hangmen out of business in this state."[53]

So, in 1903, it seemed appropriate to Thompson and Dundy to ask Edison to electrocute Topsy. Sensing an opportunity to fire another potshot at Westinghouse, Edison seized on the opportunity and hired Edwin S. Porter to document the event on film.

In the long run, the intrigue between Westinghouse and Edison didn't matter. Westinghouse prevailed over Edison, and, ironically, won the Edison Medal in 1911 for "his meritorious achievements" for the development of alternating current. Both men went on to

make their fortunes. In 1903 Edwin S. Porter made *The Great Train Robbery,* the first narrative film in American cinema, and Luna Park burned down in the summer of 1944. But Porter's filmed images of Topsy remain, endlessly resurrected at the moment of her death, as 6,600 volts of electricity vaporize the liquids of her body, enveloping her in billows of steam.

The spectacle of humbling the world's largest land animal through the exercise of modern technology proved irresistible to the public, and so, on January 4, 1903, a throng of fifteen hundred "curious persons . . . went down to the island to see the end of the huge beast, to whom they had fed peanuts and cakes." The *New York Commercial Advertiser* recorded the triumph of technology over nature:

> In order to make Topsy's execution quick and sure 460 grams of cyanide of potassium were fed to her in carrots. Then a hawser was put around her neck and one end attached to a donkey engine and the other to a post. Next wooden sandals lined with copper were attached to her feet. These electrodes were connected by copper wire with the Edison electric light plant and a current of 6,600 volts was sent through her body. The big beast died without a trumpet or a groan.[54]

Topsy had to be destroyed because she was *bad-natured.* The press had a field day characterizing her as a recalcitrant rogue, a man-killer, and the defiance that was implicit in her behavior made her execution all the more sensational. The terms of dominion were absolute, no matter how degrading or brutal the circumstances of it. However justified Topsy might have been in killing her sadistic handler, she made her death inevitable by killing him because, as Lisa Cartwright notes in *Screening the Body,* she embodied "Western anxieties about resistance to colonial authority."[55]

Edison produced two other films about Luna Park elephants after Topsy's execution. *Elephants Shooting the Chutes, Luna Park Coney Island* and *Elephants Shooting the Chutes, Luna Park Coney Island #2* (1904)—also shot by Porter—featured Topsy's *good-natured* brethren as they gingerly plucked cakes and peanuts from the palms of children or "gleefully" slid down the giant water slide at Luna Park with a big splash in the pool. Over time *Electrocuting an Elephant* has stripped away the historical circumstances that brought Topsy to her death in an American amusement park, but it remains a stark reminder that the terms of dominion are nonnegotiable, and that the price society exacts for animal disobedience is death.

GERTIE THE DINOSAUR

If Topsy represented the dark side of dominion, then Gertie represented its bright side. In 1913 Winsor McCay created an animated brontosaurus as his sidekick in a traveling vaudeville act. McCay, as the live presenter, would interact with Gertie, who was projected onto a screen next to him. McCay timed Gertie's responses so that their interactions seemed spontaneous. For example McCay would play "catch" with Gertie by throwing a ball at the screen that would then appear in Gertie's world, or when the theater orchestra struck up a tune, she would stand up on her hind legs and dance.[56]

McCay endowed Gertie with the emotional and intellectual attributes of a family dog. She was eager to please, attentive, playful, she played "catch," and she sulked when scolded. (A promotional poster of the time reads, *"She eats, drinks, and breathes! She laughs and cries!*

A promotional poster for Gertie the Dinosaur, 1914

Dances the tango, answers questions, and obeys every command!") More importantly, Gertie was compliant; McCay transformed her from a threatening brute into something endearingly domesticated. She played the role of an attentive and faithful retriever that was anxious to please. Nature had finally been rendered obedient, docile, and subject to the whims of its human masters.

Or so it seemed.

The Plow and the Gun

THE PLOW

In 1890, Robert P. Porter, the superintendent of the eleventh national census, made note, in the perfunctory style of a federal bureaucrat conducting the business of state, that "at present the unsettled area [of the United States] has been so broken into by isolated bodies of settlement that there can hardly be said to be a frontier line. In the discussion of its extent, its westward movement, etc., it can not, therefore, any longer have a place in the census reports." Porter based his conclusion upon the federal definition of the frontier, which was predicated upon the statistical density of settlers per square mile, but in the eyes of one historian at the University of Wisconsin, Porter had just published the official obituary for the American frontier.

Three years later, Frederick Jackson Turner stood in front of his colleagues at a meeting of the American Historical Society in Chicago and announced "the closing of a great historic movement" in American history. "The true point of view in the history of this nation," Turner argued, "is not the Atlantic coast, it is the Great West."

It was a bold argument. Few historians had paid attention to the West in spite of its rapid expansion and development since the Civil War, and now a historian was pointing to the West and claiming that "the existence of an area of free land, its continuous recession, and the advance of American settlement explain American development."[1] In other words, the hardships of life on the frontier had bred the first generation of men and women of truly American character.

Turner implied that the birthplace of the nation wasn't really the eastern establishment cities such as Philadelphia, Boston, New York, or Washington, but the vast uninhabited interior of the continent, where the most daring of the nation's citizens had been battling the titanic forces of nature to carve out a life for themselves as yeoman farmers. The people who lived on the eastern seaboard and in the South, according to Turner, carried "the Germanic germ" of culture and still practiced the old, effete ways of Europe. And although the settlers carried those same old laws and ways with them as they trudged past the Alleghenies, the heady demands of life on the frontier dictated that they adapt to new rules or perish. So they jettisoned the heavy furniture of their past as it bogged down their progress. The West, Turner concluded, had created a hearty people who were capable of building empires.

Traditionally, the reasoning went, nations expanded by conquering other nations, even though Turner didn't equate Native Americans with equal nations or even as civilized enemies.[2] They may have been human beings, but only marginally because they were *savages* and so did not earn moral respect. In the emerging nation's mind, the struggle for possession wasn't between men and nations as much as it was between man and nature.

From the settler's point of view, savages were raw products of nature that lived like beasts, ignorant of science or commerce. They didn't care about the value of a farm or a town, and so they were inconvenient squatters who should be swept away in favor of a nobler cause. Turner's West was a vast, unoccupied, and unclaimed domain that beckoned to the hunter and the trader to exploit the beasts, the rancher to exploit the grass, and the farmer to exploit soils that had never known the biting edge of a plow. "The United States is unique," he wrote, "in the extent to which the individual has been given an open field, unchecked by restraints of an old social order, or of scientific administration of government." The riches of the earth belonged to anyone who was bold and clever enough to claim them.

Nature, however, did not yield its treasury easily. Possession required the struggle of undaunted pioneers to overcome the prodigious forces of nature that opposed them. They fought this battle on the frontier, which became the skirmish line between nature and civilization. More of a conceptual space than a geographical place, it was here that "the hither edge of free land" created a unique breed of American man and woman. "The West, at bottom," wrote Turner, "is a form of society, rather than an area."

Turner perceived nature to be such a powerful force that it overwhelmed the pioneer by stripping away the veneer of civilization and rendering him little more than a savage. "Before long," wrote Turner, "he has gone to planting Indian corn and plowing with a sharp stick, he shouts the war cry and takes the scalp in orthodox Indian fashion." Little by little, however, the pioneer by virtue of his racial vigor rose above the primitive and transformed the wilderness into a place of his own making, just as the wilderness had transformed him into "a new product that is American."

> The result is that to the frontier the American intellect owes its striking characteristics. That coarseness and strength combined with acuteness and inquisitiveness; that practical, inventive turn of mind, quick to find expedients; that masterful grip of material things, lacking in the artistic but powerful to effect great ends; that restless, nervous energy; that dominant individualism, working for good and for evil, and withal that buoyancy and exuberance which comes with freedom—these are traits of the frontier, or traits called out elsewhere because of the existence of the frontier.

The West naturally seemed to affirm the principles of democracy, independence, and the value of private property in creating an ideal society. Turner's New American was self-made, "the Western man's ideal, the kind of man that all men might become." But then, in 1890, the frontier disappeared from the official map of America.

The Children of Cronus

The German geographer Friedrich Ratzel gave national expansionism a name: *lebensraum* (literally, *living space*). A healthy, vigorous nation had to grow for its own well-being, so the appropriation of extranational territory became a necessary part of a process of accretion that supplied critically needed space and resources. Less than forty years later, Adolph Hitler would use lebensraum as a justification for Germany's realpolitik, but Ratzel defined expansionism in 1897 as a natural metabolic process of state in less aggressive social Darwinian terms.

Ratzel conceived of the state as an organism that was in constant geographical flux. As civilizations grew, matured, and declined, the old made way for the new by surrendering the

value of its resources in order to provide for the demands of more vigorous nations. Therefore, Ratzel concluded, the unnatural imposition of static borders between countries did not allow for the natural expansion and contraction of civilizations. For an emerging nation, fixing borders was like asking a child's frame to contain its own growth permanently.

Turner prefigured Ratzel's organicism. The American West was a process of the mutual assimilation of the primitive and the civilized made possible through the process of labor. Like Karl Marx, Turner appreciated the power of labor to transform nature for the needs and purposes of humankind, but Turner (and Ratzel) departed ways with Marx when it came to attributing actual agency for change.

Marx attributed the process of change within nature and the self to the transformative power of labor. "By changing nature," Marx wrote, "man changes himself." The exigent demands of the frontier required an endless schedule of back-wrenching labor, which in return provided for immediate needs such as food, clothing, and shelter. The changes that occurred within the human psyche as a result of the interaction between the self and nature were instigated by and a result of human-induced effort. "It is life engendering life," Marx wrote of this most basic form of labor, which he called the *productive life* because it served as a means to meet some need, the need of maintaining physical existence.

Turner, however, saw more of a dialogic relationship between nature and the people who sought to colonize it. He agreed with Marx that humans had the power to change nature, certainly, but he also believed that nature held an even greater power to change humans. Turner and many that followed him such as Ellen Churchill Semple (a student of Ratzel's) and Ellsworth Huntington were determinists who believed that nature not only shaped human character but also defined social, political, and economic institutions. Turner's New American—the men and women who defied the imperious grasp of nature—were as much products of the West as the bison, the Indian, or the prairie. The land disciplined them with the emotional volatility of an imperious stepparent fresh out of a Dickens novel: generous and forgiving one moment and unpredictably intolerant and cruel the next. Whatever their lot, however, they were all children of the land, which defined them both mentally and physically.

But, as Turner pointed out, the frontier was a process rather than a place, and as such it could not put down roots because it was constantly being dislocated and relocated on the interstices between the primitive and the civilized. As the advance line of an army of conquest, the frontier necessarily had a provisional geographical status. When nature overwhelmed the settlers, the line retreated eastward, and when humans persevered and settlement followed, the line advanced westward. Every ten years since 1790 the Bureau of the Census had published a statistical atlas that showed the frontier line rolling like a tide across the empty interior of the continent, and after each census it became increasingly more apparent that the frontier would eventually run out of space. Now that the American juggernaut had reached the Pacific shore, Turner wondered, where would future generations channel the restless energy of their forbears? He wrote, "The free lands are gone, the continent is crossed, and all this push and energy is turning to channels of agitation. Failures in one area can no longer be made good by taking up land on a new frontier; the conditions of a settled society are being reached with suddenness and with confusion."[3]

By 1893 there was growing public awareness that a unique phase of American history was fading away. In July, *Harper's Monthly* sent the author Owen Wister to the West to gather material for short stories that would capture "Western life which is now rapidly disappearing with the progress of civilization." *Century* also published a series of chapters from a book by

a feisty Dakota rancher by the name of Roosevelt who wrote about "Cowboy Land" and the hardiness of character that nature engendered in those who lived there.[4] It was clear the West was entering a period of transition and that something important about its character was in danger of being lost.

Nature Materialized

The emergence of world markets in the late nineteenth century had, in the words of Karl Marx, stimulated "the exploration of the world in all directions" in order to promote the "universal exchange of products of all alien climates and lands."[5] Having blunted nature's tooth and claw, settlers were then free to turn their energies toward harvesting the material riches of the land. A new colonial order took root in the West. Capital poured in to build access to and from markets. Increasingly nature spoke less to the sustenance of the soul than it did to the sustenance of the national pocketbook. Forests, once revered as nature's cathedrals, turned into repositories of wealth.

In 1893 the nation was in the throes of the most severe economic depression of its history. National uncertainty had translated into economic instability. A public run on the nation's gold reserve destabilized the monetary system, causing hundreds of banks and many of the nation's major railways to founder. In all, 15,000 businesses failed, leaving a quarter of the nation's workforce out of jobs. In spite of the bright light that shone upon the Columbian Exposition in Chicago in 1893, the prospects of a country in desperate need of direction seemed grim.

Turner presented his thesis in the midst of this national malaise, and what he said seemed to speak to it. But other than raising a few eyebrows within the academic community, his essay went barely noticed in 1893. Yet Turner made a prediction that would prove prescient. As a progressive and an optimist, he didn't believe the nation would surrender the qualities he believed had made it great. If the frontier was gone, then it was time for the nation to look past its own shores to find new frontiers. He projected America's future: "The demands for a vigorous foreign policy, for an interoceanic canal, for a revival of our power upon the seas, and for the extension of American influence to outlying islands and adjoining countries, are indications that the movement will continue." "But," he added, "it might mean a drastic assertion of national government and imperial expansion under a popular hero." In other words, what the country needed was a strong, charismatic leader who could pull its people out of its national funk and unify the jumble of interests of a confederation of states into a single constellation that would light up the global sky.

In 1893 the prospects of such a leader seemed remote. A succession of middling party regulars had stood at the helm of state since the Civil War—Rutherford Hayes, James Garfield, Chester Arthur, Grover Cleveland, and Benjamin Harrison—none of whom had shown himself willing or able of rising above the internecine bickering that had become to symbolize federal government. The nation yearned for a clarion voice that did not waiver with moral uncertainty, a man with bold, sweeping initiatives who could restore national self-esteem by claiming a rightful seat for America at the table of imperial nations. But as Grover Cleveland returned to the presidency in 1893, the nation settled for treading water. The nation remained restless and uncertain and awaited impatiently for its hero.

Meanwhile, another historian was sitting in his study on Madison Avenue in New York City putting the final touches on the third volume of his own history of the American West. He

echoed Turner's sentiments that the frontier shaped and promoted prototypical American virtues such as self-reliance and individualism. "As our civilization grows older and more complex," he rued, "we need a greater and not a less development of the fundamental frontier values."[6]

THE GUN

When Turner delivered his paper in 1893, Theodore Roosevelt Jr. was thirty-four years old and had achieved some limited notoriety as a politician and a historian. Although he'd served three terms as a representative to the New York State Assembly (1881–1883) and had made a reputation for himself as a sober-minded reformer, his political future was anything but certain. His personal life suffered a major setback in 1884 when his mother and his wife of four years died in the same house on the same day (ironically, Valentine's Day). Heartbroken, he took refuge on a cattle ranch he owned eight miles south of Medora on the Little Missouri River in the Dakota Territory and threw himself into what became two great passions in his life: hunting and the American West.[7]

A man of tremendous energy and insatiable curiosity, he wasn't the sort of armchair dilettante who dabbled in subjects to satisfy his whim; rather, he attacked whatever the subject at hand and with the sincerity of one who wanted to be taken seriously as an authority on that subject. By turns he was a naturalist, a politician, a hunter, a rancher, a cowboy, an explorer, and, an historian. He was an American renaissance man with an insatiable appetite for knowledge and equally insatiable hunger for action.

When Turner made public his thesis, Roosevelt had already published ten books on a potpourri of subjects about American life and history ranging from a naval history of the War of 1812, to sketches of Missouri senator Thomas Hart Benton and federal statesman Gouverneur Morris, and a brief history of New York City. The fact that he'd taken only one course in history at Harvard didn't dampen his pretensions to become a historian. He preferred to think of history as a form of literature rather than as an academic discipline. As the "gentlemen historians" Francis Parkman and William H. Prescott went, so Roosevelt felt entitled to follow.

By 1893, he had already written three books on his experiences as a cattle rancher and hunter: *Hunting Trips of a Ranchman: Sketches of Sport on the Northern Cattle Plains* (1885), *Ranch Life and the Hunting Trail* (1888), and *The Wilderness Hunter: An Account of the Big Game of the United States and Its Chase with Horse, Hound, and Rifle* (1893). His books were received well by the critics and the public. He also published the first two volumes in his self-proclaimed magnum opus, *The Winning of the West,* an apologia of his aggressive racial views about the rights of dominion.[8] Turner's ideas resonated with Roosevelt, and he wrote Turner to congratulate him for having "put into shape a good deal of thought that has been floating around rather loosely."[9]

Roosevelt had already laid out his thoughts about the West and the rights to possession of it in bold detail in his 1887 "biography" of Senator Benton, in which he declared unapologetically that as a nation, it was "our manifest destiny to swallow up the land of all adjoining nations who were too weak to withstand us."[10] His argument was an aggressive mix of social Darwinism and racism. He celebrated the white race—the natural "heirs of the earth"—that by virtue of its innate superiority was "utterly careless of the rights of others, looking upon the possessions of all weaker races as simply their natural prey."[11] He also celebrated the role of

power in determining and preserving natural order. "It is only the warlike power of a civilized people," he declared oxymoronically, "that can give peace to the world."

In Roosevelt's view, the frontiersman was a warrior on the front line of the battle of accession. Like Turner, he believed that the "stern and hard surroundings of [the pioneer's] life had hammered this people into a peculiar and characteristically American type."[12] Unlike Turner, however, Roosevelt believed that the pioneers did not jettison their cultural heritage as they encountered the difficult circumstances of the frontier; rather, they affirmed their racial destiny by completing the "rough pioneer work of civilization in barbarous lands," reaffirming the customs, creeds, and laws of their European ancestry.[13]

In contrast to Turner, who treated Native Americans as if they were invisible, Roosevelt was utterly contemptuous of them: "in their paint and their cheap, dirty finery" they failed to deserve any consideration of rights or property:

> Much maudlin nonsense has been written about the governmental treatment of the Indians, especially as regards taking their land. For the simple truth is that they had no possible title to most of the lands we took, not even occupancy, and at the most were in possession merely by virtue of having butchered the previous inhabitants.[14]

Roosevelt argued that it was the prerogative of the conqueror to abrogate any treaty or agreement that compromised the national interest. Breaking a treaty, he wrote with unwavering moral certainty of an ideologue, was "not only expedient but imperative and honorable." He believed, as many of his time did, that there were three "progressive stages of civilization," starting with the savage, which evolved into the barbaric, and then into the civilized. In this chain of being, the people who were closest to nature—savages—were the most bereft of moral substance and therefore the least deserving, and those who were farthest from nature—the civilized—were the most morally evolved and therefore more deserving. As a result of his polarized view of indigenous versus modern societies, he vigorously advocated the seizure of the sixty million acres of "best land" that the muzzy-minded sentimentalists back in Washington had foolishly signed away to the Indians.[15] He also abruptly dismissed apologists such as Helen Hunt Jackson, who had written extensively upon the "shameful record of broken treaties and unfulfilled promises" with Native Americans.[16] Roosevelt dismissed her seminal work, *A Century of Dishonor*, as "thoroughly untrustworthy from cover to cover."[17] He was unequivocal about his views regarding the usurpation of Indian land: "We were the people who could use it best," he argued, "and we ought to have taken it all."[18] At times Roosevelt swerved dangerously close to advocating the extermination of Native Americans. In January 1886, he told an audience, "I don't go so far as to think that the only good Indians are the dead Indians, but I believe nine out of every ten are, and I shouldn't like to inquire too closely into the case of the tenth. The most vicious cowboy has more moral principle than the average Indian."[19] He dismissed suggestions of assimilation or integration in order to preserve people "of the same blood" who were the descendants of the Anglo-Teutonic germ that had evolved over hundreds of generations in Europe. While he did not propose what ought to be done with the Indians if the government did expropriate their lands, the threat of violence was implicit, if only in his appeal to history, which commonly condoned either radical subjugation, such as slavery, or extermination.[20]

TR also railed against the political establishment, which he thought timid—even cowardly—when it came to society's moral imperative to build an empire. He wrote acidly in *The Winning of the West*:

It is indeed a warped, perverse, and silly morality which would forbid a course of conquest that has turned whole continents into seats of mighty and flourishing civilized nations. All men of sane and wholesome thought must dismiss with impatient contempt the pleas that these continents should be reserved for the use of scattered savage tribes whose life is but a few degrees less meaningless, squalid and ferocious than those of the wild beasts with whom they held joint ownership.[21]

"By right," he continued in *Thomas Hart Benton,* "we should have given ourselves the benefit of every doubt in all territorial questions, and have shown ourselves ready to make prompt appeal to the sword whenever it became necessary."[22]

That "right" was, of course, the right of eminent domain, which required, by force if necessary, that inferior peoples default their land, their property, and even their lives for the sake of white progress. While Roosevelt conceded that his approach was "a belligerent, indeed even piratical way of looking at territory," he rationalized that the spoils of conquest were the righteous entitlement of a superior race. "The world would probably have gone forward very little," wrote Roosevelt, "indeed, would probably not have gone forward at all," had it not been for the "displacement or submersion of savage and barbaric peoples."[23]

If Turner's frontier American was the product of the powerful geographic forces that surrounded him, then Theodore Roosevelt's modern American was a product of the powerful social forces that shaped nature. He believed that history rather than nature provided the basis for human rights. But he also believed that nature was the primary generative power of human character. The paradox of progress was that as civilization progressed, so its connection with nature regressed. It was an odd contradiction: the people who were closest to nature benefited the least from it, and yet the people who were farthest from it benefited the most. He like many others of his day believed that industrialism was a withering wind that sapped men of the strengths the frontier had engendered in their forebears. Whereas modern men were dwindling in spirit and being bowed by greed and sloth, society's moral stagnation could be reversed and its virility regenerated by aggressively reasserting its dominion over nature.

In 1881, George Beard, a Yale-trained doctor, published *American Nervousness,* which declared a pernicious national malaise, which he called "neurasthenia." Symptoms of neurasthenia included a "lack of nerve force" and a "fear of responsibility, of open places or closed places, fear of society, fear of being alone, fear of fears . . . fear of everything."[24] The etiology of this modern disease, according to Dr. Beard, was the unsettling effects of rapid changes in science and technology. The steamship, the railroad, the telegraph, the printing press, and "the mental activity of women" were destabilizing the natural order of society. Men were becoming sexually debilitated and increasingly feminized. In 1886, Henry James captured this sense of social anomie in his novel *The Bostonians,* in which the character of Basil Ransom deplores his generation's effeminacy:

The masculine tone is passing out of the world; it's a feminine, a nervous, hysterical, chattering, canting age, an age of hollow phrases and false delicacy and exaggerated solicitudes and coddled sensibilities, which if we don't soon look out, will usher in the reign of mediocrity, of the feeblest and flattest and the most pretentious that has ever been.[25]

Roosevelt was not a fan of Henry James (he preferred Owen Wister and Kipling), but he agreed with James's assessment that his generation was rapidly losing its virility, which, in turn, jeopardized the superiority of his race, his gender, and his class.[26] As a result, he embarked on a personal journey to restore the values of manliness in himself and his nation.

Mr. Crockett and Mr. Boone Go to Washington

Roosevelt was a member of a class of privileged and powerful men who promoted a new environmental imaginary based upon a hunting ethos, one that reflected a social percolation from the top down, rather than a grassroots movement from the bottom up, which had been the basis of the paradigm of the frontier hunter. The parameters of race (white), gender (male), and class (upper) now produced a view of nature that reflected the anxieties of a nascent industrial age.

By the time Turner pronounced the end of the frontier, the hunt, which had been critical to survival a generation ago, ceased being work and became a *pastime*. The pioneer hunted because he had little or no choice, whereas the sport hunter hunted because it was his pleasure to do so. The Roosevelts, the Kents, and the Lodges helped to create and perpetuate a discourse they projected onto the archetypal blank of the Pioneer Hunter. As a result, the struggle shifted from being mortal to being moral, and from being physical—feeding oneself—to being spiritual—finding one's self. This radical re-visioning of America's raison d'être served as the foundation for a new national environmental imaginary.

The canvas of the new imaginary was actually a palimpsest: a new image of nature painted over the old one, but one that intentionally preserved traces of the original in order to validate the new one's authority. The pioneer and the sport hunter commonly shared the atavism of violence, the knowing of death, and the celebration of the barbaric.

For certain people like William Kent, a progressive Republican from California (1911–1917), the intrinsic value of the hunt was its primitivism. "[Y]ou are a barbarian, and you're glad of it," Kent wrote of the blood rite. "It's good to be a barbarian . . . and you know that if you are a barbarian, you are at any rate a man."[27] In other words, in order to progress, a man had to regress. The ethical valence of barbarism changed according to class and race, and what once separated the savage from the savant now seemed to join them.

The defining feature of this psychogenic discourse is the role that imperialist nostalgia played in redefining the environment and how its citizens related to it. William Kent and Theodore Roosevelt could afford to embrace the primitive because it wasn't a threat to their status as a civilized, educated men of privilege. With the threat of barbarity gone, one could become nostalgic for the very thing he had already destroyed. Using a pose of "innocent yearning," agents of imperialism coveted the world as it existed before their domination and destruction of it, "both to capture people's imaginations and to conceal [their] complicity with often brutal domination." By repeating this wilderness initiation fantasy, the sport hunter celebrated his putative role as the master of nature. The paradox of this blood rite was that "the disciple turns on his spiritual masters and achieves redemption by killing them."[28]

By the middle of the nineteenth century, the American earth, which until then had been so reticent to yield its resources to man, now heaved forth a seemingly inexhaustible supply of coal, timber, gold, water, and soil. But by 1880, it was becoming impossible not to notice—even from the legislative floors in Washington—that the inexhaustible was, in fact, exhaustible. The forests and the plains were thinning at an alarming rate. Commercial hunters were slaughtering wild game in such huge numbers that the populations of large game dropped precipitously. The passenger pigeon, the Carolina parakeet, and the bison sped toward extinction.

The sport hunter was among the first to sound the alarm. Roosevelt declared that if such wanton "butchery" went on unchecked, the bison, the wolf, the elk, and the moose would

soon recede irretrievably into history. He wanted to protect the American wild heritage, but he wanted also to reclaim hunting as the exclusive province of a worthy few. "Game-butchery is as objectionable as any other form of wanton cruelty or barbarity," he decried. "But to protest against all hunting of game is a sign of softness of head, not of soundness of heart."[29] Men of influence, assuming the mantle of the patron saints of nature, felt compelled to act.

In the autumn of 1887, Roosevelt proposed to a friend, William Bird Grinnell, editor of the popular sporting magazine *Forest and Stream,* that they form a club of like-minded sportsmen who would work together to defend big game in America. "We wanted the game preserved," recalled Grinnell, "but chiefly with the idea that it should be protected in order that there might still be good hunting which should last for generations."[30]

Roosevelt and Grinnell hosted a dinner at Roosevelt's home on Madison Avenue in New York City for several of their intimates to discuss how they might conserve America's vanishing wild heritage and promote "a sport for a vigorous and masterful people."[31] That January, they chartered a private hunting club, which they named after the American frontier heroes Daniel Boone and Davy Crockett.

Unlike Turner's paean to the Jeffersonian collective of yeoman farmers, Roosevelt and the members of the Boone and Crockett Club glorified individual men of mettle such as Kit Carson, Davy Crockett, Buffalo Bill, Daniel Boone, and Sam Houston. In their eyes, these men were hardy champions of their race, and so they commemorated them by trying to emulate them.

Membership in the club was restricted to gentlemen who'd killed with a rifle "in fair chase" at least one adult male of at least *three* different species from a roster of American big game that included cougar, musk ox, deer, wolf, elk, moose, bear, mountain sheep, buffalo, pronghorn, goat, and mountain sheep; in other words, membership was confined to an elite class of men who had the money and time to scour the continent for such a broad variety of species. Roosevelt, who had already killed eight of the big twelve, was elected as the club's first president.

The men who composed the ranks of the Boone and Crockett Club were a far cry from the sturdy pioneers for whom the lion, the wolf, and the bear represented mortal threats. This new breed of pedigreed men were a who's who of the American white male elite, among them captains of state such Cabot Lodge, Elihu Root, Henry L. Stimson, Francis Parkman, C. Merriam Hart, Gifford Pinchot, and veteran soldiers such as Generals William Tecumseh Sherman, Philip Sheridan, and A. W. Greely. Boone and Crockett was a coalition of men of influence and intellect that came together for the ostensible purpose of promoting "manly sport with the rifle."

However, Boone and Crockett wasn't simply a clique of idle, rich men who flexed their muscular fantasies about their club's namesakes. The members actively lobbied federal and state conservation legislation that protected wildlife and habitat. During the six years of Roosevelt's tenure as president, the Boone and Crockett Club successfully promoted legislation that created the Smithsonian National Zoological Park (1889), and pushed through the Forest Reserve Act (1891), which checked the rampant abuses of timber speculators who were exploiting congressional provisions that allowed homesteaders to cut timber as they needed, and the Yellowstone Game Protection Act (1894), which put Yellowstone National Park under the sole jurisdiction of the United States and established enforceable protections for the natural resources of the park.

The powerful members of Boone and Crockett provided both the substance and the momentum to create an emerging set of social norms that resignified nature and its purpose. The purpose of domestic legislation during the late nineteenth century wasn't to protect

nature so much as its newest incarnation, *the environment*—understood to be the collective sum of the country's diminishing natural assets. The rapid commodification of nature (its resources of land, timber, water, and wildlife) during this period spoke more to the practical (i.e., economic) uses of the environment than to the spiritual uses of nature.

The Roosevelt of the Dakota Badlands thought of nature in spiritual terms as he built both his physical self and his persona as a native son of the West. But as he developed his political persona during his career, he increasingly wanted to stem the rampant exploitation of nature and protect what remained of it first for personal and then for public reasons. As the self-proclaimed defender of these values, Roosevelt assumed the mantle of environmental warrior during his career as a politician. As governor of New York (1898–1900), he actively developed and promoted legislation that either limited or ended the commercial exploitation of publicly held natural resources. As president, he signed legislation that created the U.S. Forest Service (by uniting the General Land Office, the U.S. Geological Survey, and the Bureau of Forestry); in addition, he doubled the number of national parks from five to ten, created fifty-one federal bird refuges, 150 national forests, eighteen national monuments (including the Grand Canyon and Devil's Tower), four national game preserves, and twenty-one federal reclamation projects. In 1907, Roosevelt convened the Conference of Governors for the purpose of creating a National Conservation Commission, whose purpose would be to inventory and evaluate the nation's environment. "As it stands," he told a joint session of Congress in 1909, "it is irrefutable proof that the conservation of our resources is the fundamental question before this Nation, and that our first and greatest task is to set our house in order and begin to live within our means."[32]

Roosevelt promoted himself as the figure who moved conservation onto the center stage of American political debate throughout his political career. He started the process of placing the environment, which had largely gone without federal protections, under a sheltering wing. But also under his watch, and by the force of his character and leadership, was created an environmental imaginary that would dominate American political and economic thought throughout the twentieth century. The rifle led the way as the chief instrument of this new discourse by incorporating the politics of domination within nature's new name: the environment. Wherever Roosevelt the statesman went, Roosevelt the hunter followed close behind, his Winchester at the ready.

Picturing the West, 1883–1893

THE FOUNDATION FOR THEODORE ROOSEVELT'S IMAGE WAS HIS SELF-ESTEEM. IN HIS words, he had been a "sickly boy with no natural bodily prowess," pampered by a household full of fussy women and dressed by them accordingly.[1] He suffered from poor eyesight, asthma, and a quirk of speech that made him blurt out his words impulsively, which made him insecure and shy with his classmates. By the time he enrolled at Harvard, he was five feet, eight inches tall and weighed a scrappy 125 pounds.

Although his colleagues in the New York State Assembly respected Roosevelt's intelligence and dedication to purpose, they also regarded the fashionable junior assemblyman as effete and called him names like "Jane-Dandy" and "Punkin' Lily." The *New York World* called him "chief of the dudes."[2] Their criticism stung. But tenacity was Roosevelt's long suit. Once he made the decision to adopt the "strenuous life" for the purpose of remaking the physical image of himself, he never turned back on that promise. Physical fitness would preoccupy his personal and public politics for the rest of his life.

It was at this turning point, historian Sarah Watts points out, that Roosevelt found himself drawn to the overmasculinized culture of the West, acquiring "the bodily attributes of a robust outdoorsman that were becoming new features in the nation's political iconography."[3] In 1883, he went on a buffalo hunt in the Dakota Badlands and killed a prime bull, which he celebrated by whooping up his own version of an Indian victory dance around its body. He was so taken by the experience that by the time he boarded the train to return to New York, he had invested in a ranch on the Little Missouri River, Dakota Territory.[4] He had decided to make the West his personal proving grounds.

The archive of images of Roosevelt during the 1880s is particularly rich because of his near obsessive attention to remaking his physical appearance. After he committed himself financially to his enterprise in the Dakota Territory in 1883, Roosevelt started his makeover as a rancher and Western hunter with a new wardrobe. He believed the adage *clothes make the man,* or, in his case, the ranchman and the hunter. The frontispiece to his first book on hunting, *Hunting Trips of a Ranchman: Sketches of Sport on the Northern Cattle Plains* (1885), features a full-length portrait of Roosevelt dressed as a hunter either in late 1883 or early 1884 (see figure 4). Dressed in his fringed buckskins, a silk neck scarf, and a jaunty beaver-felt hat, Teddy carries his Winchester Model 1876 at port arms with his finger ready on the trigger. His oversized hunting knife, bought from Tiffany's, is tucked into his cartridge belt. His posture is a frontier version of a minuteman: staunch and full of pluck. "You would be amused to see me," he wrote his lifetime friend and confidante Henry Cabot Lodge in 1884 as he described himself in a "broad sombrero hat, fringed and beaded buckskin shirt, horse hide chapajaros

or riding trousers, and cowhide boots, with braided bridle and silver spurs."[5] His vanity was self-deprecating. "I now look like a regular cowboy dandy," he wrote his sister, "with all my equipments finished in the most expensive style."[6]

Roosevelt posed for this and the other portraits for his book in a New York photography studio standing before a backdrop of a painted forest. He had his moccasins and his buckskins handmade to his fastidious specifications by a seamstress in the Dakotas.[7] He looks less like a hunter on the Dakota plains than a self-conscious imitation of James Fenimore Cooper's hero, Natty Bumppo, (the real "Deerslayer"), who appeared in the popular frontier novels known as the *Leatherstocking Tales* published between 1821 and 1847.

The image Roosevelt constructed of himself was a blend of American frontier heroes, real and imagined, ranging from Daniel Boone and Davy Crockett to the Virginian, the hero of Owen Wister's novel of the same name (Wister also went to Harvard, and he and Roosevelt were friends). By employing the iconic characters of the West, he insinuated himself into the literal and literary stream of American western history.

Certainly the well-seasoned men who worked the Maltese Cross ranch in the Dakota Territory must have scratched their heads when they saw their new boss show up for work dressed in high couture, but they quickly found out that Roosevelt wasn't some idle, rich dude from back east who thought he could become a cowboy just by dressing like one. He took an active interest in every part of ranch life in much the same way a method actor seeks to immerse himself in the details of the life of the role he intends to play. He came ready to share the sweat, dirt, pain, and frustration that defined the life of the ordinary ranchman because he craved what he considered the authentic experience of the West and because he was determined to "harden up" his body.

Roosevelt posed for another series of portraits a year or two after his had commissioned the portraits of himself for the frontispiece of *Hunting Trips of a Ranchman*. He continued to sport the same affectations of his earlier poses but without all the ostentatious ornamentation such as the "Deerslayer" fringed shirt and lace-up moccasins, the Tiffany's hunting knife, and the beaver-felt cap, which he had since replaced with a cowboy hat and a pair of working boots. His erect stance, arms crossed and shoulders set, make him appear formidable as he glares at the viewer. Endless hours in the saddle had toughened him up. He overcame his asthma and his speech impediment, and had bolstered his self-confidence. "What a change!" remarked the *Pittsburgh Dispatch* in 1886: "He is now brown as a berry and has increased 30 pounds in weight."[8] Theodore Roosevelt was ready for the prime-time camera.

The still camera (and later the motion picture camera) found the new Roosevelt irresistible.

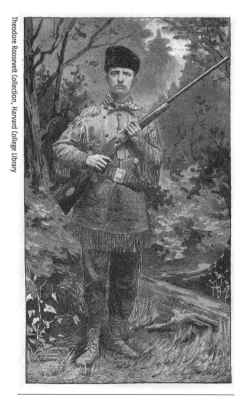

Theodore Roosevelt Collection, Harvard College Library

Roosevelt in hunting costume stands in front of a painted backdrop in a New York City studio, c. 1883.

The photographs he had taken of himself during his Dakota Territory days started out as a personal testament to his progress towards masculinity and self-assurance, but once he reentered the public sphere, they defined him to a much broader audience, and in the end, they played a critical role in defining his political persona. He loved the camera, and the camera loved him: his persona filled the screen. A superb actor who would appear in countless photographs, printed representations, and over a hundred films over the next twenty years, he became both the unofficial and official spokesman for the American empire.

Roosevelt sold his ranching properties after the starvation winter of 1887 nearly killed off his herds. His investment ruined, he sold his ranch properties and turned his attentions to his second wife, Edith, and his daughter from his first wife, Alice, whom Teddy had left in the care of his sister. In spite of his claim in 1910 that he lived "for the major part of seven years,

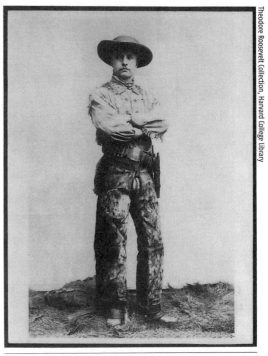

Theodore Roosevelt Collection, Harvard College Library

Roosevelt "hardens up" after working on his ranch in the Dakota Territory, 1885.

and on and off for nearly fifteen years" in the Dakota Territory, he actually spent less than a year of his life in residence in the Dakotas as he constantly shuttled back and forth from New York.[9] But the effect of the time he spent living in the West rippled through his life. Later Roosevelt acknowledged the formative influence his experience in the Dakota Territory had played in defining his political persona. "I never would have become president," he admitted late in life, "if it had not been for my experiences in North Dakota."

Teddy wrote the other two books in his Dakota trilogy, *Ranch Life and the Hunting-Trail* (1888), and *The Wilderness Hunter* (1893) from his New York estate at Oyster Bay on Long Island. After placing a poor third in the contest for mayor of New York City in 1886 at the age of twenty-eight, his prospects for a career as a politician languished, so he focused his attention on writing, hoping to make his reputation and his living as a gentleman historian.

In 1889, however, the Republican candidate for president unseated the incumbent, Grover Cleveland. Roosevelt, ever dogged and hopeful, had campaigned hard for Benjamin Harrison, and in return, he had hoped to receive an appointment as an assistant secretary of war. Instead, Harrison offered him an appointment to the U.S. Civil Service Commission, a job with little political stature or chance for advancement. Roosevelt wasn't fond of Harrison, whom he called "the little gray man in the White House," but he was eager to reenter politics and didn't hesitate to accept Harrison's offer.[10]

An inveterate crusader, Roosevelt relished the fray, and he didn't mind kicking up a cloud of political dust. Almost immediately he announced his intention to reform a federal civil system that had been hopelessly crippled by cronyism over many decades of corrupt administration.[11] "The spoils-monger and spoils-seeker invariably breed the bribe-taker and the bribe-giver,

the embezzler of public funds, and the corrupter of votes," he crowed. His announcement even caused members of his own party to fidget, and President Harrison, who was seen as the "main grinder of the administration's patronage mill," remarked cattily that the overzealous Roosevelt intended "to put an end to all the evil in the world between sunrise and sunset."[12] When senators threatened him, he dared to withhold further civil service commissions in the senator's state, which in turn would effectively cripple government services there. Roosevelt started to appear in political cartoons as a tiny but fearless David who was unafraid of the bloated federal Goliath. But in 1889, the dean of American political cartoonists, Thomas Nast, drew Roosevelt as a cowboy on "Uncle Sam's Ranch" astride a bucking bronco entitled "Civil Service Reform Spoilsman." Nast's cartoon was the first instance in which Roosevelt had been depicted politically as a cowboy. What had started out as a personal metaphor for Roosevelt began to merge with the body politic. Roosevelt embodied the West, and the West embodied a new political ethic of fearless mavericks who were anxious to reform the stale and corrupt institutions of government.

Roosevelt went west to find himself, and in the course of his search, he found a theory of nation. He pointed westward and said it was there, as a nation, "we shall ultimately work out our highest destiny."[13] At the heart of his worldview was the belief in the prerogative of the white man to assume responsibility for and command nature. As he leaned back on his horse Manitou from the top of a bench overlooking the expansive sweep of the Badlands in the Dakota Territory, he saw the frontier as an unfinished work awaiting completion by those who were strong and determined enough to reform nature's chaos. The force of his personality made up for his own uncertainty by fashioning a national hero that would transform the emerging American experience through a vocabulary of words that were already familiar and a vocabulary of images that were new.

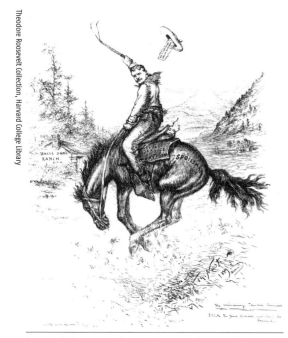

Theodore Roosevelt Collection, Harvard College Library

Roosevelt the cowboy fuses with Roosevelt the politician in *Roosevelt the Reformer*, by Thomas Nast, 1889.

THE FIRST SCALP FOR CUSTER

Popular images of the West were relatively uncommon during the 1880s. Since the 1820s, artists such as Charles Bird King, George Catlin, and Karl Bodmer had been painting their visions of the West, and a later wave of artists just prior to, during, and after the Civil War portrayed both the Turnerian and Rooseveltian heroes of westward expansion.[14] George Caleb Bingham's *Daniel Boone Escorting Settlers Through the Cumberland Gap* (1851) and Emanuel Leutze's *Westward the Course of Empire Takes its Way* (1861), for example, capture the naive idealism of white settlers crossing the borderlands into the unknown. But images such as these were largely

unavailable to anyone except members of the most privileged class, who hung them in their parlors and drawing rooms.

The same held true for photography. While pioneer photographers such as Timothy O'Sullivan, Carleton Watkins, and William Henry Jackson had captured extensive images of the early West during the later decades of the nineteenth century, the physical bulk of the camera and the amount of time it took to set up and expose a photographic plate limited it to "still" subjects, which favored landscapes and portraits rather than action. Because the technology for reproducing photographs for mass dissemination would not be available until the turn of the century, photographs remained closely held objects.

By 1890, the number of weekly and monthly magazines available in the United States skyrocketed to over four thousand (from six hundred at the end of the Civil War), and the number of newspapers during the same period quadrupled, with circulations that now reached 20 percent of the American population.[15] The development of mass production printing techniques also created the dime magazine, which provided a major source of reading entertainment for the literate working class. By the mid-1880s, images had become relatively common on the covers of dime novels and in a illustrated newspapers and magazines such as *Scribner's Monthly: An Illustrated Magazine for the People* (renamed *Century Illustrated Monthly Magazine* in 1881), *Frank Leslie's Illustrated Newspaper,* and *Harper's Weekly.*

Readers regarded the images in these magazines and newspapers as documentary images even though artists had produced them. Pictorial journalism, as it became known, had gotten its start during the Civil War when sketch artists joined the troops in the field in order to provide a visual account of the war dispatches. The public saw these images as credible representations of reality, and by the 1880s, the engraved image enjoyed the same objective status as a photograph.

Images of the West, however, comprised only a small percentage of the visual content of illustrated newspapers and magazines prior to 1880. Tony magazines such as *The Living Age, Harper's, Scribner's,* and *The Atlantic Monthly* dealt almost exclusively with the leisurely class sport of hunting big game such as bear, moose, chamois, mountain goat, and caribou. Those who could not afford the cost of a book or one of these "highbrow" magazines found images of the West on the vaudeville stage, on the cover of a dime novel, or in a Wild West show.

"Six Genuine Wild Indians!" reads a variety show playbill from 1875. Morality skits on the stage were popular with the working class, which delighted in characters that were so burlesqued that they were morally either white as snow or black as coal. The performances were generally little more than a romp on the stage, mixing the real with the surreal. They were part circus, part freak show, and all performance. These stage productions played an important role in picturing the West, and no one performer was more influential than the legendary "Buffalo Bill" Cody.

William Frederick Cody launched into his own career as a stage actor in 1872 in a play called *The Scouts of the Prairie*, written by the journalist Ned Buntline for Cody and "Texas Jack" Omohundro. Buntline had already made Cody famous in his dime novel *Buffalo Bill Cody—King of the Border Men*, which first appeared serialized in the *New York Weekly* in 1869 and helped make him a national celebrity.

On opening night, the men were so flummoxed they couldn't remember any of their cues or lines, so they improvised their way through the evening. Still, "Buffalo Bill" and "Texas Jack" managed to establish a rapport with the audience by remaining true to their established personalities. The play opened to scathing reviews for its bad writing and horrendous acting.

One critic for the *Chicago Times* wrote: "Such a combination of incongruous drama, execrable acting, renowned performers, mixed audience, intolerable stench, scalping, blood and thunder, is not likely to be vouchsafed to a city a second time, even Chicago."[16] But it didn't matter that the men couldn't act; audiences flocked to see the flamboyant twenty-seven-year-old Cody, who had just been awarded the Congressional Medal of Honor for "Gallantry In Action" in the Indian campaigns.

A year later Cody parted ways with Buntline over money and started his own stage company. He cajoled his friend "Wild Bill" Hickok to join the troupe in his first production, *Last of the Great Scouts*, which proved to be just as big a theatrical disaster as Buntline's play. "The dialogue of that performance must have been delightfully absurd," wrote Cody's sister, Helen Cody Wetmore: "Neither Texas Jack nor Wild Bill was able to utter a line of his part during the entire evening. In the Indian scenes, however, they scored a great success; here was work that did not need to be painfully memorized, and the mock red men were slain at an astonishing rate."[17]

Despite its rough staging, the show was a success and toured several major American cities, although Hickok never got over his stage fright. He hated acting and wanted out of his contract. When the producers refused to release him, the cantankerous Hickok began shooting "his blank cartridges so near the legs of the dead Indians on stage that the startled [actors] came to life with more realistic yells than had accompanied their deaths."[18] When the producers threatened to fire Hickok if he didn't stop shooting dead Indians, he happily accepted their offer to dismiss him and left the company the next day.

Cody appeared in fourteen "border dramas" over the next fourteen years.[19] He combined his emerging talent as a showman with a liberal interpretation of his personal experiences as a Pony Express rider, a scout during the Civil War, a buffalo hunter, and as a scout for the Fifth Cavalry at Fort Laramie. His performances owed more to the stage than they did to history, but all his plays affirmed the moral certainty of the rightful place of whites on the frontier.

"Wild Bill" Hickok and "Buffalo Bill" Cody represented the new and old archetypes of the western frontier. Hickok was a morally ambiguous figure, like many of the frontier lawmen of the 1870s, who might uphold the law one day and break it the next. After he left the playacting business in 1873, Hickok continued his gradual descent into dissolution as a gambler and an alcoholic. Finally, on August 2, 1876, he was shot in the back of head while playing cards at a gaming table in a saloon in Deadwood, the Dakota Territory, five weeks after the Battle of the Little Big Horn, as if to mark the passing of an age.

"Buffalo Bill" Cody, on the other hand, presented a persona that lived in a world of moral absolutes. He had killed thousands of

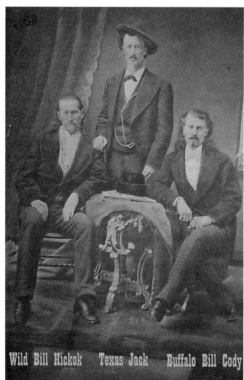

Wild Bill Hickok, Texas Jack Omohundro, and Buffalo Bill Cody, 1873

bison, but in the name of progress, because his job was to provide meat for the railroad crews that were laying track to open the West. He had killed Indians in order to make the frontier safe for the frontier families that followed in wagons. He believed in the rightness of the white man's claim to the continent, and his lives as a showman and as a champion of the new Americanism were inextricably bound to each other.

Cody blurred the line between history and the stage so that they became extensions of each other. In June 1876, Cody received a plea from the army for help as a scout in the campaigns against the Sioux and Cheyenne who had been agitated by the prospectors who had invaded the Black Hills in search of gold. While en route to join the Fifth Cavalry at Fort Laramie, Sitting Bull and Crazy Horse wiped out Custer's Seventh Cavalry at the Little Bighorn in Montana.

Three weeks later Cody was in Nebraska with the Fifth seeking to intercept a large force of Cheyenne that was reported to be traveling north to join the Sioux. The Fifth intercepted the Cheyenne at Warbonnet Creek, Nebraska, and while the troops prepared to launch an offensive, Cody changed out of his trail clothes and into one of his stage outfits, "a Mexican costume of black velvet, slashed with scarlet and trimmed with silver buttons and lace."[20]

Narratives diverge dramatically about what happened next, but the most popular version of the time (and probably the least accurate) was Colonel Prentiss Ingraham's dime novel, *Adventures of Buffalo Bill from Boyhood to Manhood: Deeds of Daring, Scenes of Thrilling, Peril, and Romantic Incidents in the Early Life of W. F. Cody, the Monarch of Bordermen* (1882?).[21] In Ingraham's version, a Cheyenne chief known as Yellow Hand recognizes Cody across the battlefield and challenges him to a duel.[22]

> Then the Indian cried out in his own tongue: "I know Pa-e-has-ka the Great White Hunter and want to fight him."
>
> "Then come on, you red devil, and have it out," shouted back Buffalo Bill, and forgetting General Merritt's orders not to expose himself, and to the horror of the regiment, every man of whom saw him, as well as did the Indians, he dashed at full speed toward the chief, who likewise, with a wild yell rode toward him.

The men shot the horses from under one another and then fought to the death with knives:

> The hand-to-hand fight was hardly five seconds in duration, and Buffalo Bill had driven his knife to the broad red breast, and then tore from his head the scalp and feather war-bonnet, and waving it over his head, shouted in ringing tones: "Bravo! The first scalp to avenge Custer!"[23]

Just as Cody had brought the theatrical to the historical, so he brought the historical to the theatrical. That October, less than three months after the incident at Warbonnet Creek, Cody opened *The Right Red Hand; or, Buffalo Bill's First Scalp for Custer,* in Rochester, New York. It was a rambling "five act play, without head or tail, and it made no difference at which act we commenced the performance." In Cody's words, it was "a noisy, rattling, gunpowder entertainment" that ended with Cody killing Yellow Hand in a knife fight and then holding aloft the scalp that he had actually ripped from Yellow Hand's head at Warbonnet Creek and shouting "The first scalp for Custer!"

A reviewer from the *Cleveland Herald* remarked that "more Indians [were] laid out cold than Custer, Crook, and Terry ever killed in all their campaigns." Nonetheless, *The Right Red Hand* toured successfully for eight months and was eventually incorporated into Cody's Wild West shows. The incident at Warbonnet Creek, Nebraska, became so famous that dozens of

popular images of it proliferated for decades as it settled into the grain of western mythology. Even Charlie Russell commemorated Cody's death in 1917 with his own version of "Buffalo Bill's Duel with Yellowhand."[24]

In 1883, Cody premiered his first Wild West show in Omaha, Nebraska, before an audience of 8,000 people. He cast real Indians, real cowboys, and real horses in elaborate skits that reaffirmed the conquest and submission of the Indians. By 1885, "Buffalo Bill" Cody's West Wild shows had become a national attraction with an estimated attendance of one million people, and in 1893, as Frederick Jackson Turner quietly pitched his idea to a few of his colleagues at the Columbian Exposition, two million people watched Buffalo Bill's reenactment of his morality play, *The Drama of Civilization*, on the Exposition Fairgrounds nearby.[25]

Cody's *Drama of Civilization* included vignettes of settlers struggling against the forces of nature—in one skit, they battle a prairie fire, and in another, a "typhoon" threatens to destroy everything they have built so laboriously—but in the end, the settler triumphs over nature and confirms his rightful place on the land. The message of these scenarios was to affirm that while there was a calculated risk in moving west, the risk was manageable and well worth the rewards as settlers "reduced the land to fruitful subjection."[26]

Cody's images of the West, however stylized and morally simplistic, served as a major disseminator of the new environmental imaginary that redefined the West from the 1880s. Another major source of images that supported this new vision came from the dime novel. Like its English cousin, "the penny dreadful," dime novels provided sensationalistic stories printed on cheap paper for their main audience, working-class children. A precursor to the comic book, the dime novel had no illustrations within the text, but did have an illustrated cover (and sometimes a back cover) that depicted in the greatest dramatic terms possible the stories within the pamphlets.

Buffalo Bill Cody's Last Scalp for Custer, Ornum and Company's Indian Novels, no. 6, 1872

Dime novels by the thousands flooded the market in the late nineteenth century.[27] "Buffalo Bill" Cody himself appeared as the main character in an estimated *seventeen hundred* dime novels, including *Cody's First Scalp*.[28] Other fictional and semifictional heroes with colorful names such as Deadwood Dick, Texas Jack, Big Foot Wallace, and Crack Skull Bob—which, like "Buffalo Bill," were at times loosely based upon real people—also reaffirmed moral order on the frontier. Their dramatic role, however, was to make the West *safe* for the others who would follow, and so the heavy reliance on heroic deeds required formidable antagonists such as dangerous beasts, Indians, and lawless gunmen who stubbornly refused to conform to the rule of law.

TAMING MAN

The reputation of the West as an *un*settled place during the 1880s was not entirely undeserved. In April 1881, Marshall Dallas Stoudenmire shot four men in the "Four Dead in Five Seconds Gunfight" on the streets of El Paso, Texas.[29] That July, Pat Garrett shot down Billy the Kid at Fort Sumner in the New Mexico Territory, and three months later, on October 26, the Earp brothers squared off against the McLaurys and the Clantons at the O.K. Corral in Tombstone, Arizona Territory.[30] Reacting to the violence and instability on the frontier, President Arthur blamed the "armed desperadoes known as 'cowboy'" for the terror and bloodshed that had plunged that part of the country into lawlessness. In 1881 the president called upon Congress to authorize the army to establish control in the Southwest.[31] Even though the violence that had plagued the 1870s and early 1880s had begun to taper off by 1883, it occasionally flared, as in December 1884, when a small army of cowboys stormed Frisco, Arizona Territory, and waged a thirty-six-hour gun battle with a deputy sheriff who had arrested one of their friends for being drunk, and in 1886, when the *New York Times* reported on "murderous cowboys" in New Mexico who had killed one deputy and wounded another when they tried to arrest them for systematically shooting sheepherders to keep them off open range being used by cattlemen.[32]

Cody and Roosevelt, however, promoted a stabilized image of the West. Sure, there was still work to be done, but the law had put down strong roots, paving the way for honest citizens to take advantage of the opportunities that awaited them. The Sioux Wars of the late 1870s were ancient history, a point "Buffalo Bill" underscored emphatically by parading many of the great Indian war chiefs, including the great Hunkpapa Lakota chief, Sitting Bull, "the slayer of Custer," in his Wild West shows. The theatrical postures of Cody and Sitting Bull standing side by side in a cabinet photograph (c. 1885) domesticated the Indian as a bit player in the white man's melodrama.

The proliferation of images of the West that appeared on stage, on the covers of dime novels, or in the Wild West shows created a sense of a stable, predictable environment in which white morality triumphed over the savage amorality of nature. In 1888, Roosevelt published a chapter from *Ranch Life and the Hunting-Trail,* his forthcoming book on ranching and hunting in the Dakota Territory, in *Century Illustrated Monthly Magazine.* "Sheriff's Work on a Ranch" tells the dramatic story of how he had tracked down, in the dead of winter, three scofflaws who'd stolen a "clinker built" boat the ranch hands used to ferry cattle across the Little Missouri.

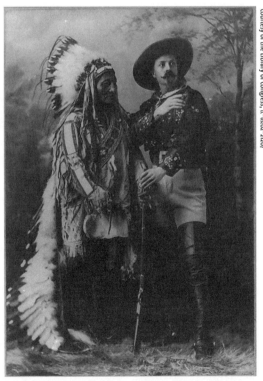

Courtesy of the Library of Congress, LC-USZ62-77207

Cabinet photo of Sitting Bull and Buffalo Bill Cody, c. 1885

Roosevelt chased the men—a red-haired Irishman named Finnigan who was "rather a hard case, and has been chief actor in a number of shooting scrapes," a scruffy German named Pfaffenbach, "whose viciousness was of the weak and shiftless type," and a "half-breed" named Burnsted—for three days in bitter cold before he caught them.[33] "We simply crept noiselessly up," Roosevelt wrote his friend, Henry Cabot Lodge, "and rising when only a few yards distant covered them with the cocked rifles."[34]

It took another six days for Roosevelt to get back to the ranch with his prisoners in tow so he could turn them over to territorial authorities in Dickinson for prosecution. "The average westerner, of course, would have hanged the thieves out of hand," a local doctor noted at the time. "But evidently that did not occur to Roosevelt."[35]

Roosevelt's exercise in lawgiving was not a matter of practicality or efficiency so much as a performance of his own morality play about law and order in the West, a "wild country where the power of the law is little felt or heeded and where everyone has to rely upon himself for protection."[36] To underscore his point, he staged several photographs with his friends standing in for the real thieves.

In one photograph, Roosevelt stands watch over his "prisoners" with his Winchester. He is sharply focused in the foreground, dressed in his tailored hunting coat and fur cap, unlike Finnigan, Pfaffenbach, and Burnsted (played by Bill Sewall, Wilmot Dow, and a unidentified companion), who dissolve into sinister silhouettes in the background. A bleached buffalo skull, a heavy-handed prop meant to garnish Roosevelt's allegory about frontier justice, sits in the foreground at the feet of one of the thieves.

Even though the picture employs the dramatic conventions of vaudeville—the brooding villain, the vigilante hero, and the precarious imposition of frontier justice by the gun and

Roosevelt the lawgiver: the capture of Finnegan, Pfaffenbach, and Burnsted, Dakota Territory, c. 1887. Roosevelt staged the photo with his friends.

the rope rather than the formal institutions of law—it also validates the text historically. The unwritten caption of the picture reads: *Roosevelt brings law to the West.*

The illustration of the event in *Ranch Life and the Hunting-Trail*, however, portrays the moment at which Roosevelt actually catches the thieves. "Hands-Up! The Capture of Finnigan" bristles with action as though it were a frame cut from the scene of a Western motion picture melodrama when the posse, led by the determined sheriff, gets the drop on the outlaws. The original oil, which was painted by an artist little known at the time, Frederic Remington, still hangs in the White House, perhaps as a cautionary tale for Roosevelt's successors.

Roosevelt chose Remington to draw the illustrations for *Ranch Life and the Hunting-Trail* because of his unique talent for capturing the spirit of the West. Remington's relaxed style captured an energy and instantaneousness the others lacked. His quick-handed vignettes embody a feeling of authenticity because of his careful attention to authentic details such as a spur or a bit. He also captured the masculine physicality of the West. Not a single female appears in the nearly hundred illustrations for *Ranch Life and the Hunting-Trail*. Remington's West, like Roosevelt's, was a land by and for men.

In his first book about life in the Dakota Territory, *Hunting Trips of a Ranchman* (1885), Roosevelt is the singular focus of the illustrations. Anyone else who appears in a picture with him either has his back turned to the viewer or has been relegated to the shadows of the background. In *Ranch Life and the Hunting-Trail*, however, Roosevelt shares the stage with the cowboys, the vaqueros, the mountain men, and trappers who comprised the soul of the West with whom he claimed close kinship. Free to paint men "with the bark on," Remington explored the range of their character as they rode, roped, bucked, and branded. He also captured them during moments of exhaustion or reflection. His expressive line drawing of a saddled cowboy taking the simple pleasure of a cigarette, for example, captures the sense of hard work well done. Remington's cowboy, like Roosevelt's, lives, works, and plays in tune with the rhythms of nature. They are in his blood and in his flesh: he is a native son. "They talk Uter, Coloray-do, Illinoise, Missourer, Nevada, Ioway, Arkinsaw, and Wyóming," wrote Julian Ralph in 1893. "In a word, they are distinctly, decidedly, pugnaciously, and absolutely American."[37]

White House Historical Association (White House Collection)

Frederic Remington's version of the capture of the outlaws on the Little Missouri. *Hands Up! The Capture of Finnigan* (c. 1888) hung in the White House for years.

Roosevelt, like Cody, reassured the reader that in spite of the fact that West could still be a "wild and woolly" place from time to time, "if a man minds his own business and does not go into bar-rooms, gambling saloons, and the like, he need have to fear of being molested."[38] Even the Indian, which so recently portrayed a mortal threat to anyone who dared venture too far into the open, had been reduced to a nuisance.

In the chapter "Red and White on the Border," from *Ranch Life and the Hunting Trail,* Roosevelt starts out with an inflammatory description of Indians' genetic bloodlust: "even the best Indians are very apt to have a good deal of the wild beast in them; when they scent blood they wish their share of it, no matter from whose veins it flows." He acknowledges the rampant abuse of Indians by whites, though he quickly assigns equal blame so as not to appear soft on the subject:

> In our dealings with the Indians we have erred quite as often through sentimentality as wrong-doing. Out of my own short experience I could recite a dozen instances of white outrages which, if told alone, would seem to justify all the outcry raised on behalf of the Indian; and I could also tell of as many Indian atrocities which make one almost feel that not a single one of the race should be left alive.[39]

In the end, however, Roosevelt concedes that Indians posed no substantial threat. "At different times [Indians] proved more or less troublesome," he wrote, "burning the grass, and occasionally killing stock or carrying off horses that have wandered some distance away."

As the Dakota Territory prepared itself for statehood in 1889, the perception of nature had shifted precipitously away from chaos and toward control. By 1893, the rough edges of the Dakotas had been sanded off by boosters who rallied the industrious and enterprising in the East to come to the promised land. Julian Ralph recalculated the Dakotas in terms of their economic potential in *Our Great West: A Study of the Present Conditions and Future Possibilities of the New Commonwealths and Capitals of the United States* (1893). As he described them, the Dakotas were untended gardens awaiting their gardeners.

Easily accessible by the "modern and luxurious easy-rolling trains of the Northern Pacific Railroad," North Dakota was bursting with grain: 55 million bushels of wheat, 300,000 bushels of corn, 10 million bushels of oats, all of which provided an average annual income of $250 to each farming family. "The certainty of the wheat crop is the best gift the good fairies gave it at its christening," wrote Ralph.[40]

Ralph's brand of boosterism became a common refrain as writers tried to entice the population westward across the next river, the next mountain range, or the next prairie. If the lure of cheap farmland "christened" by good fairies with two feet of rich, black loam wasn't enough to convince a man to bring his family to the Dakotas, then perhaps a factual appeal to dollars and cents could:

> Any farmer who attends to his business can make $6 to $8 an acre on wheat at its present price, and, considering that he buys his land at about $25 an acre, that is an uncommonly good business proposition . . . I use these figures because the average crop of the valley is 19 or 20 bushels to the acre. That they told me on the ground, where they said, "There's no use lying when the truth is so good."[41]

In spite of an errant tornado or two and winters that were so cold they could "freeze the fingers off a bronze statue," the weather was "perfect" for farming. "The windstorms do their worst

damage in the newspapers and the public imagination," Ralph reassured his readers, "and the cold of the winter is not as intense or disagreeable as the cold of more southerly states."[42]

Then there was gold and silver. The Homestake Mine had already taken more than $50 million worth of gold ore out of the Black Hills, and there was more to be had. The banks in North Dakota were bursting at the seams with millions of dollars in cash. In addition, endless seams of coal and untapped beds of nickel, lead, tin, and copper were also waiting to be mined.[43] Perhaps the foremost economist of his time, Francis Amasa Walker, confirmed a sense of limitless abundance in America by declaring in the most widely used economics text of its time, *Political Economy,* "there never comes a time when more laborers will not produce larger harvests. There never comes a time when additional capital introduced into agriculture cannot secure for itself some return."[44] If there was ever a time for a nation to justify irrational exuberance regarding its boundless economic potential, the massive convergence of land, labor, capital, and entrepreneurship made the economic future of America seem virtually assured.

By 1893 nature was rapidly losing its appeal as an agent of spiritual transformation to a citizenry that was intent on progress based upon the accumulation of wealth. Once homesteaders felt it could be tamed, nature turned into a calculated risk to be factored into the cost of doing business. The booster's message, like Cody's and Roosevelt's, was clear: The way was no longer unknown or uncertain. The new environmental imaginary, built upon "the assembled proofs of the triumphs of man and civilization," became a rallying cry for progress and beckoned all but the most timid.

TAMING NATURE

The new vision of nature that Roosevelt, Cody, and others helped to create during the 1880s mitigated the prevailing view of the West as a place of unrelenting danger and violence by reframing nature as a garden of bright promise rather than a gloomy and desolate wilderness. They moderated the image of nature from an overwhelmingly oppressive force to one that, although fickle, was more inclined to embrace those who had come to harvest its material wealth than to reject them. Whereas Cody provided images of the new environmental imaginary to the lower classes, Roosevelt aimed his appeal at the genteel class of like-minded entrepreneurs, writers, statesmen, and sportsmen.

During the four years he owned his ranch properties in the Dakotas, Roosevelt wrote as though he were a veteran rather than a tourist, in spite of the fact he actually spent less than a year there. Unlike Turner, who spoke to a tightly circumscribed circle of historians, Roosevelt wanted to speak to people who could afford the price of his books or one of the prestigious literary magazines he preferred to publish in. His coy description of himself as a "literary feller" simultaneously assigned himself a high- and a lowbrow status in the same self-effacing way Mark Twain might have described himself as a humble man of ordinary talent. In spite of his claim of modesty, however, Roosevelt certainly took pride in sharing the pages of literary magazines with the likes of Henry James, Owen Wister, Bret Harte, John Burroughs, Joel Chandler Harris, William Dean Howells, and, of course, Mark Twain.

Although Roosevelt did not speak in the idiom of the people he wrote about, his voice nonetheless rang true with his audience and his critics, who embraced his invigorated vision of the West. Cody's simplistic representations of nature in his Wild West shows characterized

nature as a capricious force that periodically threatened the settlers, but Roosevelt interpreted nature as a magnificent *force majeure,* terrible in aspect and yet generous of spirit for those able and willing to endure its test. The true value of nature was its power to anneal manhood by reversing the withering effects of modernity.

For Roosevelt, the primal virtue of nature was strength, and the ultimate goal was to become the apex predator. In his view, the weak, the lazy, and the lame of society would perish just as surely as any creature in the forest that could not or would not fend for itself. He railed against the vapid "stay-at-home" men such as Presidents Arthur, Cleveland, and Harrison (and later, McKinley and Taft) who had succumbed to "a certain softness of luxury—a condition of mind and body in which long-continued hardship becomes intolerable." Men who preferred the billiard table to the wrestling mat were physically and therefore mentally unprepared for the rigors of leadership. They became "fickle and hysterical under pressure of danger; they shrink from the grim necessities of war [and] will not show the necessary brutal heroism in attack and defense."[45] To learn the lessons of leadership, one had to study as a disciple under the tutelage of nature, with the intent, in the end, of becoming its master.

As a naturalist, Roosevelt insisted upon a detached view of the world. His dispassionate descriptions of landscape at the beginning of *Hunting Trips of a Ranchman* read as though written by a surveyor of nature and history. "After bloody fighting and protracted campaigns [the Plains Indians] were defeated, and the country thrown open to the whites," he wrote perfunctorily, "while the building of the Northern Pacific Railroad gave immigration an immense impetus."

His descriptions of landscapes and wildlife are equally dispassionate. "The voice of the antelope is not at all like that of the deer," Roosevelt wrote in *Hunting Trips of a Ranchman.* "Instead of bleating it utters a quick, harsh noise, a kind of bark; a little like the sound 'kau,' sharply and clearly repeated. It can be heard a long distance off; and is usually uttered when the animal is a little startled or surprised by the presence of something it does not understand."[46] Prairie dogs, rattlesnakes, beavers, and badgers get the same descriptive treatment as objects realized through close study.

Roosevelt's gaze of nature is observational, and his description is exhaustive. Such a gaze is "silent and gestureless," wrote Michel Foucault in *The Birth of the Clinic* (1963) as he explored the organization of knowledge. "Observation leaves things as they are; there is nothing hidden to it in what is given."[47] The idea is a reiteration of Linnaeus's belief in the power of naming things. The ideal of exhaustive description is to gain control of the object by gleaning the facts that constitute the essence of its behavior, in the case of animals. Such description, argued Foucault, must be completely faithful, without lapse of information, and precise. Foucault wrote, "Descriptive *vigour* will be the result of *precision* in the statement and of *regularity* in the designation: which, according to Pinel, is 'the method now followed in all other parts of natural history.'" The role of language untainted by the feelings or emotions of the observer creates its value as a denominator by being precise, and Roosevelt's "speaking eye" values the language of factuality above all. "Over all these endeavors . . . to define its methods and scientific norms," wrote Foucault, "hovers the great myth of the pure Gaze that would be pure Language." The keystone of the myth of the pure Gaze depends upon the fallacious assumption that "all that is *visible* is *expressible,* and that it is *wholly expressible.*" The pretense of total description is a feint of omniscience. "Total *description* is a present and ever-withdrawing horizon," noted Foucault. "It is much more the dream of a thought than a basic conceptual structure."[48]

As the objective observer, Roosevelt removed himself from nature in order to clarify it, and yet he would, at times, abandon the persona of the scrupulous observer and engage the persona of a poet. "The skylark sings on the wing," he rhapsodized on the song of the Missouri

skylark, "soaring over head and mounting in spiral curves until it can hardly be seen, while its bright, tender strains never cease for a moment.[49] Frequently he would abandon his restrained prose for a sentimental, even melodramatic prosody. In the middle of an antelope hunt, for instance, he took time to meditate upon the harsh aesthetic of winter: "The blizzards whirl and sweep across them with a shrieking fury which few living things may face. The snow is like fine icedust, and the white waves glide across the grass with a stealthy, crawling motion which has in it something sinister and cruel."[50]

Roosevelt's appeal as a writer before the turn of century derived from his combination of the objective and the subjective as his narrative voice alternated between the personas of scientist and artist. At times he would describe the elemental details of nature as though he were observing it through a long lens, and then, without provocation other than his own inspiration, he would free himself to be a naturalist-poet. Roosevelt's dual voice appealed to his audience. "To the average reader the scientific sportsman is rather a bore," complained a reviewer of *Hunting Trips of a Ranchman* in *The Atlantic Monthly.* "But we do ask that he should be a lover of nature, and capable of giving us his impressions of something more than his own shots. Add to this a capacity for spirited and faithful narrative, and you have the hunter whose writings every one likes to read."[51]

Indeed, Roosevelt loved nature. Unlike Transcendentalists such as Henry David Thoreau, who believed that the spiritual value lie "through and beyond" nature, Roosevelt believed that the beauty of nature resided in its surface details, such as the flush of color in the feather of a pheasant rooster or the trill of a sandhill crane in spring. He also believed that the "truth" of a thing lies in the absoluteness of the "speaking eye." And yet, lurking behind the persona of the pure Gaze lay a man of action. Roosevelt's true fascination—or perhaps more rightly, his true fixation—was hunting. "Game shooting," he declared in the first chapter of *Hunting Trips of a Ranchman*, was "chief of the cattle-man's pleasures."[52]

ROOSEVELT'S HUNTER

As much as he celebrated the ethic of the men who worked the cattle and the land, Roosevelt cared more about the hunt and the hunter. His observations of nature were almost always made in the context of the hunt. While he valued knowledge for its own sake, he also valued it as the hunter's prowess. "In hunting, the finding and killing of the game is after all but a part of the whole," he declared in *The Wilderness Hunter* (1893): "The free, self-reliant, adventurous life, with its rugged and stalwart democracy; the wild surroundings, the grand beauty of the scenery, the chance to study the ways and habits of the woodland creatures—all these united to give to the career of the wilderness hunter its peculiar charm."[53]

The images in Roosevelt's books and articles simultaneously illustrate his vision of the West and situate his place in it. The engravings in his books during the 1880s capitalized on the public's confidence in the indexicality of pictorial journalism. Pictures of rampaging savages have been replaced with still lifes of work, life, and nature on the ranchland. Unlike the homesteader's shack, "rude as a magpie's nest," which seemed so vulnerable to the whim of nature, Roosevelt's Elkhorn ranch house in *Hunting Trips of a Ranchman* sits in a tranquil setting shaded by huge cottonwoods. The Elkhorn has settled itself into both landscape and history, a claim made by the elk rack tacked to the forepeak of the ranch house and the rocking chairs on the porch. But the illustrations in the book do not try to portray the ordinary life

of the cowboy as much as they portray the exceptional life of a hunter. Roosevelt, like Kent, Grinnell, and Lodge, imagined himself as an exceptional hunter, and the illustrations in his works testify to his deeds as a great hunter. Of the twenty-six illustrations in *Hunting Trips of a Ranchman,* only two deal with ranching. Other than a few images of English sporting scenes, such as hounds coursing after turkey, and braces of goose and rabbit hanging ready for the pot, the rest of the illustrations constitute a gallery of date-stamped trophy heads. "Head of Bull Elk, Shot Sept. 12, 1884"—"Head of Grizzly Bear, Shot Sept. 13, 1884"—"Head of Black-Tail Buck, Shot Sept. 14, 1884"—and so on for each of seven major game species, all shot within the span of ten days.[54] At the center of each of these stories and illustrations, was a singular character: the hunter.

Roosevelt's hunter was a hardy man, a warrior in the struggle for the ownership of his soul. In his eyes, nature was unforgiving and demanding, not for the weak of spirit or body. To pit himself against its rigors, the hunter had to be a stalker, a scout, a pathfinder, and a marksman. His goal was to purify his soul through the assertive if not violent domination of nature. It was a saga about blood, bone, and muscle.

Ironically, the subsistence hunter would not have squandered the labor necessary to undertake a seven-week, thousand-mile trek into the wilderness in order to kill the largest male mountain goat he could find. The subsistence hunter was an opportunist and would not hesitate to kill game by whatever means possible. He did not care about the size or the sex of an animal, the length of horn or its beard. Nor did he hunt by a complex set of socially determined rules that constituted the gentlemanly conception of "fair play." He cared only about what he needed to know in order to survive: what he could kill and what could kill him; he cared about the efficient use of his labor and time, which created the energy that kept him and his family clothed, housed, and fed.

The Coming of Winter, an illustration in an 1888 copy of *Century Illustrated Monthly Magazine,* captures the tentativeness and precariousness of life for a settler's family living alone on the land. Standing before their cramped cabin, the young father holds a shotgun at the ready as he scans the sky for the migrating geese he has heard flying overhead. "Now that the wild-geese are beginning to fly," reads the text, "a chance shot may furnish a meal, where every meal counts."[55] It is a moment of quiet desperation that hangs upon a "chance shot."

Roosevelt's hunter cared less about provisioning than about pitting himself *against* nature so he could benchmark his manhood. He was an American Hercules who welcomed pain because it defined him and his purpose. In Roosevelt's words, he was "sinewy, hard, self-reliant," and led a life that forced him "to be both daring and adventurous." He was a man whose history was etched in the lines of his face, "lines that tell of dangers quietly confronted and hardships uncomplainingly endured."[56] Every hardship and every mile only added value to the test.

Nor was he hesitant. For him, the hunt was a duel between himself and nature's proxy, a trophy male of a species that lived in haunts inaccessible to man. Roosevelt's hunter sought to confront the grizzly, as opposed to the homesteader who had no choice but to defend himself against it. Roosevelt's hunter chose to hunt mountain goat and bighorn sheep in their aeries, just as he chose to track down grizzly, moose, elk, caribou, mountain lion, and wolves, not because they posed a threat but because they posed a challenge. The economy of labor and the conservation of energy did not matter. What mattered was the *philosophy* that held a man should be held accountable, in Roosevelt's words, to stand "for what he actually is, and can show himself to be."[57]

DRAWN BY MARY HALLOCK FOOTE. THE COMING OF WINTER. ENGRAVED BY J. H. E. WHITNEY.

A hardscrabble life on the frontier. *The Coming of Winter* in *Century Illustrated Monthly Magazine,* 1888.

OLD EPHRAIM

Roosevelt's hunter was unflappable in the face of mortal danger. He was prepared to stand toe to toe—to fight hand and knife against tooth and claw, if necessary—to decide the contest. Roosevelt devoted the last chapter of *Hunting Trips of a Ranchman* to Old Ephraim, the mountain man's name for *Ursus horribilis,* the grizzly bear. Although he confided that "hunting the grizzly has been greatly exaggerated," his account of still-hunting a grizzly boar is not an emotional celebration of animal death but a lesson on method and discipline, and on the values of a steadfastness of nerve and unerring marksmanship:

> [When] he saw us [he] dropped down again on all fours, the shaggy hair on his neck and shoulders seeming to bristle as he turned toward us. As he sank down on his forefeet I had raised the rifle; his head was bent slightly down, and when I saw the top of the white bead fairly between his small, glittering, evil eyes, I pulled trigger. Half-rising up, the huge beast fell over on his side in the death throes, the ball having gone into his brain, striking as fairly between the eyes as if the distance had been measured by a carpenter's rule.[58]

An illustration by A. B. Frost, one of the major sporting artists of the late nineteenth century, accompanies the narrative moment when the bear stands up on his rear legs to confront the hunter. Roosevelt opined, "In killing dangerous game, steadiness is more needed than good shooting."[59] Another illustration by Frost later in the book depicts Roosevelt taking aim on a full-curl bighorn ram that stands defiantly above him on a rock precipice. Roosevelt kneels in the foreground as he frames the ram in his sights; his inferior position in the frame suggests the ram is the king of the mountain, but only momentarily, for he is about to fall to Roosevelt's steady hand and unerring aim.[60]

The frontispiece of *The Wilderness Hunter,* which depicts Roosevelt standing over the hulk of the dead bear, is a figurative fulfillment of God's promise to Noah in Genesis 9:2 (KJV): "And the fear of you and the dread of you shall be on every beast of the earth, on every bird

Roosevelt confronts Old Ephraim, by A. B. Frost, 1885.

of the air, on all that move on the earth, and on all the fish of the sea; into your hand are they delivered." Over the course his hunting career, Roosevelt would kill several more bears, and yet he never felt emotionally fulfilled.[61] The trophy heads mounted on the walls of his homes, his clubs, and in city and state museums provided his credentials as a hunter, and in terms of the measurements that matter to sport hunters—the length of claw or tooth, the circumference and reach of antlers, Roosevelt's credentials were impressive by any standard. A hundred years later hunters still marvel at that masculine *mass* of his trophies. But hunting went beyond spectacle for Roosevelt. He was too restless and too demanding to feel he would reach any goal that would be determined by something as arbitrary as metrics. He was focused on the goal beyond the goal. Writing to his sister about killing his first grizzly in 1884, Roosevelt described coming "face to face with the great bear." His resolve hardens him "steady as a rock" and he shoots it "exactly between his eyes." But his description is matter-of-fact and is tinged with discontent. "But unless I was bear hunting all the time," he confided to Bamie, "I am afraid I should soon get restless with this life as with the life at home."[62]

One gets the sense Roosevelt grew dissatisfied with the rifle because it kept death at too far a distance; the true predator would feel the hot breath of his prey on his face and feel its body struggling to escape his grasp. When one of his San Juan Hill comrades gave him a gift of a hunting knife, he remarked that some day he hoped he would use it to "kill a big grizzly or silver tip, which would be great sport." His words were not the empty rhetoric of a grateful recipient of a gift; it reflected a real desire to move closer to the biting edges of death. The next year he would use a hunting knife to kill a mountain lion after his hunting dogs had mobbed it. But even the knife was not enough. In 1905, when Roosevelt watched Jack "Catch-'em-Alive" Abernathy jump on the back of a wolf, "thrusting his gloved hand into its mouth, and mastering it then and there," he concluded that the true primal contest between man and beast should be with bare hands.[63]

Over the course of his years as a hunter Roosevelt shared company with several men who had gone hand to hand with the beast. One such hunter was Carl Akeley, an American big game hunter who had strangled a leopard that had ambushed him in the African veldt. But Akeley did not share Roosevelt's naive enthusiasm about killing. "I have seen a good deal of a certain [men] whose greatest joy is to come up with a wounded animal, whip out his knife

and cut its throat," he wrote circumspectly of men like Roosevelt. "He derives infinitely more pleasure from wounding the animal and finishing it off with his own hands than he could possibly get out of a clean kill with the rifle."[64]

FAIR, MANLY HUNTING

However much Roosevelt's hunter claimed to want to tear away the last pieces of connective tissue that bound him to modernity, he stuck to a code that dictated the terms of "fair chase." "The true way to kill the noble beast," Roosevelt declared, was not "stealth and stratagem" but "fair, manly hunting," a set of arbitrary rules that defined the appropriate conduct of the hunter.[65] A hunter, for example, should not lie in wait to shoot an animal, but should stalk it. He should not shoot an animal that was swimming or bogged down in mud or deep snow. He should not set fires to drive animals to the gun, although it was a "legitimate, but inferior, kind of sport" to use dogs to do the same. Nor should a female be killed, unless she was barren. "As I rule, I never shoot anything but bucks," Roosevelt explained. "Killing a reasonable number of bulls, bucks, or rams does no harm whatever to the species; to slay half the males of any kind of game would not stop the natural increase, and they yield the best sport, and are the legitimate objects of the chase."[66] As Sarah Watts points out in *Rough Rider in the White House,* his biological rationalization camouflaged a much more resonant reason for killing not just males, but ideal males in the prime of their life, "with "an unusually fine head"; unspoiled plumage or pelt; or long horns, fangs, or claws, which could be measured, photographed, entered in record books, carried home, and mounted on a wall.[67] Such victories were unequivocal evidence of dominion.

The last illustration in *Hunting Trips of a Ranchman* depicts Roosevelt working his way down the steep slope of the Bighorn Mountains of Montana, which loom with medieval darkness in the background. He leads a pack train of horses laden with furs and the heads of five magnificently antlered elk. He is like the huntsman of the fairy tale who has returned from the darkest of forests with the glowing heart of the stag in his palm.

And yet he remained unfulfilled.

American Idol, 1898

IN 1895 NEW YORK CITY MAYOR WILLIAM STRONG OFFERED ROOSEVELT THE JOB OF commissioner of the New York City Police Board. TR resigned from the Civil Service Commission and refocused his restless energy on overhauling the New York City Police Department by rooting out fraud, waste, and corruption. When he wasn't sitting in meetings, he would prowl the streets at night trying to catch lazy or crooked cops on the beat or shut down bars that defied the city's Sunday closure law, a strategy designed to enhance his profile as a man dedicated to the reform of a corrupt system. During this time Roosevelt also made friends with Jacob Riis, a reporter and photographer for the *New York Sun* who earned a reputation as an agitator for social reform of the brutal conditions of life in the sweatshops and slums of New York City.[1] Roosevelt and Riis became ideological allies, which would serve Roosevelt's purposes well when the *Sun* sent Riis to Cuba to cover the Spanish-American War in 1898.

In 1897, President-Elect William McKinley appointed Roosevelt as an assistant secretary of the navy in return for his dogged party loyalty, his forthrightness, and his reputation as a no-nonsense supporter of the "truth." The *Washington Post* welcomed him as a man "inspired by a passionate hatred of meanness, humbug, and cowardice. He is a fighter, a man of indomitable pluck and energy, a potent and forceful factor in any equation into which he may be introduced." And then the editorial writer wondered aloud, "A field of immeasurable usefulness awaits him—will he find it?"[2] Within the span of the next four years, Roosevelt would skyrocket from virtual obscurity to the highest office of the nation. During that span of time, he served not only as the assistant secretary of the navy (1897–1898), but also as a lieutenant colonel in the Spanish-American War (1898), the governor of New York (1898–1900), vice president of the United States (1901), and finally, upon the assassination of McKinley in September 1901, he became at the age of forty-two the youngest man ever to become president of the United States.

ROOSEVELT AND THE MOTION PICTURE CAMERA

The rise of Theodore Roosevelt to political power was intimately connected to the role of the motion picture camera. Roosevelt was the first major political figure to recognize and embrace the power and the reach of film to shape public opinion, almost twenty years before Lenin would make his famous pronouncement about the critical role cinema would play in shaping the political process. He actively courted the camera, often brilliantly and sometimes to his acute dismay. "During speeches," wrote documentary film historian Eric Barnouw, "he noted

any cameraman and gave him the full benefit of vigorous grins and gestures, sometimes walking to the side of the platform to do so."[3] Albert E. Smith, a cofounder of American Vitagraph, claimed that Roosevelt stopped in the middle of his charge up San Juan Hill in Cuba in order to "strike a pose" for his camera.[4] Roosevelt captured a generation in large part based upon his image as a man of nature, not in the mold of the gentlemanly naturalist such as John Burroughs or John Muir, but in the romantic traditions of the rider of the range, the cowboy, the frontier lawman, wilderness hunter, and soldier-poet.

Roosevelt was not the first president to be filmed at length. His predecessor, William McKinley, appeared in over fifty films, even though the majority of them are about his state funeral after a deranged assassin gunned him down in the early weeks of his second term as president. But McKinley was a passive subject—an idle curiosity to an inquisitive lens. His nomination by the Republican Party coincided with the emergence of the portable film camera, and so the first footage of an American president was shot in 1896 upon his election as the chief executive. *McKinley at Home, Canton, Ohio* (1896) consists of a shot of the president lounging on the porch of his home. He waves stoically for the camera. The motion picture camera, uncertain of its status or its capabilities, mostly filmed McKinley's coming and goings, such as in *McKinley Leaving Church* (1897) and *McKinley Leaving State House, Boston* (1899), or attending ceremonial functions, such as in *McKinley Taking the Oath* (1897) and *President McKinley Reviewing the Troops* (1899) as America prepared to launch its Spanish-American campaign.

The camera kept a respectful distance and seemed more interested in chronicling the duties of the presidency than in the private man who was president. As a result, McKinley appears stolid and emotionally distant in the twenty-two films made about him prior to his assassination at the Pan-American Exposition of 1901.

In many ways, McKinley was a perfect foil, both visual and political, for Teddy, who seemed tailor-made for the camera. McKinley was plain, dour, and looked overweight and soft, especially in contrast to Roosevelt, who was animated, doughty, and physical. Roosevelt's directness is implicit in a campaign ad that features both McKinley and Roosevelt. Teddy addresses the viewer directly, almost aggressively as though to take on all doubters, whereas McKinley looks askance and dreamy. McKinley looks old; Roosevelt is in his prime.

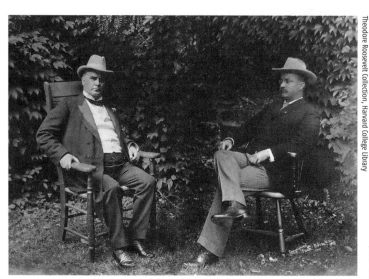

Theodore Roosevelt Collection, Harvard College Library

McKinley contrasts with a physically fit Roosevelt, 1900.

On camera, McKinley looked hesitant and indecisive; Roosevelt, on the hand, appeared direct, indomitable, and primed for action. Hunter, cattleman, horseman, soldier: the photo and political cartoon archive of Roosevelt already reflected a man of action, a man connected to the land, a man not only willing but eager to wrestle the powerful forces of nature and man. His body and his posture reflect certainty, courage, and a willingness to fight.

Roosevelt intuitively grasped the potential of the moving image to enlist the sympathies and allegiances of the American public. The earliest known film of him, *Theodore Roosevelt Leaving the White House* (1898), was made on the eve of the Spanish-American War when he was assistant secretary of the navy.[5] The fifteen seconds of film shows TR in formal dress and a bowler hat striding down the steps of the Treasury Building toward the camera with the south portico of the White House in the background. It's a glimpse of a man of purposeful gait who appears just as much at home amidst the trappings of power as he was around the ranch house.

In 1898 Roosevelt, like a lot of Americans, was spoiling for a fight with the Spanish, who were embroiled in a bloody struggle against Cuban revolutionaries who'd taken up arms against a repressive colonial regime in 1895. In fact, Roosevelt had been agitating for a big fight for years. In 1886, he suggested mustering a troop of men "as utterly reckless a set of desperadoes as ever sat in the saddle" to force the release of an American journalist who had been jailed in Mexico, and in 1889 he had hoped for "a bit of a spar" with Germany over Samoa. He wrote to Cecil Spring-Rice, a British diplomat who had been the best man at his wedding to Edith, that "the burning of New York and a few other seacoast cities would be a good object lesson on the need of an adequate system of coast defences; and I think it would have a good effect on our large german [*sic*] population to force them to an ostentatiously patriotic display of anger against Germany."[6] And in 1895, when Great Britain rebuffed President Cleveland's demand to arbitrate Britain's intention to annex 23,000 square miles of Venezuelan territory to British Guiana, Roosevelt supported Cleveland's aggressive stance and suggested publicly that Britain would take America much more seriously if the United States invaded and conquered Canada. Once "wrested from England," Roosevelt wrote, Canada "would never be restored."[7] In *Theodore Roosevelt and the Rise of America to World Power,* Howard K. Beale concludes Roosevelt "came close to seeking war for its own sake."[8]

Roosevelt's dream for war was finally realized as news of atrocities in Cuba circulated in the American press, and American public opinion bristled against the Spanish. Tensions between Spain and the United States escalated rapidly. Then, on February 15, 1898, the battleship *Maine,* which McKinley had sent to Cuba to protect American interests under the guise of a "friendly visit," mysteriously blew up in Havana harbor, killing over 250 crew and officers. Many, Roosevelt among them, were quick to accuse the Spanish of sabotage. "The *Maine* was sunk by an act of dirty treachery on the part of the Spaniards, I believe," Roosevelt wrote in a letter, "though we shall never find out definitely, and officially it will go down as an accident."[9]

Moderates, led by McKinley, tried to counsel patience pending an investigation of cause of the disaster, but the public hue and cry of "Remember the Maine!" became a rallying point for war. The rush to judgment was, in Woodrow Wilson's opinion, "a war of impulse," and there was no more impulsive figure than Theodore Roosevelt.

Assistant Secretary to the Navy Roosevelt deplored McKinley's hesitancy to commit to war. The president, Roosevelt complained to a friend, was feckless and had "no more backbone than a chocolate éclair." Roosevelt openly agitated for war, and he wanted to be part of it. "One of the commonest taunts directed at men like myself," Teddy wrote to Dr. W. Sturgis Bigelow on March 29, 1898, "is that we are armchair and parlor jingoes who wish to see

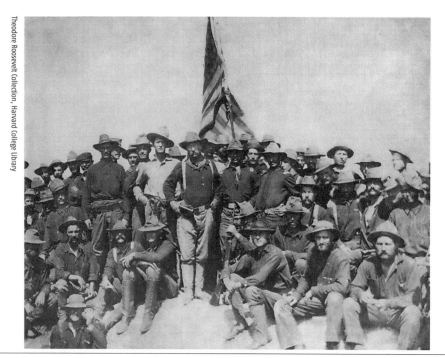

Theodore Roosevelt Collection, Harvard College Library

Lt. Colonel Theodore Roosevelt and the Rough Riders atop San Juan Heights, 1898

others do what we only advocate doing. I care very little for such a taunt . . . but I cannot afford to disregard the fact that my power for good, whatever it may be, would be gone if I didn't try to live up to the doctrines I have tried to preach."[10] Privately, Roosevelt was, in the words of one of his friends, "going mad wild to fight and hack and hew."[11] There was going to be what Remington called "a big murdering" and Roosevelt intended to be part of it. "If unable to participate, I shall be eating my heart out," he wrote Bigelow. "I like action."[12]

Unable to subdue mounting public outrage, McKinley conceded, and in April, Congress passed three resolutions that let loose the dogs of war. Roosevelt impulsively quit his desk as assistant secretary of the navy for an appointment as a field officer in command of a volunteer cavalry regiment in Cuba. Roosevelt wanted to prove himself on the field of battle. "[I]t will be awful," he worried in a letter to a friend, "if the game is over before we get into it." Teddy's boss, Secretary of the Navy John D. Long, lamented Roosevelt's reckless, vainglorious move: "He thinks he is following his highest ideal, whereas, in fact, as without exception every one of his friends advises him, he is acting like a fool."[13]

Roosevelt, however rash, was anyone but a fool. Mark Twain described Roosevelt to Andrew Carnegie as "the Tom Sawyer of the political world of the twentieth century, always showing off; always hunting for a chance to show off; in his frenzied imagination the Great Republic is a vast Barnum circus with him for a clown and the whole world for an audience; he would go to Halifax for half a chance to show off, and he would go to hell for a whole one."[14] It was that exaggerated sense of bravado, however, that endeared him to the public. "They were captivated by the flashing grin," writes Roosevelt biographer, Nathan Miller, "the determination in the blue eyes . . . and the vigor in the staccato flood of words driven home

by the . . . pounding of the fist on palm."[15] His decisiveness and his moral certainty made him the "right" man for "right" war at the "right" time.

Meanwhile, newspaper tycoon William Randolph Hearst, who was also agitating for war, sent a complement of reporters to Cuba. Sensing an opportunity, both Edison and the American Mutoscope and Biograph motion picture companies sent camera crews to Tampa, as the troops readied for war. The first of these films started showing in New York in late March 1898, as the nation seesawed between war and peace. "The patriotic feelings of the audience invariably get fresh and sterling material for frequent outbursts," read a review in the *New York Clipper* about the film footage coming out of Cuba.[16] Advertisements for Biograph films were just as inflammatory: "Peace at Any Price! Do We Want It?"[17]

In early 1898 people flocked to see footage of the wreckage of the USS *Maine* in Havana Harbor (*Wreck of the Battleship "Maine"*), the burial of the sailors killed in the explosion (*Burial of the "Maine" Victims*), the capture of the Spanish ship *Panama* (*Capture of the "Panama"*) and a group of starving *reconcentrados* with plates and cups in hand waiting to be fed in *Cuban Refugees Waiting for Rations*. None were more popular, however, than films about Roosevelt's volunteer regiment, the Rough Riders.

CHILDREN OF THE DRAGON'S BLOOD

When word was put out that Roosevelt was seeking volunteers for his own regiment, twenty-three thousand men applied. "It was a remarkable spectacle, this flocking to a man not yet forty," historian William Roscoe Thayer wrote. "But Roosevelt's name was already known; it excited great admiration in many, grave doubts in many, and curiosity in all."[18] In the five years since he had first stepped out onto the Dakota Badlands, Roosevelt had created a national identity as a man of the West, which, remarked Roosevelt's sister Corinne, "provided the essential factor in the flocking to his standard of that mass of virile manhood."[19]

Roosevelt handpicked a thousand recruits. They came from every niche of life and included miners, cowboys, Ivy League polo players and crewmen, hunters, ranchers, and even football players. They cut across virtually ever section of society and included Jews, Italians, Scandinavians, and Irishmen. But the overwhelming majority of his regiment, in Roosevelt's words, came from Arizona, New Mexico, Texas, the Oklahoma Territory, and the Indian Territory, or what Roosevelt called "the Four Territories which yet remained within the boundaries of the United States; that is, from the lands that have been most recently won over to white civilization, and in which the conditions of life are nearest those that obtained on the frontier when there was still a frontier."[20] The volunteers were the prototypes of Frederick Jackson Turner's new American, "wild rough riders of the plains" who "possessed in common the traits of hardihood and a thirst for adventure."[21] They sported names such as Cherokee Bill, Happy Jack of Arizona, Smoky Moore, and Rattlesnake Pete. There were legendary lawmen such as Bucky O'Neill, the sheriff of Prescott, Arizona, notorious for "his feats of victorious warfare against the Apache, no less than against the white road agents and man-killers," and Benjamin Franklin Daniels, the marshal of Dodge City, Kansas, "when that pleasing town was probably the toughest abode of civilized man to be found anywhere on the continent."[22] There was "tall Profitt, the sharpshooter, from North Carolina—sinewy, saturnine, fearless; Smith, the bear-hunter from Wyoming, and McCann, the Arizona bookkeeper, who had begun life as

a buffalo-hunter . . . and Crockett, the Georgian, who had been an Internal Revenue officer, and had waged perilous war on the rifle-bearing 'moonshiners'."[23] There were Indians too: Cherokees, Chickasaws, Creeks, and Pollock, a full-blooded Pawnee. "I doubt if there was any regiment in the world," crowed Roosevelt in *The Rough Riders* (1899), "which contained so large a number of men able to ride the wildest and most dangerous horses."[24]

The Rough Riders captured the imagination of America. Unlike the regular troops that stood in row upon stolid row, the Rough Riders embodied an untamed spirit that seemed to make them fit for the rigors of war. "My men were children of dragon's blood," wrote Roosevelt. They were not just unafraid of violence but welcoming of it. They were child-men of grit "tall and sinewy, with resolute, weather beaten faces, and eyes that looked a man straight in the face without flinching."[25] Rambunctious and jejune, they were ready to fight at the drop of the hat. "Rough, tough, we're the stuff," went their war chant, "We want to fight and can't get enough!"[26] They were, wrote Roosevelt unself-consciously, "great big, goodhearted, homicidal children."[27]

Mindful of his image and the image of his men, Roosevelt chose their uniforms so they looked "exactly as a body of cowboy cavalry should look," with their "slouch hats, blue-flannel shirts, brown trousers, leggings, and books, with handkerchiefs knotted around their necks."[28] In the tradition of Custer and Cody, TR had his own uniform custom-made by Brooks Brothers in New York, a "blue cravennet [*sic*] regular lieutenant-colonel's uniform without yellow on collar, and with leggings." His spurs, belt buckle, and pearl-handled revolver came from Tiffany's.[29]

The motion picture camera played a major role in depicting the spectacular heroism of Roosevelt and the Rough Riders to the public. Although the movie camera did not accompany the troops into battle, it did capture the staging for war and several re-creations after the war that often passed themselves off as documentary images. Biograph and Edison made three films that featured Lt. Colonel Roosevelt in Tampa as he readied his men for war. Edison's *Roosevelt's Rough Riders Embarking for Santiago* was shot on June 8, 1898, five days before the troops shipped out to Cuba on Troop Transport No. 8, the *Yucatan*. The film, which is twenty-eight seconds long, consists of a single static shot of Lt. Colonel Roosevelt as he barks orders to his men as they load crates of materiel onto the steamship in the background. If the country had any hesitancy about going to war, Roosevelt's exuberant pertinacity dispelled it.

The Biograph films portrayed Roosevelt even more dynamically than Edison's. *Col. Theodore Roosevelt and Officers of His Staff* (1898)[30] (also known as *President Roosevelt and the Rough Riders*), captures the freshly minted lieutenant colonel of the First U.S. Cavalry Volunteers galloping on his horse with other prominent officers to his field headquarters, where he dismounts and marches off screen to his tent. There's no mistaking his swagger or the calculated cut of his profile.[31] These images of Roosevelt confirmed the impression that he was a man in command, certain of his duty, and fearless in the discharge of his orders. "This view was taken in the camp with the Rough Riders," the Biograph summary of the film reads, "and is an excellent picture of Col. Roosevelt in the environment he loves so well." Another film shot by Biograph in May, *Roosevelt's Rough Riders,* shows Roosevelt's I Troop in battle dress charging the camera at a full gallop and then wheeling away in front of the lens.[32] It's a rousing shot of American men impatient for glory. These moving images played in endless loops in street kinetoscopes and imprinted on the American consciousness the connection between the cowboy West and valiant American soldiery.

The Rough Riders landed on the shores of Cuba on June 22, 1898, and were finished fighting less than four weeks later, when the Spanish surrendered on July 17. "It has been a splendid war," Secretary of State John Hay gloated in a letter to Roosevelt, "begun with the highest

motives, carried on with magnificent intelligence and spirit, favored by that Fortune which loves the brave."[33] Roosevelt concurred. "There was never a war in which so much was accomplished for humanity, at so small a cost of blood, as the war which resulted in the freeing of Cuba," he wrote.[34] Then he privately added, "The only trouble was that there was not enough war to go around."[35] Within the span of a hundred days, the United States destroyed the Spanish fleet in Cuba and seized the Spanish possessions of Philippines, Guam, and Puerto Rico.

THE COWBOY'S WAR

The motion picture camera recorded little of the military action in Cuba because of a lack of experience in filming military action, and although still photographers documented some aspects of the campaign, documentary sketch artists and painters such as Remington produced the dominant battlefield images of the Spanish-American War, including Colonel Roosevelt's famous charge at the Battle of San Juan Heights. The movie camera, had it been more present, might have provided clearer documentary proof of what became known as Roosevelt's "crowded hour," the defining moment of his life that would ultimately shape his sense of foreign policy and its relation to the lessons he had learned on the western frontier about masculinity and American destiny.[36]

On an insufferably hot afternoon on the first of July, Roosevelt led "fragments of six cavalry regiments" to the top of Kettle Hill, and then over San Juan Ridge where the heavily fortified Spanish had dug in at the top of San Juan Hill. Only Roosevelt was mounted. "Are you afraid to stand up when I am on horseback?" he purportedly shouted at a terrified trooper as he spurred his horse, Little Texas, up the hill at the head of the charge.[37]

About sixty yards from the top of the hill, Roosevelt found himself stymied by a wire fence. He dismounted, jumped over the fence, crested the hill and then continued along the ridge to San Juan Hill for about a hundred yards before he realized only five of his men were following him. "The troopers were so excited," Roosevelt explained, "what with shooting and being shot, and shouting and cheering, that they did not hear, or did not heed me."[38] He ran back, berated the men, and then goaded them to follow him.

The army overran the Spanish fortifications, but the victory was costly in terms of human life. The Rough Riders suffered a casualty rate of nearly 20 percent, the "heaviest loss suffered by any regiment in the cavalry division," Roosevelt remarked with a flourish of pride.[39] The reports from the field, most of which were written by friends of Roosevelt such as Jacob Riis and Richard Harding Davis, portrayed him as an irresistible figure. "He was, without doubt, the most conspicuous figure in the charge," wrote Richard Harding Davis, the war correspondent for Hearst's *New York Journal:*

> Roosevelt, mounted high on horseback, and charging the rifle-pits at a gallop and quite alone, made you feel that you would like to cheer. He wore on his sombrero a blue polka-dot handkerchief . . . which, as he advanced, floated out straight behind his head, like a guidon. Afterward, the men of his regiment who followed this flag, adopted a polka-dot handkerchief as the badge of the Rough Riders.[40]

Reminiscent of his experience in the Dakota Badlands when he hunted down the scofflaws Finnigan, Pfaffenbach, and Burnsted, Roosevelt posed for the camera at his moment of

victory. But the static documentary image of Roosevelt, however laden with symbolism (with Roosevelt standing high in the center of the frame, the American draped flag over his shoulder) could not match the dramatic quality of Davis's vivid dispatches or the colorful (often imaginative) pictorial renderings of Roosevelt as he led the mad dash up the hill.

The visual representations of Roosevelt's charge started to appear in the popular press within weeks of the war and captured the imagination of the public, which was heady with victory. Most of these visualizations, however, played loose with the facts. W. H. Read's rousing "Rough Riders Charge up San Juan Hill," for example, shows Roosevelt brandishing his sword as he leads a full cavalry charge, when in fact, he was the only soldier who was mounted and he had not carried a sword into battle. And even though a contemporary promotional broadside for William H. West's stage production of *The Storming of San Juan Hill* ("*The Most Stirring Scene Ever Produced on Any Stage*") more accurately depicts the troops on foot (although Roosevelt is still waving a sword), the line of men following Roosevelt in close order falsely represents the way the men actually made their way up the hill.

Roosevelt himself commissioned Frederic Remington to paint *The Charge of the Rough Riders at San Juan Hill* at the end of the war. In Remington's version, Roosevelt, still mounted on Little Texas, heads a swarm of Rough Riders running up the closely clipped grass of San Juan Hill. Two dead Spaniards lie spread-eagled on the ground before them. "The Rough Riders charged," wrote Riis of the scene, "through a hail of Spanish bullets, the men dropping by twos and threes as they ran."

> Forward! Charge! Lieutenant-Colonel Roosevelt led, waving his sword. Out into the open the men went, and up the hill. Death to every man seemed certain. . . . Up, up they went, with the colored troops alongside of them, not a man flinching, and forming as they ran. Roosevelt was a hundred feet in the lead. Up, up they went in the face of death, men dropping from the ranks at every step. . . . Roosevelt sat erect on his horse, holding his sword and shouting for his men to follow him. Finally his horse was shot from under him, but he landed on his feet and continued calling for his men to advance. He charged up the hill afoot.[41]

Richard Harding Davis criticized these images in *The Cuban and Porto Rican Campaigns* (1898). "In the picture papers," he wrote, "the men are running up hill swiftly and gallantly, in

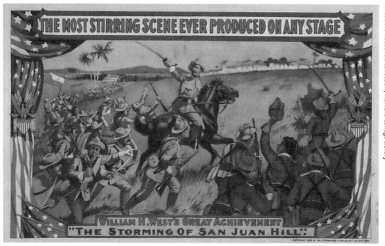

Theodore Roosevelt Collection, Harvard College Library

William H. West's minstrel version of the storming of San Juan Hill, 1899

regular formation, rank after rank, with flags flying, their eyes aflame, and their hair streaming, their bayonets fixed, in long, brilliant lines, an invincible, overpowering weight of numbers." In fact, the sight of advancing troops disheartened Davis. "I think the thing which impressed me the most, when our men started from cover, was that they were so few," he wrote.

> It seemed as if someone had made an awful and terrible mistake. One's instinct was to call to them to come back. You felt that someone had blundered and that these few men were blindly following out some madman's mad order. It was not heroic then, it seemed merely terribly pathetic. The pity of it, the follow of such a sacrifice was what held you.
>
> They had no glittering bayonets, they were not massed in regular array. There was [*sic*] a few men in advance, bunched together, and creeping up a steep, sunny hill, the tops of which roared and flashed with flame.[42]

But such details did not matter to the public. It did not matter that Roosevelt had led the charge up Kettle, not San Juan Hill, and that the Rough Riders had arrived only after the regular army had already taken San Juan; nor did it matter that Roosevelt did not carry a sword and that he had crested the hill without his horse or that by the time they had reached the summit the Spanish had already largely deserted their positions. Nor did it matter that the Ninth and Tenth Regular Cavalry, which was largely comprised of black soldiers, had suffered the brunt of the casualties, not the Rough Riders.[43] What mattered, writes Sarah Watts, was the affirmation of "the Rough Rider as true inheritors of the cowboy tradition of white, aggressive, nationalist manhood."[44] What mattered was American exceptionalism. "In how many American homes was that splendid story read that morning with a thrill never quite to be got over?" wondered Jacob Riis as he read the narrative of Roosevelt's charge in the newspaper. "We laid down the paper and gave two such rousing cheers in Richmond Hill that Fourth of July morning, one for the flag and one for Theodore Roosevelt!"[45]

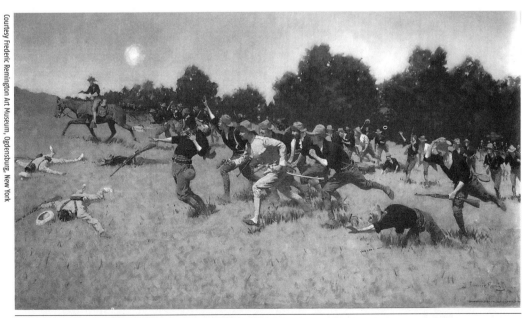

Courtesy Frederic Remington Art Museum, Ogdensburg, New York

Charge of the Rough Riders up San Juan Hill, Frederic Remington, 1898

Like many of his generation, Roosevelt grew up with an overly romanticized view of the Civil War, and his attitude and conduct about war reflected an almost sentimental attachment to violence. He reflected General George Armstrong Custer's naive attitude about war and glory. "I shall regret to see the war end," Custer wrote in 1862. "I would be willing, yes glad, to see a battle very day during my life."[46] Roosevelt and the Rough Riders scorned danger with a reckless disregard for their safety. Just before the charge up Kettle Hill, Bucky O'Neill, the fearless sheriff of Prescott, Arizona, stood up in the field of fire and calmly smoked a cigarette as bullets whizzed past him. He ignored calls from the other men to get down as he paraded his disdain for the enemy, claiming "the Spanish bullet ain't made that will kill me." A moment later a bullet struck him in the mouth and he dropped dead on the spot.[47]

For his part, Roosevelt rose to the challenge of his own high expectations as a leader of men, but he also sank to the bestial as someone who was attracted to the visceral thrill of killing and death. While he recklessly exposed himself as the only mounted soldier at the head of the attack—a gesture perceived as valiant—when he came out of the battle unscathed, he regretted not having received his own red badge of courage. "I have always been unhappy, most unhappy, that I was not severely wounded in Cuba . . . in some . . . striking and disfiguring way," he told a reporter several years after the battle.[48] He even admired the battle wounds of others.[49]

Roosevelt often descended to the ignoble as when he related how he had "probably" killed a Spanish soldier during the charge up Kettle Hill.[50] He dehumanized his victim by using the terms of a dispassionate hunter, observing that the Spaniard had "doubled-up neatly as a jack-rabbit." And when noncombatants came to visit the battlefield, Roosevelt ingloriously invited them to "look at those damned Spanish dead."[51] In addition, he denigrated the effort of the Cubans, whom he characterized as "grasshopper people."[52] In spite of the fact that the Cuban insurgents had made it possible for the American forces to land at Ponce with a minimum of casualties by fighting back the Spanish, Roosevelt disparaged their effort. "They were unable to make a serious fight, or to stand against even a very inferior number of Spanish troops," he wrote scathingly of Cuban soldiers,

> but we hoped they might be of some use as scouts and skirmishers. For various reasons this proved not to be the case . . . we should have been better off if there had not been a single Cuban with the army. They accomplished literally nothing, while they were a source of trouble and embarrassment, and consumed much provisions.[53]

The base side of Roosevelt the warrior was forgotten in the written and visual narratives that played out as the American public seized upon the image of a bold, brave warrior, unflinching in his duty to his nation and to the downtrodden of other nations. As the embodiment of a belief in the innate superiority and uniqueness of character that had arisen from the American West, the Rough Riders in general and Colonel Theodore Roosevelt in particular suddenly found themselves elevated as national icons.

The exultant renditions of them by writers, artists, and filmmakers created what Richard Slotkin defines as a "myth-ideological system," which created heroes in a narrative about the war that served the interests of an emerging American political hegemony. "The continuing social and cultural turmoil of modern societies creates a dialectic between myth and ideology," explains Slotkin, between the system of symbolizing stories that sustains, invokes, and carries traditional values and worldviews, and the rapidly changing body of arguments generated by rising and falling classes and institutions—as they respond to the shifting relations of the modern political economy.[54] The myth-ideological system created a leader for which

the country yearned, a hero who embodied the best virtues of Americanism as they had been defined by the other mythic men in the pantheon of American heroes.

Public acclamation—and adoration—of Roosevelt and the Rough Riders quickly followed. Within a week of the action at San Juan Heights, the commanding officer of the volunteers, Colonel Leonard Wood, recommended Roosevelt for a promotion to full colonel and the Congressional Medal of Honor.[55] "I think I earned my Colonelcy and medal of honor," Roosevelt crowed in a letter to Henry Cabot Lodge, "and I hope I get them." A few days later, Roosevelt wrote Lodge again and added, even more immodestly, "I do not want to be vain, but I do not think that anyone else could have handled this regiment quite as I have handled it during the last three weeks."[56] He boasted to another friend, "I rose over those regular army officers like a balloon."[57]

Mark Twain, among others, was far more skeptical of the Colonel Roosevelt's performance. "I think [he] is clearly insane in several ways, and insanest upon war and its supreme glories," he remarked. "I think he longs for a big war wherein he can spectacularly perform as chief general and chief admiral, and go down in history as the only monarch of modern times that has served both offices at the same time."[58] Twain's acerbic wit notwithstanding, Roosevelt's popularity continued to grow.

Teddy got his colonelcy, but to his own bitter disappointment and the dismay of the public, the "Brevet Board" convened by Secretary of War Russell Alger to determine the validity of recommendations for the Medal of Honor denied him the award in spite of the fact he had lobbied intensely for it. ("If I didn't earn it, then no commissioned officer can ever earn it," he complained in a letter to Henry Cabot Lodge. "I am entitled to the Medal of Honor, and I want it.")[59]

Few dispute that Roosevelt cut a dashing figure mounted on his steed, seizing command during a momentary lapse of authority, and leading the scramble up the hill in support of the regular troops who were conducting the charge against the main fortifications on San Juan Hill. But the conflicting testimonies of witnesses cast doubt on whether Roosevelt's contribution truly exceeded the heroic actions of many others, most of whom served their nation with equal or greater valor but anonymously. Certainly Roosevelt's frequent insubordination and his stinging and very public criticism of the bungled logistical effort of the War Department during the war did not help his cause either. "Not since the campaign of Crassus against the Parthians has there been so criminally incompetent a General as Shafter; and not since the expedition against Walcheren has there been grosser mismanagement than in this," he complained to Lodge about the commanding general of American expeditionary force in Cuba.[60] Roosevelt explained away the sleight of the Brevet Board by saying he was refused the Medal of Honor because he was outspoken and refused to be "a cog in a gigantic machine," even though a year later as the governor of New York he would demurely characterize himself as "just one cog in a complicated bit of machinery."[61] Nonetheless, Roosevelt emerged as an American Pericles. "I am quite content to go now," he later wrote Lodge. "I am more than satisfied even though I die of yellow fever tomorrow, for at least I feel that I have done something which enables me to leave a name to the children of which they can rightly be proud."[62] However sentimental, this Roosevelt was the one the public adored.

The Rough Riders also adored their leader, perhaps because they felt they shared many of his traits. He was demanding and tough, but he wasn't afraid to break the rules, such as in Cuba, when he drank beer with his own men (Roosevelt was officially reprimanded) or when he disobeyed the orders of a superior officer and released a man who was, in Roosevelt's judgment, being held for a court-martial he did not deserve. He did not hold himself above them, and yet he led them.

When the Rough Riders were mustered out of service on September 15, 1898—133 days after they were first enlisted—the regiment presented their leader with a Remington bronze, *Bronco Buster,* of a cowboy masterfully astride a nearly airborne horse. "There could have been no more appropriate gift," said Roosevelt as he accepted the gift. "The foundation of the regiment was the cow-puncher, and we have him here in bronze."[63]

Not only did *Bronco Buster* serve as a metaphor for man's dominion over nature, the sculpture also embodied the growing fervor for aggressive nationalism. Remington's cowboy holds onto the reins confidently with one hand while he raises a quirt to whip the horse into submission with the other. He is deliberate and controlled in contrast to the horse, which is wild and furious. The cowboy epitomizes certainty and skill. He is taciturn, yet powerful. Most of all, he is fearless and undaunted by the challenge that lies before him. Remington's cowboy offered a vigorous remedy to a nation that was weary of suffering from Dr. Beard's neurasthenia.

The Rough Riders fused the cowboy with the soldier, and Remington's *Bronco Buster* endorsed the connection. The iconic image of the cowboy grasped the imagination of the country, making *Bronco Buster* the most popular and financially successful American sculpture of the nineteenth century.[64]

CHARGE!

On August 4, 1898, a month before the Rough Riders were mustered out of service, "Teddy the Terror" made the cover of *Life,* which pictured him in his Rough Rider uniform astride a bucking bronco with both his six guns blazing. It is perhaps the first image of Roosevelt that conflated the cowboy and soldier. Roosevelt's ascension through the political ranks relied heavily upon associating himself as a westerner and as a soldier. Within weeks of retiring from active service, he started to campaign for governor of New York. He brought uniformed men from his regiment on the campaign trail as he stumped through the state, at one point giving forty speeches within a span of two days. With a flair for the theatrical, Roosevelt would have Emilio Casse, the bugler of A Troop, sound the call for *Charge* from the caboose of his campaign train before he gave a speech. "You have heard the trumpet that sounded to bring you here," Colonel Roosevelt told the people who thronged to see him and his troopers. "I have heard it tear the tropic dawn when it summoned us to fight at Santiago."[65] He drew huge crowds wherever he went. Not one to shy from the limelight ("He was his own limelight," wrote Owen Wister, "and could not help it"), Roosevelt stepped easily into the role of celebrity.[66]

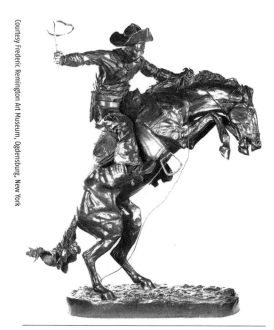

Courtesy Frederic Remington Art Museum, Ogdensburg, New York

The Rough Riders gave their leader Remington's bronze, *The Bronco Buster,* upon mustering out of the regiment, 1898.

In November 1898, less than ninety days after returning from Cuba, Roosevelt was elected the governor of New York. Less than a month after taking office, he published the first installment of his book, *The Rough Riders,* in *Scribner's Magazine.* His account of the war met with criticism from some quarters for being self-aggrandizing, but the book was an immediate success and contributed to the rapidly growing cult of Theodore Roosevelt and the Rough Riders. The popular momentum that continued to build behind him would soon result in his nomination as the vice presidential candidate on the Republican ticket in the summer of 1900 in spite of vigorous opposition by Republican leaders, such as political kingmaker and Republican senator from Ohio Mark Hanna. "Don't any of you realize," he cried, "that there's only one life between this madman and the White House?" (When Hanna heard that McKinley had died, Hanna famously grumbled "Now look—that damned cowboy is President of the United States!")[67] Hanna's strenuous objections notwithstanding, the Republicans nominated William A. McKinley, "a western man with eastern ideas," for president and Theodore Roosevelt, "an eastern man with western characteristics," for vice president.[68]

Roosevelt cast the only dissenting vote for his nomination.

ROOSEVELT, MOVIE STAR

Roosevelt deftly commixed the symbols of the West and the war throughout his political career. In 1905, for example, he brought Chiricahua Apache leader Goyathlay (Geronimo) from Fort

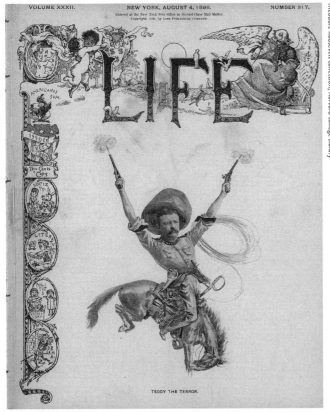

Theodore Roosevelt Collection, Harvard College Library

The cover of *Life* magazine, August 1898

Sill, Oklahoma, to Washington to march in his Inauguration Day Parade as a nostalgic reminder of the heyday of the wild and wooly West. He also let the matinee cowboy idol Tom Mix dress in the uniform of a Rough Rider and ride with the real veterans down Pennsylvania Avenue.[69] By that time the Rough Riders had already blurred historical reality with fantasy. At the end of the war, "Buffalo Bill" Cody signed up sixteen Rough Riders to perform the Battle of San Juan Hill in his Wild West Show, and in 1900, other veterans joined Colonel Zack Mulhall's Wild West show, sometimes also known as the Congress of Rough Riders and Ropers, which featured his teenaged daughter, Lucille, America's first "cowgirl," (whom Roosevelt invited to ride in the 1901 Inaugural Parade in Washington) and a trick roper from Claremore, Oklahoma, named Will Rogers, who also went on to become a staunch Roosevelt friend.[70]

Roosevelt appeared constantly at Rough Rider reunions, rodeos, and parades around the country as he campaigned for vice president. He was a grandstander, and his appearance guaranteed a huge turn out. But Roosevelt's stature depended in no small part on his frequent appearance in the cinema, which perpetuated the myth-ideology of a cowboy hero.

The Spanish-American War—or the Cowboy war as it became to be known—reinvigorated a movie business that had become lethargic because of a lack of stimulating content. The success of the films that had been shot in Cuba inspired a spate of reenactments both during and after the war. Edison's footage from Cuba played in vaudeville houses continuously for months, generating major revenues, as other financially troubled distribution and production companies seized upon the opportunity to make profits from war footage as well.[71] Documentary footage of the Rough Riders in the Peace Jubilee Parade in *Philadelphia City Troop and a Company of Roosevelt's Rough Riders* (1898) immediately after the war promoted national pride. But the relative lack of dramatic footage incited hungry filmmakers to create their own documentary versions of the war, which proved to be more effective in rousing public sentiment than the staid footage of homecoming parades.

In 1898, American Vitagraph produced *Tearing Down the Spanish Flag,* which film encyclopedist Ephraim Katz identifies as the world's first propaganda film.[72] The film consists of a single static shot of a flagpole flying a Spanish flag against an empty sky. A pair of hands strikes the Spanish flag and then raises Old Glory in its place. The principals of American Vitagraph, Albert E. Smith, a sometime magician and bookbinder, James Stuart Blackton, and William "Pop" Rock, the owner of a pool hall in Harlem, shot the footage not in Cuba but on a rooftop in Brooklyn as they tried to capitalize on rising nationalist passions.[73] The film was such a success that it prompted Edison to produce his own version, *Raising Old Glory over Morro Castle* (1899), which was nearly identical to Vitagraph's version but also included a patently fake drawing of Morro Castle, the main Spanish fortification at Havana Harbor, in the background.[74] In October 1898 Edison staged the execution of Cuban insurgents in *Shooting Captured Insurgents,* which the Edison catalogue describes emotionally disjunctively: "A file of Spanish soldiers line up the Cubans against a blank wall and fire a volley. The flash of rifles and drifting smoke make a very striking picture."[75]

Smith and Blackton claimed to have gone to Cuba to shoot documentary footage of the opening days of the war, and it remains unclear if they really did go, and if so, if they actually managed to secure any images of it. Smith claimed he had shot footage of Roosevelt's charge up San Juan (Kettle) Hill (*Fighting With Our Boys In Cuba*), but he explained that the footage lacked the wildly dramatic feel of a battlefield charge compared to the illustrations that were showing up in magazines and newspapers. His footage, in Smith's words, made Roosevelt's charge appear like "a dull uphill walk," so he and Blackton decided to spice it up by combining

their footage of Roosevelt with dramatic footage of the United States' decisive defeat of the Spanish naval squadron at Santiago de Cuba, which they also claimed to have shot even though they were in New York when the battle took place.[76]

The battle of Santiago de Cuba took place on July 3, 1898, when U.S. battleships crushed Admiral Cervera's squadron. Smith and Blackton, however, shot their version of the naval engagement in a tenement bathtub in Brooklyn. They pasted pictures of the warships onto cardboard, rigged the photos of the vessels with gunpowder, and then floated them in two inches of water. As the men blew up the cardboard battleships, Mrs. Blackton blew a thick veil of cigarette smoke over the scene, which helped hide the poor production values of the film.[77] Smith and Blackton passed off *The Battle of Santiago Bay* as a documentary, when in truth, it might be regarded as the nation's first special effects film. Later during his career, Blackton became a pioneer in film animation, famous for such early stop-motion and drawn animations as *Humorous Phases of Funny Faces* (1906), which many regard as America's first animated film.

The Battle of Santiago Bay was a big hit, as were many other films that involved Roosevelt either directly or by implication. Edison's *U. S. Infantry Supported by Rough Riders at El Caney* (1899) and *Skirmish of Rough Riders* (1899) weren't shot in Cuba, but near Edison's labs in West Orange, New Jersey, after the war. The films star the New Jersey National Guard in the role of the Rough Riders and start with a shot of infantry troops firing, advancing, kneeling, and then firing again, followed by "a troop of Rough Riders, riding like demons, yelling and firing revolvers."[78] Although Roosevelt did not appear in these re-creations, they enhanced his reputation and that of the Rough Riders as they figured into the myth-ideological system of conquering heroes. The appearance and representations of Roosevelt and his Rough Riders in parades, in Wild West shows, on the vaudeville stage, and in the cinema created a national fiction that ultimately carried Roosevelt into the White House.

But as Teddy would soon learn to his chagrin, the camera giveth, and the camera taketh away.

The End of Nature, 1903

DURING A NATIONAL PROMOTIONAL TOUR THAT TOOK HIM WEST DURING THE SPRING of 1903, Roosevelt asked the naturalist John Muir if he would serve as his guide during a visit to Yosemite. The grizzled Muir did not mince words with the president when he confronted him about his hunting exploits. "Mr. Roosevelt, when are you going to get beyond the boyishness of killing things?" he asked. "Are you not getting far enough along to leave that off?"

Sheepishly, Roosevelt conceded that Muir was right.[1]

"The older I grow the less I care to shoot anything except 'varmints.'" Roosevelt wrote to Herbert K. Job in 1905:

I do not think it at all advisable that the gun should be given up, nor does it seem to me that shooting wild game under proper restrictions can be legitimately opposed by any who are willing that domestic animals shall be kept for food; but there is altogether too much shooting, and if we can only get the camera in place of the gun and have the sportsman sunk somewhat in the naturalist and lover of wild things, the next generation will see an immense change for the better in the life of our woods and waters.[2]

Until the end of his life, however, TR could not reconcile his understanding of the political need to protect nature with his personal urge to kill it. In 1909, six years after Muir took him to task in Yosemite, TR wrote about his safari in Africa that he had "killed most of the things that I specially desired to kill—the lions and rhino. Indeed I simply had to kill them!"[3] In fact, Roosevelt literally killed thousands of animals during his safari to Africa. The hunter was the foundation of Roosevelt's psyche; his identity depended upon his ability to express domination physically, and death was the extreme expression—and gratification—of that power.

But Roosevelt learned quickly once he rose to power that everyone did not share his feelings about the hunt, and the topic became contentious for him as he increasingly found himself embroiled in public controversy with people who, like Muir, felt bloodlust was unseemly in the nation's top leader. In 1901, an editorial in the *New York Sun* lambasted the president for his "ruthlessly taking the lives of innocent and unoffending animals without provocation and with the sole aim of gratifying a desire for killing."[4] Once Roosevelt became president, the *Sun* published doggerel written by the British Humanitarian League that criticized him as a game-butcher, a title that Roosevelt himself despised:

Hail, blustering statesman, butcher of big game,
Less President than Prince in pride of will,

Whose pastime is the princely sport, to kill,
Whose murderous feats unnumbered fools acclaim![5]

Roosevelt staunchly refused to give up hunting during his tenure as vice president and later as president, and he aggressively defended his right to do so on the grounds that he was making a meaningful contribution to science as a naturalist. "As you know, I am not in the least a game butcher," he wrote in an open letter to the secretary of the Smithsonian, Charles Doolittle Walcott, in 1908. "I like to do a certain amount of hunting, but my real and main interest is the interest of a faunal naturalist."[6] He defended the role of "the big-game hunter who is a good observer, a good field naturalist, [who] occupies at present a more important position than ever before, and it is now recognized that he can do work which the closest naturalist cannot do."[7]

As science increasingly described nature in objective, material terms, it also became increasingly intolerant of more traditional forms of narrative, especially those written by contemporary best-selling nature writers such as Reverend William J. Long, Ernest Thompson Seton, Charles G. D. Roberts, and Jack London. In March 1903, the *Atlantic Monthly* published an article entitled "Real and Sham Natural History" written by the naturalist John Burroughs, in which he dismissed "the yellow journalists of the woods" who took liberties in their depictions of animal behavior, such as a mother eagle that saves a chick that had fallen out of the nest by flying beneath it or a woodcock that makes a mud cast for its broken leg. Burroughs reviled these writers as "nature fakers" whose only agenda was to "float into public favor and into pecuniary profit."[8] In particular, Burroughs launched a blistering attack on Ernest Thompson Seton, arguably the most famous nature writer of the time, who had just published *Wild Animals I Have Known* (1903). "Such dogs, wolves, foxes, rabbits, mustangs, crows, as he has known, it is safe to say," Burroughs wrote, "no other person in the world has ever known."[9] A more apt title for Seton's book, Burroughs suggested cattily, would have been *Wild Animals I Alone Have Known.*

Roosevelt increased the profile of Burroughs's argument when he publicly sided with his friend. "I don't believe for a minute," he announced in his typically imperious fashion during an interview, "that some of these men who are writing nature stories and putting the word 'truth' prominently in their prefaces know the heart of the wild things." In particular, Roosevelt took particular exception to the works of Reverend Long and Jack London. "What a ridiculous creature the Rev. Long is!" he confided to John Burroughs.[10] But he was more public with his criticism of Jack London. "In [*White Fang*] London describes a great dog-wolf being torn in pieces by a lucivee, a northern lynx," he wrote. "This is about as sensible as to describe a tom cat tearing in pieces a thirty-pound fighting bull terrier. Nobody who really knew anything about either a lynx or a wolf would write such nonsense."[11] It didn't help Roosevelt's case that he had gotten the details of London's story backwards: the dog-wolf kills the lynx, not the other way around.

Outraged by Roosevelt's self-righteousness, Reverend Long was the first to fire back. "Who is he to write, 'I don't believe that some of these nature-writers know the heart of the wild things?'" he retorted. "I find after carefully reading two of his big books that every time he gets near the heart of a wild thing he invariably puts a bullet through it."[12] In 1908 Jack London joined the fray when he accused both Burroughs and Roosevelt of a homocentric "medieval" arrogance that viewed animals as incapable of even the most rudimentary rationality. "[Roosevelt] may able to observe carefully and accurately the actions and antics of tom-tits

and snipe," London wrote in *Collier's Weekly,* "but that he should be able, as an individual observer, to analyze all animal life and to synthesize and develop and know all that is known of the method and significance of evolution, would require a vaster credulity for you or me to believe than is required for us to believe the biggest whopper ever told by an unmitigated nature faker."[13]

Roosevelt's impolitic attempt to draw a "line in the sand" between works of scientific realism and science fantasy polarized portions of society that did not believe that the subjective life of animals as they played out in the fictions of Seton, Long, Roberts, or London should be dismissed so readily in the name of objectivity. The issue became a lighting rod for criticism for Roosevelt as he continued to hunt throughout his years in office. He dismissed those who did not agree with his sentiments about hunting as weak-kneed intellectuals who were incapable of understanding the importance and necessity of the "strenuous life." But to Roosevelt's dismay, he found that those who opposed his views on hunting were often in positions to air their contrary opinions in devastating ways. In the face of such criticism, Roosevelt refused to back down from his beliefs, and although he grudgingly learned to be more circumspect about his passion of hunting, his opposition continued to pepper him with criticism, at times to his acute embarrassment.

ROOSEVELT UP A TREE

Two months before his inauguration as vice president in 1901, Roosevelt went on a cougar and bobcat hunt with a pack of eleven hunting hounds for five weeks on a ranch near Meeker, Colorado. The press sent a handful of correspondents to Meeker to report on the hunt. When Roosevelt denied the reporters permission to ride along with him, they whiled their time sitting around the wood stove gleaning what information they could and, at times, concocting hair-raising stories about the vice president-elect's exploits in the Colorado woods. The *New York Times* published an outrageous story about Roosevelt being chased by a twelve-hundred-pound grizzly bear "fairly quivering with rage" after Teddy had shot him. "[T]hen Roosevelt turned to flee," reported a supposed eyewitness, Dr. Webb, "but to our horror he stumbled and fell sprawling." A fusillade of shots by his comrades brought down the bear a mere fifteen feet from Roosevelt.[14]

Three days later both the *Times* and the *New York Herald* ran stories that a pack of wolves had treed Roosevelt after he had gotten lost in the dark. "Roosevelt up Tree Four Hours," ran one headline ran in the *New York Herald* on January 19, 1901, as it related in breathless detail to a rapt public how a pack of wolves had treed Roosevelt while out on an evening constitutional. By the time a search party finally located the missing vice president-elect, they found at the base of the tree the bodies of six wolves that Roosevelt had shot dead with his revolvers.[15]

The *New York Herald* reported Roosevelt had bagged twelve of the fourteen mountain lions that the hunting party had killed, which was true, if one does not count the two near-term fetuses carried by pregnant females he had shot or the three cougar kittens the dogs tore apart after Roosevelt had killed their mother.[16] "Eight of the lions were unusually large," wrote the *Herald,* "and nearly all have been killed with a knife." This claim was not true. The lions for the most part were females of average size, and Roosevelt shot eight and stabbed four lions to death.[17]

According to the *Herald*, Roosevelt's preferred method for killing lions was "to run in when the lion is cornered by the dogs and stab the beast to death."[18] In fact, Roosevelt relished using a knife to kill the mountain lions. "The fighting dogs were the ones that enabled me to use the knife," he wrote, "All three [dogs] went straight for the head, and when they got hold they kept their jaws shut, worrying and pulling, and completely absorbing the attention of the cougar, so as to give an easy chance for the death-blow."[19] He killed at least one lion with a knife that his thirteen-year-old son, Ted, had given to him. "I ran in and stabbed him behind the shoulder," TR wrote Ted, "thrusting the knife you loaned me right into his heart. I have always wished to kill a cougar as I did this one, with dogs and the knife."[20] He killed another female by forcing the butt of his Winchester .40-.90 into her jaws with his left hand and then "[striking] home with the right, the knife driving straight to her heart."[21] In later years he proudly showed off the cougar's teeth marks on his rifle to his friends as he recounted the story.[22]

On the final day the hunt, February 14, Roosevelt killed a trophy male that measured eight feet and weighed 227 pounds, which remained the world's record for the largest mountain lion for over sixty years. "It would be impossible to wish a better ending to a hunt," he wrote triumphantly.[23]

But Roosevelt quickly soured on the experience when he saw how the press had willfully mischaracterized his exploits. "The sensational stories such as those describing adventures with bears and wolves, were deliberate and willful fabrications, and, I understand, were written by men who were not within hundreds of miles of where I was," he protested at a press conference in Colorado Springs after the hunt. "We did not see a bear or wolf on the entire trip." Then the charge surfaced that Roosevelt's "press agent" had coordinated the hunting trip as a publicity stunt. "It is very exasperating to have humiliating adventures which never occurred attributed to me in connection with bears and wolves (neither of which animals did I so much as see)," Roosevelt wrote to his friend, New York congressman Winthrop Chanler of his Colorado hunting trip, "and then to have the very same papers that have invented the lies state that they were sent out by my press agent with a view to my own glorification."[24]

Publicly, Roosevelt doggedly maintained the position that the purpose of his hunt was to advance science. He sent the skulls of the mountain lions he had killed to C. Hart Merriam, the head of the U.S. Biological Survey at the Department of Agriculture. Merriam, who had been Roosevelt's friend for many years, wrote back that the specimens the vice president had sent were "incomparably the largest, most complete and valuable series ever brought together from any single locality, and will be of inestimable value in determining the amount of individual variation." Roosevelt included Merriam's letter in his 1901 essay for *Scribner's*, "With the Cougar Hounds" as a validation of his contribution to science.[25]

But the damage to Roosevelt's public image as a hunter was already done. The chorus of critics that deplored his excessive killing grew louder as stories of the mountain lion hunt continued to spread like wildfire through the American press. "My experience on the hunt," Roosevelt wrote to a friend, "increased my already existing respect for the infinite capacity of the newspaper press to manufacture sensations."[26]

The press and the motion picture camera, which had been so sympathetic to Roosevelt as a Rough Rider in 1898, now ran roughshod over him. The *Philadelphia Bulletin* suggested that a medal inscribed "The Game Exterminator" should be presented to Roosevelt on his return from Colorado. The *New York Journal*, which was owned by one of Roosevelt's most powerful detractors, William Randolph Hearst, was equally inflammatory:

Terrible Teddy, the young slayer of grizzlies, who killed more than half the wild beasts in Colorado in less than a week, and frightened the rest, said he made the sun-and-wind-tanned faces of the old trappers turn as white as the writing paper on which they kept tally of the steadily rising animal death rate. "When I kill grizzlies with a gun," said he, "the poor things have no chance. They are handicapped. Hereafter I shall kill them with my bare hands. It's more strenuous."[27]

By the end of February 1901—nine days before Roosevelt was inaugurated as the twenty-fifth vice president of the United States—the Edison Manufacturing Company released a lampoon of Roosevelt's hunting trip called *Terrible Teddy, the Grizzly King* based upon political cartoons that had appeared earlier that month in another of Hearst's papers, the *New York Journal Advertiser.* "Our hero stood transfixed with horror," reads the caption beneath a drawing of Roosevelt standing triumphantly over a heap of animal corpses. "A bear, a mountain lion, a deer and a pack of other wild beasts were advancing madly upon him in solid phalanx, bent upon his destruction. From another direction marched a squad of fierce photographers to take snap-shots of his last moments, to picture him in his mortal defeat."[28]

Edwin S. Porter, a pioneer of narrative film, most famously known as the director *The Great Train Robbery* (1903), and the man who filmed the electrocution of Topsy the elephant for Edison, produced the filmed version of the political cartoon in less than three weeks in 1901.[29] Little more than a minute long, the film opens with an actor playing the role of Teddy running down a hillside with a photographer and press agent in tow. They stop at a tree, whereupon Roosevelt kneels and then shoots what is supposed to be a mountain lion in the tree (but in truth isn't much larger than an ordinary house cat). "Immediately upon the discharge of his gun," reads the Edison catalogue description of the film, "a huge black cat

falls from the tree and Teddy whips out his bowie knife, leaps on the cat and stabs it several times, then poses while his photographer makes a picture and the press agent writes up the thrilling adventure."[30] The film reiterates the accusation that Roosevelt had staged the hunt in collaboration with his press agent and a photographer.

Stung by the caricatures of him in the press as an opportunist and worse, as a conniving, wanton killer, Roosevelt increasingly shied from public view when it came to his hunting, although he continued to publish articles in *Scribner's* about his bear, wolf, lion, and coyote hunting trips while in office.[31] Nonetheless, as American expansionism and dominion over nature became consanguineous, Roosevelt continued to prove himself as the master of both. He depicted the virtues and the virtuosity of the American spirit, fearlessly certain of America's right to fulfill the pledge that Senator Beveridge had made on the floor

William Randolph Hearst's lampoon of Roosevelt as Terrible Teddy, "the young slayer of grizzlies," 1901

of the U.S. Senate, that the United States would embrace its mission as the master of all things, civilized and wild. And yet by the following year, Roosevelt found himself embroiled in yet another hunting controversy, one that not only reverberated throughout American culture but also left a hallmark imprint on it.

DRAWING THE LINE IN MISSISSIPPI

In November 1902, Roosevelt stepped out of his private railroad car at the depot at Smedes, Mississippi, as president of the United States. He was dressed in leather leggings, a blue flannel shirt, and a corduroy hunting jacket. The colonel had come at the invitation of Governor Andrew Longino to hunt on a private estate far from prying eyes. He carried his favorite rifle, a .40-.90 Winchester—the one with the cougar bite marks on the stock from his hunt in Colorado the year before—and a cartridge belt with both steel-jacketed and soft-nosed bullets tucked into its loops.[32] Roosevelt had hoped to keep the location secret, but word had gotten out even before he stepped foot off the train that the president was on the hunt for bear in the Yazoo Delta of Louisiana.

Roosevelt forbade any of the six other men in his hunting party from shooting anything before him. "I am going on this hunt to kill a bear," he announced imperiously, "not to see anyone else kill it."[33] So for five days Roosevelt and his sporting partners tramped around in the thick briar and canebrake of the Little Sunflower River in a vain search for Teddy's bear.

To the president's exasperation, the press was already filing stories about the president's misadventures in Sharkey County, Louisiana, but on the sixth day, the pack of hounds they were using to flush game from the thicket picked up the scent of a bear.

The chase was on. The lead tracker was Holt Collier, a former plantation slave, who had a reputation for killing as many as 3,000 black bears during his lifetime.[34] But this bear had the advantage of the terrain and after several strenuous hours of pursuit, the hounds lost the scent trail. Roosevelt and others decided to return to camp for lunch while Holt Collier pushed his dogs to pick up the scent again.

Late that afternoon, Collier's hounds cornered the bear next to a pond. A messenger rode back to camp. "They done got a bear out yonder about ten miles," he announced breathlessly. "'Ho' [Holt] wants the Colonel to come out and kill him."[35] The men mounted up and raced back. But the dogs, impatient for a kill, had already attacked the bear, and Roosevelt found the dogs exhausted and bleeding. One was dead, its back broken by the enraged, cornered black bear, which was itself dazed after Collier had knocked it in the head with the butt of his rifle. Collier had tied the spent bear by the neck to a tree so the president could shoot it. Caked with dried mud and bleeding from the wounds that it had suffered while fighting off the dogs, the bear presented a pitiful sight to the president.

Disgusted, and no doubt sensitive to the charge that he was himself a "slob hunter," Roosevelt refused to shoot the bear. "Put it out of its misery," he ordered, whereupon one of the men fatally stabbed it.

Clifford Berryman, a political cartoonist mythologized the incident a few days later in the *Washington Post.* In a cartoon *Drawing the Line in Mississippi,* Berryman intended to satirize Roosevelt's disavowal to kill the bear as a way to caricaturing the president's race policy, which had of late been a lightning rod for criticism, especially in the South, where racial prejudice

was simmering to a slow boil. In fact, just days before the hunt began, Governor Longino's gubernatorial rival, James K. Vardaman, a white populist Democrat who later became known as "the Great White Chief" because of his hard-line stand in favor of white supremacy, had inflamed racial tensions in the South by openly soliciting for "16 coons to sleep with Roosevelt" while he was in Mississippi.[36] Vardaman declared that the African American amounted to little more than "lazy, lying lustful animal which no amount of training can transform into a tolerable citizen."

Roosevelt, by contrast, had already expressed his misgivings about the unequal apportionment of justice for African Americans. (Over 400 African Americans would be lynched during Roosevelt's first administration, the majority of them in Mississippi.)[37] Roosevelt, whom white racists had characterized as the boss of the "nigger loving gang in Washington," had just appointed Dr. William Demos Crum, an African American physician from Charleston, South Carolina, as the collector of the Port of Charleston—the first black man ever appointed to high federal office.[38] Dr. Crum's appointment polarized extreme elements in his own party (the so-called Lily Whites) and infuriated southern whites, who saw Roosevelt's act as direct challenge to Jim Crow. African Americans, on the other hand, led by Booker T. Washington and W.E.B. DuBois, interpreted Roosevelt's act as an affirmation of the rights of African Americans as citizens. Roosevelt was, in terms of race relations in the United States, resisting the drawing of a color line.

Meanwhile, James K. Vardaman of Mississippi was adamant in his refusal to allow African Americans to become equal citizens. "If it is necessary every Negro in the state will be lynched," he declared unequivocally; "it will be done to maintain white supremacy."

Berryman intended for his cartoon *Drawing the Line in Mississippi* to address Roosevelt's reticence to endorse the lynching of African Americans. By contrasting a small, cuddlesome but nonetheless very black bear next to a white man who has a noose tied around the bear's neck, Berryman hoped to characterize the president's attempt to distance himself from the extreme racial politics of southerners like Vardaman.

Such political subtleties, however, were quickly lost on the public. Rather, people were more impressed by the president's steadfast good sportsmanship (in spite of the fact that the bear was killed and skinned anyway) and the irredeemable cuteness of Berryman's portrait.

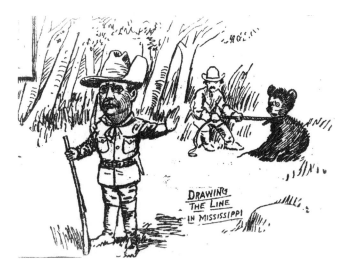

Clifford Berryman's *Drawing the Line in Mississippi*, a political cartoon in the *Washington Post* commenting on Roosevelt's position on race in the South, 1902

Teddy and his bear became inseparable, a fact to which Roosevelt grudgingly conceded. "We have all been delighted with the little bear cartoons," Teddy wrote Berryman in December 1902. "I begin to feel as if it was like those special signs of the early Egyptian kings–I have forgotten their names—cartouches, is it not?"[39]

Ironically, the teddy bear would in fact become Roosevelt's cartouche. Within weeks of the incident, an enterprising shopkeeper in Brooklyn launched the newest national fad, the teddy bear.[40] And in 1907, Edwin S. Porter, the director of *Terrible Teddy the Grizzly King* (1901), lampooned Roosevelt again as a merciless stalker of the woods in *The "Teddy" Bears,* which hopelessly muddles Roosevelt's botched bear hunt in Louisiana with the story of Goldilocks and the Seven Bears.[41]

Roosevelt now regarded the press and the cinema far more circumspectly than in the early days when the media helped to propel him into office. Although he continued to go on hunts during his presidency, he managed to dodge the fickle eye of the media. Then, in 1903, Roosevelt, the staunch champion of Yellowstone National Park, decided he wanted to hunt mountain lions in America's first national park.

KILLING LIONS IN YELLOWSTONE

"The Yellowstone Park is something absolutely unique in the world," Roosevelt told the enthusiastic crowd that attended the laying of the cornerstone of the Gateway to the Park

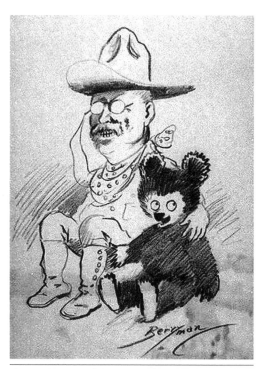

The Rough Rider and the irrepressible teddy bear, by Clifford Berryman

in Gardiner, on April 24, 1903. He called upon all Americans to join him "by jealously safeguarding and preserving the scenery, the forests, and the wild creatures" in perpetuity.[42] That is, all animals except the Serpent in the Garden, the mountain lion.

Traditional wisdom held that the mountain lion was preying unmercifully upon the impoverished elk and deer herds of Yellowstone at a time when they were struggling to rebound from the hunting excesses of poachers, who'd nearly wiped them out until the secretary of the interior had banned hunting of ungulates in the park in 1894, a result of the Yellowstone Game Protection Act, which the Boone and Crockett Club had helped pass. Almost ten years after the passage of the act, however, park officials were still routinely killing predators in spite of the fact that the herds had already swollen beyond the park's natural capacity to provide for them. By 1903 the leading cause of death for ungulates in Yellowstone was starvation, not predation by mountain

Courtesy of the Yellowstone Gateway Museum of Park County, Montana

Roosevelt dedicates the cornerstone of the Arch at the northern entrance of Yellowstone National Park, 1903.

lions. But the broadly held impression of wolves and lions as inveterate predators that endangered the survival of deer and elk remained entrenched in the mind of the government and the public. "The rangers have grown to love all wild life except those predatory species which so often observe destroying young antelope, deer, or elk," declared a former park superintendent. "Aside from those outlawed animals, a national park ranger is never known to kill a native animal or bird of the park, or to express a desire to kill."[43]

Roosevelt too believed that the depredations of the mountain lion were endangering the park's herds. In December 1902—barely a month after his ill-fated bear hunt in Louisiana— Teddy asked Yellowstone Park's military superintendent, Major John Pitcher, "what is the practice about killing mountain lions? If I get into the Park next June I should greatly like to have a hunt after some of them—that is, on the supposition that they are 'varmints' and are not protected."[44] Roosevelt already knew Pitcher from his second trip to Yellowstone in September 1891 as he was returning from an elk-hunting trip in northwestern Wyoming. They had spent time camping together in the park and trading stories.

Major Pitcher responded to Roosevelt's request enthusiastically. "These lions have simply got to be thinned out," he insisted, "and if you will lend us a hand in the matter, you will be of great help to us and no one can offer any reasonable objection to your doing so."[45]

Roosevelt invited John Goff, his host and guide for the Colorado lion-hunting trip in 1901, to join him in Yellowstone. He asked Goff to bring along his pack of seasoned lion-hunting dogs with him. Goff, however, was recovering from a bullet wound from a trigger-happy dude who'd shot him during the excitement of a hunt and wasn't sure if he'd recover in time for the Yellowstone hunt. Worried that Goff couldn't keep their rendezvous, Roosevelt instructed Major Pitcher and the secretary of the interior to send for the government's official hunting dog pack to replace Goff's.

Elihu Root, Roosevelt's secretary of war, thought the hunt ill-advised. As a close friend and confidante, he warned the president that his detractors might try to make political hay of what could conceivably be construed as an abuse of presidential authority. If hunting in

the park was illegal for all citizens, Root questioned, then how, in good conscience, could the president exempt himself? What would the public think if the president turned Yellowstone into his own hunting reserve?

Roosevelt conceded the point but refused to give up on the hunt. "Secretary Root is afraid that a false impression might get out if I killed anything in the Park," he wrote Major Pitcher. But, he wondered, would it be possible "to go just outside the border [of the Park] and kill any mountain lions?"[46]

When "Buffalo" Jones, the man whom Roosevelt had appointed as Yellowstone Park's first game warden, heard that the president wanted to hunt lions in the park, he started the government's hunting dogs on an intense training program. He trapped a mountain lion, which he used to incite his dogs to run the hapless cat up a tree as preparation for being shot out of it. The dogs, it turned out, didn't have the right stuff.

Roosevelt was disenchanted. "An untrained hound is worse than useless," he wrote when he found out about the incompetence of the government dogs. "Such a pack will run deer or elk in the place of lion, and will be a perfect curse to the Park."[47]

Jones wasn't dismayed, however. In a surreal echo of what had happened in the canebrake of Louisiana the year before, Jones chained his captive mountain lion to a spike in the ground and offered the cat to Roosevelt the same way Holt Collier had offered him the bear.

By then word of the hunt had leaked out to the press, and the public raised a hue and cry. The press resurrected the image of Roosevelt as a killer. Roosevelt understood then that Root had been right.

Reluctantly, he canceled the hunt. "I will not fire a gun in the Park," the president told John Burroughs, his companion and naturalist mentor on the trip. "Then I shall have no explanations to make."[48] On April 10, Major Pitcher recorded the following entry in his diary: "Before starting out, the president announced that under no circumstances would he fire a shot in the Park, even if tempted to do so by a mountain lion up a tree, lest he should give people ground for criticism."[49] Meanwhile, the mountain choked itself to death on its chain. "The captured lion thus having lived in vain," read the editorial in the *Livingston Enterprise,* "he concluded to die."[50]

Courtesy of the Yellowstone Gateway Museum of Park County, Montana

Buffalo Jones poses for the camera with the live mountain lion he trapped for Roosevelt's hunt, 1903.

Roosevelt toured the park for two weeks that spring. In spite of the fact that the *New York Times* reported that he had killed a lion during a big snowstorm, the only animal the president killed was a mouse, which he skinned and sent to C. Hart Merriam in the hopes that he had discovered a new species (he hadn't).[51] Meanwhile, Burroughs fretted about the scandal that might follow if the press, which had already proved itself reckless when it came to Roosevelt's hunting exploits, substituted *moose* for *mouse* and gave the impression that the president was on another one of his killing sprees. Burroughs, who also believed the mountain lions in the park "needed killing," later admitted he had entertained the hope that he too "might be allowed to shoot a cougar or bobcat; but this fun did not come to me."[52]

During his tour of the park, Roosevelt spent time studying the elk at close range and realized that the elk were indeed "too numerous for the feed," and that the mountain lion wasn't the marauding villain he'd believed it to be. From that experience, he gradually revised his opinion of the role of predators in natural systems and took an active interest in the management of wolves and mountain lions in the Yellowstone ecosystem. Five years after his trip to Yellowstone, Roosevelt ordered the park's superintendent to cease killing mountain lions with the hope that mountain lions might restore what was in his estimation a badly skewed balance of nature.[53]

The mountain lion captured by Buffalo Jones choked to death on its chain, resparking outrage over Roosevelt's "bloodlust" as a hunter.

Roosevelt and John Burroughs in Yellowstone National Park, 1903.

DEATH AND THE BALANCE OF NATURE IN YELLOWSTONE

During the Roosevelt years Yellowstone National Park became an icon of nature and a metaphor for a nation. Conceived as both *exemplum* and *refugium,* Yellowstone morphed into a self-consciously created "Wonderland."

One of the most powerful and enduring narrative tropes in Western culture is the story of the Garden of Eden. As a vision of natural perfection in which everyone and everything lives in unwavering abundance and harmony, the Garden of Eden is a system that, according to Newton's second law, can stay at rest only so long as the sum effect of the forces acting upon it equals zero. By definition, therefore, the Garden of Eden exists in a perpetual state of static equilibrium. Change is not possible. Nature exists in perpetual balance, exempt from the cruel shocks of want, decline, or death. But the net effect of the forces acting on the system changed when Adam and Eve violated the Lord's prohibition not to taste the forbidden fruit. In order to maintain the Garden's equilibrium, the Lord had to cast out the destabilizing variables.

Since the exile of our great-ancestors, argues Carolyn Merchant, Western humanity has been looking for a way to regain its prelapsarian grace. The idea of the Garden, unlike the "howling wastes" of the unruly wilderness, had taken hold as an emblem of humanity's quest. This historical narrative, which Merchant calls the Recovery Narrative, "is perhaps the most important mythology humans have developed to make sense of their relationship to the earth."[54] Our collective desire to return to innocence allows us to invest the hope of return into idealized landscapes such as Yellowstone. "To the extent which people believe in or absorb the story," writes Merchant, "it organizes their behavior and hence their perception of the material world. The narrative thus entails an ethic and the ethic gives permission to act in a particular way toward nature and other people."[55]

Roosevelt's Yellowstone sought to mimic the static equilibrium of the Garden of Eden by defining nature as a self-regulating, or homeostatic, system. According to the principle of static equilibrium, nature is fixed and therefore immutable. In a homeostatic system, however, nature is less stable and therefore subject to a range of variances, which are perturbations or deviations from an established or speculative norm. A homeostatic system seeks to stabilize these deviations by returning itself to the norm. For example, the human body is a self-regulating system that normally maintains a stable temperature of 98.6 degrees Fahrenheit. An infection that causes a fever of 103 degrees destabilizes and potentially jeopardizes the system, so the body fights to restore equilibrium by fighting off the infection. If successful, the system returns to normal; if not, the system may languish or even perish.

Scientists have used the same metaphor to describe the process of nature even though the systems involved in populations, communities and ecosystems are far more complex and dependent upon other often highly variable conditions. The simple elegance of a metaphor for nature that is constant has proved hard to resist historically.

George Perkins Marsh, often cited as the first American environmentalist, wrote in 1865:

> Nature, left undisturbed, so fashions her territory as to give it almost unchanging permanence of form, outline, and proportion, except when shattered by geologic convulsions, and in these comparatively rare cases of derangement, she sets herself at once to repair the superficial damage, and to restore, as nearly as practicable, the former aspect of her dominion.[56]

Perkins argued that over the long term nature would always remain stable, constant, and harmonious. When disruptions did occur, whether by geophysical convulsion or the errancy

of human beings, nature would restore itself, in Marsh's words "as nearly as practicable" to its original condition. Over a century later, scientists and philosophers continue to play variations of the same refrain. Lewis Thomas, in *The Lives of a Cell,* imagined the planet even more simply as a single-celled organism. "We derived, originally, from a single cell, fertilized in a bolt of lightning as the earth cooled," he wrote in 1974:

> I have been trying to think of the earth as a kind of organism, but it is no go. I cannot think of it this way. It is too big, too complex, with too many working parts lacking visible connections. If not like an organism, what is it like, what is it *most* like? Then, satisfactory for that moment, it came to me: it is *most* like a single cell.[57]

Five years later James Lovelock and Lynn Margulis proposed the Gaia hypothesis, which described the biosphere as a "self-regulating entity with the capacity to keep our planet healthy by . . . [keeping] constant conditions for all terrestrial life."[58] To this day, many of the mathematical and computer models that attempt to predict nature depend upon the concept of a relatively constant biosphere, although global warming (as a human-generated disruption) may challenge the assumption that the planet can or will "correct" itself by returning to conditions that favor human habitation in a "timely" manner.

Similarly, Roosevelt and his contemporaries understood nature as an example of classical static stability, a concept derived from the tendency of a mechanical system to return to a steady state after a disruption.[59] According to its principles, even though a dynamic play of forces (either natural or human-made) may deflect nature from its steady state, nature will endure these insults and eventually recover its balance. A powerful and reassuring concept, it treated nature in general and Yellowstone in particular as a kind of perpetual motion machine.

The idea that nature was stable and resilient appealed to Roosevelt and to the majority of Americans for powerful psychological reasons. Stability spoke of permanence, constancy, and, in spite of how much society overfeminized nature as unruly and volatile, Americans believed ultimately that nature conformed to a given set of rational and therefore calculable laws. The seasons came and went, animals were born and died, and the sun rose and set. And even though natural catastrophes seemed capricious, we could nonetheless explicate their etiologies.

If landscape is indeed, Carole Crumley notes, "the material manifestation of the relation between humans and the environment," then Yellowstone National Park was, and remains, the premier historical exhibit of that relationship in the United States.[60] As a "repository of human striving," Yellowstone National Park is a cultural text as much as it is a geophysical or biophysical space, in which "memory, identity, social order, and transformation are constructed, played out, re-invented, and changed."[61] An environmental imaginary is an ideational construct that undergoes constant revision as it plays out in its host culture. In this sense, the park provides a stage upon which people "engage with the world, and create and sustain a sense of their social identity."[62] For Theodore Roosevelt, Yellowstone National Park became a natural laboratory in which he and others could restore the imbalances created by the excesses of rampant consumption over the last half-century. Underlying the assumption of restoration, however, was an implicit claim that nature's tendency was to return to its original state, free of the injunctive influences of humans, and that we understood what constituted normalcy in nature.

The implications were profoundly moral. First, it implied that humans existed outside the pale of nature and were a dangerously exploitative species lacking vigorous checks and balances to prevent destructive behavior. Second, it implied that human beings understood

nature enough to be able to restore it to a natural state of balance. Absolute dominion depended upon a belief that by controlling nature, humans could engineer it so that it would remain nature. These attitudes had been brewing in the social and scientific consciousness for centuries, but they started to come into sharp focus in the United States under Roosevelt's administration because of his deepening concern for protecting nature.

Roosevelt's rational and political understanding of nature underwent a profound transformation between 1893, the year Turner declared the American frontier closed, and 1903, the year Roosevelt went to Yellowstone not only to hunt to mountain lions but more importantly to dedicate the Gateway Arch at Yellowstone Park. In 1893 the rancher Roosevelt described the American wilderness as a place of rapture, a place where "prairies seem without limit, and the forest never-ending,"[63] For him, the wilderness wasn't a place so much as it was an unknown and unnamed space. Wilderness belonged to the beast and cared nothing about men. For Roosevelt, the American identity lay in the "tropical swamps, and sad, frozen marshes; deserts and Death Valleys, weird and evil, and the strange wonderland of the Wyoming geyser region."[64] Roosevelt's interaction with first nature inspired him; he saw nature as a historical actor that existed independently of human influence.

By 1903, however, Roosevelt went from the salvation of the soul to the salvation of "the scenery, the forests, and the wild creatures." His rhetoric changed. The West of Owen Wister's stories and Frederic Remington's drawings, the West of the Indian and the buffalo hunter, the soldier, and the cowpuncher also had changed. "The land of the West has gone now, gone, gone with the lost Atlantis, gone to the isle of ghosts and strange dead memories," he lamented some years later. "In that land we led a hardy life. Ours was the glory of work and the joy of living."[65] Roosevelt believed in the reciprocal power of nature in the 1880s and 1890s, but as he dedicated the Gateway Arch that marked the official boundary of Yellowstone on April 24, 1903, Roosevelt presented a different West, one that turned Uncle Sam's property into "a great natural playground" that had been created "for the benefit and enjoyment of the people." He defined Yellowstone as a landscape of consumption, a product of second, not first nature, that was now defined more by its interactions with people than by nature itself.[66] Yellowstone became an inscription of social relations.[67]

Roosevelt celebrated the domestication of Yellowstone. He redefined it as a landscape of mass consumption, calculated its value in terms of money and time: "Already its beauties can be seen with great comfort in a short space of time," he declared at the dedication of the arch, "and at an astoundingly small cost." In addition, he called for the building of an extensive road system so people could enjoy the park from their cars.[68]

As the chief steward of the public good, Roosevelt prized social efficiency and responsibility when it came to the measured exploitation of the nation's natural resources. He understood that progress was essential to the continued well-being and prosperity of the nation; he also knew, however, that without restraints, the venture capitalists, the speculators, the poachers, and the bootleggers would strip America as bare as they had Europe, destroying forever the unique American signature that nature had created.

The American environmental ethic underwent a dramatic change of emphasis from subject to object during Roosevelt's tenure as a politician. The subjective wilderness that had been the inspiration of Emerson, Moran, and William Henry Jackson now increasingly belonged to a generation of practical, hard-edged men who measured forests in board feet and lakes in acre feet, men who exploited the potential for capital empire that lay within property and labor. The implication of capitalism changed the landscape into a new form of "theater" that overpowered the material changes that were taking place in the park.[69]

Similarly, the Great Plains, which had inspired Roosevelt to poetry during his days in the Dakota Territory, had been undergoing a major environmental transformation since the passing of the Timber Culture Act of 1873. As agricultural settlers fanned westward in the late nineteenth century, they found themselves stymied by the parched, treeless plains. Homesteading required fuel, lumber, and water, and the plains offered precious little of them.

In order to encourage settling of the Great Plains, Congress ceded ten million acres of public domain in 1873 to homesteaders in return for planting trees on their grassland.[70] In a variation of the commonly held belief that "rain will follow the plow," these trees were expected to turn into forests, which in turn would bring rain, thus transforming wasteland into productive farmland. It was a noble scheme made even more notable by the spectacular extent of its failure.

As president of the Boone and Crockett Club, Roosevelt had been active in land use reform. He had urged the repeal of the Timber Culture Act, which had encouraged wanton land fraud under the pretense of homesteading. In its place, he supported the Forest Reserve Act of 1891, which sought to preserve rather than exploit the nation's timber capital.

In Roosevelt's words, the conservation movement was "a direct outgrowth of the forest movement."[71] The Forest Reserve Act of 1891 and the Forest Management Act of 1897 not only paved the way to the National Forest System, they also invested the president of the United States with the authority to place lands under federal protection, an entitlement that Roosevelt made full use of when he came into power. "We have become great because of the lavish use of our resources," Roosevelt said in 1908, "and we have just reason to be proud of our growth."

> But the time has come to inquire seriously what will happen when our forests are gone, when the coal, the iron, the oil, and the gas are exhausted, when the soils have been still further impoverished and washed into the streams, polluting the rivers, [and] denuding the fields.[72]

So the poet became the scientist. As the poet sought his personal salvation *from* nature, so the scientist sought salvation *for* nature. The semiotic shift was profound: the new name for nature was *the environment*.

As a maturing politician, Roosevelt also believed science was more consonant with politics than poetry. Science was knowledge, knowledge was power, and power got things done. "The men who misinterpret nature and replace facts with fiction," Roosevelt wrote in 1907, "undo the work of those who in the love of nature interpret it aright."[73] The future of nature depended not upon sentimental or spiritual attachments to it, but upon rational, political solutions. The story that had begun with individuals seeking genuine innocence and a return to psychic wholeness transformed into a capitalist narrative of equations that balanced gross worth against net value, at times necessarily amalgamating the forces of first nature to create a synthesis between human and nonhuman nature. "Nothing in nature," writes William Cronon, "remains untouched by the web of *human* relationships that constitute our common history."[74]

Roosevelt was the first president to affirm the intercessory power of the state to regulate nature. He was the first president to nationalize nature on a large scale and make the state its guardian. When Roosevelt saw the starving elk herds in Yellowstone just days after he dedicated the Gateway Arch in the spring of 1903, he saw nature out of balance and decided he needed to restore it to an illusory sense of its first state. Even though the park superintendent maintained that winter die-off would naturally cull the herds, Roosevelt rejected the solution as inhumane, an assertion that the health and well-being of animals rightfully belong

to men, not nature. Nature was turning into an econometric model. "Nowhere else in any civilized country is there to be found such a tract of veritable wonderland made accessible to all visitors," Roosevelt said at the stone-laying ceremony, "where at the same time not only the scenery of the wilderness but the wild creatures of the park are scrupulously preserved, the only change being that these same wild creatures have been so carefully protected as to show a literally astounding tameness."[75]

Roosevelt had seen his own cattle herd in the Dakota Territory devastated by the starvation winter of 1886–1887. Almost twenty years later, the ranch manager in him assessed the Yellowstone elk herd problem as a need to reestablish the correct ratio between population and its food supply; in other words, to restore the *balance of nature.* For Roosevelt that meant restoring the mountain lion as the primary predator of elk in the park. "It is a mere question of mathematics," he wrote George Bird Grinnell in 1918, "to show that if protected as [the elk] have been in the park they would, inside a century, fill the Whole United States; so that they would *then* die of starvation!" Roosevelt's solution, which he admitted as "hardhearted," was managing the herds by letting them starve or by shooting them.[76]

Roosevelt spent the rest of his life jiggering with the elk problem in Yellowstone. A solution eluded him for several reasons, foremost of which was a poor understanding of the role predators played in regulating herd size and an overestimation of the number of mountain lions that were actually left in the park. (Like the wolf, the mountain lion was already in danger of being extirpated from the Yellowstone ecosystem.)

At the heart of Roosevelt's policy decisions lay two critical assumptions about nature. First was the belief that nature was elastic and would therefore snap back to its original shape no matter how egregious the physical insult to it. Second was the belief that since the imbalance had been caused by the interference of humans, then it followed that only affirmative action could restore nature's balance. "The time has passed," Roosevelt wrote, "when we can afford to accept as satisfactory a science of animal life whose professors are either mere roaming field collectors or mere closet catalogue writers who examine and record minute differences in postage-stamps—and with about the same breadth of view and power of insight into the essential."[77] In other words, the passive naturalist had to give way to the active interventionist.

To this day Yellowstone continues to be a theoretical and practical laboratory in which real and proposed policy decisions generally reflect the quest for an idealistic, if not Edenic balance of nature. The federal mandate to reintroduce wolves in Yellowstone in 1995 under the provisions of the Endangered Species Act (1973), mirrors Roosevelt's attempts to manage a "balanced" ecosystem by returning the landscape to an imagined ideal in which wolves play an active role as an apex predator. Over the past century, state and federal agencies continue to struggle with issues related to balance. For example, the current history of bison management in the park parallels the struggle of elk during Roosevelt's time. Federal, state and public agencies persistently wrangle over questions of suitable population size, genetic diversity, geographic distribution, humaneness, public safety, legality, and the ethics of hunting. The state of Montana resumed bison hunts in 2007 using some of the same logic that Roosevelt proposed for the hunting of elk in 1903. When it became obvious that there were not enough mountain lion or wolves to restore a balance, Roosevelt proposed an annual elk hunt that would be limited "up to the point of killing each year on average what would amount to the whole animal increase."

The problem may be that there is no single balance but multiples of them between predator and prey, between flora and fauna, between landscape and the biotic communities that live within and without it, and between human and nonhuman. The complex interplay of

dependencies and the unceasing stream of environmental variables that affect them create a statistical history that suggests that the idea of balance as a baseline for normalcy is more of a human construct than a biological reality. With only a century of ecological data to consider—a short history, indeed—society speculates and constantly revises what the proper image of Yellowstone should be.

NATURE'S CONTINENT

By the end of Roosevelt's second term, the new environmental imaginary was sending up rhizomes into every quarter of the American domain. Nature recoiled turned toxic to tonic; antagonist to protagonist; terra incognita to *jus cogens*; wild to tame, and male to female. Nature, once the stern, unforgiving master, turned into mistress, who presented herself variously as mother, bitch, dominatrix, virgin, and whore, while the men who suckled of her reclaimed their virility and the virility of their nation.

By framing the old environmental imaginary of the frontier, Frederick Jackson Turner provided an ideological foundation that allowed American elites at the end of the nineteenth century to frame a new one that salvaged the roughly hewn ideals of progressivism, social Darwinism, and environmental determinism, each of which was based upon the power, strength, and integrity they had invested in the character of nature. "Each continent has, therefore," wrote Arnold Guyot, the Blair Professor of Physical Geography at the College of New Jersey in *Guyot's Physical Geography* (1873), "a well-defined individuality, which fits it for an especial function."[78] The American frontier created exceptional men, and those men created an exceptional nation. In other words, environment was destiny.

The idea that climate and geography determined the quality of a civilization served as a rationale for European and American superiority for more than half a century. In 1864, Carl Ritter, arguably the most influential geographer of his century, argued that each continent "was so planned and formed as to have its own special function in the progress of human culture,"[79] and in 1872, English historian Henry Thomas Buckle decided that the reason civilization flourished so well in Europe was because nature was "feeble" there, which gave everyone more time to think about things rather than struggle against a wild environment.[80] Forty years later, another environmental determinist, Ellsworth Huntington, reaffirmed the view. "Today a certain peculiar type of climate prevails wherever civilization is high," he wrote in 1915. "In the past the same type seems to have prevailed wherever a great civilization arose. Therefore, such a climate seems to be a necessary condition of great progress."[81]

When Theodore Roosevelt sailed for British East Africa in early 1909, he represented a vanguard of men who'd shifted their focus from native to foreign shores for their inspiration. In Guyot's view, the fulsomeness of *man's life*—indeed, the model of civilization itself—belonged to America, Europe, and Asia. But the culmination of *nature's life,* he argued, belonged to Africa.

Six years before the publication of Huntington's *Civilization and Climate,* Roosevelt set sail for the Dark Continent to test what was to become Huntington's central premise regarding the role that environment played in determining the character of men. Was it race or place? In Roosevelt's mind, Guyot's Africa was the cradle of the nature. For the Hunter, it was the home of the Leviathan.

On March 4, 1909, Teddy Roosevelt stepped down as the twenty-sixth president of the United States. Three weeks later, Roosevelt and his son Kermit were standing on the deck of

the ocean steamer *Hamburg*, ready to set sail to East Africa for a hunting safari that would last nearly a year. As the ship pulled away from the Hoboken pier, a voice cried out from the crowd: "Kill a lion for me, Teddy!"[82]

As Roosevelt embarked for Africa, Winchester Arms launched an advertising campaign in *Collier's Magazine*. The first ad of the series shows an illustration of a hand wearing a cavalry glove thrusting a Model 1895 Winchester through the African continent. "Coming Events Cast Their Shadows," the ad's copy reads portentously.

The allusion to Roosevelt was thinly veiled. Winchester had supplied the former president with rifles and ammunition for the safari, and although Roosevelt would not endorse Winchester openly, the cavalry glove was an obvious reference to the colonel.[83] In the months that followed, Winchester published several more ads that featured dangerous African game, but none so portentous as the one on April 3. Winchester, the "Gun that Won the West," was ready to conquer Africa.

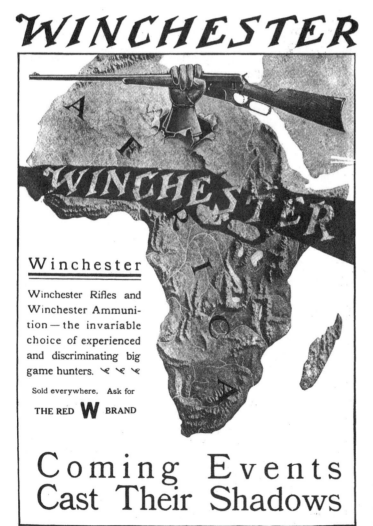

Roosevelt's cavalry glove bursts through Africa grasping a Model 1895 Winchester, 1910.

African Romance

THE YEAR BEFORE THEODORE ROOSEVELT LEFT THE WHITE HOUSE FOR BRITISH EAST Africa, he dined with Carl Akeley, a taxidermist who for the Field Museum in Chicago had produced a series of dioramas of deer in their natural habitat called *The Four Seasons.* Roosevelt had already seen Akeley's work when he'd awarded him first place in a taxidermy competition at the Sportsman's Show in New York City in 1895. The president wanted to meet the artist whose groundbreaking work set animals dynamically into their environment rather than isolate them as stiffly posed specimens, which had been the style until then.

Carl Ethan Akeley had graduated from Ward's Natural Science Establishment in Rochester, New York, which had a reputation without peer as an "emporium for natural history material."[1] Recognizing the artistic talent in his nineteen-year-old protégé, Henry Ward had assigned Akeley to help stuff Jumbo, the star attraction in P. T. Barnum's "Greatest Show on Earth," when a freight locomotive rammed the disoriented elephant on the tracks outside St. Thomas, Ontario, in September 1885.

The eponymous elephant was so big it derailed the locomotive. Billed as "The Towering Monarch of his Mighty Race," Jumbo reportedly stood over eleven feet tall and weighed close to seven tons. P. T. Barnum had made a fortune exhibiting the elephant after buying him from

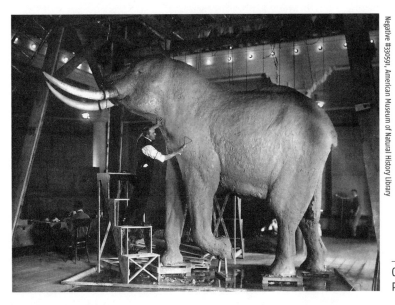

Negative #330591, American Museum of Natural History Library

Carl Akeley stuffing
P. T. Barnum's "Jumbo," 1885.

the British Zoological Society over the protests of Queen Victoria in 1881.[2] Barnum instructed Professor Ward to produce two Jumbos from the elephant's remains: one to be made from the animal's 2,400-pound skeleton, and another, which he called "Double-Jumbo," to be made from his hide. When Ward explained to Barnum he could stretch Jumbo's hide to make him look considerably larger than he had been in life, Barnum, who appreciated the potential to exploit such a colossus even in death, replied, "Let him show like a mountain."[3]

Akeley's work on "Double-Jumbo" was revolutionary. Except for a previous and clumsy attempt to mount an elephant in Paris in 1817, no one had ever tried to preserve a beast of such immense proportions. Akeley approached his subject as a sculpture rather than as an artifact. He built a wooden armature molded with thin strips of basswood that created a sense of musculature beneath the elephant's hide. Jumbo's alert, erect posture, his head and tusks held high, his body captured in midstride, began an era in taxidermy that no longer treated its subjects like upholstery but as action figures.

Roosevelt had already made up his mind to leave Washington at the end of his second term. Even though his popularity was still strong, he didn't want to run for the presidency in 1908; instead, he supported his secretary of state, Howard Taft, for the office. Republicans, feeling resentful that Roosevelt had foisted Taft upon them, knew that if Taft were to have any chance of stepping out from Roosevelt's shadow, then it would be prudent for president to get as far from Washington as possible. "One of my chief objects in making the trip," Roosevelt said in explaining his decision to go on a hunting trip out of the country, "is to be out of the United States for the year or year and a quarter immediately succeeding the installation of my successor."[4]

Roosevelt first decided he wanted to hunt big game in Alaska, a dream he'd toyed with for years. "It may be that some time I can break away from this sedentary life for a hunt somewhere," he wrote while still the assistant secretary of the navy, "and of all things possible to me I should like to take this hunt among the big bears of Alaska."[5] But Roosevelt harbored a deep-seated fascination for big game hunting in Africa. He was intrigued by the challenge of hunting brute beasts that put even Old Ephraim to shame.

Big game hunting Africa had been the province of princes, dukes, counts, and lords as well as former military officers who had remained in Africa after a variety of wars. Stories of legendary white hunters who'd left home to hunt foreign shores such as the Brits Gordon Cumming, William Finaughty, Chauncey Stigland, Cornwallis Harris, and the Scot James Sutherland, who reputedly shot 1,200 elephant bulls with his .577 Westley Richards, were the stuff of legend. "It seems to be the acceptable panacea in British or Continental society that a young or a middle-aged man, who has been crossed in love, or has figured in the Divorce Court . . . must go out to Africa and kill big game," the British adventurist and hunter Sir Henry (Harry) Hamilton Johnston wrote disapprovingly of sport hunters in 1906.[6] Such criticism did not faze Roosevelt. For years he sustained a correspondence with Captain Frederick Courteney Selous, a Brit who hunted elephants and lions from the Congo to the Transvaal (and reportedly was the model for the character of Allan Quatermain in Sir Henry Rider Haggard's classic African action-adventure novel, *King Solomon's Mines*). Captain Selous appealed to Roosevelt not only because he was a veteran of several wars and an explorer, but also like himself, the Brit justified his killing "by claiming to be [a] scholarly shooter collecting for scientific specimens."[7] Selous represented the consummate hunter, whose understated prowess and British reserve appealed to Roosevelt as a model of the gentlemanly hunter. "Probably no other hunter who has ever lived has combined Selous's experience with his skill as a hunter," he wrote glowingly of him in 1910. "He has killed between three and four hundred lions, elephants, buffaloes, and rhinos."[8] In fact, Selous had killed 199 elephants and over 3,000

other large game animals in Africa. The "smoking room" at his manor in Wargrave in Britain had the heads of twenty-five lions mounted on its walls. "It's a great mistake to suppose that I'm a great hunter," he demurred. "I've killed animals only as I wanted them."[9]

Roosevelt also had some correspondence with Lt. Colonel John Henry Patterson, another Brit whose hunting exploits fascinated him. In 1898 the British East Africa Company commissioned Patterson as an army engineer to supervise the construction of a bridge over the Tsavo River for the Uganda Railroad, the so-called Lunatic Line that went from "nowhere to utterly nowhere." Coincident to his arrival in Uganda, a pair of marauding lions started to drag African railway workers out of their tents at night and eat them. Patterson, an inveterate hunter who had hunted tigers in imperial India, pitted himself against the chary lions for nine months as they, in Patterson's words, "waged an intermittent warfare against the railway and all those connected with it."[10] In spite of his efforts, however, the lions uncannily eluded every trap Patterson set for them during their "perfect reign of terror." At times they even seemed to defy gravity itself as they returned to the fortified camp week after week, month after month, killing and eating as many as 140 hapless Africans.[11] Some of the workers believed the lions were the "angry spirits of two departed native chiefs" who'd come to revenge the machine in the garden that had violated the sanctity of their homeland.

The British East Africa Company wanted the lions that were wreaking havoc dead, and Lt. Colonel Patterson devoted himself to the task. On December 9, 1898, he killed the first of the lions, which measured nine feet eight inches from nose to tail. He killed the other lion three weeks later.[12] Soon afterward, the story about Patterson and the lions appeared in the Field Museum newsletter and caught the attention of Frederick Selous. "A lion story is usually a tale of adventures, often very terrible and pathetic, which occupied but a few hours of one night," he wrote, "but the tale of the Tsavo man-eaters is an epic of terrible tragedies spread out over several months, and only at last brought to an end by the resource and determination of one man."[13]

Selous told the story to Roosevelt, who gushed over Patterson's exploits. "The incident of the Uganda man-eating lions is the most remarkable account of which we have any record," Roosevelt wrote to Selous, "[and] ought to be preserved in permanent form." So prompted, Patterson, who had since become the chief game warden of the East African Protectorate (Kenya), published *The Man-eaters of Tsavo* in 1907, a little more than a year before Roosevelt stepped down as the chief executive.

The story, in the mind of the colonialist, amounted to no less than the titanic struggle between rival royalties for the ownership of the soul of Africa. Roosevelt, himself a social Darwinist who subscribed to Rudyard Kipling's notion of the "White Man's Burden," echoed the imperial mind-set when he told an audience at Oxford University in 1910, "In the long run, there can be no justification for one race managing or controlling another unless the management and control are exercised in the interest and for the benefit of that other race."[14] In Roosevelt's mind, Africa was contestable terrain, not as extranational territory to be colonized, but as the ultimate test of manhood. As he had done a quarter-century before in the Dakota and Montana Territories, he dreamed of marching into the dark lair of the beast.

THE KILLING FIELDS OF AFRICA

By the time Lt. Colonel Patterson published his book on the Tsavo lions, Carl Akeley had already been to Africa twice under the auspices of the Field Museum to "collect"—as it was

euphemistically called—prime specimens of animal life for mounting and display in Chicago. Even though the Field Museum had sanctioned his hunting for the sake of science, Akeley, like Patterson and Selous before him, was enthralled by the African hunt. "I confess," Akeley wrote in his biography, "that in hunting elephants and lions under certain conditions I have always felt that the animal had sufficient chance in the game to make something like a sporting proposition."[15]

Akeley returned from his first collecting expedition in 1896 with over 300 animals skins, heads, and body parts as well as 300 photographic negatives of his experiences on the "Dark Continent." Having failed to collect any of the key African charismatic megafauna (such as elephant, rhino, hippo, and cape buffalo), Akeley returned to Africa in 1905 to complete the Field Museum's bid to join the ranks of the premier natural history museums in America. During his second trip, he barely escaped death when a bull elephant used him as a "prayer rug" while he was hunting alone on the upper slopes of Mt. Kenya. Akeley took months to recover from his traumatic injuries.

By the time Akeley showed up for dinner at the White House in April 1908, the president was already considering going hunting in Africa instead of Alaska. A few weeks before his meeting with Akeley, Roosevelt had written Patterson to ask his advice about taking a safari in eastern Africa. "I suppose that in a year's trip I could get into a really good game country," wrote Roosevelt by hand. "I am no butcher, but I would like to *see* plenty of game, and kill a few head."[16] If Roosevelt had any lingering doubts about whether or not to go to Africa, then Akeley dispelled them. "When I am through with this job," Colonel Roosevelt declared to Akeley after their dinner at the White House, "I am going to Africa."[17]

In Roosevelt's social world, one of the hallmarks of the Great White Hunter was his ability to tell a good story. Both Patterson and Selous were superb storytellers, and Akeley was no less of one. He told an astonished Roosevelt about his first trip to Africa, when he'd choked a "vindictive" leopard to death with his bare hands after it had ambushed him in brush while he was looking for a warthog he'd just shot:

Negative #211510, American Museum of Natural History Library

Carl Akeley recovering after being mauled by an elephant on the slopes of Mt. Kenia, 1910.

I wheeled to face the leopard in mid-air. The rifle was knocked flying and in its place was eighty pounds of frantic cat. Her intention was to sink her teeth into my throat and, with this grip and with her forepaws, to hang to me while with her hind claws she dug out my abdomen . . .

I was conscious of no pain, only of the sound of the crushing of tense muscles and the choking snarling grunts of the beast. As I pushed her farther and farther down my arm, I bent over her. Finally, when my arm was almost freed, I fell to the ground with the leopard underneath me. My right hand was in her mouth, my left hand clutching her throat, my knees on her lungs, my elbows in her armpits spreading her front legs so that her frantic clawing did nothing more than tear my shirt.

I still held the leopard and continued to shove my hand down her throat so hard she could not close her mouth and with the other hand I gripped her throat in a strangle hold. Then I surged on her with my knees. To my surprise I felt a rib go, I did it again. I felt her relax, a sort of letting go, although she was still struggling . . . Little by little her struggling ceased. My strength had outlasted hers.[18]

It's hard to read Akeley's description of his encounter with the leopard without being reminded of how Jack Abernathy had captured wolves by forcing his fist down their throats or the time Roosevelt had killed a lion while ramming his Winchester down its throat in 1901. But for a man whose own experience of killing at close quarters was limited to a bowie knife, Akeley's barehanded contest with the leopard doubtlessly epitomized primal virility. The photograph of a bandaged Akeley standing in front of the dead leopard is a primal image of violence, aggression, and bestiality.

Soon after Akeley's visit to the White House, Roosevelt asked Selous to make preparations for a safari. By August the president was immersed in the details of the hunt. He even made detailed amendments to the provisions list, which reflected Selous's European bias. Roosevelt changed coffee for cocoa, Boston baked beans for pâté de fois gras, gingersnaps for German rusks (zwiebacks), and canned peaches for imperial French plums.[19] Then he struck out "1 tin Salt" on Selous's provisions list in favor of "2 tin Salt," adding, "I like plenty of salt." No doubt Selous raised an eyebrow when the president rebuffed his request to include twelve cases of whiskey, two cases of wine, and two cases of champagne. "I have cut out most of the wine and whisky supplies, as you will see," Roosevelt reproved. "I do not believe in drinking while on a trip of this kind, and I would wish to take only the minimum amount of whisky and champagne which would be necessary in the event of sickness."[20]

"I fairly dream of the trip," Roosevelt handwrote on the bottom of one of his letters to Captain Selous. "It sounds too good to be true. I never expected to be again in a good game country; and never at all in such a game

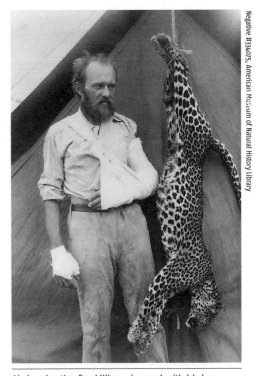

Negative #334075, American Museum of Natural History Library

Akeley shortly after killing a leopard with his bare hands.

country as East Africa must be; I long to see the wild beasts, and to be in the wilderness."[21] Roosevelt was the "archetype of the new safari client," writes Kenneth Cameron in *Into Africa: The Story of the East Africa Safari,* "a newcomer to Africa, able to command big money, eager to gulp down everything in a big swallow, hungry for trophies."[22] Meanwhile, Roosevelt's detractors merrily forecast his doom, predicting that he would die from overexposure, sleeping sickness, or most fittingly, mauling by lions. General Nelson Miles, one of Roosevelt's long-standing political enemies, snidely declared that only a "depraved" man would go to Africa in order to shoot an elephant.[23]

At age fifty Teddy was no longer as trim or physically fit as he had been a decade earlier. He had gained a considerable amount of weight while in the Oval Office and had developed a potbelly, which would prompt his African porters to nickname him *B'wana Tumbo*— Master Stomach—behind his back. Roosevelt preferred instead to be called *B'wana Makuba,* Great Master.

Wary of the public characterization of him as a game-butcher, Roosevelt disguised his hunt, as Akeley had done before him, as a scientific collecting expedition conducted under the sheltering wing of the Smithsonian. Hoping to blunt criticism of his African adventure, he publicly proclaimed as mission of the "Smithsonian African Expedition" to "get one specimen or perhaps one specimen of the male and one of the female of each of the different kinds of game, for the National Museum at Washington."[24]

The pretense was thin. "One cannot escape the conviction that Mr. Roosevelt is just a little bit more of a hunter than of a 'faunal naturalist,'" the *New York Times* noted wearily, "and that he hasn't been spending his time and money merely . . . for the sake of making the Smithsonian's collection of African animals larger and better than that possessed by any other museum in the world."[25]

Roosevelt had reason to worry about criticism. His entourage had taken on the proportions of a full-scale military expedition and was one the most expensive and the elaborate safaris of its, or any other, time.[26] In addition to Roosevelt and his son, Kermit, the caravan included an adjutant, a safari leader, his outfitter, two zoologists, a physician-naturalist, more than 260 porters, servants, gun bearers, horse boys, and a contingent of native British East African soldiers who were smartly dressed in red fez, a blue blouse, and white knickerbocker trousers.[27] End to end, the caravan stretched out for over a mile, with an oversized American flag flying at the head of the column.[28]

The overwhelming size of the expedition was required by the sheer volume of supplies that were necessary for the preservation of the skins and skeletons of the animals the expedition intended to collect over the course of a year. In addition to providing for the elaborate comfort and security of the white colonials, the porters carried with them as much as ten tons of fine salt for curing the animal skins, hundreds of traps, a virtual arsenal of weapons and ammunition, and Roosevelt's beloved "pigskin library" of literary works to read while in the field.

The Smithsonian put up 60 percent of the estimated $100,000 needed to conduct the expedition, which was provided by twenty-eight contributors, who represented a cross-section of the social elite, among them Andrew Carnegie, Cleveland Dodge, George W. Perkins, Elihu Root, and Isaac Seligman. Roosevelt paid the remainder out of his own pocket. Although *Collier's* offered the ex-president $100,000 to write about his adventures in Africa, Colonel Roosevelt considered the magazine unseemly for a person of his social and political status; instead, he accepted a commission from *Scribner's,* a more respectable publication, for $50,000, to write twelve articles from the field, the content of which would ultimately comprise his book, *African Game Trails* (1910).

Pundits lost no time lampooning Roosevelt's safari. C. H. Cunningham, the political cartoonist for the *Washington Herald,* drew an outline of the African continent overshadowed by the unmistakable silhouette of Roosevelt carrying a rifle. Beneath Roosevelt's gaze, the wildlife runs for cover. The day Roosevelt set sail for East Africa, the *New York Evening Mail* published an editorial cartoon by Homer Davenport entitled *Hist! See Who's Coming!* that depicts a lone tree on the African savannah, its branches overcrowded with elephant, lion, hippopotamus, zebra, and Cape buffalo huddled together in trepidation of TR's impending arrival. On the ground, an ape lopes toward the tree with a ladder under his arm.[29]

Davenport's cartoon inspired one of the earliest animated films in American cinema. *TR's Arrival in Africa* (1909) also lampoons Roosevelt's proclaimed motives for his expedition. The cartoon opens with a title card that reads: "Teddy's arrival caused some commotion in the Jungle." The twenty-second animation opens with the same animals huddled in the tree as Davenport's cartoon. On the ground, an agitated monkey scampers up the tree as Roosevelt the Hunter stalks into view, rifle in hand.

These and other editorial jabs made Roosevelt nervous about how the press might report the expedition. He hoped that "by the time I come back it may be that I will have been sufficiently forgotten to be able to travel without being photographed." But he knew that the press intended to follow his every step in Africa as best it could. He plotted to dissuade journalists from following him abroad. "They will never catch up with me if I get ahead of them once," he wrote his chief aide, Archie Butt.

[I]f they do in the jungle you may see my expense report to the National Museum read something after this order: "One hundred dollars for buying the means to rid myself of one *World* reporter; three hundred dollars expending in dispatching a reporter of the *American;* five hundred dollars for furnishing wine to cannibal chiefs with which to wash down a reporter of the New York *Evening Post.*"[30]

Instead of posting a bounty on reporters, Roosevelt imposed what amounted to a media ban on his safari. He intended to write his own account of the safari, and he entrusted the still photographic record to his son Kermit. He asked Cherry Kearton, a little-known cinematographer from Thwaite, a village in Swaledale, England, to make the motion picture record of his expedition.

Visually, Africa was still an enigma to the American public. Most people weren't sure which animals lived there, and it was common to mix up lions with tigers and orangutans with gorillas. Edward North Buxton's *Two African Trips with Notes and Suggestions on Big Game Preservation* (1902) and C. G. Schillings's *Flashlights in*

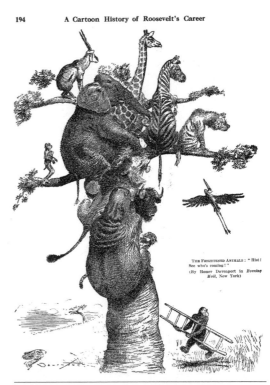

194 A Cartoon History of Roosevelt's Career

THE FRIGHTENED ANIMALS: "Hist! See who's coming!"
(By Homer Davenport in *Evening Mail,* New York)

Roosevelt's reputation as a hunter precedes him to Africa, 1910.

the Jungle (1906) published the earliest if not the first still picture accounts of faunal Africa.[31] The motion picture camera, however, had yet to penetrate the veldt or the savannahs of Africa. Only four films are known to have been made prior to 1909 in tropical Africa: two based upon military expeditions in the Somali region of Ethiopia, one by an Austrian ethnologist in East Africa, and one by a German in German Africa. These films were unknown in the United States, and none of them photographed wildlife. Cherry Kearton's footage of the Smithsonian African Expedition, on the other hand, portended a new age in the depiction of nature.

THE MOTION PICTURE CAMERA IN AFRICA

Before setting sail for Africa, Roosevelt received a proposal from Colonel William Selig to provide an official motion picture record of the expedition. Roosevelt, who understood the political and social power of film, found the idea of an *official* visual record irresistible for several reasons. First, the expedition validated his lifelong ambition as a faunal naturalist. He was, in the words of his friend, C. Hart Merriam, the chief of the United States Biological Survey, "the world's authority on the big game mammals of North America."[32] Indeed, Roosevelt had been fascinated with the natural world since the age of eight when he created the "Roosevelt Museum of Natural History" in his parent's house at Broadway and Fourteenth Street in Manhattan, a collection that consisted of twelve specimens, the centerpiece of which was a seal's skull that he'd found in a fish market on Broadway. "Certainly, I can no more explain why I like 'natural history' than why I like California canned peaches," Roosevelt tried to explain his passion, "nor why I do not care for that enormous brand of natural history which deals with invertebrates any more than why I do not care for brandied peaches."[33]

By the time Teddy entered Harvard in 1876, he'd decided to pursue a career as "a scientific man of the Audubon, or Wilson, or Baird or Coues type." He became an adept and dedicated observer, which led to his collaboration on a paper with the Massachusetts naturalist Henry David Minot entitled "The Summer Birds of the Adirondacks in Franklin County, N.Y." (1877), which drew praise from another naturalist by the name of C. Hart Merriam. During his senior year, however, Roosevelt's attention turned to politics, but he never lost interest in nature. He took great pride in keeping company with other naturalists such as John Burroughs and John Muir. His appointment as the chief agent of the Smithsonian African Expedition wasn't a pretense; indeed, being appointed as the chief agent of the National Museum of Natural History was a validation of his vision of himself as a world-ranked faunal naturalist-explorer.

Second, the expedition sanctioned Roosevelt's desire to kill the ultimate beasts of Guyot's Africa. If America represented the height of the civilized world, then Africa represented the supreme kingdom of the animal world, and he intended to conquer it. White male elite hunters such as Roosevelt, Patterson, Selous, and Akeley, notes historian Richard Slotkin, "presented [themselves] as a more advanced type [of hunter], capable of an intellectual appreciation of the beast and the hunt, able to exercise a selectivity in killing that was almost aesthetic."[34] They were the real-life precursors of the literary characters of Joseph Conrad, Ernest Hemingway, and F. Scott Fitzgerald. They were the social elite attracted to Africa's "heart of darkness." For these men, danger acted as a surfactant: one's courage was defined by the degree of resolve and calm one could exhibit by confronting what Roosevelt described as the "dread brutes that feed on the flesh of man."[35]

Last, for Theodore Roosevelt, the personal, the social, and the political equation shared the same terms: to hunt was to dominate and to dominate was to rule. Although he waxed primeval about places "of gorgeous beauty, where death broods in the dark and silent depths," where all life trembled with dread of talon and fang, the expedition also provided Roosevelt with a bully pulpit.[36] Although he intended to fulfill his promise to leave Washington physically, he didn't intend to leave Washington figuratively. The logic was deliciously ironic: the farther Roosevelt traveled from Washington, the more the public's fascination for him and his travels to the Dark Continent grew. Africa became a stage for Roosevelt to act out his personal ambition as the Grand Hunter. True to his promise to remain out of sight, he had no intentions of being out of mind.

So when Colonel William Selig proposed the idea of providing the official film record of the expedition, Roosevelt considered the offer. Selig was clever enough not to presume to send his own cameraman on the expedition; rather, he asked to show Kermit how to use a motion picture camera so he could shoot the images himself and then bring them back to America for Selig to edit into a film.

Colonel William Selig, however, was really Willy Selig, a vaudevillian who'd started his career as a magician called "Selig the Conjurer." Failing that enterprise, he toured the western states in a horse-drawn wagon as a blackface minstrel in Martin and Selig's Mastodon Minstrels, an itinerant troupe comprised of five whites, four blacks, and a "Mexican" who played the trombone. Finally, Willy Selig gave himself a commission as a colonel and went into the movie business.[37]

Appreciating Selig's motive of exploiting the official film of the expedition financially, Roosevelt rejected his offer. Although he knew the work of the Selig Polyscope Company from the five shorts it had filmed about him between 1900 and 1904, Roosevelt did not intend to share control of the film with Selig or anyone. Instead, he turned to a thirty-eight-year-old son of a Yorkshire farmer to record the official visual record of the expedition: Captain Cherry Kearton.

FOAMING AT THE BIT AND READY TO DIE

Roosevelt chose Kearton because he was cut from the same cloth as himself. He was a military man who had served eighteen months in the Anglo-Boer War (1899—1902) as Cecil Rhodes's chief intelligence officer. He was a member of Pocock's Legion of Frontiersmen, the "outriders of Empire," who dedicated themselves "to mutual fellowship and service to the State in times of need." Foaming at the bit and ready to die in service to their monarch, their ranks included luminaries such as Captain Frederick Selous, explorer Sir Ernest Shackleton (who led an expedition to the Antarctic in 1914), the novelist Joseph Conrad, explorer Robert Falcon Scott (who died on the way home from the "Race to the South Pole" in 1912), and British field marshal Lord Kitchener.

Like his contemporaries, Kearton was a risk-taker. "One of the very narrowest escapes from death my brother has perhaps ever had also illustrates his coolness in face of imminent danger," Cherry's brother Richard wrote about an incident in which Cherry accidentally stepped off a rock face while filming birds on the cliff below him. After falling between nearly thirty feet, Cherry landed on a ledge only to have a rock "as large as a man's head" crash inches from his head. "I was so overcome by the sight," recalled Richard Kearton,

that for a moment I ceased to breathe and to turn the handle of the kinematograph camera, but, as far as I could see, my brother neither turned a hair, not changed colour, and, in comparing notes after the incident, he teased me unmercifully, and wound up by saying: "Call yourself a photographer! Why, you missed the very feature that would have made the picture valuable as a record of the dangers of cliff work!"[38]

Although Kearton was a pioneer of natural history filmmaking, his work as a cinematographer was plodding. He didn't regard cinematography as an art, but rather a skill that provided a means to an end, which was to record his own daring exploits as an adventurer. In fact, Kearton claimed it took more courage to film a ravening beast at close quarters than it did for the "pseudo-sportsman" to shoot one with a rifle. "It is much easier, much less dangerous," Kearton wrote dismissively of hunters in his autobiography, "to shoot a lion, after your boys have led you up to him, and your white hunter—who is by your side, ready for emergencies—has given you explicit instructions, than it is to creep close to that lion and take a moving picture of him."[39]

Nonetheless, Roosevelt praised the authenticity of Kearton's work. "My attention was particularly directed toward Mr. Kearton's work because of its absolute honesty. If he takes a picture it may be guaranteed as straight," he wrote.

> I can personally vouch for [the] fidelity to the actuality. His views of the charging lion, in which several natives are trampled and torn by the infuriated beast, are wonderful—really wonderful! It is a really phenomenal record of a really phenomenal feat, and I congratulate Mr. Kearton with all my heart on what he has done.[40]

Indeed, the elite hunting community had already embraced the camera as a sporting device equal to if not greater than the rifle. In 1892, William Bird Grinnell, the editor of *Forest and Stream*—the self-professed magazine of "true sportsmen"—commented, "As we grow older we incline more and more to the opinion that a camera is sometimes *a more satisfactory instrument* to hunt with than a gun."[41] Like many sport hunters, Grinnell (with whom Roosevelt had chartered the Boone and Crockett Club just four years before) was concerned by the alarming rate at which game was disappearing.

The camera tried to resolve the paradox of the sports hunter, who destroyed the object of his veneration. Both Grinnell and Roosevelt rationalized hunting as the imposition of the civilized over the savage. At the same time, both men recognized the growing urgency to protect the very thing they were destroying. And so the camera offered the possibility to transform the kill from a literal into a figurative act without jeopardizing the integrity of the hunt itself. "More and more, as it becomes necessary to preserve the game," Roosevelt wrote a few months before his lion-hunting trip to Colorado in 1901, "let us hope that the camera will largely supplant the rifle."[42]

> The shot is, after all, only a small part of the free life of the wilderness. The chief attractions lie in the physical hardihood for which the life calls, the sense of limitless freedom which it brings, and the remoteness and wild charm and beauty of primitive nature. All of this we get exactly as much in hunting with the camera as in hunting with the rifle.[43]

Carl Akeley also claimed that "camera hunting takes twice the man gun hunting takes," but he was less sentimental in his assessment of the role the camera might play. "There is just one relieving circumstance in this doleful prospect," he remarked, "what man seems bent

upon destroying with his gun can at least be rescued from complete oblivion and given the illusion of reality through the camera."[44] Consequently, the index of the early natural history cameraman had more to do with bravado than with aesthetics. Like Roosevelt, Kearton was in it for the hunt. And even though the "shot" was literal for Roosevelt and metaphoric for Kearton, Kearton's cinematography was no more nuanced for it.

It was inevitable, perhaps, that the camera became an indispensable appendage to the hunt. The camera authenticated the hunter's claim by documenting the kill in a way that words or drawn images could not. The photographic image acted as irrefutable proof of conquest with the further power to penetrate "the essence of nature and retrieve truths camouflaged from the human eye."[45] Whereas the still photograph more commonly captured the brute postmortem—a staged photograph of the hunter posed with his weapon in hand in front of his prostrate victim—the motion picture camera had the ability to capture the breathless dynamics of the hunt itself.

The still image of the John Henry Patterson posed in front of the propped-up body of the massive Tsavo lion he had just killed is a visual act of triumphalism. It is, within the context of its time, a grand valorization of masculinity and the claim of dominion over nature. Similarly, the picture of Roosevelt and his son, Kermit, sitting astride the haunches of a Cape buffalo they'd just shot reflects an unequivocal celebration of imperial authoritarianism. The archive of still pictures taken during the Smithsonian African Expedition bursts at the seams with images of Roosevelt standing beside his fallen quarry. Wantonly, they abandoned their pledge to kill only a single male and female of each specimen. Together they *officially* recorded 512 kills "of game shot with rifle," ranging from baboons (3) to zebra (20). Their list included, by Roosevelt's account, seventeen lions, eleven elephants, twenty rhinoceros, ten Cape buffalo, eight hippopotamus, nine giraffes, many hundreds of hoofed animals, and a potpourri of porcupines, crocodiles, ostriches, flamingos, a pelican, and four pythons. The actual toll was significantly higher if one factors in animals Roosevelt and Kermit wounded and lost trail of. Roosevelt admitted, for example, shooting at least three hippos and not knowing what happened to them when they submerged.[46] The Roosevelt who had refused to shoot a dazed bear that was tied to a tree in Mississippi a few years earlier now had no qualms about shooting

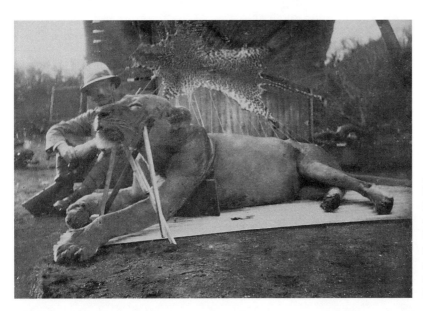

Lt. Colonel John Henry Patterson displays one of the man-eating lions of Tsavo that reportedly had killed as many as 135 workers on the Kenya–Uganda Railroad, 1898.

Theodore Roosevelt Collection, Harvard College Library

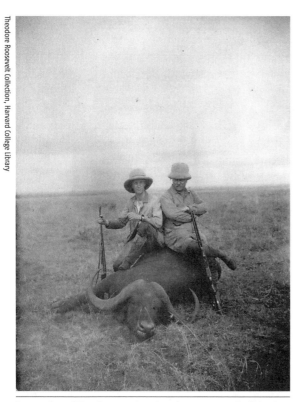

Roosevelt and Kermit pose triumphantly over a cape buffalo shot while on safari in Africa, 1910.

a rare white rhinoceros while it was asleep and then killing its orphaned calf.[47] Twenty-six years after he had shot his first big game animal on the plains of North Dakota and whooped up a war dance around the bison's corpse, Roosevelt at age fifty-one sat around a campfire "all splashed with blood from head to foot" and "toasted slices of elephant's heart on a pronged stick before the fire."[48] He was indeed *B'wana Makuba,* the Great Master, lord of the realm.

In all, the Roosevelts overwhelmed the Smithsonian with a staggering array of over 21,650 specimens of animal and plant life, including 12,000 mammals, birds, and reptiles, 5,000 plants, 3,500 insects, 1,500 shells, and 650 miscellaneous invertebrates.[49] And yet Roosevelt declared his restraint: "We did not kill a tenth or a hundredth part of what we might have killed had we been willing," he wrote.[50]

And although he justified the killing on the basis of "need" for the Smithsonian, the museum did not have the time, the space, or the manpower to process a collection of this magnitude. To his dismay, Roosevelt later learned that the Smithsonian could exhibit only fifty of his specimens. The other 21,600 were shelved. C. H. Cunningham's editorial cartoon in the *Washington Herald* showing animals running for cover upon his arrival on the shores of Africa had proved prophetic after all.

ROOSEVELT IN AFRICA

After Roosevelt rebuked *Collier's,* the magazine tried to "scoop" the ex-president by sending an English hunter-turned-photographer with the unlikely name of A. Radclyffe Dugmore to photograph Africa's most dangerous game in advance of Roosevelt's expedition. During 1909, while the country waited for the first pictures of Roosevelt to come back from Africa, *Collier's* periodically published Dugmore's photos of lions, rhinos, and hippos under the banner of "Snapping Africa's Big Game, The Camera that Beat Roosevelt to the Jungle." While they were not the first images of Africa's wildlife, they were the first to frame Africa as an untamed continent in the political terms of the American West. Rather than overshadow Roosevelt, the photos served instead to whet the public's appetite for news and pictures of how he and his Winchester would fare over the anarchic, bestial nature of Africa.[51]

The public was fascinated with the exoticism of Africa and Roosevelt's foreign adventurism. The American public—indeed much of the world—eagerly followed his exploits in Africa as they leaked out into the press. Every month Roosevelt sent out a personal dispatch from the field that played out in installments on the pages of *Scribner's Magazine*, much as Dickens had serialized his own stories for the public. The poet who had been long suppressed by the scientist reemerged. "I speak of Africa and golden joys," he opened his account of *African Game Trails*, "the joy of wandering through lonely lands; the joy of hunting the mighty and terrible lords of the wilderness, the cunning, the wary, and the grim."[52] Provocative chapter titles such as "Lion Hunting on the Kapiti Plains," "A Buffalo-Hunt by the Kamiti," "Elephant Hunting on Mount Kenia," and "The Great Rhinoceros of the Lado" promised to deliver the sensational adventures of an American white hunter, the former chief of state, the Rough Rider who had dug the Panama Canal, the man who had won the Nobel Prize for Peace for bringing the Russians and the Japanese to the table to resolve their imperial ambitions in Manchuria.

"There have been many of these men," wrote Roosevelt biographer Charles Morris, author of the unabashedly hagiographic *The Marvelous Career of Theodore Roosevelt (Including What He Had Done and Stands For; His Early Life and Public Services; The Story of His African Trip; His Memorable Journey through Europe; And His Enthusiastic Welcome Home)* (1910):

> We have not told their names nor described their deeds, reserving the story of hunting exploits in Africa for one of the latest and boldest of them all, Theodore Roosevelt, the first great American to meet these savage creatures on their native soil. The records of hunting adventures are much alike, and the exploits of our hero were of the same type as those of his predecessors.[53]

Morris's panegyric reflected the widespread public perception that Roosevelt was an exceptional man who had risen above a soporific federal bureaucracy to achieve greatness. The chatter that was critical of Roosevelt's hunting bloodlust faded into the background, silenced by the audacity and the scale of his ambitions in Africa. This hunting trip was different from all the others because it hinted at a new American frontier on foreign shores. The public couldn't get enough of it. Even after being serialized in *Scribner's*, *African Game Trails* sold over a million copies.[54] His exploits spawned a surge of books, some of which had titles that were reminiscent of Colonel Prentiss Ingraham's dime novels, such as Jay Henry Mowbray's account of the expedition, which must contend for the longest book title in American publishing history: *Roosevelt's Marvelous Exploits in the Wilds of Africa: Containing Thrilling Accounts of His Killing Lions, Rhinoceros and Other Ferocious Beasts of the Jungle Including Full and Graphic Descriptions of Hunting Big Game, His Miraculous Adventures and Wonderful Feats with His Rifle, Terrible Experiences with Ferocious Animals, Strange People, Startling Revelations and Amazing Achievements in Darkest Africa, the Whole Comprising Thrilling Stories and Fascinating Narratives of Roosevelt's Adventures in Search of Scientific Knowledge* (1910). As a man considering running for another term as president, he could not have asked for better press.

As a naturalist Roosevelt intended to know nature as a prelude to possessing it. He reported faithfully on every mammal he encountered, from the elephant to the elephant shrew. The appendices of small mammals at the end of *African Game Trails* were his bona fides as a faunal naturalist as he dutifully listed each species by its Latin binomial and then described it in the tradition of the taxonomists who came before him. Surely not one reader in a thousand bothered to read them. His sere prose would have appealed only to the most diehard naturalist who was interested in the quotidian variety of African shrews, moles, mice, and gerbils that

lived in British East Africa. "*Scotophilus migrila colias,*" reads one entry. "Common at Nairobi; flying among the tree tops in the evenings. Greenish back, with metallic glint; belly sulphur. Has the same flight as our big brown bat *vespertilio fuscus.*" The spiritual core of *African Game Trails* does not lie in its tedious cataloguing of species or in Roosevelt's field observations about zebras and zebra mice, however. It lies in his quest for dominion over nature. And for Roosevelt and the nation addicted to his every move in Africa, one animal more than any other embodied the essence of that quest.

THE KING OF THE JUNGLE

In Roosevelt's words, the lion was "the maned master of the wilderness, the terror that stalked by night, the grim lord of slaughter."[55] The mountain lion paled in comparison to the King of the Beasts. When TR wrote Frederick Selous to tell him of the trophy male cougar he had killed on his 1901 Colorado hunt, he related the event to the seasoned lion hunter of Africa deferentially. ("The cougar certainly cannot be as formidable as the jaguar or leopard," he wrote. "It hardly ever charges either man or dog, simply clawing and biting when it is attacked.")[56] Still, he could not help but compare his cougar to an African lion. "As it lay stretched out," he wrote wistfully, "it looked like a small African lioness."

Patterson's account of the marauding lions of the Tsavo and the stories Selous and Akeley had told Roosevelt about hunting lions had convinced him that "the weight of opinion among those best fitted to judge is that the lion is the most formidable opponent of the hunter."[57] Sir Alfred Pease, author of what was then considered the definitive text on hunting lions, *Book of the Lion,* explained the appeal of the lion hunt in emotional terms: "Fear is the very essence of pleasure or sport," he wrote. "The real sport begins when there is the excuse to feel afraid."[58] But for Roosevelt hunting lions was more than about confronting fear. An enraged elephant or rhinoceros was capable of inspiring just as much fear when it charged. The difference was that lions were themselves hunters, and, at times, they preyed on human beings. In *African Game Trails* Roosevelt spends more time relating stories about lions that preyed upon hapless Africans than any other animal. Lions were the apex predators of Africa. Hunting them framed the ultimate battle for supremacy between man and beast, and thusly served as the test not only of dominion but also masculinity.

In one of the most riveting episodes in the book, Roosevelt described how Nandi tribesman armed only with spears and shields had hunted down a lion. "He was a magnificent beast, with a black and tawny mane; in his prime, teeth and claws perfect, with mighty thews, and savage heart," he wrote of the lion as it fed on a wildebeest it had just killed. He watched from horseback as the tribesmen surrounded the lion and then cinched the circle. Roosevelt's narrative is laden with admiration for and awe of both the lion and the young warriors who dared to kill him:

> The lion looked quickly from side to side, saw where the line was thinnest, and charged at his topmost speed. The crowded moment began. With shields held steady, and quivering spears poised, the men in front braced themselves for the rush and the shock; and from either hand the warriors sprang forward to take their foe in flank. Bounding ahead of his fellows, the leader reached throwing distance; the long spear flickered and plunged; as the lion felt the wound he half turned, and

then flung himself on the man in front. The warrior threw his spear; it drove deep into the life, for entering at one shoulder it came out of the opposite flank, near the thigh, a yard of steel through the great body. Rearing, the lion struck the man, bearing down the shield, his back arched; and for a moment he slaked his fury with fang and talon. But on the instant I saw another spear driven clear through his body from side to side; and as the lion turned again the bright spear blades darting toward him were flashes of white flame. The end had come. He seized another man, who stabbed him and wrenched loose. As he fell he gripped a spear head in his jaws with such tremendous force that he bent it double. Then the warriors were round and over him, stabbing and shouting, wild with furious exultation.[59]

Eight months earlier, Roosevelt's first lion hunt did not fare so gloriously. He had been in Africa less than a month as the guest of Sir Alfred Pease on his ranch in the shadow of Mount Kilimanjaro. One morning Sir Alfred took the Roosevelts lion hunting along a dry streambed, where they found the tracks of several lions. When a "mongrel bull-dog" named Ben picked up the scent, the native "beaters" began throwing rocks into the brush hoping to roust the lion from its cover. "I shifted my position, peering eagerly into the bushes for some moments before I caught a glimpse of tawny hide," wrote Roosevelt. "As it moved there was a call for me to 'shoot,' for at that distance, if the lion charged, there would be scant time to stop it; and I fired into what I saw."[60]

Kermit fired a second shot.

Two lions burst out of the bush. They had ambushed a pair of lion cubs, "the size of a large dog," that had been hiding in the grass, awaiting the return of their mother. "Each was badly wounded," wrote Roosevelt dispassionately, "and we finished them off."

In spite of his "great disappointment," an undeterred Roosevelt continued the hunt, and later that day he shot two adult lions in quick succession, one of which required five bullets to kill, the other three. The hunters then skinned the lions, loaded them on poles that they placed on the shoulders of the black porters who carried them back to camp. For Roosevelt the moment was intoxicating. "The stalwart savages who carried the bloody lion skins along at a faster walk as the sun went down and the moon rose higher," he reminisced, "and they began to chant in unison, one uttering a single word or sentence, and the others joining in a deep-toned, musical chorus."[61]

A few days later Roosevelt proudly showed off his "first" lions to Captain Selous, who was visiting a neighboring ranch.[62] In the company of two of the greatest lion hunters of his time, Roosevelt finally achieved his validation as a true African hunter.

News of Roosevelt's lion kills spread like wildfire in the world press. While his expedition to Africa had fulfilled his personal ambition to hunt and kill the world's most dangerous game "for the eager pleasure of it," as a figure the world followed closely, his actions imputed a greater political significance. The obvious appeal of the battle of symbols—the American lion versus the African lion—proved irresistible not only to political pundits but also to the American public. An editorial cartoon in the *St. Louis Dispatch* captured the political symbolism adroitly. The first panel of Robert Minor's "The King is dead; long live the King!" depicts a lion standing on at the edge of a precipice lording over his realm. In the second panel, the lion explodes like a balloon, and in the final panel, Roosevelt stands in place of the lion, lording over his new realm. The silhouettes of Roosevelt the Hunter and Roosevelt the Statesman became fused.

America sensed a hero would emerge out of the African bush, a man who could ascend the squabble of domestic politics, someone who could put the world on alert. In fact, Roosevelt

intended to run his victory lap in Europe before going home. Even though no longer a head of state, he could still command audiences with the grand imperial powers of Europe: Italy, France, Germany, England, and the Vatican.[63] In the background, one could still hear the battle cry of the Rough Riders: *Rough, tough, we're the stuff / We want to fight and can't get enough!"* Anticipating Roosevelt's arrival in England, the satirical magazine *Punch* published a cartoon of the statues of the British imperial lions in Trafalgar Square wearing signs around their necks that read "Not To Be Shot."

Roosevelt's African safari polished the image of him as a man who was bold—at times even reckless—but most of all, unflinching. He was a leader of men of all nations. By comparison, the men who had preceded and followed him in the presidency, from Andrew Johnson to Howard Taft, whom TR had disparagingly characterized as the "grey men in the White House," seemed to lack the courage, the vitality, and the ambition to assert America's power and influence in the world.

Roosevelt projected the American conquest of wild Africa by translating the continent into American terms and symbols of the western hunter. He constantly translated the African landscape into an American landscape with familiar references to the American West. "Again and again the general landscape struck me by its likeness to the cattle country I knew so well," he wrote:

> As my horse shuffled forward, under the bright, hot sunlight, across the endless flats or gently rolling slopes of brown and withering grass, I might have been on the plains anywhere, from Texas to Montana; the hills were like our Western buttes; the half-dry watercourses were fringed with trees, just as if they had been the Sandy, or the Dry, or the Beaver, or the Cottonwood, or any of the multitude of creeks that repeat these and similar names, again and again, from the Panhandle to the Saskatchewan.[64]

Roosevelt was not simply a tourist who was taking in the exotic sights of a country whose wildlife and landscape were charmingly foreign to his experience. Rather, he calculated British East Africa in terms of its likeness and its utility as an American place.

"A Westerner far better than an Easterner could see the possibilities of the country," he wrote, speculating upon how water could be stored in reservoirs built by the government and the plains irrigated in order to make an "excellent opening for small farmers, for settlers, for actual home-makers, who, above all others, should be encouraged to come into a white man's country like this of the highlands of East Africa."[65]

When TR described a place, an animal, or even life in general, he often resorted to the American western experience, by using the phrase "What in the West we would call . . ." He correlated African animals with American animals, making the strange seem familiar, as though Africa were an extension of the American continent. "I speak of the American animals only for the purpose of securing a familiar standard of comparison," he explained.[66] Therefore the wildebeest and the gnu looked like a bison; the leopard reminded him of the cougar, and "the sand rats that burrowed in the dry plains were in shape, in color, eyes, tail, and paws strikingly like our pocket gophers."[67] He used the same technique when describing indigenous people: the native African shared many traits in dress and customs with the Native American. He compared life in Africa to the way it was in the early days of the American West, with hardened explorers, hunters, and prospectors blazing the trail for others to follow. Roosevelt had no pretenses of the United States invading or occupying any part of Africa; he was interested

in the literal and symbolic gesture of a show of force in Guyot's Africa as both a spiritual and a political affirmation of manhood.

HUNTING BIG GAME IN AFRICA

In May 1909, Americans flocked to the movie houses to experience the vicarious thrill of watching Roosevelt kill his first lion in Africa. "There is no doubt about this lion," *The Moving Picture World* raved about *Hunting Big Game in Africa*; "he stalks majestically about the picture, thus enabling an audience to realize how a lion would look, not on the war path, but peaceably ambling about among natural surroundings."[68] While the lion may have been real, nothing else about the film was.

Hunting Big Game in Africa might have been properly titled *Willy Selig's Revenge.* Like Roosevelt, Selig was a restless, ambitious man, and when the president turned down his request to teach Kermit how to use a movie camera, Selig decided to make his own version of the expedition instead. He bought an old lion out of the Los Angeles zoo and then hired a Roosevelt impersonator to "hunt" the lion on a set in Chicago with unemployed Pullman porters playing the role of authentic native Africans.[69] Selig had the lion killed offscreen and then photographed the costumed Pullman porters dressed as African natives carrying the dead lion strapped to poles.

Shrewdly, Selig didn't release his bogus documentary until the press reported that Roosevelt had killed his first lion. Audiences flocked to see *Hunting Big Game in Africa* thinking they were watching their nation's great *B'wana* kill the ultimate symbol of savage nature. Although a few writers suspected a hoax, they readily overlooked it for the narrative excitement of the picture. "Unless we are mistaken, there is a mixture of Indian and African costumes in the dressing of the natives," one writer at *Moving Picture World* cautioned, "but the whole thing is full of movement and shows great resource on the part of the producers."[70]

Roosevelt found out about Selig's film in May 1910, a full year after the film had been released, when he arrived in Berlin to visit with the kaiser. The colonel denounced Selig's film as a fraud. "In moving pictures of wild life there is a great temptation to fake," he commented, trying to revive the nature fakery debate of 1903, "and the sharpest discrimination must be employed in order to tell the genuine from the spurious."[71] But it was too late. Selig's commercialism, however crass and exploitive, was based upon his experience as a vaudevillian and an understanding of the emerging role of narrative in film. As the first jungle melodrama, *Hunting Big Game in Africa* had already created a template that would help to define the visual discourse about Africa for decades.

In spite of the commercial success of *Hunting Big Game in Africa,* advance word of Roosevelt's film created a national buzz. "After years of unremitting labor, at obvious peril of life and limb," an advertisement for the film read in December 1909, Cherry Kearton had "obtained the most natural reproductions possible of prowling lion, the stealthy tiger, the ourang-outang (the first authentic moving picture of this interesting citizen of the jungle) and scores of other beasts of the Dark Continent."[72] *Moving Picture World* declared, "[Kearton] lays bare the innermost secrets of the animal kingdom by means of the motion picture camera."[73]

In order to distinguish it from Selig's enterprise, Roosevelt's film paraded its credentials, which included official endorsements including the American Museum of Natural History, the

New York Zoological Society, the National Geographic Society, and the American Museum at Washington. The Duke and Duchess of Connaught and the Princess Patricia, themselves about to embark on their own African safari, sat in the audience at the film's premiere at the Alhambra Theater in New York and watched as a black porter carried the portly Roosevelt across a stream on his back so that the colonel would not get have to get wet.

Roosevelt in Africa was in wide release by May 1910. By then, however, the static *actualités* of the end of the century were giving way to the emerging hegemony of plot. The innovative narrative techniques in Edwin Porter's *The Life of an American Fireman* (1902) and *The Great Train Robbery* (1903)—and, of course, *Terrible Teddy the Grizzly King* (1901)—were evolving into sophisticated story forms. By 1908, Selig made *The Count of Monte Cristo,* the first narrative film to be shot in Los Angeles, and D. W. Griffith, who started his career in film working as an actor for Porter, directed *The Adventures of Dollie,* the first of nearly 450 films he would make during his career. The new tools of trade included suspense, pathos, and melodrama, and unfortunately, *Roosevelt in Africa* lacked all of them.

Roosevelt in Africa was a box office catastrophe. "There is not a picture in the 2,000 feet that is fit to be called a picture," reported one exasperated exhibitor. "To tell you the honest truth, most any operator would be ashamed to run such a thing through a machine. Anybody could take a .22 rifle and go out in the sagebrush of Idaho and get more excitement hunting jack rabbits."[74] The film contains thirty-six vignettes with no dramatic structure that document mundane events: planting a tree in front of trading company building, tribesmen posing for the camera or going about their daily business, and so on. It is more of a visual chronicle of the daily events of the expedition than an adventure featuring the daring exploits of Roosevelt the Hunter. The film does not include a single hunting scene. In fact, none of the dramatic scenes that made *African Game Trails* successful in print were in the film. "[Audiences] were expecting to see Teddy slaughtering lions and tigers and wallowing in the gore," said a contemporary journalist, accounting for the film's lackluster performance at the box office. "It was of no use to explain the difficulties incidental to the taking of such a picture."[75]

Compared to Colonel Selig's "blood curdling romance of the dangerous animal infested jungleland of Africa," *Roosevelt in Africa* seemed stultified, passé. Kearton shot the animals as simple, uneventful nature portraits: a herd of giraffe, a serval cat walking in the grass, and hippopotamuses at play. And there were no lions. The King of Beasts had managed to elude Kearton's repeated attempts to film them,[76] so instead he inserted a flashlight photograph of a lion into the film,[77] which, one reviewer carped, was "flatter than a pancake."[78] For audiences cutting their teeth on melodrama, *Roosevelt in Africa* held little appeal.

The emergence of narrative during the first decade of the twentieth century deepened the cultural and social schism between classes. Simply put, the lowbrows went to storefront nickelodeons to see their films, and the highbrows went to museums and libraries to see theirs. Roosevelt's popular appeal rose, at least in part, from the more than one hundred films that played in Edison's Kinetoscope parlors. For five cents a working-class American could go to a "peep" show and watch Roosevelt and his Rough Riders ride to glory through a slit at the top of a wooden cabinet. By 1905 the nickelodeon, a crude, storefront theater with a muslin screen and cheap folding chairs, started to replace the "peep" show. They were crowded, hot, unsavory places. By 1910, when the population of the United States was just over 92 million, 26 million people went to a nickelodeon *every week.*[79] And while Roosevelt was shrewd enough to understand the implications of having his image in front of all the social strata of the electorate, he personally disdained the base entertainments of the lower classes for the

same reason he spurned mass circulation magazines for more literary ones and snubbed Willy Selig in favor of Cherry Kearton.

The colonel held firm to his belief that the value of film laid in its veridicality—what he called *the authentic*—and not in the glib pretense of telling a story. Although he valued a good story well told as much as anyone, he believed his film should aspire to a higher moral purpose than simply to entertain. The purpose of *Roosevelt in Africa*, as he understood it, was to elucidate natural history through the rigorous disciplines of observation and objectivity.

The film's roots are the *actualités* that had helped to propel Roosevelt into power. He understood shorts such as *Theodore Roosevelt Leaving the White House* (1898), *President Roosevelt at the Army-Navy Game* (1901), and *President Roosevelt at the Dedication Ceremonies, St. Louis Exposition* (1903) to be historical documents, firsthand knowledge of events recorded through the nonpartisan lens of a camera. *Roosevelt in Africa* was meant to serve the same purpose: to record impartially, on behalf of the Smithsonian Institution, the events, the people, and the wildlife of Africa. He saw the camera as a scientific inscription device that could produce reliable, unmediated field notes about nature. "If possible, [the big-game hunter] should be a field naturalist," he wrote:

> If possible he should be adept with the camera; and hunting with the camera will tax his skill farm more than hunting with a rifle, while the results in the long run give much greater satisfaction. Wherever possible he should keep a note-book, and should carefully study and record the habits of the wild creatures, especially when in some remote regions to which trained scientific observers but rarely have access.[80]

The camera had substantial precedent as a putatively objective observer by the time Kearton took it to Africa. The work of Marey and Muybridge had already focused the attention of scientists on the locomotion of animals, and August Lumière had turned the attention of his *cinématographe* from *actualités* of daily life to medical research by 1900. "In its very earliest stages the value of [motion picture] photography," wrote F. A. Talbot in 1912, "was conceded to be in the field of science rather than that of amusement."[81] In Roosevelt's mind, *Roosevelt in Africa* simply consisted of visual notes in an observer's notebook. The public, however, was unimpressed. Nonetheless, others with cameras and guns quickly followed.

The Dark Continent

BOTH SELIG'S SPURIOUS CONSTRUCTION OF AFRICA AND ROOSEVELT'S MORE CALCU-
lated construction of it trade on the myth of Africa as the Dark Continent. The myth of the
Dark Continent was an elaborate social fiction created and perpetuated by Victorian England
as a strategy for expediting the morality of its colonial enterprises in Africa. The incursion into
Africa by prognostic agents of imperialism—men like Roosevelt and Akeley—shared much
of the same colonial discourse as the British colonizers who preceded them. An ideational
landscape converts the geographical spaces of Africa, or what Edward Said calls "the structures
of location and geographical reference," into a cultural striving through discourses such as
literature, history, or ethnography that justified and affirmed the ideology of empire.[1]

The first conjunction between the imperial Self and the foreign Other was most com-
monly the landscape. "Landscape," writes cultural ecologist Carole Crumley, "provides a focus
by which people engage with the world and create and sustain a sense of their social identity."[2]
The imperial frame, however, usurps the native frame by inventing "structures of attitude and
reference" that are relevant to the metropolitan rather than the indigenous culture as essential
elements in the "ongoing contest between north and south, metropolis and periphery, white
and native."[3]

Similarly, the myth of the Dark Continent counterposes the Western myth of the Garden
of Eden. Verbal and visual depictions of Eden emphasize orderliness, harmony, and perpetual
light. It lacks shadow. Europe and, later, the United States, on the other hand, depicted Africa
as anti-Edenic: chaotic, unruly, and bestial. Africa typified the substance of shadow. Hegel
even dismissed Africa "as static, despotic, and irrelevant to world history" because its people
lived in too "rough [a] state of nature."[4] He and others argued that Africa existed either before
or out of time but not *in* time. It lacked history because it lacked civilization; it was, as Guyot
and other environmental determinists had already pointed out, nature's continent.

The Edenic myth was created by a people for themselves about themselves, whereas the
myth of the Dark Continent was created by a people for themselves about another people.
The mission of this privileged myth was to create a place (in this case an entire continent) that
was utterly bereft of the self-proclaimed virtues of civilization in order to give a moral justi-
fication to its colonial mission in Africa. In this sense, an entire continent submitted itself as
an unwilling and unwitting host to a variety of parasitic European nations, including signifi-
cantly Great Britain, France, Germany, Belgium, and finally the United States. "It is necessary,
then, to accept as a principle and point of departure the fact that there is a hierarchy of races
and civilizations," wrote the French colonialist Jules Harmand in 1910,

and that we belong to the superior race and civilization, still recognizing that, while superiority confers rights, it imposes strict obligations in return. The basic legitimation of conquest over native peoples is the conviction of our superiority, not merely our mechanical, economic, and military superiority, but our moral superiority. Our dignity rests on that quality, and it underlies our right to direct the rest of humanity. Material power is nothing but a means to that end.[5]

The keystone of the myth of the Dark Continent served to uphold the racial superiority of the colonialists by characterizing Africans as a monogenic degradation of humankind that was slumping towards its animal roots.[6] "The white man is to the Black as the Black is to the monkey, and as the monkey is to the oyster," wrote Voltaire in the late eighteenth century.[7] A century later Thomas Dixon Jr. (credited as one of the writers of D. W. Griffith's *Birth of a Nation*, 1915) wrote a scene in his novel, *Leopard's Spots* (1902), in which a white father rebuffs a Harvard-educated "mulatto" who seeks permission to marry his daughter by saying, "I happen to know the important fact that a man or woman of Negro ancestry, though a century removed, will suddenly breed back to a pure Negro child, thick-lipped, kinky-headed, flat-nosed, black skinned. One drop of your blood in my family could push it backwards three thousand years in history."[8] By default, such a race did not deserve equal consideration of the rights that been declared common to all men in 1789 both in France (*Declaration of the Rights of Man and Citizen*) and the United States (*The Bill of Rights*). Of course there were powerful economic, social, and political reasons for maintaining this imposture in Africa during the nineteenth century, and it is not the purpose of this work to examine them other than to remark that through imperial eyes, the gates to Africa were left open to any nation that wished to exploit it.

The discourse of justification that emanated from the metropole was necessarily monologic because it consolidated its authority not simply by connecting "to the function of social power and governance," as Edward Said wrote, but by being "made to appear both normative and sovereign, that is, self-validating in the course of the narrative."[9] To a major extent, the egregious imperialist incursions of the eighteenth and nineteenth centuries justified themselves on emerging scientific theories about race. In 1795 Johann Friedrich Blumenbach published *De Generis Humani Varietate Nativa* (*On the Natural Variety of Mankind*), which classified humans into five races in order to arrange "the varieties of man according to the truth of nature." Of the five races, Caucasians represented the ideal, because, in Blumenbach's opinion, Caucasians exhibited the greatest beauty as a people, and because the Caucasus Mountains were likely the birthplace of humanity. If Europe was the fountainhead of civilization, then Africa, if only by virtue of its dislocation from the source, represented its degeneration.[10]

In the early 1800s, the French anatomists Baron Georges Cuvier and Henri de Blainville compared the genitalia of an African woman (Saritje Baartman, known famously as the Hottentot Venus) with the genitalia of an "orang-outang," concluding that Africans were a backward race ("la derniere race") of the human species.[11] The scientific racism of the time, buttressed by the research of men like Bufon and Broca, regarded Africans as incapable not only of higher orders of brain function such as reasoning but also in lower orders of sensation as well.

A widely held belief about Africans that supported their subhuman (and therefore equated with animal) status in the Chain of Being was that they could not feel pain. Louis Figuier, a nineteenth-century scientist and a prolific writer on a wide range of subjects, conducted a series of "experiments" on African subjects in which he concluded that black people "were

endowed with thick skins and insensitive nervous systems, making them impervious to pain."[12] Figuier, like Cuvier and Blumenbach, was a monogenist, and so his conclusions buttressed the trope of Africans not only as an inherently inferior race, but also one that was devolving to its animal roots. Simply put, civilization, and by implication humanity itself, required diligence and vigilance in order to progress; unattended, any race would gradually revert to the bestial.

With the zeal of evangelicals, Victorian scientists, explorers, and missionaries portrayed themselves as the bearers of a light they considered so Promethean that it could not fail but light up the pitch blackness of the unwashed peoples of Africa. (Indeed, the design for the first postage stamp of British Central Africa featured two Africans, one holding a pick and the other holding a shovel, supporting a British coat of arms, under which is the colonial proclamation, "Light in Darkness.")[13] This rhetoric constituted the thrust of much of England's imperialist ideology during the nineteenth century. The construction of Africa as backwards and uncivilized made England, by comparison, appear irrefutably forward and civilized. "The metaphor homogenizes and flattens places and people," writes Lucy Jarosz, and "denies the actualities and specificities of social and economic processes which transform the continent, and obscures a nuanced examination of the forces of cultural and economic imperialism unfolding within Africa in their relation to Europe and America. Thus, the metaphor legitimates the status quo and perpetuates unequal relations of power."[14]

Said writes at length in *Orientalism* about the process by which a culture can act as the primary agent for determining the basis for differentiation between itself and Others. The prerogative for making these basal determinations about political, social, and cultural status comes by way of the culture's "elevated or superior position to authorize, to dominate, to legitimate, demote, interdict, and validate."[15] During the early nineteenth century, the presentation of Africans as primeval, if not bestial, people provided heady grist for the ideological mills of England, which worked overtime to create the myth of the Dark Continent even though such an attitude was, paradoxically, in direct contradistinction with the ideals of the growing abolitionist movement in the United Kingdom, which sought to outlaw slavery and elevate the status of black people as social beings deserving of humane if not equal treatment.

This irony notwithstanding, the abolitionist movement worked in a different social and intellectual sphere than did the portrayal of African people as members of an inferior race within the context of English middle-class values. Promoting Africans as members of an inferior race allowed the English to self-validate their sense of superior worth.

For the British of the nineteenth century, the Babel of diverse African tongues translated into incoherency, and the pagan rituals and customs (which commonly included violations—real or imagined—of the taboos of incest, bestiality, cannibalism) spoke to savagery.[16] In the British mind, however, there was only one tongue, one God, and one civilization. The fact that science, which was invested with unassailable authority as a result of the Enlightenment, could provide an alleged objective and factual basis for the inferiority of other races provided a foundation for European and American racist attitudes over the next century.

Images of skittery Negroes half-clad in animal skins dancing around a night fire in a heathen frenzy not only provided a social and cultural dais for Great Britain to sit upon, it also created a climate for intense sexual and social fetishism. The tribes of Africa served as a dark mirror in which the British (and other Europeans most notably the Germans and the French) reflected their own dark impulses.[17] In the process, Europeans conflated the human with the animal in order to maintain the illusion of distance necessary for constructing a colonial (and later a postcolonial) Other.

Stephen Jay Gould writes that while biological arguments in favor of racism were common before 1850, "they increased by orders of magnitude following the acceptance of evolution theory. The litany is familiar: cold, dispassionate, objective modern science shows us that races can be ranked on a scale of superiority."[18] We had rearrived at Aquinas's *scala naturae.*

By the early twentieth century, monogenism had given way to a polyphyletism that acceded to the Darwinian view that all people were indeed descended from apes, but that the various races of humans had developed from *different types* of apes, some of which were superior to others. The primate ancestors of white people were chimpanzees, the most intelligent of primates, whereas Africans were descended from gorillas, which were perceived to be stronger but significantly less intelligent than chimpanzees. Orientals, on the other hand, were descended from Orangutans, which, presumably were situated somewhere between chimps and gorillas.[19] The real question at the turn of the century, then, wasn't about who was human, "but who was *more* human, and finally, who was the *most* human."[20] Darwin provided an opportunity for political theorists (such as Herbert Spencer, who coined the phrase "survival of the fittest") to retool evolutionary theory to analyze human societies. If the white race was, on its own merits, demonstrably superior, then by extension, the African race was, by the calculation of social Darwinists, doomed to extinction without the generosity of those more fortunate. It consolidated the connection with primitive peoples with nature rather than civilization. Africans were not people of the city, they were of the bush, and therefore the implied kin of all that lived there.

Social Darwinism traveled well to America. In April 1903, Theodore Roosevelt presided over the dedication ceremonies of the Louisiana Purchase Exposition in St. Louis (which Selig filmed) to celebrate a century of American progress. "As is so often the case in nature," Roosevelt declared, "the law of development of a living organism showed itself in its actual workings to be wider than the wisdom of the wisest."[21]

The Louisiana Purchase Exposition was itself an unremitting celebration of social Darwinism and burgeoning American imperialism. Over 80,000 people a day spread out over a thousand acres, visiting over 1,500 buildings, including various "Palaces" that glorified everything from art to electricity, mines and metallurgy, horticulture, machinery, and transportation. One of the major attractions was a series of "Living Exhibits" sponsored by anthropology professor Frederick Starr of the University of Chicago (who later famously predicted that Roosevelt would not survive his trip to Africa) and Professor W. J. McGee, the chief of the Anthropology Section of the World's Fair.

Over 1,200 Filipinos went on colonial display at the fair in order to consolidate and normalize the American claim to the Philippines. "This enormous presentation," writes Robert Rydell, "confirmed America's willingness to take up the 'white man's burden' on the world stage."[22]

The live exhibits contained specimens from a variety of cultures from around the world, including many Native Americans, among them Quanah Parker, Chief Joseph, and Geronimo—who spent much of his time signing autographs for ten cents a piece—"Esquimaux" from Greenland; a variety of indigenes from the Philippines (including the Igorots, who ate dogs); and sundry Africans. These peoples represented various levels of developing civility, but the "lowest degree of human development" consisted of three people in particular: the Patagonian "giant," the "hairy" Ainu of Japan, and the diminutive African Pygmy.

The stated purpose of the living exhibits was to give anthropologists (and the public) an opportunity to study "savage tribes" of the world who had not "profited by the onward

Ota Benga while on display at the Bronx Zoo, 1906

march [of civilization]; aborigines that are . . . lower in the scale of development."[23] In reality, of course, the living exhibits were little more than an intellectually legitimized version of the freak show, a claim supported by the *New York Times* headline that reads, "Dr. McGee Gathering Types and Freaks from Every Land."[24] The veneer of intellectual legitimacy allowed newspapers such as the *St. Louis Register* to muse that the exhibit of these strange peoples would provide the onlooker with "the basis for many a thought as to the reasons why the white man, or the Anglo-Saxon, has come to the front in a few hundred years, while these others have stood still or *retrograded* in some thousands of years."[25] Roosevelt shared the popular American view of Africans. "The dark-skinned races that live in [Africa] vary widely," he wrote in 1910. "Some are warlike, cattle-owning nomads; some till the soil and live in thatched huts shaped like bee-hives; some are fisherfolk; some are ape-like, naked savages, who dwell in the woods and prey on creatures not much wilder or lower than themselves."[26]

Professor McGee of the Louisiana Exhibition commissioned an American missionary, Reverend Samuel P. Verner, a young, highly strung man from South Carolina, to conduct an expedition to Africa to collect human specimens to put on display at the fair. McGee wrote out a shopping list of Africans for Verner, which included kidnapping a variety of Pygmies and, "if practicable, King Ndombe of the Bikenge."[27]

The prize catch for McGee—that which he most desired from Verner—was "One Pygmy Patriarch or chief, One adult woman, preferably his wife . . . two infants, of women in the expedition . . . (and) four more pygmies, preferably adult but young, but including a priestess and a priest, or medicine doctors, preferably old."[28]

McGee's racism was evident in the fact that he regarded the capture of Pygmies in the same way he regarded the capture of wild animals. He expressed no humanitarian concerns for their rights, safety, or well-being. His main worry, as reflected in his correspondence with Verner,

was whether or not the Belgian government would grant him a license to export the Pygmies from the Congo to America.[29]

McGee intended for the Pygmies to be the centerpiece of the anthropology exhibit. Pygmies were little known in the West, and the same sensationalistic mythologies that had abounded in Victorian England about the Dark Continent persisted in America. Like many of his peers, McGee viewed Pygmies as the lowest form of humanity, an attitude reflected by many prominent authors of the time.[30] Pygmies represented "the lowest known culture," and their presence would contrast with, by default, the "highest culmination" of civilization, the Caucasian.

The *St. Louis Dispatch* reflected McGee's racist view of Pygmies by describing them as "Amazing Dwarfs of the Congo Valley" who "antedated the Negro in Equatorial Africa."[31] This same view was reflected in popular scientific magazines of the time. Most notably, *Scientific American* described the African Pygmy as "a small, apelike, elfish creatures, furtive and mischievous, [which] closely parallel the brownies and goblins of our fairy tales. They live in the dense tangled forests in absolute savagery, and . . . exhibit many ape-like features in their bodies."[32] Orson Munn, the owner and editorial writer of *Scientific American,* speculated on the Pygmy at greater length:

> Even today, ape-like negroes are found in the gloomy forests (of Africa) who are doubtless direct descendants of these early types of man, who probably closely resembled their simian ancestors. . . . They are often dirty-yellowish brown in color and covered with a fine down. Their faces are fairly hairy, with great prognathism, and retreating chins, while in general they are unintelligent and timid, having little tribal cohesion and usually living upon the fringes of higher tribes.[33]

Samuel Verner returned from Africa with five male Pygmies in tow, ranging in age from sixteen to twenty-eight.[34] He also returned with a Pygmy named Ota Benga, from the "Chirichiri" tribe. In spite of Verner's claim that he had saved Ota Benga from the pot as he was about to be devoured by cannibals, he more likely bought the Pygmy on the open market. "Poor little Otabenga—most to be pitied, most to be feared!" wrote the *St. Louis Dispatch,* "He is a Chirchiri. That's the name of his tribe, *a name suggestive of the chattering tongue of his monkey-like people*."[35] Although McGee grumbled that Verner hadn't returned with a full complement of Pygmies as he had hoped, the arrival of Otabenga and his Pygmy brethren dissipated his frustration.

Prior to their arrival in St. Louis, the *St. Louis Dispatch* published a list of "queer facts" about the Pygmies that not only underscored their deficiencies as humans but also emphasized their animal-like nature:

> They are very agile, leaping about like grasshoppers;
> If caught young, they are said to make excellent servants;
> They are pigeon-toed; their arms are long and thin;
> They are remarkable mimics.
> Their bodies are exceptionally hairy.
> They have long heads, long narrow faces and little red eyes, set close together, like those of ferrets.
> [Their] skin darkens in summer and pales in winter.[36]

The Pygmies dispelled many of these assumptions when they arrived in St. Louis. They weren't hairy, pigeon-toed, red-eyed simians, although one newspaper described Ota Benga as "not much taller than an orangutan . . . their heads are very much alike, and both grin in the

same way when pleased."[37] But people did generally perceive the Pygmies as clever and agile, words often used to describe higher primates. They were also described in childlike terms, with the body and mental functions of either a twelve-year old or a mentally defective adult.[38] At four feet eleven inches and 103 pounds, Ota Benga certainly would've looked like a case of arrested development to those who had a different expectation of human adult morphology.

If some were disappointed not to see the apelike beasts of the African forest, they couldn't help but be fascinated by what was perhaps the most remarkable physical characteristic about Ota Benga: his teeth had been filed down to sharp points, evidence to many he was a cannibal, an outrageous claim that Verner himself perpetuated: "he is of a man-eating tribe who file their teeth to a point for the purpose of tearing human flesh," he told the *St. Louis Dispatch.*

> And because he is a cannibal, the black Lilliputians brought with him out of Africa look down on him. He is not in their set. And Otabenga is bowed with shame because he, too, realizes that man-eating is an old fogy idea. His people are behind the times in darkest Africa.[39]

Drs. Starr and McGee descended upon Ota Benga and the other Pygmies in the name of scientific inquiry the same way that Cuvier, de Blainville, and Blumenbach had done a century before them. The anthropologists concerned themselves with determining a variety of anthropological issues about Pygmies. They asked several pressing questions:

- Could they discern the color blue?
- How did they compare intellectually with intellectually defective Caucasians?
- How did the ratio between head and body size correlate with cleverness?
- How would pygmies respond to optical illusions?
- How would they respond to pain?[40]

McGee and Starr designed a battery of psychometric and anthropometric tests that were intended to measure the intelligence and physical vigor of the subjects of their living dioramas. Predictably, the subjects of the test performed according to the expectations of the examiners. They determined physical dexterity, for example, by the subject's ability to throw a javelin, throw a baseball, kick a baseball, and play tug-of-war. Geronimo refused to participate in the "games" and stood by sullenly as others participated enthusiastically. The *St. Louis Dispatch* published the results on the sports page ("Barbarians Meet in Athletic Games")[41] next to the baseball scores of the St. Louis Browns.[42] The Pygmies, except for one event that paralleled scampering up a tree, failed to place in any of the competitions, thus reinforcing the foregone conclusion of the anthropologists that Pygmies were racially inferior, a point of view echoed by *Scientific American*, which described Pygmies as the "rudest" of humans who, being unable to practice agriculture, had to steal from "big negroes" in order to provide for themselves. "They have seemingly become acquainted with metal only through contact with superior beings," the author concluded.[43]

For all their shortcomings, the Pygmies apparently grasped the concept of discrimination. The *St. Louis Republic* reported that the Pygmies criticized their hosts for treating them inhumanely:

> "When a white man comes to our country," complained Latuna, "we give them presents, sometimes of sheep, goats or birds, and divide our elephant meat with them. The Americans treat us as they do our pet monkey. They laugh at us and poke their umbrellas in our faces. They do the same to our monkey."[44]

By the time the 1904 World's Fair closed its doors on December 1, 1904, more than twenty million people had visited its exhibits.[45] The fair was an unapologetic celebration of Caucasian triumphalism staged at the expense of the indigenous Other. By displaying indigenous peoples of the world as dioramas, the same way museums or zoos displayed exotic animals from the far-flung corners of the world, Euro-Americans reinforced Blumenbach's categorizations of race. The anthropological exhibitions at the St. Louis Exposition provided visual proof to what white clergy and politicians had already preached for years, that white people were in God's favor, and the rest should be delivered unto them for their purposes.

THE SHORT, UNHAPPY LIFE OF OTTO BINGO

Ota Benga served as an example of the African Homunculus. At the end of the World's Fair, Verner returned the other Pygmies to the Congo, but Ota Benga, as an "orphan," did not want to return to Africa having already lost one wife to cannibals and another to a viper.[46] Not certain what to do with him, Verner put Ota Benga on "loan" to the New York Zoological Society and asked its director, William Hornaday, to provide care for him until he could figure out what to do with him.[47]

On September 9, 1906, Director Hornaday put Ota Benga on display in the primate house in the company of chimpanzees and an orangutan named Dohong, where, according to a story in the *New York World,* Ota ruled the monkey house "by jungle dread."[48] The *New York Evening Post* reported that Ota Benga took quickly to his surroundings, "rolling around the floor of the cages in wild wrestling matches and chattering to [the other primates] in his own guttural tongue, which they seemed to understand."[49]

Director Hornaday had a placard placed in front of Ota Benga's cage that used the same language and incorporated the same type of information as the other placards used to describe wild beasts in the zoo:

> The African Pygmy, "Ota Benga." Age, 23 years.
> Height, 4 feet 11 inches. Weight, 103 pounds.
> Brought from the Kasai River, Congo Free State,
> South Central Africa by Dr. Samuel P. Verner.
> Exhibited each afternoon during September.[50]

The public thronged to see the Pygmy in the monkey house. "Crowds that fluctuated by between 300 and 500 persons watched the little black man amuse himself in his own way," the *New York Times* reported: "It is a good thing that Benga doesn't think very deeply. If he did it isn't likely that he was very [proud] of himself when he woke in the morning and found himself under the same roof with the orang-utangs and monkeys, for what is where he really is."[51] The display of Ota Benga gave one viewer the opportunity to "study . . . points of resemblance" between the Pygmy and his cage-mates: "Their heads are much alike, and both grin in the same way when pleased. Sometimes the man and the monkey hugged each other. That pleased the children and they laughed uproariously."[52] Not surprisingly, the juxtaposition of human with ape encouraged speculation of the relationship between the two. "Was he a man or a monkey? Was he something in between?" wrote the *New York Times.* "'*Ist das ein Mensch?'* asked a German spectator. '*Is it a man?'*"[53]

There was a sense of unease in the air. "There were laughs enough in it, too," noted a *Times* editorial, "but there was something about it which made the serious minded grave. Even those who laughed the most turned away with an expression on their faces such as one sees after a play with a sad ending or a book in which the hero or heroine is poorly rewarded."[54] Within a day, the African American community in New York denounced the display as inhumane. "The person responsible for this exhibition degrades himself as much as he does the African," charged Reverend Dr. R. S. MacArthur of the Calvary Baptist Church.[55] Reverend James H. Gordon, the chair of the Colored Baptist Ministers' Conference, agreed. "Our race, we think," pled Reverend Gordon "is depressed enough without exhibiting one of us with the apes. We think we are worthy of begin considered human beings, with souls."[56]

Dr. MacArthur called on Hornaday to release Ota Benga into the care of the African American community, but Hornaday refused his request. "If the little fellow is in a cage," replied Hornaday, "it is because he is most comfortable there," and in reply to the placard identifying Ota Benga, Hornaday justified its presence on the grounds that "it is only because without it some one would be kept busy all day long answering questions."[57]

By September 11, the *New York Times* called for the return of Ota Benga to Africa. The next day, the African American community of New York City appealed directly to the mayor of New York to intervene, but the mayor refused to intercede on the grounds that "the conduct of the Bronx Zoological Society rests with the New York Zoological Society."[58]

Eventually bowing under increasing public pressure, Hornaday released Ota Benga to the care of the Howard Colored Orphan Asylum in Brooklyn on September 29; there the African American community began the process of "civilizing him." Over the next ten years Ota Benga, Pygmy, turned into Otto Bingo, a resident of Lynchburg, Virginia, where he lived at a local black seminary. His pointed teeth were capped, he wore the clothes of a gentleman, and he spoke in halting English. Ten years after Verner abandoned Ota Benga as an exhibit in the monkey house at the Bronx Zoo, Ota Benga pulled the caps off his teeth, stripped off his clothes, and while sitting before a fire on a moonlit night, shot himself through the heart.[59]

By that time, history had revised his past. "During his stay in this city he was employed in the Zoological Park in the Bronx," noted the *New York Times*. "He fed the anthropoid apes. It was this employment that gave rise to the unfounded report that has being held in the park as one of the exhibits in the monkey cage."[60] William Hornaday, ever the recalcitrant racist, remarked upon the report of Ota Benga's suicide, "Evidently he felt that he would rather die than work for a living."[61]

In 1924, Hornaday reflected upon Ota Benga, "pygmy negro of the Congo who had once upon a time flourished in our Primate House, against a background of picturesque chimps and orangs." Had it not been for "the idiosyncrasies of Mankind" Hornaday wrote, "Ota might well have happily continued here to this day."[62]

IMAGINING AFRICA

The myth of the African as a degraded and devolving species of humanity persisted in the nineteenth and twentieth centuries in large part as a result of the contributions of scientific racism, which served a legitimizing function in the process of empire. By the time Colonel Roosevelt arrived in Mombasa, British East Africa, in 1909, the structures of domination and oppression that supported the politics of unequal power were already entrenched.

In spite of the fact that popular audiences shrugged off Cherry Kearton's *Roosevelt in Africa,* the film nonetheless had a major impact on the American perception of Africa because it presented an unequivocally dominionist view to a class of people of influence who were convinced of the superiority of their own race and infatuated with the notion of an American empire. The film is important because it frames the newly emerging environmental imaginary of the Dark Continent.

Roosevelt in Africa embodies this historical, political, and social discourse through the visual representation of the geography of Africa as the Dark Continent. Its images legitimate the continued oppression of Africa by providing evidence through the "unbiased" eye of a camera that the *place* (as opposed to artifacts of that place, such as the animals or the Africans that were put on display in America) was both primitive and savage. Roosevelt's argued that Africa was irrefutably nature's land, a land, he was fond of saying, *that time forgot.*

In March 1909, Sir Harry Johnson compared the president's impending trip to Africa as a journey backward into time by invoking H. G. Wells's novel *The Time Machine.* "One fascinating aspect of the study of backward parts of Africa," Sir Johnson writes, "is like mounting Mr. Wells [*sic*] time machine and traveling backward to vanished phases of European life in the stone age."[63] Likewise, Roosevelt described his trip as a regression in time toward the dawn of humanity, or as he put it, "a railroad through the Pleistocene."[64] The Africans, Roosevelt reported home, were "just as primitive as our cave-dwelling ancestors were a hundred thousand years ago, where men are fighting practically the same beasts as those ancestors of ours fought."[65]

The metaphor of Africa as timeless supported the conclusion of the syllogism crafted by social Darwinians that the African race of "wild men" lacked the vigor, the mentality, and the maturity to wrest the land from the grip of nature. "They were like great big children," Roosevelt told the National Geographic Society in 1910. "They live a perfectly grasshopper life, with no capacity to think of the future."[66] Roosevelt boasted to the audience that his expedition had not lost a single white man. The Africans, however, did not fare as well. A leopard killed one man, a rhino killed another, and a few "died from dysentery and fever, because," Roosevelt reported, "it is almost impossible to make them take care of themselves."[67]

Roosevelt described a race of incompetents who were unworthy of the responsibilities of empire. They were, in his paternalistic words, "strong, patient, good-humored savages, with something childlike about them that makes one really fond of them."[68] Therefore it was up to those who were able to take control of "the wide waste spaces of the earth, unworn by man" by wielding the instruments of civilized power: science, religion, and industry.[69] Therein lay Roosevelt's justification of British East Africa as a "white man's country," "and the prime need is to build up a large, healthy population of true white settlers, white home-makers, who shall take the land as an inheritance for their children's children."[70] Yet, curiously, Kearton's *Roosevelt in Africa* was an homage to primitive man. His exultation of the Nandi warrior lion hunt in November 1909 visually defined the hundred thousand words he had written—and would write—about men whose lives were "reduced to its elemental conditions," men of action, "not theories," who pitted themselves, their collective cunning and strength against rapine nature.[71] The Nandi epitomized the greatest virtues among men: courage and daring. Roosevelt adulated the lion, the warriors, even the tall grass whisking around them in *African Game Trails.* "They were splendid savages," he wrote, "stark naked, lithe as panthers, the muscles rippling under their smooth, dark skins."[72] In one scene of the film called "Zulu Warriors" (who were actually either Kikuyo or Masai), the lion hunters stage a mock advance with spears raised and shields at the ready as though the camera were a lion couched in the grass before them. While Roosevelt may have admired the "proud, cruel, fearless" African who dared face a lion with

only a shield and a spear, he did not identify with them as brothers in the hunt; rather, he saw them as the atavistic embodiment of the primal Hunter. He celebrated the lion hunter as an archetype, not as a race.

Roosevelt embodied the dominant Western imperial attitude that saw Africans who were not indentured to nature as children who had lost their way. *Roosevelt in Africa* supports the stereotype of the lazy, shiftless, juvenile African who lacks not just the skills but also the innate ability to determine his own destiny. One scene entitled "Native Amusements in Mombasa" shows a group of Swahilis riding two miniature Ferris wheels at an amusement park in the port city. The Ferris wheels, which barely rise twelve feet off the ground, are childlike in their proportions, and the people themselves seem juvenile as they squeeze themselves unmercifully into the undersized cars. From the Western viewers' point of view, the "native amusements" seem jejune and reinforce the racial attitude that childish things easily distracted the Negro.

Another scene, "The Roosevelt Party Crossing a Stream," is emblematic of the ideological structure of power that saturates the film. The sequence, which runs nearly two minutes long, opens with a static shot of a small African stream with the opposite bank in view. Within seconds, the Great Bwana Roosevelt, smartly dressed in safari clothes, strides into view, followed by a lethargic procession of native bearers who are loaded down with expedition supplies. Roosevelt stops at the edge of the water and waits as an African man suddenly ducks between his legs and lifts him onto his shoulders. Roosevelt then rides his African beast of burden across the stream.

From the far shore it's hard to distinguish the form of a man staggering under the weight of Roosevelt as they cross the stream, but as the figures draw closer to the camera, it becomes clear that Roosevelt is indeed riding a man. As the colonel approaches the opposite bank, he tips his pith helmet at the cameraman as a gesture of courtesy the way one gentleman would tip his hat at a fellow traveler.

Once Roosevelt passes in front of the lens, the camera holds steady on the supply train behind him as each of twenty-two heavily laden bearers stoically follows his Bwana in single file. The shot re-creates the emperor's procession; only a sedan chair is missing.

The image is startling because it is so stark and unapologetic. On one hand, scenes such as "The Roosevelt Party Crossing a Stream" reaffirm—even glorify—the vanguard of a master race on foreign soil. On the other hand, the film justifies the moral right of the oppressor either by infantilizing Africans (as in "Native Amusements in Mombasa" or animalizing them as in "The Roosevelt Party Crossing a Stream"). As Roosevelt told fellow Republicans in 1905, "Laziness and shiftlessness, these, above all, vice and criminality of every kind, are evils more potent for harm to the black race than all acts of oppression of white men put together."[73]

For over a century Africa qua Africa served as a battleground upon which men waged war against putative darkness, a place in which all Africans, no matter how slavish or proud, lived in the shadowlands between the animal and the human. Until 1909, however, the animals in the zoos and circuses and the indigenous peoples who'd been put on display in such scientifically rationalized exhibits as the Louisiana Purchase Exposition or the New York Zoological Society were little more than floating signifiers, bereft of the environmental (and cultural) matrix that generated them. But *Roosevelt in Africa* took the next step in depicting nature. Instead of presenting animals and people in a vacuum, the film captured the environment, the *world*, of Africa itself. It created a new visual syntax in colonial discourse that colonized the wild kingdom as a whole—the beast, the indigene, and the continent. The lion no longer had to serve as a metonym for Africa: instead, Africa presented itself, and Roosevelt, much like conquistadors arriving upon the shores of virgin lands, planted his culture's flag in its unoffending sands and declared them, at least figuratively, America's own.

CHAPTER EIGHT

When Cowboys Go to Heaven

EVEN BEFORE COLONEL ROOSEVELT HAD RETURNED TO THE UNITED STATES IN 1910, another colonel was busy finalizing arrangements for a cowboy safari to Africa "to show the world how easy it would be for American cowboys to rope and subdue the fiercest and biggest of game."[1] The idea of roping African wild game struck some contemporaries as outrageous even in 1911. "The idea that any one should seriously contemplate a journey to Africa for the purpose of lassoing such creatures as sportsmen to either shoot or photograph at the longest range possible, seems quite absurd," wrote an editor of *Everybody's Magazine.* "But an American frontiersman has done it, with American cowboys, cow-ponies, and hunting-dogs, and with wonderful moving pictures to prove it."[2]

Charles Jesse Jones was yet another self-commissioned colonel in the tradition of William Selig. A gaunt, sinewy man with piercing blue eyes, he promoted himself as an original frontiersman, which he proved by roping and tying, "often single-handed, every kind of wild animal of consequence to the found in our western country." C. J. Jones was a self-styled "lord of the beasts" who embodied the same ambivalence toward nature as Theodore Roosevelt.[3] He believed in the wildness of nature and that it was essential to developing the unique character of the American, and yet, at the same time, he devoted himself to humbling nature in order to prove the superiority of men over the land and the beasts that dwelled upon it.

Born in 1844, Jones moved from Illinois to the edge of the frontier in eastern Kansas in 1866. He homesteaded in north central Kansas, which was in the middle of the buffalo range, but he quit the backbreaking life of a homesteader when he realized he could make eighty dollars a day killing buffalo bulls for their hides, hams, and tongues. The buffalo were plentiful and the hunting was easy. Some days he shot so many of them he claimed he had to urinate down the barrel of his Sharps .44 in order to cool it down.[4]

Between 1871 and 1873, the buffalo hunters turned the Kansas grasslands into killing fields. The "prairie looked like a slaughterhouse floor, dotted with carcasses left to rot or butchered and the choice pieces removed, and the hides pegged out to dry."[5] And like most of his contemporaries who were busy claiming the right of empire, they justified the depredations of the Native peoples of the plains as well. "I would as soon have killed an Indian as a rattlesnake," claimed Jones, who regarded Native Americans as morally unfit and an impediment to progress.

If you had been with me from 1869 to 1886, hounded and haunted by these savages; compelled to go hungry, thirsty, and sleepless; losing cattle and horses through their devilish machinations; and had seen with your own eyes, as I have, scores of innocent people mutilated, tortured, and even

115

butchered, simply because they were of the hated white race—it would be indeed a strange thing not to have sworn eternal vengeance against the perpetrators of such hellish deeds.[6]

Buffalo Jones's true passion, however, was for killing buffalo, not Indians. But as their numbers plummeted, his interest in bison increased, and he started to rope orphan calves and bring them back to his ranch near Garden City, where he nursed them to health. In the spring of 1889, he lassoed the last wild herd of southern open range buffalo. News of the last roundup reached Washington. "This was a remarkably brilliant feat," William T. Hornaday, the zoologist at the Smithsonian who had put Ota Benga in the monkey house, reported to the Fiftieth Session of Congress in 1889, "and can be properly appreciated only by those who have themselves endeavored to capture the buffalo, and know by experience how difficult the task, to say nothing of the extreme danger in an undertaking of this character." In a show of gratitude, Congress awarded Jones a pension for life for his inspired work to protect the species. The man who had devoted years of his life slaughtering thousands of buffalo now found fame as their savior.

The frontier was often a romancing of facts, the stuff of penny dreadfuls and dime novels that created the plains legends of Wild Bill Hickok, Buffalo Bill Cody, and Wyatt Earp. Likewise, "Buffalo" Jones found himself the subject of newspaper writers and novelists who were fascinated by his histrionics as much as his history. The infamous "nature faker" Ernest Thompson Seton wrote about him, and Zane Grey characterized him in his novel *Roping Lions in the Grand Canyon*. But being a legend didn't always provide a living, so Buffalo Jones tried to parlay his reputation as a hunter, plainsman, and Indian fighter into a variety of hare-brained business schemes, all of which were doomed to failure. He took buffalo to county fairs, charged admission to see them, and auctioned them off as pets.[7] He sold buffalo to zoos and wealthy collectors, tried to sell them as plow animals, and even tried to cross buffalo with cattle to create "cattalo." By 1889, Jones owned the largest private buffalo herd in the country. Five years later, he went bankrupt and lost everything, including his herd.

Jones started over with a fresh set of ideas: he tried to build a railroad in Texas that went bankrupt after laying seventy-five miles of track, and in 1897, he went to the Arctic to capture musk oxen to sell to museums and zoos. Failing those ambitions, he got a job in 1900 with the Smithsonian to catch Rocky Mountain sheep for the National Zoo. In 1901, he published an account of his daring exploits as a wild animal catcher in *Harper's*. The cover of that month's magazine also happened to feature the children of the newly elected vice president of the United States, Theodore Roosevelt. The paths of the two men, once crossed, would remain tangled over the next decade.

YELLOWSTONE'S FIRST GAME WARDEN

Roosevelt admired Jones because he exemplified the rough-and-tumble ethic of the frontiersman. "They fear neither man, brute, nor element," Roosevelt wrote in *Ranch Life and the Hunting Trail*. "They are generous and hospitable; they stand loyally by their friends, and pursue their enemies with bitter and vindictive hatred."[8] He saw in Jones one of the "old race" of hunters and dauntless Indian fighters who were disappearing as rapidly as the big game. His gaunt, almost haunted face was a product of the hardships of the native soil.[9] Perhaps for this reason, and because the park was in danger of having its native herd of bison go extinct,

President Roosevelt appointed Jones as the first official game warden of Yellowstone National Park in 1901. (Jones was in the park during Roosevelt's 1903 visit, but there is no evidence the two men talked.)

For years poachers had been methodically plundering the resources of the nation's first national park. In 1886, the Department of the Interior deployed the U.S. Cavalry to assume the administrative management of the park. "Appointing the U.S. Cavalry to protect buffalo was like asking the fox to guard the henhouse," writes Judith Hebbring Wood. The unofficial position of the United States at that time was to annihilate the Indians or at least move them onto reservations. By eliminating the buffalo, officials hoped to end the Indians' way of life. In 1894, Congress passed the Lacey Act "to protect the bird and animals in Yellowstone National Park, and to punish crimes in said park."[10] But the act defined poaching as a misdemeanor, punishable by a fine not to exceed a thousand dollars and the forfeiture of the poacher's weapons or traps.[11] In the meantime, black market prices for bison had soared so high that by the turn of the century that a bison head fetched as much as $1,500—enough not only pay the fine but still make a handsome profit—at a time when the earnings of a factory worker averaged $8 a week.[12] Lax enforcement by the cavalry only made the calculated risk that much more attractive to poachers. By the time Jones arrived in the summer of 1902, less than thirty bison were left in the park. They were the last wild, free-roaming buffalo in the United States.

Over the course of the next three years, Jones doubled the size of Yellowstone's herd with bison purchased from private herds in Texas and North Dakota, which, ironically, contained animals from his original herd.[13] But Jones's rugged individualism ran contrary to the grain of military discipline; consequently, Jones and the acting superintendent, Major John Pitcher, were frequently at loggerheads. The major accused Jones of selling trinkets to tourists, cheating them of money, and "generally prostituting himself for commercial gain and against Park regulations."[14] In return, Jones leveled charges that Pitcher was trying to undermine his powers as the game warden, and so he and made a public call for the removal of federal troops from the park because the army was "utterly useless in the work of protecting game in Yellowstone Park."[15] In a nine-page typewritten letter, Major Pitcher appealed to the secretary of the interior to take action against Jones.

The secretary replied to Major Pitcher in a letter dated July 6, 1905. "I deem it best that you should be no longer burdened with the details of the preservation of game in the reservation," he wrote in dry politic. "Henceforth, Yellowstone's game would come under the sole jurisdiction of Colonel C. J. Jones." However, his victory was short-lived: Jones resigned his commission as Yellowstone's first game warden three months later.

SUCH STUFF DREAMS ARE MADE OF

Jones continued his restless pursuit of dreams. Not a practical man, he didn't care to be accountable to anyone but himself. Over the next five years he roped lions in the Grand Canyon to sell to zoos and, failing that, killed them for the bounty. He borrowed a bighorn sheep from Yellowstone so he could crossbreed it to a Persian sheep, and when that didn't work out he tried to cross a Persian with a Merino (which he would call a "Perserino").[16] When one plan failed, he moved on to the next. One evening while sitting around a campfire, Jones told his friend, Zane Grey, that for forty years he'd an ambition: "It's to get possession of an island in the Pacific, somewhere between Vancouver and Alaska, and then go to Siberia and capture a

lot of Russian sables. I'd put them on the island and cross them with our silver foxes. I'm going to try it next year if I can find the time."[17] Of course, he never found the time.

A year later Jones hatched what was arguably his biggest scheme ever. While camping on the Kaibab Plateau at the northern rim of Grand Canyon, he proposed his idea to Charles Sumner Bird, a wealthy industrialist from Massachusetts who'd come to Arizona to hunt lion. Jones told him that he'd read about Roosevelt's ongoing exploits in Africa and thought he could go the president one better by roping elephant and rhinoceros and lion and whatever else Africa could throw at him.

Unlike Jones, however, Charles Sumner Bird was a practical man. "I knew, of course, the chances were that the African trip, absurd and impossible as it seemed to be, might end in failure and ridicule," Bird wrote.[18] And yet, oddly, he agreed to back Jones's madcap plan.

Bird related that Jones's infectious enthusiasm made the proposal irresistible. If true, it was a wildly expensive whim to indulge. A few have argued that Bird's motives were shrewdly political.

Roosevelt's African safari had been widely accepted as a public relations stunt craftily designed to by the colonel himself to keep him in the limelight so he could run for president at the end of Taft's first term in 1912. Bird, who was a Democratic Party activist and who would later run as the Progressive candidate for governor of Massachusetts in 1912, may have wanted to fund the expedition *because* it was so outrageous so that it would take the shine off Roosevelt's craftily scripted glory.[19] Whatever Bird's motivations, Colonel C. J. "Buffalo" Jones found himself, at the ripe age of sixty-seven, on his way to Africa to prove that Americans were indeed made of the right stuff.

Jones presented himself as a quintessential American cowboy. He bridged the old age with the new, from the heart of the American frontier to the American imperial dream abroad. Jones summoned up the heroic spirits of the past—the hunter, the Indian fighter, the rancher—all of whom spoke not in the language of the politicians, boosters, or bankers, but in plain language, simple words that carried big concepts, tinged with swagger. "Well, the African lion is a difficult problem," he spoke with mock authority to a reporter from the *New York Globe* as he prepared to leave for Africa. "It's got to be solved. I'll catch him all right, but what will happen after that I don't pretend to know, being a hunter and not a prophet. I am taking my branding irons, and the lions I don't want I'll brand and turn loose to fight another day."[20] Jones spoke cowboy politics, as did Mark Twain before him and Will Rogers after him. It didn't take a genius to grasp the idea that Jones wasn't branding a lion: he was branding a continent. Africa was the new American frontier, bursting at the seams with countless beasts and savages, and Colonel Jesse Jones intended to lead the charge.

COWBOY IMPERIALISM

On March 5, 1910, Jones sallied out of Nairobi with a resplendent caravan that consisted of "eleven Europeans, some three hundred natives, fifteen horses, and seven dogs of various sizes and breeds."

> The Colonel rode first, with the assorted pack of dogs at his horse's heels. Then came the cowboys with the led horses; then the picture department; then the long single line of black porters, bringing

up the rear. Above the loads on the porters' heads two flags flashed their colors in the sunlight—the stars and stripes, and the house flag of the company, with the while buffalo skull against the red background, and underneath the motto, *Sapiens qui vigilat. (A wise man watches.)*[21]

Jones brought along two of his best cowpunchers—Marshall Loveless and Ambrose Means. Bird had insisted that Jones bring a writer and filmmaker so he might recoup his investment, and so he chose Guy Scull, a Harvard crony of Roosevelt's who'd served with him in Cuba, to do the writing, and Cherry Kearton, fresh off *Roosevelt in Africa,* to do the filming. Both had impeccable credentials, but more importantly, they were Roosevelt's men, and so their witness was unimpeachable.

Over the next several weeks, Kearton filmed Jones and crew running down and roping virtually every game animal that crossed their path, including a warthog, an eland, a hartebeest, a small cat called a serval, a leopard, a jackal, a zebra, a giraffe, a rhinoceros, and finally, their prize of prizes, a lion. (Jones had second thoughts about trying to lasso and brand an elephant.) The Africans stood by and watched in stunned disbelief as the Americans rode down animal after animal, roped it, dragged it before the camera, branded it, and then let it go.[22]

After they'd roped a cheetah, Jones noticed the porters talking animatedly among themselves. He took aside his tent "boy," Mac (which was a crude, Americanized version of his real name, Mohammed) and asked him what the others were talking about. "The white gentlemen are able to do what they want to do," Mohammed explained, "but just the same they are all crazy."[23]

No one could have explained to the Africans why anyone would want to climb on the back of a zebra and ride it anymore than anyone could have explained why someone would brand an animal with his initials and then let it go. Nor would have anyone tried. The point of the exercise wasn't to convince Africans of American ingenuity and grit; the point was to convince Americans of them. The sight of a cowboy on the back of a bucking zebra spoke volumes to an American audience. Africa was to Americans in 1910 as the Americas were to the Spanish in 1492. The Americans pined to repeat the magnificence of the conquest of the western frontier, just as the Spanish sought to repeat their victory over the Moslems in Iberia.

As Jones galloped across the open range scattering herds of wildebeest and zebra, he relived the thrill of the wild charges he made after buffalo on the Kansas plains during the 1880s. And just as the unforgiving plains of the American West had provided a proving grounds for those who struggled to master them, so the African grasslands presented the illusion of the same primordial landscape, free of sodbusters and fence lines, where the land was "everything to the hero; it is both the destination and the way. He courts it, struggles with it, defies it, conquers it, and lies down with it at night."[24] Jones viscerally re-created the frontier of a half-century before, unlike Roosevelt, who re-created his charge up Kettle Hill in San Juan in 1898. Roosevelt still hunted his *Other.* In Cuba it had been "His Spaniard," and in Africa, it was the lion.

Unlike the American West that was settled, Africa was still raw and undisciplined, a place where only natural law mattered. It was a sped-up tale of social Darwinism that pitted the man against nature in a series of dramatic vignettes, each one affirming human dominion.

Stripped of the pretensions of civilization, both men believed they could return to their innate primal state, a state in which action determined survival, in which you either mastered fear or you died. Unlike William Kent, the effete Progressive from California who celebrated barbarism in order to define manhood, Jones and Roosevelt celebrated a code of values they found within the land that raised the man *above* the barbaric, values that enabled the white race to climb onto the highest limb in the great tree of life.

Both men were icons in America. Roosevelt was the Exceptional Man. Even though he had been born in a posh brownstone in New York City, he provided an image of the new American: bold, forward-looking, and strong. Jones, on the other hand, was the Common Man. He was hardworking, unafraid to chase dreams even as he neared the age of seventy. Jones understood failure but not defeat. A flame of hope burned steadily within him.

Both men communicated their image through books and film. Books appealed to those who could afford them, and film appealed to those who couldn't. Less than ninety days after Roosevelt returned from his safari in 1910, Guy Scull's printed version of "Lassoing Wild Animals in Africa" appeared in three monthly fall editions of *Everybody's Magazine.* Shortly after, it appeared in book form. "Colonel C. J. Jones is tall and spare, with a strong, rugged face and keen blue eyes," wrote Scull in the opening paragraphs.[25] "During his sixty-five years of life, he has roped and tied, often single-handed, every kind of wild animal of consequence to be found in our western country, and his experience with these has led him to believe implicitly that man is the master of all wild beasts." The perfect image of an undying frontiersman, Jones resonated with a public that was already enamored with cowboy films. In early 1911, Jones released the film version of *Lassoing Wild Animals in Africa,* which, in the opinion of the *New York Times* had taken "all the wind out of the sails of those who go thither to hunt with guns." Film, more so than prose, was expert at catching "the expression of amazed and outraged dignity of some of the animals, notably the giraffe and the zebra, when finally they stand subdued with ropes on necks and legs."[26] The media applauded the men's skill, shrewdness, and resourcefulness, and "cool courage" and "reckless absorption" in their task. However, when confounded by the task of releasing a giraffe from all the ropes it had taken to subdue it, Jones ordered the men to put a ladder next to the giraffe and untie the shaking beast as best they could.

The images of the cowboys Loveless and Means throwing their ropes and hobbling even the great rhinoceros didn't seem much more exotic than the Western, which was becoming a dominant narrative in American cinema.

By 1910, 20 percent of all the movies being made in the United States were Westerns.[27] Shot on distinctly American landscapes with distinctly American characters, the Western celebrated the same cultural values as *Lassoing Wild Animals in Africa.* And while the immigrants in New York and Chicago and Pittsburgh who flocked to the movies had never known the frontier firsthand, they came to know it from the movies. "For a mere nickel, the wasted man, whose life hitherto has been toil and sleep, is kindled with wonder," the American poet Vachel Lindsay reportedly wrote of the nickelodeon. "He sees alien people and begins to understand how like they are to him; he sees courage and aspiration and agony, and begins to understand himself. He begins to feel himself a brother in a race that is led by many dreams."[28]

In this dream, crafted in the same manner as a Tom Mix Western, Jones is the sheriff who declares the lion an outlaw. His duty is to run him down and slap him in irons—in Jones' case, literally.

Scull writes that on his way to Africa, Jones stopped at a London hardware store and asked to see the largest handcuffs the store had to offer.

"Not large enough," he announced when he saw them.

"How large would you want them, sir?" the shopkeeper asked.

"Twice that size."

"May I ask for what purpose you require them, sir?"

"For lions," said the colonel.[29]

Jones did not find his handcuffs, but the images of Jones, Loveless, and Means throwing ropes on a redoubtable rhinoceros or hanging a lion upside down from a tree are surreal juxtapositions of an American fantasy on an African material reality. By imposing the iconography of the American frontier—the cow pony, the lasso, and the branding iron—on the African landscape, Jones resurrected the American frontier. "The presence of familiar objects repeatedly confirms what kind of movie we are watching," writes Richard Maltby, "and reinforces our expectations of how the story will develop."[30] The inevitable outcome of *Lassoing Wild Animals in Africa* was the assertion of American hegemony over nature and nations alike. From now on, Jones's cowboy hat would replace Roosevelt's pith helmet, and his Winchester would replace Roosevelt's Holland and Holland.[31]

At the end of his expedition, Jones recorded a conversation he supposedly had with an Englishman in Nairobi whom he identified as Lord Delmar, who admired Jones's courage and determination. The conversation reflects clearly the political agenda of Jones's Wild West rodeo:

> "Buffalo, have you any more cowboys in the U.S. like these?" [Lord Delmar] asked.
>
> [Jones] airily but truthfully answered "Oh, about ten million of them!"
>
> "Well," [Lord Delmar] said, "there is one thing I have settled in my mind, that there is not a nation of earth that could buckle up against the U.S.A. in warfare."
>
> "Please, your Lordship," [Jones] answered. "I hope that the United States will never give any nation provocation to buckle up against the peaceful, yet heroic, cowboy, if so you choose to call us, for the Lord help them if they do."
>
> [To which Lord Delmar replied] "this little handful of men in his expedition . . . has been more convincing of the greatest of America, her mercy to the helpless, than had she sent a fleet of battleships around the world."[32]

Lord Delmar's reference to the "fleet of battleships" was a clear allusion to the sixteen battleships and the 14,000 sailors of the U.S. Atlantic Fleet that Roosevelt had sent to twenty major ports of call on six continents between December 1907 and February 1909 as a brazen show of American naval sea power. Known as the "Great White Fleet" because the ships had been painted white with gilded scrollwork on the bows (and for its obvious racial implication), Roosevelt intended to impress upon the world (and the Japanese in particular) that the United States had the will and the might to protect its foreign interests. America was, in the words of the fleet's commander, Rear Admiral Robley "Fighting Bob" Evans, "ready at the drop of a hat for a feast, a frolic or a fight." Lord Delmar, a person of whom there is no apparent historical evidence, elevates Jones's feat above Roosevelt's grandstanding of American naval prowess.

Whether or not Jones made up his conversation with the mysterious Lord Delmar is irrelevant; it does, however, frame his own understanding of the political context of the expedition and allows a potshot at Roosevelt. In the final analysis, however, Jones didn't upstage Roosevelt's accomplishments in Africa so much as magnify them. Both men came to humble Africa and to glorify America with their own peculiar brands of cowboy imperialism. The political reasons for staging Jones's farce in Africa—if indeed there were any—were quickly forgotten for the much more powerful image of an old American frontiersman rolling up his sleeves to reveal his sinewy arms to show he could still wrestle *hand to hand* the wildest nature had to offer.

If Charles Sumner Bird had intended to discredit Roosevelt, he clearly had changed his mind when he invited the former president to write the introduction to the book version

of *Lassoing Wild Animals in Africa.* Roosevelt accepted Bird's invitation. "No hunting trip more worthy of commemoration ever took place in Africa," he lauded. Jones and his cowpunchers, he wrote in the introduction, had "showed a cool gallantry and prowess which should rejoice the hearts of all men who have known the West, and who have felt the old-style plainsman and his modern representative, the cowpuncher, are fit to grapple with any emergency of wild life."[33] Jones, Roosevelt, and Bird wore their costumes well, and the American public loved it.

Africa re-created the imperial imaginary of the American frontier but cast it in terms of an environmental allegory that projected an American vision of strength and character on the blank slate of an uncivilized continent. As it had with the American West, the natural landscape provided both the medium and the message. Superimposing the language, symbols, and customs of the American West onto the African landscape allowed an equivalent discourse to root on foreign soil. Roosevelt had created a cultural, social, and political bridge from the United States to a continent that was perceived to be the province of nature rather than civilization. In other words, there were no nations to conquer; only nature. For those who pined for the earlier days of the American frontier, Africa offered a wonderful surrogate.

CHANGING POINTS OF VIEW

Lassoing Wild Animals in Africa can be dismissed as the political hyperbole of a nation giddy with imperial power except that it records an important shift in the public visual discourse about dominion. Prior to either of Kearton's films, an aggressive act of dominion was achieved primarily through killing and secondarily by its testimony, which was recorded after the fact, either by word or by still photograph. Because the motion picture could provide evidence of the event *as it happened,* however, it naturally favored action over verbal or still testimony. The motion picture camera changed the nature of performance from a literal sense of *doing* into a sense of *presenting* action to an audience.

Before the introduction of the motion picture camera, the hegemonic instrument of the hunt had been the rifle; by 1911, the camera usurped that authority. Cherry Kearton's camera in *Roosevelt in Africa* was passive; it simply addressed events that occur before it. In *Lassoing Wild Animals in Africa,* however, his camera required that action be brought to it. With steady improvements in camera technology such as longer and better lenses and better film stock and with the improved technical and creative skills of the filmmakers themselves, it became increasingly common that the action should unfold before the camera rather than just for the participants of the action, who were now more or less relegated to the status of actors in their own films. Whereas the lion hunter of 1890 stalked into the bush with his double rifle, shot the lion, and then had it mounted for his trophy hall, the lion hunter of 1911 choreographed his hunt for the camera. When Jones found his lion after weeks of searching, he and his men spent "upward of two hours, by means of the dogs, firecrackers, and the lighting of grass," maneuvering the lion into position for the camera.[34] In other words, they weren't going to capture the lion unless the camera could. No longer a passive observer of events, the camera now became the axis around which those events occurred. Documentary film acted as a visual testimony of dominion, which replayed itself fictionally in the burgeoning industry of fictional melodramas that exploited the fantasies and nightmares of the Other.

THE UNBLEMISHED MIRROR

While "Buffalo" Jones was busy roping his lion for Kearton's camera, Paul Rainey, a yachtsman, polo player, and big game hunter from Cotton Plant, Mississippi, landed in Mombasa with a plan for his own Wild West show. Rainey, who had inherited a fortune from his father's coal empire, financed a three-year expedition to Africa, India, Borneo, and the Malay Archipelago at a projected cost of a quarter-million dollars (thereby outspending Roosevelt's safari by $100,000).[35] Rainey's retinue included, in addition to a cadre of select friends and a taxidermist from the Smithsonian, a string of fine hunting horses and a pack of twenty of his best "Mississippi bear-dogs" and their trainers.[36]

"I have passed the stage, I think, where numbers of dead animals count most," Rainey told the *New York Times* before he embarked for Africa. "My principal desire is to trap wild animals and bring them back alive." Rainey declared a lack of interest in the "wild animals that are common like lions, elephants, and tigers," but intended to concentrate lesser-known species of scientific interest such as "rare antelopes, monkeys, and birds." The Smithsonian, the American Museum of Natural History, and the New York Zoological Society officially endorsed the Rainey African expedition not because Rainey had any particular scientific expertise but because he'd been a loyal and generous contributor to those institutions. In fact, just before he'd left for Africa, Rainey made the single largest financial contribution to the American Museum of Natural History to help finance its own African expedition.[37]

Once Rainey hit the ground, however, the expedition moved like a column of army ants through British East Africa, killing virtually every mammal in its path. Over the next year, Rainey killed more than 700 major game animals on his licenses, including buffalo, cheetah, hippo, rhino, elephant, and lion. Within one thirty-five-day period, Rainey and his dogs killed twenty-seven lions and wounded a great many more. He killed dozens of different species of ungulates, monkeys, hundreds of birds, "including some of the rarest species," and virtually anything else that came into his crosshairs. A company of skinners and porters worked around the clock to preserve Rainey's specimens. In all, he collected in excess of 4,700 mammals alone, with an emphasis on more sporting species such as "predators and ungulates."[38]

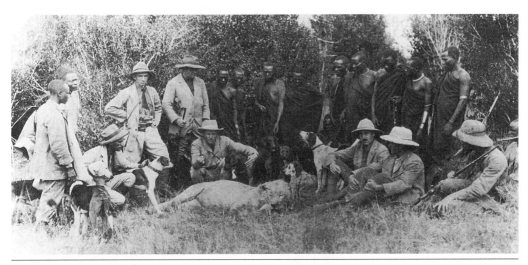

Paul Rainey (with moustache) poses over a dead lion with his hounds, 1912.

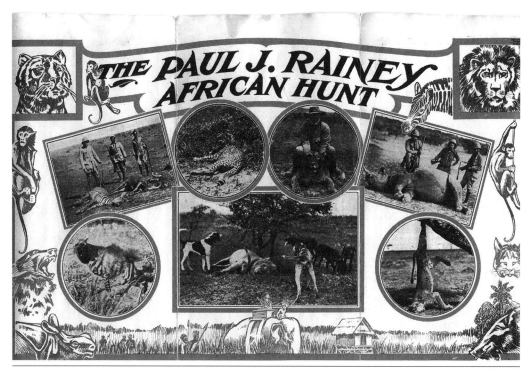

A montage of scenes from Rainey's African expedition displaying some of its trophies, 1912

The *New York Times* lamented Rainey's excesses in an editorial entitled "Abandoning Sport to the Dogs": "Lions, in a country where civilized settlers are increasing as fast as they are in Africa, have probably become intolerable, and the more quickly they are killed off the better, but it does seem as if the man who killed of them nearly one a day were doing something much like butcher work."[39] In the end, Rainey failed to capture any live animals except for an orphaned baby rhino, which he sent to London, and a hyena and a wild dog, which he sent to the New York Zoological Society as proof of his original intent. His expedition was a killing spree disguised as a legitimate inquest on behalf of science.

Like Roosevelt and Jones before him, Rainey decided to bring a filmmaker to Africa with him. He hired John C. Hemment, a photographer who had already made a reputation during the Spanish-American War. His book, *Cannon and Camera* (1898), was generally accepted as the unofficial pictorial history of the War.[40]

Hemment brought 100,000 feet of moving picture film with him to Africa.[41] "Next to capturing living animals, I hope to photograph them," Rainey told the *New York Times.* "I have had moving picture machines built with extra long focus lenses, that the very shy beasts that live in the open may be pictured clearly." But the true action of *Paul J. Rainey's African Hunt,* which opened in April 1912, was anything but pastoral shots of shy beasts. Rather, Hemment favored Rainey's sporting hounds as they rampaged across the African countryside. In one particularly gruesome scene in the film, Rainey's dogs mob a cheetah. In gladiatorial language, *The Moving Picture World* reported the combat: "A battle between a cheetah and a pack of dogs is described as most exciting, being shown to the finish, when the dead animal is hung up by the tail, with the dogs viewing the victim of their conquest."[42]

The film contains other difficult scenes as well, including one in which the dogs chase a lioness while one of the men picks up her cubs to show off to the camera. The enraged lioness suddenly "became most ferocious,"

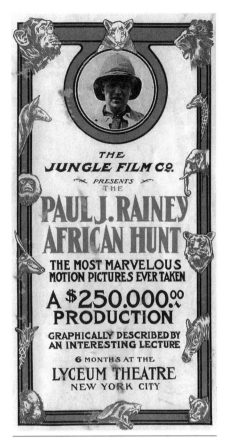

and without a second's warning broke through the ranks of the dogs and made directly for the motion picture camera, behind which stood Mr. Hemment, diligently grinding at the machine. Mr. Rainey stood close by and, realizing the perilous situation, immediately took aim and fired, the bullet penetrating the lungs of the lioness. A second shot, fired by Mr. Black, a thoroughly experienced big game hunter, penetrated the brain, and the lioness dropped dead, within forty inches of the camera.[43]

As with Kearton's *Lassoing Wild Animals in Africa,* the action plays directly to the camera. In fact, this scene, in which the intrepid cameraman refuses to abandon his camera even as he is about to be attacked by a wild animal (which is then shot dead at his feet at the last possible second), became a standard cinematic trope for many years to come. More importantly than the gratuitous violence in the film, however, Hemment was the first American cinematographer who had an aesthetic sense of how to film nature.

A brochure advertising Rainey's *African Hunt*

The films Cherry Kearton shot for Roosevelt and "Buffalo" Jones lacked a sense of intimacy for their subject matter. His images consisted mostly of a quick succession of poorly focused images taken at long range, which *The Moving Picture World* described as "short and irritating glimpses" of wildlife. Kearton shot Africa as though he were a census taker working his way down a master checklist of animals, from antelope to zebra. John Hemment, on the other hand, understood the aesthetics of imagery better than Kearton. He framed Africa as a community rather than as a compendium of animals. When he wasn't filming Rainey's bear hounds terrorizing the wildlife, Hemment photographed an Africa that audiences had never seen before. "We see a sight which reminds us of Noah's Ark," wrote the reviewer for *The Moving Picture World.* "It shows nature in all its innocence." Hemment's long takes of the huge herds calmly trailing along in the open grasslands gave pause to the idea that Africa was a place of incessant danger and violence. "The pictures show that many heretofore accepted notions of African animals are a fallacy," the reviewer noted: "Animals that we had often been told were the most timid of creatures, appear quite at their ease in mixed company; while those ferocious animals that are commonly supposed to devour everything in sight, are really quite peaceable citizens of the jungle."

Hemment's scenes of life at a water hole suggested that Africa might be an idyllic, Edenic place instead of a nightmarish landscape plagued by horror and death. "To see all these

creatures together in one picture is a remarkable sight," concluded the reviewer. "One that will interest any man, woman, or child."[44]

The museums that had incautiously endorsed Rainey's expedition conveniently side-stepped the issue of egregious violence by concentrating on Hemment's sweeping, pastoral views of Africa. In contrast to Kearton's collecting card approach to cinematography, Hemment gave the viewer an opportunity to *watch* rather than just to *look*. His cinematography was superior to Kearton's not just for the quality of its imagery but also because it was the first to capture natural animal behavior. Henry Fairfield Osborn, a professor of biology at Columbia University and the president of the American Museum of Natural History, praised *Paul J. Rainey's African Hunt* as "the greatest contribution to natural science of the decade," while film magazines raved that the film was certain to become part of the "archives of many governments as an authentic record in the study of natural history." *The Moving Picture World* lauded Hemment as an "educational cinematographer" and thanked him for bringing such "thrilling encounters" of the jungle into the American classroom.[45]

The juxtaposition of the violent with the pastoral in *Paul J. Rainey's African Hunt* awkwardly combines the ideals of education and entertainment. The violent scenes of Rainey's American dogs mauling African cats seem gratuitous. Some critics charged that those scenes served no other purpose other than to provide "cheap thrills" that catered to the baser instincts of an audience eager for violence. Hemment's panoramas of life in Africa, on the other hand, display a *peaceful* kinship within the community of beasts. These scenes were considered educational because they informed rather than titillated, and because they were sedate, respectable, and unadventurous. (Ironically these were the goals Kearton had pursued but had failed to capture in his film for Roosevelt.)

These attitudes were the products of Victorian social mores that heralded education as a virtue and demonized entertainment as a vice. The purpose of education was considered to be fundamentally moral: to inculcate citizens with a set of ethical principles and moral values that were concomitant with society's. The purpose of entertainment, on the other hand, was considered to be fundamentally immoral because it typically subverted those goals. By definition, therefore, education and entertainment were irreconcilable.

The spectacle of Rainey's hounds fatally swarming a cheetah reflected an American political discourse about the exercise of power on foreign soil and the dream of an emerging American political and military hegemony in the world. Unlike the restrained violence in *Lassoing Wild Animals in Africa,* the violence in Rainey's film is literally and figuratively unleashed. Rainey's dogs are the dogs of war.

WAR IN THE GARDEN OF EDEN

"Buffalo" Jones and Paul Rainey flaunted that same Rooseveltian adventurism in Africa. They were raw, boisterous, and impatient men, full of pluck and ready for a fight. Rainey's hounds embodied American aggressiveness and their unflinching readiness to fight to the death with the king of beasts spoke of their determination, their fearlessness, and the need for cooperation to defeat a superior foe. But this assertive political ideology flew in the face of another social discourse that ran on a parallel track in *Paul J. Rainey's African Hunt.* If Rainey's feisty hounds symbolized American political aggressiveness, then Hemment's pastoral Africa symbolized a

social longing for a peaceful egalitarian world, in which all of God's creatures stood shoulder to shoulder at the water hole. "One touch of nature makes the whole world kin," wrote one reviewer about the film.

> That is the secret of the extraordinary success of this picture. It has one vital appeal to all classes which makes them forget for the time their stations in life in their absorbing interest in the domestic joys and sorrows of god's obscure four-footed kingdom, which, after all, are much the same as their own. There is something in it that appeals to every mother, that appeals to every father, and, best of all, it appeals to every child.[46]

The moral polarity of the political discourse reversed. In the peaceable garden, innocence prevails over experience, and harmony and ever-lasting life prevail over discord and death. The lessons of the political discourse about the survival of fittest becomes moot because time stops. The Garden is a classless utopian vision of a world that embraces all equally.

Paul J. Rainey's African Hunt fails to mediate the crosscurrents of these two discourses. The religious overtones of the social discourse of Eden appealed to those who felt the purpose of education was to reinforce traditional Christian morality, but the political discourse was heady and exciting, full of claw and fang, and it riveted audiences with bloody scenes of might making right.

The embedded social and political discourses that created these opposing canvases of nature—one at war and the other at peace—instructed the body politic about the natural behavior of the state and the citizens that comprised it. Neither Cherry Kearton nor John Hemment was a polemicist. Politics flowed through them unfiltered and without editorial comment because they didn't perceive themselves as filmmakers but as film takers. In their minds, the camera was an unblemished mirror that reflected the world as it was. Whereas the action had provided the reason for the camera, now the camera provided the reason for the action. As the camera gradually discovered its authority, it moved out of the background as a passive observer and into the foreground as an active participant, and the mirror cracked.

On February 29, 1912, the American Museum of Natural History premiered *Paul J. Rainey's African Hunt* for its members. Over 5,500 people showed up for the 1,400 seats in the museum's lecture hall.[47] When the film opened publicly in April, audiences flocked to the movie houses. The film earned a box office of more than a half million dollars over the next year, making it one of the most financial and critical successes of its time, a fact that did not escape the attention of the directors of the museum.[48]

Late that year the directors of the American Museum of Natural History approved plans by a "master mind" to build a grand hall of Africa that would "illustrate well the need that existed for advance in the methods of animal exhibition." That "master mind" was Carl Akeley, the man who had convinced Roosevelt to go to Africa.[49]

Transplanting Africa

THE NATURAL HISTORY MUSEUM OF THE EARLY TWENTIETH CENTURY SOUGHT TO CAP-
ture and suspend the natural world in dramatic tableaux vivants—"living pictures"—that
suspended time at a moment of ideological perfection. Major institutions such as the Field
Museum, the Smithsonian, the American Museum of Natural History, and the Oakland
Natural History Museum actively sponsored expeditions to Africa during this period to
collect specimens for public display. Recent advances in taxidermy that combined techni-
cal expertise with artistic temperament stimulated curators to think about a more dynamic
presentation of their specimens. Instead of presenting a stiff, inexpressive representation of
a lion, for example, it was now possible to show a lion dynamically, interacting with other
lions, within some limited reflection of its physical environment. Not coincidentally, the
transition from still life to dynamic life in the diorama parallels the transition between the
still and the motion picture camera.

The technique of representing nature dramatically has its American roots in the works of
such early natural history artists as John James Audubon, whose *Birds of America* provides an
insight into treating nature both as an object and as a subject. Plate 17 of *Birds of America,*
for example, consists of a montage of three drawings: two of Northern goshawks and one of
a Cooper's hawk. Audubon drew the birds in the lower half of the frame—a mature goshawk
and the Cooper's hawk—in 1809 at the age of twenty-four. He depicts the birds as static
objects, much like the work of his contemporary Alexander Wilson (*American Ornithology,*
1808–1814). Audubon drew the third figure, an immature goshawk, over twenty years later
in 1830.

The attitude of the 1830 goshawk is dramatically different from the other two. It is perched
at the end of a branch, its wings bunched on the verge of taking flight; its long talons, open
beak, and fierce gaze create a sense of immediacy, what the French poet Mallarmé called "the
moment seized by the throat." While Audubon was still interested in the bird as an object, he
also discovered the power of the subjective, which expressed itself as a narrative.

These narratives take a more complete form in other drawings such as in plate 76, which
depicts a mated pair of red-tailed hawks fighting for possession of a dead hare in midflight.
Audubon's written narrative emphasizes the event more than its object:

> It was after witnessing such an encounter between two of these powerful marauders, fighting hard
> for a young Hare that I made the drawing, in which you perceive the male to have greatly the
> advantage over the female, although she still holds the prey firmly in one of her talons, even while
> she is driven towards the earth, with her breast upwards.[1]

The Birds of America contains many other tableaux vivants that depict subjective renditions of birds engaged in various hunting and domestic behaviors. Audubon's interest in telling stories with pictures helped to propel his work into greatness and also prefigured a new way of presenting nature to the public.

In 1889, nearly forty years after Audubon's death, Carl Akeley, the celebrated graduate of Ward's Natural Science Establishment, produced for the Milwaukee Public Museum what could arguably be called the first modern group habitat diorama: a domestic scene in the lives of a family of muskrats at their den. Behind them, a pellucid blue sky brightens a pristine marsh. It's a distinctly cinematic frame—what Akeley called "a peep-hole" into nature—created with an eye to proportion, vanishing perspectives, color, and melodrama.

In spite of its pretense to realism, the diorama is a hyperidealized vision of nature that seeks to overcome death by resurrecting the appearance of life. The motivation for creating a diorama, as Stephen Bann points out, is a sense of loss:

> The restoration of the life-like is itself postulated as a response to a sense of loss. In other words, the Utopia of life-like reproduction depends upon, and reacts to, the fact of death. It is a strenuous attempt to recover, by means which must exceed those of convention, a state which is (and must be) recognized as lost.[2]

The subject no longer lives within an organic history; rather, it exists as part of an inorganic history locked behind thick sheets of plate glass within a cross-section of moment that has been shaved from an imagined sample of life and then fixed within a static frame.

In the lefthand corner of Akeley's *Muskrats at Home*, a male muskrat standing on his hind legs scans the horizon for hints of danger while a female and her juveniles repair their home below him. A cross-section of the stream lets the viewer to see below water and into the muskrats' den, where a fifth muskrat snuggles within the safety of the nest. Akeley's diorama is a wild place seized in time in which every detail has been positioned so the viewer, like an

Courtesy of the Milwaukee Public Museum

Carl Akeley's diorama of muskrats at the Milwaukee Public Museum was the first complete natural diorama, 1890.

omniscient god, can witness the secret heart of nature. Nature submits itself to human inquisition, stripped of its powers to hide its innermost workings.

At first the illusion is convincing because of the completeness of biological detail and the quality of its expressiveness. Beneath the male muskrat's sleek coat, we can feel his muscles tense as he strains to see beyond the frame. But the illusion fades once we realize there the water in the stream does not ripple and the reeds do not shiver and that the muskrats' whiskers are forever still. Like Audubon's birds, the moment is frozen and excised from time: it has no past and no future.

The dioramas present static psychodramas that define the meaning and purpose of nature to society in a way that is oddly reminiscent of the subjective literature that accompanied the bestiaries of the sixteenth and seventeenth centuries. Dioramas are visual tropes, three-dimensional simulacra of nature that have been invested with the power of allegories, fables, and parables. Like the *emblemata* of the naive traditions of medievalism, they are also fraught with meaning. No longer the thing itself, the muskrat specimens that had once been preserved, tagged, and stored in collection cabinets for future reference now appeared on the museum stage of the diorama in order to invent new networks of meaning that claim victory in the historical struggle for domination over nature.

The natural history museum was no longer just a repository of objects that autonomously reflected knowledge; rather, the museum started to arrange its objects in ways that produced meaning for the human community by creating a sense of a totality of nature. This "idea of accumulating everything," wrote Michel Foucault in 1986, "of establishing a sort of general archive, the will to enclose in one place all times, all epochs, all forms, all tastes, the idea of constituting a place of all times that itself outside of time and inaccessible to its ravages, the project of organizing in this way a sort of perpetual and indefinite accumulation of time in an immobile place, this whole idea belongs to our modernity."[3] Through its dioramas, the natural history museum creates a skein of "fantasmatic" juxtapositions that not only telescope time, distance, and space but also fix them in a single, simultaneous "big bang" moment of nature that creates an illusion that its world is "as perfect, as meticulous, as well-arranged as ours is messy, ill-constructed, and jumbled."[4] However, the sun neither rises nor sets in this immutable world. Hearts do not beat; lungs do not inhale; eyes never blink. The world is deathly silent except for the hum of the ventilation system.

Although the dioramas reflect a collective yearning for utopia, they more accurately constitute a heterotopia, a term coined by Michel Foucault to describe an "effectively enacted utopia" that juxtaposes "in a single real place several spaces, several sites that are in themselves incompatible."[5] Unlike a utopia, which is an imagined and therefore an unreal space, a heterotopia is a "counter-site" to a utopia that blends elements of both the real and the imagined. For example, African Hall at the American Museum of Natural History in New York combines a variety of geographically diverse landscapes into a unified space. The desert of Sudan is a few feet from the slopes of Mount Kenya, the forests of Cameroon, the mountain volcanoes of the Democratic Republic of the Congo, and the Serengeti Plain of Tanzania. Animals that do not live within hundreds or even thousands of kilometers of each other in Africa now cohabit the same (albeit partitioned) space in New York City. The mountain gorillas in the mountain highlands of the Congo stare across the room at a pair of cheetahs in Mozambique, and the gemsbok of the Kalahari Desert in Botswana share the same room with the mountain nyala of Ethiopia. Wrote Foucault, "We are in the epoch of simultaneity: we are in the epoch of juxtaposition, the epoch of the near and far, of the side-by-side, of the dispersed."[6]

The diorama is a mirror that reflects both the creator and the viewer rather than the actuality of life, time, or place in Africa. The gaze, Foucault pointed out, is focused not on the objects behind the glass but on the viewer,

> from the ground of this virtual space that is on the other side of the glass, I come back toward myself; I begin again to direct my eyes toward myself and to reconstitute myself there where I am. The mirror . . . makes this place that I occupy at the moment when I look at myself in the glass at once absolutely real, connected with all the space that surrounds it, and absolutely unreal, since in order to be perceived it has to pass through this virtual point which is over there.[7]

The natural history museum undertakes the translation of biological scripture by providing a concordance of what is *real* and by using nature as a baseline for what is normal and therefore moral. The fabulous beasts of Ambroise Paré, Ulisse Aldrovandi, and Fortunio Liceti derived their power as subjects of awe and dread; more importantly, they served as lubber lines on the moral compass of nature. The farther one drifted from True North, the more radical life became. The new project of the Enlightenment, however, hewed to its own idea of North: now the onus of meaning fell on form, "provided by surfaces and lines, not by functions or invisible tissues." Linnaeus and Buffon superimposed a biological grid on nature that allowed for a meticulous examination, a method that would be directed, in Buffon's words, "towards form, magnitude, the different parts, their number, their position, and *the very substance of the thing*."[8]

But as museums established themselves as national institutions, they reflected the ideologies of state. Their authority as learned institutions provided stable, authoritative sites open to the public that conflated nature and culture and created what Donna Haraway has called the "unified biography of nature." In order to play out these social and political dramas, the state employs animals as moral exemplars meant not only to inspire awe and dread, but also to teach the national catechism.

The natural history museum claims a direct and unmediated correspondence between its objects and the real world, which allows science, politics, and economics to coincide for the purposes of education. As "coveted substitutes for firsthand experience," the diorama shaped social reality and so became, in Susan Sontag's words, "indispensable to the health of the economy, the stability of the polity, and the pursuit of private happiness."[9] For example, Akeley's muskrat diorama allegorically unites nature with the progressive idealism of the American frontier spirit. By their courage and determination, the muskrats reflect the unstinting life of labor and hardship of life on the American frontier. They face the same dangers, the same losses, and the same victories as the men, women, and children who built their homes and communities in the empty expanses of the West. They establish order over chaos by their unremitting vigilance, diligence, and commitment to core values such as family and fidelity. "Each individual," Roosevelt wrote admiringly of the frontiersman in 1893, "is obliged to be a law to himself and to guard his rights with a strong hand."[10]

The male of the species dominates the diorama: he is father, husband, protector, and provider. The female is wife, mother, and provider for her children. "She is a good mother and a hard-working housewife," wrote Roosevelt about the frontier woman, "always putting things to rights, washing and cooking for her stalwart spouse and offspring. She is faithful to her husband, and like the true American that she is, exacts faithfulness in return. Peril cannot daunt her, nor hardship and poverty appall her."[11] The composition of figures in the diorama

supports her subordinancy; the male stands vertically in the frame while the female huddles beneath him, chewing on a reed that will reinforce the defenses of their home. This "is not a random world," writes Donna Haraway, "but the moment of origin at which nature and culture, private and public, profane and sacred meet—a moment of incarnation in the encounter of man and animal."[12]

Akeley's muskrats are natural citizens, children of the land, as much defined by their environment as their environment defines them. And even though their effort unites the frontier family, the roles as pioneer father and mother embody the worldly values of the Protestant ethic and the spirit of capitalism. Their homesteading normalizes Adam Smith's concept of the natural value of labor; they are the *jus cogens* of nature, the purest expression of manifest destiny. And so the natural history diorama joined the *New England Primer* and the McGuffey Readers as the definitive public edition of nature's text in the early twentieth century.

ROOSEVELT'S RULES OF ORDER

The American Museum of Natural History is an ontogenic fantasy about nature, or, in Francis Bacon's words, "a model of universal nature made private."[13] It is an inexhaustible compendium of fossils, minerals, and artifacts collected across many orders of magnitude of time and space, from the subatomic to the glacial and the galactic, from a time before to a time beyond humans. The museum's reach is universal—from the Milstein Hall of Ocean Life, to the Gottesman Hall of Planet Earth, or the Margaret Mead Hall of Pacific Peoples and the Akeley Hall of African Mammals—but the museum's grasp is decidedly national. As the museum enfolds the natural world, so the state, in the person of Theodore Roosevelt, enfolds the museum. Roosevelt acts as a metalogue—the overarching political narrative of the American experience—that physically and figuratively surrounds and shapes the museum and the representation of nature itself.[14]

To enter the museum, a visitor must first pass James Earle Fraser's monumental equestrian statue of Theodore Roosevelt at the main entrance on Central Park West. Mounted on a stallion (modeled on the famous American racehorse Man o' War), Roosevelt looks as though he's been working his ranch, sleeves rolled up and a pair of six guns tucked into their holsters. The largest equestrian statute in the world at the time, it rises twenty-six feet from the base of its pedestal at street level. Two men on foot press up against the shoulders of Roosevelt's horse: an African on one side and a Native American on the other. "The two figures are guides symbolizing the continents of Africa and America," Fraser explained in a privately printed description of his work, "and if you choose, may stand for Roosevelt's friendliness to all races."[15]

The museum unveiled Fraser's monument in October 1940, as the clouds of war gathered on the American horizon. The horrors of Nazi eugenic policies were already wreaking havoc on the civilian populations of occupied Europe. The future of the German people, Germany's leadership declared, depended upon its determination to protect the purity of its racial stock. Therefore, the rulers of the state believed it had a *moral* obligation to protect itself against those who would compromise the integrity of its race. A healthy society, the reasoning went, preserved the order and balance of nature. Nature did not coddle the infirm of body or mind; Darwin had "proved" that with his theory. Only the fit survived. The cost of aberrancy was social failure and gradual extinction.

The United States had been wrestling with its own eugenics demons for decades. At the turn of the century, guardians of race (mostly upper-class whites) openly worried that Americans were rapidly losing the vigor that had once made the nation great. The unchecked proliferation of immigrants, criminals, poor, lame, and mentally feeble people was the result, according to some, of an incautious liberalism that threatened to compromise American social integrity. Roosevelt himself expressed concern that the lack of sound reproductive policy was dangerously weakening the American fiber, a view he shared with Henry Fairfield Osborn, the president of the American Museum of Natural History between 1908 and 1933. "Society has no business to permit degenerates to reproduce their own kind," Roosevelt complained in a letter to the American eugenicist Charles Davenport in 1913: "Some day we will realize that the prime duty—the inescapable duty—of the good citizen *of the right type* is to leave his or her blood him in the world: and that we have no business to formulate the perpetuation of citizens *of the wrong type*."[16]

Roosevelt, Osborn, and others like them based their argument upon the premise that nature provided an inalienable model that defined what was normal and therefore moral. Genetics and selective breeding, for instance, resulted in healthy, robust stock, whereas breeding weak strains or cross-breeding ("race-mixing") resulted in weakened genetic vigor. Charles Darwin's half-cousin, Francis Galton, had proposed that the theory applied to the inheritance of mental as well as physical traits. People of weak mind or character spawned more of their own kind; they were evolutionary dead ends and posed a threat to social stability.

In 1912, Franklin Kirkbride characterized the nation's downhill slide toward degeneracy in his essay "The Right To Be Well-Born" in a 1912 publication of the American Philosophical Society:

A study of either town or country shows the dwarfed intellect, the perverted instinct, the weakened body, and the preventable disease in every community. In some places they have run riot to the almost entire extinction of the finer and higher types. The pyromaniac continues to amuse himself by destroying property and life; insidiously, but no less surely, the union of defective and degenerate parents is destroying the vitality of whole communities.

The eugenics movement in the United States, which defined itself as "the self-direction of human evolution," undertook the political task of correcting the errant biology of human beings by promoting idealized racial standards through affirmative legislation. "The right to be well-born has been denied to many," Kirkbride continued: "Society can redeem this injustice only in part, and for that reason the very best that intelligence and science can give is imperative. To the large and more fortunate majority who have been well-born, education and a higher social conscience must teach race improvement."[17]

In 1908, Indiana became the first of thirty states that passed a bill that protected the welfare of society by *requiring* the compulsory sterilization of society's detritus, which included an eclectic mix of habitual criminals, sexual perverts (most notably masturbators), epileptics, the insane, and the imbecilic; in short, anyone the court concluded was unfit for reproduction. Between 1920 and 1928, the American Eugenics Society sponsored "Fitter Families for Future Fireside" contests at state fairs and other public venues that judged family members "on their physical, mental, and eugenic health."[18] Those who conformed to the highest ideas of racial standards were awarded a gold medal inscribed with a line from Psalms 16:6, "Yea, I have a goodly heritage."[19]

In 1927, the United States Supreme Court addressed the constitutionality of compulsory sterilization law in *Buck v. Bell,* in which a writ of error charged that the superintendent of the State Colony for Epileptics and Feeble Minded in Lynchburg, Virginia, had denied eighteen-year-old Carrie Buck her rights to due process and equal protection of the law by mandating her sterilization. In one of most egregious decisions ever made in American judicial history, the Court held eight to one that as a feeble-minded female capable of reproduction, Carrie Buck constituted a menace to society as "the probable potential parent of socially inadequate offspring."

In the majority opinion, Chief Justice Oliver Wendell Holmes Jr. wrote: "It is better for all the world, if instead of waiting to execute degenerate offspring for crime, or to let them starve for their imbecility, society can prevent those who are manifestly unfit from continuing their kind."[20]

Noting that both Carrie Buck's illegitimate child and mother were also "feeble-minded," the chief justice famously remarked, "Three generations of imbeciles are enough."[21] In the Court's view, and in the view of those who pursued this same rationalization during World War II, sterilization was a "vaccination" that protected society from the deleterious effects of continued lines of weakened human strains.

If we return to Fraser's epic statue of Roosevelt in front of the museum, the African and Native American who attend Roosevelt perhaps do not reflect a goodwilled effort to embrace the less fortunate races of the world so much as they serve as reminders of their place in the hierarchy of race. The African and the Native American may stand in for Roosevelt's "friendliness" to other, less fortunate races as Fraser would have us believe, but the gesture of the goodly shepherd now seems condescending.

The state justifies its structures of power by establishing nature as a moral system distinct from humankind's so that it can perform a juridical function as the ultimate arbiter for what is right, proper, and just. *If it is that way in nature,* the argument that establishes nature as the gold standard goes, *then so it must be right.* When Chief Justice Holmes invoked "the health of the patient and the welfare of society" as the basis for the Court's decision to uphold the "corrective action" of the lower court to sterilize Carrie Buck, he affirmed the primacy of "natural" over "human law." Yet, within the text of the decision, Holmes appealed directly to nature to demonstrate that "heredity plays an important part in the transmission of insanity, imbecility."[22] Galton's theory has since soured, of course, but Holmes, as did many of his race and class, believed in the irrefutably of the "proofs" provided by nature.

The animals on display within the natural history museum are themselves noble specimens of their race. They did not need marriage laws to halt indiscriminate breeding; they did not need immigration laws, because each animal had and knew its place in nature. Nor did they need sterilization laws because there were no lame, blind, feeble-minded, or senile animals in nature: all were either biologically prepared for the challenges of survival, or they died.

In 1921, Henry Fairfield Osborn hosted what he called "[p]erhaps the most important scientific meeting ever held in the Museum": the Second International Congress on Eugenics.[23] "Like a tree, eugenics draws it materials from many sources and organizes them into a harmonious entity," the conference poster reads. Those sources included the sciences (including genetics, medicine, biology, psychiatry, geology, physiology, and "mental testing") that provided a foundation for deciding law, economics, and education. Fraser's statue, like Osborn's museum, echoes this theme in virtually every hall and every room of the museum. Pedigree is everything.

Behind Roosevelt *en cheval,* John Russell Pope's bright marble terrace curves in a 250-foot semicircle around the front of the museum. Roosevelt's bona fides are chiseled into the stone face

of the terrace wall, each one punctuated by an imperial wreath: *Ranchman—Scholar—Explorer—Scientist—Conservationist—Naturalist—Statesman—Author—Historian—Humanitarian—Soldier—Patriot.* Fifty feet above the street, four men who defined the nature of the American wilderness stand watch atop the capitals of Ionic columns: Boone, Audubon, Lewis, and Clark. Beneath them, chiseled into the façade, are the words TRUTH, KNOWLEDGE, WISDOM.

From the street, the visitor must climb twenty-six steps to pass through the crypt-like doors of the museum into Roosevelt Rotunda, "a conception of grandeur and dignity in harmony with the spirit of Roosevelt's lofty ideals and fearless character."[24] The massive room has the feeling of a pharaonic antechamber, with its hundred-foot coffered vault ceiling, fifty-foot red marble columns, and mosaic floors. Sprawling golden murals that relate the deeds of a great man cover the walls. On the north wall, the mural charts three centuries of Roosevelt's genealogy, establishing him as the kith and kin to kings and queens, explorers, and other builders of empire.[25] Four large stone panels, each topped with an American eagle, frame the Roosevelt Memorial. Inscribed with a pastiche of quotes from Roosevelt, they present the political context of the museum: the method by which the state employs nature to vindicate its power.

The panels inscribed THE STATE and NATURE face outward and toward the east. The other pair—inscribed YOUTH and MANHOOD—faces inward and toward the west. The murals around them map a globe—complete with longitudes and latitudes. Both literally and figuratively, the journey through the museum is a journey to the west.

The eastward stone panel, THE STATE, reads, in part, "Aggressive fighting for the right is the noblest sport the world affords."[26] Next to it, its companion tablet, NATURE, reads, "The nation behaves well if it treats the natural resources as assets which it must turn over to the next generation increased and not impaired in value." THE STATE declares victory in the battle for dominion over nature and claims the contents of the museum as the spoils of war. NATURE, on the other hand, establishes not the value *in* nature so much as the value *of* nature by using the sign-words of economics—"assets" and "resources"—and then warns sternly, "Conservation means development as much as it does protection."

Traveling into the museum—westward—Roosevelt speaks to the citizens of THE STATE: YOUTH and MANHOOD. The panels stand like sentinels on either side of the archway that leads to the interior chambers of the museum. "Character, in the long run," reads YOUTH, "is the decisive factor in the life of an individual and of nations alike." And to the right of the arch, MANHOOD reads, "Only those are fit to live who do not fear to die; and none are fit to die who have shrunk from the joy of life and the duty of life." YOUTH binds the self to the state; they are one and indivisible. The actions of a citizen *are* the actions of a state. And if the actions of a citizen are the actions of the state, then it follows that it is the moral duty of every male citizen to pledge his duty to it.

Then can the citizen enter his nation's hoard of treasures.

NATURE'S PEEP SHOW

The Roosevelt Memorial is an airy space, flooded with natural light. But once the visitor passes under the arch into the passageway, the ceilings lower and the light turns dusky. Across the hall lies African Hall, once to be known as the Roosevelt Hall of African Mammals, but now known as the Carl Akeley Hall of African Mammals.

In a room nearly as large as the Roosevelt Memorial, two tiers of brilliantly lit dioramas line the walls like glass-fronted crypts in a cavernous art deco mausoleum. Hewn out of polished black volcanic stone, each crypt contains a different species transfixed in a stately afterlife.

Like the passageway to the hall, the light is dusky. What light there is comes out of the dioramas. "We shall be looking from the hall into the source of light rather than from the source of light outward," the museum explained in 1914. "The effect as we pass through this hall will be that of looking out through open windows into an Africa out of doors."[27]

The dioramas are synopses of African charismatic megafauna that comprise an elaborate nexus of paradoxes in which death presents itself as life, theater as reality, stasis as motion, and the present as a timeless past. Each diorama is a page in the biological *Book of the Dead,* an ode to the transmigration of the soul from mortality to transcendence. The animals in African Hall are so exquisitely re-created that, Donna Haraway writes, they "hold their pose forever, with muscles tensed, noses aquiver, veins in the face and delicate ankles and folds in the supple skin all prominent."[28]

The twenty-eight dioramas in the Hall—fourteen on the main floor and fourteen on the mezzanine—contain animals of the claw and fang (lion, cheetah, leopard, and several species of canine); animals of the horn (African buffalo, Black and White rhinoceros, and about thirty other species of trophy ungulates); and animals of the tusk (elephant and warthog). They also include four groups of simians, which include colobus monkeys, mandrills, chimpanzees, and gorillas. "In [the dioramas]," wrote Akeley, "is sketched in visual form a biography of untouched Africa."[29]

Although the dioramas emphasize species more than spaces, the displays diligently relate the geography, geology, or flora of the animals' environments. Each diorama has a plaque next to it that lists by genus and species the names of the plants and incidental fauna on display within the case. The plaque next to "Mountain Gorilla," for example, cites *Brayera anthemintica, Galium spurium, Polypodium spp,* as native plant species and *Funisciurus carruthersi* (a rare mountain squirrel) that is so well hidden that only the most determined viewer will find it.

A second plaque cites the names of the smoking volcanoes of the Kivu (Virungan) range of central Africa that have been painted on the background wall (*"from left to right: Nyiragongo, Nyamlagira, and Mikeno"*). These congregated details make a truth-claim that this place and these things are real.

The museum maintains these indexical claims by "sending a team of both scientists and curators to *an exact location,* using scientific methods to collect data, to collect photographs and field sketches and preserve specimens in order to create the habitat and that animal back here in the Museum's exhibition halls."[30] In other words, the background painting and the faunal and floral accessories in the foreground validate the veridicality of the "exact location" of the scene and the "exact inhabitants" of that scene. The *Mountain Gorilla* diorama further reinforces its truth claims by telling the audience that in 1926 Carl Akeley was himself buried "at the site featured in the diorama."[31]

When innovations in taxidermy in the late nineteenth century brought the animals out of the dusty closets and bins of the museums to be displayed to the public as objects of veneration, they became products of mass consumption. The staid Victorian attitude about knowledge for its own sake yielded to a less didactic approach to education that relied upon entertainment as a way of drawing and engaging general audiences. As a result, the natural history museum recast the animals that had been objects of scientific contemplation as characters in domestic melodramas about nature and history. "A diorama is eminently a story, a

part of natural history," writes Donna Haraway. The animals "are actors in a morality play on the stage of nature, and the eye is the critical organ."[32]

Akeley's allegiance to the aesthetics of sculpture revolutionized taxidermy in a way that spurred natural history museums to rethink the interface between the public and nature. Osborn believed that Akeley's genius lay in his skill in modeling animals "to be the completed thing itself."[33] For Osborn, dioramic art—sculpture, painting, and narrative—provided a means of producing science. The diorama sought to capture (or in its own words, "recapture") an exact moment in place and time—a history—but also the moment of the natural experience itself. The purpose of the diorama, according to the AMNH, "is to recreate that *personal* encounter with wildlife or with animals in the field."[34] In other words, a visitor standing in front of the glass window of *Mountain Gorilla* in Akeley Hall off Central Park West in Manhattan should have the same experience as someone in the Congo. The diorama and nature share the same *emotional* equivalence, "the same epiphany that occurs when one experiences beauty and wonder in the natural world." Following the museum's logic, the image *is* the event. "The reason why you come to a natural history museum," the museum contends, "is to see the real thing and to encounter the real thing."[35]

It's hard to believe that someone who's never seen a gorilla in the mountain highlands of Central Africa could experience that same sense of "personal encounter" as someone standing in the dense forest of Rwanda or Uganda simply by standing in front of a thermostatically controlled diorama of stuffed gorillas on the Upper West Side of Manhattan. Yet the appeal to truth remains invested in a token of the thing itself. "It is no good arguing that the public wants attractive entertainment," wrote Stewart Edward White on "The Making of a Museum,"

> and that as far as the general effect is concerned they [*sic*] do not know whether it is exactly right in finicky little details or not, and do not care. That isn't the point. The point is that we are purporting to exhibit the *thing as it is;* and in so purporting we have assumed an obligation [that] we are building for the future as well as for the present.[36]

The paradox lies in the equivocation of the word "thing," which is used conterminously as "an object" and, more colloquially, as "an experience." The thing itself, the "Mountain Gorilla," for example, is minimally organic—only the hide remains of the original animal. The rest was built from inorganic materials such as clay, plaster, glass, papier mâché, beeswax, and paint. This combination of technology with biology created gorilla cyborgs, a spectral echo of animals that once lived in the mountain highlands of central Africa. "The social relations of domination are built into the hardware and logics of technology, producing the illusion of technological determinism," writes Donna Haraway.[37]

Within the contexts of meaning, Akeley's dioramas look to the future as much as they do to the past. They look to the past by awakening the hibernating semiotics of Liceti, Aldrovandi, and Gesner, and they look to the future by creating a new way of seeing nature. In spite of the museum's claim that the diorama is a literal experience, it is, in fact, a false cognate: a biological gorilla isn't its cyborg cousin. While the effigy may in some small part be a "real thing" it is not *the* "real thing" any more than a sculpture is the thing it represents. A diorama is a plastic construction that requires artists—painters, sculptors, and modelers—to translate a time, a place, and the species that inhabited them into a static vision of them. And yet Henry Fairfield Osborn insisted, "Every specimen is a permanent fact."[38] Osborn understood factual to mean literal and biological, but it turned out to mean figurative and historical.

Additionally, the gorillas' environment consists of objects collected from the "actual" site that also have been plasticized and then set before a painted backdrop of the Virungan volcanoes that straddle Rwanda, Uganda, and Zaire. The claim that *Mountain Gorilla* is a "perfect replica of an exact individual" that has been depicted in a real location makes an indexical claim that because some small portion of the gorillas were real at some place at some time and that the mannequins in the diorama are based upon historical rather than an imaginary gorillas. Using the museum's logic, it follows that because of this prior relationship between objects, the modeled representation of a gorilla is as real as its living precedent.

Yet the museum acknowledges that the diorama is as much an artistic as a scientific rendition: "The methods that were used to collect for the dioramas and the habitat groups were so scientific and so objective in their intent that *the artists* were able to achieve such a close duplication of the environment and the animals depicted that the experience is very close to one in nature."[39] The role of "artists" in a putatively scientific process compromises the integrity of the indexical claim made by the dioramas. Art that has been put "into the service of science" is still art. Even though the background artists intended "to imitate nature so closely in their work that their own role becomes invisible," their paintings are nonetheless highly stylized and interpretative.[40] James Perry Wilson, arguably the greatest of the diorama painters of the twentieth century, best expressed the philosophy of using art to represent science objectively: *ars celare artis* . . . art to conceal art.

The museum acknowledges its mix of objective and subjective content when it calls itself "the greatest art gallery in the world ever built and dedicated to the beauty and splendor of the wildlife of Africa."[41] James Lipsitt Clark, Akeley's protégé and the man the museum charged with the responsibility for completing African Hall after Akeley's death, wrote that building a diorama "was like [making] a little doll's house—placing each little piece of furniture so as to develop the best decorative treatment of that room."[42]

One of the first artists Akeley hired to paint the backgrounds of the early dioramas was William R, Leigh, a western genre artist, sometimes called "the sagebrush Rembrandt." Leigh's portraits of the Navajo and Hopi depict a highly romanticized vision of the West, and his backgrounds for the natural history dioramas reflect the same paradisiacal style. Leigh's "habitats" are lush representations of nature depicted in light that is always gentle and glowing, never flat or blazing. His palette of colors is rich and full of apricot and plum. *African Buffalo* and *Mountain Gorilla* are idylls of a land that *once was,* a land populated by exceptional animals that wandered primitive Africa.

AKELEY'S ELEPHANTS

In 1910, while convalescing after being mauled by a bull elephant on the slopes of Mt. Kenya, Akeley dreamed of an exhibit for the American Museum that would eulogize his "Brightest Africa," a prehistoric land that was rapidly being lost to farmers, railroads, and ivory poachers.[43] He feared the rapid extinction—"the coming doom," as Henry Fairfield Osborn called it—of Africa's great game mammals, and the marathon killing of elephant, rhinoceros, lion, giraffe, hippopotamus, and gorilla unnerved him even though he was as responsible as any—and perhaps more than most—for their untimely demise. Tusks and horns were getting

shorter, the animals smaller. The museum approved Akeley's hymn to Africa in 1912, and the hall began construction in 1914, but was slowed down by World War I.

Wrote *Time* upon the hall's opening in May 1936, "It was as if groups of animals feeding, drinking, hunting, traveling or resting in Africa, had been immobilized by some mighty power and transported in their natural surroundings across the Atlantic to the Akeley Memorial Hall of African Mammals."[44] That "mighty power" was, of course, the United States.

The social justification for creating the exhibits came from the feeling of impending loss of nature. According to a senior project manager at the museum,

> Habitat group dioramas really emerged when there were great environmental concerns among the scientific community. Those concerns were stemmed [*sic*] by habitat destruction and also the wanton slaughter of animals for food. . . . So the scientists and curators in science museums that were concerned about the vanishing wilderness and wildlife were looking for some medium to their story—to evoke an awareness and appreciation for nature and wildlife.[45]

Akeley's dream may have been to build a memorial for the vanished; ironically, he built one for the vanquished instead.

Akeley reduced the continent of Africa into a 60' by 152' hall with a thirty-foot ceiling instead of heaven. And in the middle of that space, he intended to sing a personal hymn to Africa. In 1909 Henry Fairfield Osborn sent Akeley to Africa—at the same time Roosevelt was in Africa—to collect "materials" for a group of African elephants for the African Hall. As "one of the most splendid of all animals past or present,"[46] the elephant was chosen as the presiding metaphor for Africa and African Hall.

Unlike the dioramas, which would be in hermetically sealed cases, *African Elephants* would stand in the open atop a four-foot pedestal. Akeley had already mounted two bull elephants in combat for the Field Museum (in addition to P. T. Barnum's Jumbo), but Osborn wanted something different, something that captured the full dynamic of Africa. He and Akeley finally decided upon a family grouping of elephants. Today, the group contains eight elephants, but Akeley's original group consisted of four: an old bull—the patriarch—a female and her calf, and a young bull, which still comprise the core of its dramatic mise-en-scène.

Much like the muskrat diorama he created for the Field Museum decades earlier, the elephant group speaks more loudly of American progressive idealism than biological realism. Described by *Time* in 1936 as "tons of monstrous life on the move," the elephants duplicate an American family of the 1880s crossing the perilous frontier, sharing a solidarity of purpose, a certainty of leadership, and a unity of spirit.

The story line would have been familiar to viewers who would have already seen the same action played out many times on the movie screen, particularly in Westerns, which had emerged as a film genre in 1910, the same year as *Roosevelt in Africa*.[47] In Akeley's version, the patriarch (the lead bull) senses danger ahead, "silently feeling for scent with his trunk, ears fully extended to catch the least sound, for he does not see the source of disturbance." His intimidating size and his outstretched and uplifted trunk make him the unequivocal focus of the family. Meanwhile the cow at his side reacts to his alarm, "ears back, trunk pendant, prepared for any move she may decide on," and her frightened calf wraps its little trunk around its mother's for reassurance. Behind them, the young bull swivels around to protect the family from an assault from behind, "his trunk thrown back to catch the scent" of the danger that surrounds them.[48] "[T]he relations of knowledge and power at the American Museum of Natural History should not be narrated as a tale of evil capitalists in the sky conspiring to

obscure the truth," writes Donna Haraway. "Quite the opposite: the tale must be of committed Progressives struggling to dispel darkness through research, education, and reform."[49]

In the museum's textbook on exceptionalism, the page on *African Elephants* appears in bold print. The elephants in Akeley's display transcend mortality, not because they are so lifelike or seem like they are on the verge of stampeding or charging, but because they are the flawless beasts, much like the perfect specimens Audubon depicted in *The Birds of America*. Akeley's elephants have no missing, damaged, or even stunted tusks, no torn or notched ears, nor any scars healed over, no evidence at all of a hard life lived on the land. Free of dust and dried mud, their skins now have an olive sheen that glows dully at the center of the hall.

The elephants are balanced, symmetrical, and synchronized. Their *elephant-ness* harmonizes them into an archetype, what the museum calls the *real thing*. For Akeley, like Audubon, the *real thing* meant perfection. Roosevelt collected the *representative* animal, and so he was happy to shoot whatever presented itself to his gun. Akeley, on the other hand, collected the *transcendent* animal. He was Ahab hunting a hundred whales.

But Akeley's dream gradually turned into a nightmare. A reflection of the eugenics discourse of his time, Akeley's animals had to be the gods and goddesses of their breed, so they would inspire awe in anyone who looked upon them. He hunted magnificence, and so he rejected any animal that was too small or too cowardly, or because its tusks or horns were too short or broken. He assessed every animal according to his aesthetic ideals of color, confirmation, and character. The animals of Akeley's imagination earned his respect by their size, their natural majesty, their stalwart defiance of those who would kill them, and their courage to defend their honor or the honor of their family.

Akeley spent two years searching for perfect elephants. His pursuit of the climax animal in the name of science justified the sacrifice of lesser specimens that he left to rot on African soil, but, as did many generations of men before him, he justified killing as necessary to the acquisition of knowledge. The learning that science would derive from a museum's specular archive of beasts provided the moral justification for killing them. As a result, Akeley and his two wives killed dozens of elephants in Kenya and Uganda—young and old, bulls, cows, and calves—always looking for bigger and better specimens. And although he would readily "sacrifice" an elephant for ivory in order to finance himself in the field, he steadfastly refused to send a flawed specimen back to New York.[50] "Since January," Akeley bemoaned to museum director Hermon Bumpus in 1910, "I have inspected well over one thousand elephants here and in Uganda, but have not been fortunate in finding the desired perfect specimen. I am determined that the old bull shall be as near right as possible even if it takes another year."[51]

ROOSEVELT'S "OLD COW"

In mid-November 1909 Akeley trekked to the Uasin Gishu Plateau in British East Africa to find Roosevelt, who had been hunting lions on the Ugandan border. When Akeley had been to dinner at the White House the year before, he had talked with the president about joining his hunt for specimens for the African Elephant Group at the American Museum of Natural History. Roosevelt obviously did not forget the invitation, and in early November, he asked Leslie Tarlton, the expedition's organizer and leader, to invite Akeley to their camp. Two weeks later, the two men were stalking elephant in the tall grass of the Great Rift Valley.

Akeley wasn't about to let Roosevelt shoot a bull; he claimed that right for himself. However, he was willing, either out of courtesy or respect for man who displayed many of the same characteristics as the animals he hunted, to let the colonel shoot the cow for his display. Kermit could shoot the calf.

The next day, the hunting party found a small band of elephant cows and calves snoozing under a clump of brush. "I waited for the Colonel to take a shot, expecting him to do this from behind the termite hill where we were afforded a splendid protection against a charge," Akeley recalled the hunt, "but he started forward toward the elephants and I, with Kermit, was obliged to follow closely."[52] Roosevelt pushed to within twenty-five yards of the elephants when one of the cows suddenly flattened her ears, dropped her trunk, and charged him.

Roosevelt shot her in the forehead with the same steadiness as he'd shot Old Ephraim years before. The cow stumbled onto her knees. The sound of the shot so agitated the other elephants that Akeley felt that "quick action was necessary," and the men opened fire on the remaining members of the group. By the time the smoke cleared, four elephants lay dead. The colonel had shot three cows and Kermit his calf.[53]

Akeley was not happy with the results. Roosevelt had killed two juvenile cows and an old female. The young cows were too small to be of value to the museum, and the mature cow, Akeley later complained to the museum, was too small and too old. But Akeley said nothing as he watched as the skinners stripped the flesh off the cows and the calf and salted their hides so they could be shipped back to New York to be prepared for display. Once the skinners were finished, Akeley quickly parted ways with Roosevelt and went off in search of his perfect monster.

Akeley reported having the skins of all three of Roosevelt's cows on hand in a letter to Henry Fairfield Osborn on April 9/11, 1910. But two of the skins never showed up in New York. There is no record of what happened to them; they simply vanish from the record.[54]

The keystone of the museum's argument for authenticity is its patent attention to detail. The museum maintains that the animals on display are not homogenized replicas of things, but *the things themselves.* Akeley, however, frequently crossed into the heterotopic no-man's-land between the real (that which has been documented) and the imagined (that which had been created). Akeley played loose with some of the facts, especially when it came to his masterwork, *African Elephants*, which is a curious blend of fact and fiction.

According to the American Museum's Mammalogy Department's accession tags—which record the details of how and when specimens come into its collection—Akeley contributed the large and the "young" bull (Museum accession nos. 54085 and 32734), Roosevelt contributed the female (no. 32732), and Kermit contributed the calf (no. 32727). However the "young bull" at the rear of the display was not young, but "according to the conditions of its molars rather older, but certainly not younger than the large bull (no. 32734).[55] Nor did Akeley shoot the large bull (no. 54085) in the display; rather, his first wife Delia ("Mickie") had shot him in the Budongo Forest in Uganda in 1910. While Akeley was quick to attribute the cow and calf to the Roosevelts, he was slow to attribute the large bull to his wife. Privately, he declared that Mickie's bull was the largest ever shot by a woman in Uganda, but publicly, he might have thought it unseemly if the public knew a petite white woman had killed the patriarch of the elephant group.

Kermit's calf remains uncontested. It is a small specimen, barely four-and-a-half feet tall at the shoulder. Its tusks emerge less than two inches. Akeley's photograph of Kermit sitting astride the dead calf parodies the trophy photographs of other men who sit triumphantly astride their monsters.

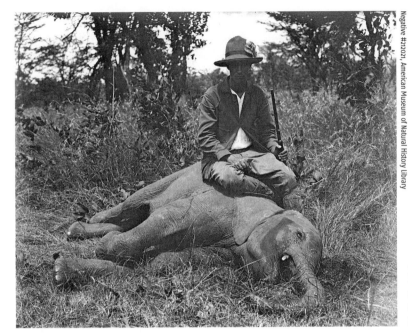

Negative #22021, American Museum of Natural History Library

Kermit Roosevelt's juvenile elephant shot on the Uasin Gishu Plateau in British East Africa, 1909.

Of the four elephants in the original group, however, none is more problematic than Roosevelt's cow. Would Akeley have swallowed his ambition by allowing Roosevelt's painfully inferior cow into the display after looking over more than a thousand elephants for a perfect specimen? At least one author has suggested that Akeley swapped Roosevelt's cow for one of his own while he was mounting the elephants at the museum.[56] The argument has merit. Unfortunately, as an institution devoted to the precise attention to detail, its records of Akeley's and the Roosevelts' elephants muddy rather than clarify the water.

The American Museum's accession tag for Roosevelt's cow records the kill site as north of Mt. Kenya in 1912, whereas Roosevelt shot his cow 150 miles to west in the Uasin Gishu Plateau in 1909. Akeley wrote to Herbert Lang, the head of Mammalogy, in 1924—five years after Roosevelt's death and fifteen years after the event itself—and asked that he correct the accession tags so that they would reflect that Roosevelt had shot his cow not near Mt. Kenya, as the tag read, but near the N'zoi River on the Uasin Gishu Plateau.[57] Lang amended the original entries. It is difficult to tell if Akeley was correcting faulty records or changing them, but additional evidence suggests that Akeley may have in fact switched Roosevelt's old cow for another, more ideal specimen.

The Akeley photo archive at the AMNH is a graveyard of slain animals. Among his many talents, Akeley was an avid photographer and a filmmaker. He invented the Akeley camera, which became the motion picture camera of choice for an entire generation of explorers and adventurer filmmakers. (Robert Flaherty shot *Nanook of the North* with an Akeley.) Akeley documented many of his hunts with a still camera, and he took pictures of Roosevelt's cow both before and after the colonel had shot her.

The photographs show the ears and tusks of Roosevelt's clearly. Her right ear is badly notched, and her tusks are short, uneven, and skewed.[58] The cow in the African Hall, however, has tusks that are symmetrical, even, and straight. Her ear is regularly shaped. (An elephant's

ears provide an accurate way to identify individuals; they are the equivalent of animal "fingerprints.") The museum's fidelity to realism would not have allowed Akeley to "fix" the cow by replacing the tusks and patching her ear: the cow elephant on the floor of the African Hall may have been a particular individual, but based upon the photographic evidence at least, she is not the same animal that Roosevelt shot that day in the Great Rift Valley. Akeley, who was in charge of the mounting of the elephants at the museum, would have had both motive and opportunity to switch specimens. He understood the value of publicity in maintaining the fiction that Roosevelt had indeed shot the cow in the display; at the same time, he might not have wanted to compromise his own personal ambition to create models of perfection.

The Hall of African Mammals brims with exceptionalism, both animal and human. Akeley found his perfect bull, just as he would later find his perfect gorilla, and all the other perfect animals in the dioramas. The American Museum is, in many ways, America's hunting lodge, similar to the trophy rooms of kings and magnates who mounted their keepsakes in displays of overwhelming dominion, and the educational lessons created within its rooms are as social and political as they are biological. Whether or not Roosevelt actually killed the cow on display is less important than the assertion that he did. As an exceptional man of exceptional deeds, and as a man who had not only mastered America's continent but Africa's as well, Akeley and Osborn made Roosevelt lord of both realms and reinforced America's imperial story. An emerging part of that story would play out in the emerging art of cinema, and the stillborn images in African Hall provided the aesthetic and rhetorical foundation of what would soon become known as the "nature film."

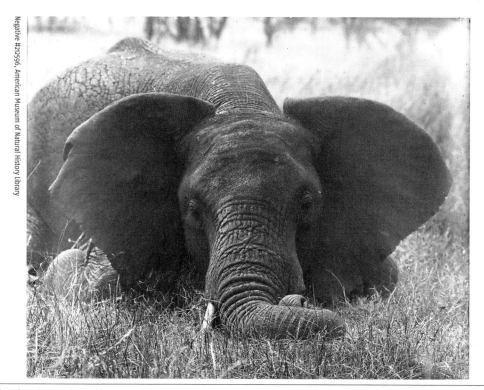

Negative #212596, American Museum of Natural History Library

Theodore Roosevelt's "old" cow was purportedly shot for the elephant diorama in the American Museum of Natural History, 1909.

Of Ape-Men, Sex, and Cannibal Kings

THE NATURAL HISTORY DIORAMA FRAMES OUR WAY OF SEEING AND KNOWING NATURE by telling stories. These stories graft social theory onto the material reality of the world in order to organize knowledge in terms of its value to society. Just as the Enlightenment preempted God's authority over nature three centuries ago, so science of the early twentieth century sought to wrest power from nature in order to maximize production, as Barber Conable phrases it, "to make most of nature's resources so that human resourcefulness can make the most of the future."[1]

As a confederacy "between words and things, enabling one *to see* and *to say*," the diorama attested to the meaning and importance of nature to society.[2] African Hall deploys the weighty authority of science to validate the use of animals as vessels for meaning and then camouflages its content in order to make it appear free of social narrative. The museum tries to preempt any negotiation of meaning by claiming the animals and the places within its halls are not human artifacts but *real*.

When Roosevelt and Burroughs joined forces to attack what they called the "nature fakers" in 1903, they argued that "Truth as pure science" was proof of itself. Anything else distorted the "Truth" and therefore polluted the mind. Roosevelt argued to abolish fanciful stories about nature from the national curriculum. "If the child mind is fed with stories that are false to nature, the children will go to the haunts of the animal only to meet with disappointment," he wrote. "The result will be disbelief, and the death of interest."[3]

The absoluteness with which they regarded the objective facts of science did not allow Roosevelt, Akeley, or Osborn to grasp the fact they were engaged in the creation of a new imperial narrative about nature that credentialed itself as rational, objective, and moral. Roosevelt insisted that nature was a literal text based on self-evident facts. But, as Judge Learned Hand cautioned from the bench in 1944, "There is no surer way to misread any document than to read it literally."[4]

Inside Africa Hall, nature was an orderly representation of facts. Outside, away from the legislative halls and political offices that imposed the ideological structures upon those facts, nature continued to wend its own inscrutable path. "Progressive humanism," wrote Roland Barthes, "must always remember to reverse the terms of this very old imposture, constantly to scour nature, its 'laws' and its 'limits' in order to discover History there, and at last to establish Nature itself as historical."[5] The discourse of nature inside Africa Hall blends matter and power to formulate a distinctly American environmental and imperial imaginary.

Outside African Hall, however, images of nature had undergone their own revolution through American cinema, which employed a dogma radically divergent from that of the men who zealously promoted the ideology of knowledge and power within cultural institutions such as the natural history museum. Outside African Hall, the cinema produced its own revelations about the relationships of Americans to foreign landscapes.

By 1910, the motion picture replaced the picture newspaper and the pulp magazine as the primary vector of images of nature. In that year, 26 million people went to the movies on average *once a week*. A ticket typically cost five cents, and yet box office receipts topped $91 million that year in a nation with a population of only 92 million.[6]

The heart of this economic juggernaut was the nickelodeon, which acted as a huge cultural blender by combining into a single program a potpourri of subjects that ranged from vaudeville, current events, melodrama, travelogues, and sports, to "potted culture from the art galleries and the legitimate stage."[7] In the struggling, yet highly competitive film industry, producers concerned themselves more with their own economic viability than with the scientific education or political indoctrination of a nation. Forces in the marketplace (abetted by a lack of formal censorship) and the fierce competition for audiences compromised the idealistic notion that cinema should instruct or uplift the moral tenor of those who watched it rather than pander to their base tastes.

As this reality became increasingly obvious during the early years of cinema, those who had insisted that art and entertainment were subordinate to education found themselves succumbing to the demands of dramatic narrative as the only viable way to attract audiences sizeable enough to justify underwriting the massive expense of mounting expeditions to the interior of unknown worlds such as Africa, Borneo, or the South Sea Islands.

"A REAL SENSATIONAL AND EDUCATIONAL FEATURE!" declares a 1909 advertisement in *Moving Picture World* for *Roosevelt in Africa,* using the prerelease title of *Capt. Cherry Kearton's Wild Life and Big Game in the Jungles of India and Africa.* Silhouettes of lions, tigers, kangaroos, and elephants stalk the perimeter of the text of the ad, which promises a "complete zoological review from an ant to an elephant," from Borneo, India, and Africa that Capt. Kearton had secured, "after years of unremitting labor, at obvious peril to his life and limb, and thus obtained the most natural reproductions possible of prowling lion, the stealthy tiger, the ourang-outange (the first authentic moving picture ever taken of this interesting citizen of the jungle) and scores of other beasts of the Dark Continent."[8]

The claims were invented by a fledgling film producer named Adolph Zukor, who obviously had not seen the film. There were no ants, tigers, kangaroos, or "ourang-outanges"—not even a prowling lion in the film—and none of it was shot in Borneo, India, or any place other than Africa. But the ad appealed to the romance and adventure of the jungle, *"with its silence and mystery, its movement and color and its fascinating lure."* The advertisement also flaunted endorsements from Theodore Roosevelt, the American Museum of Natural History, the New York Zoological Society, National Geographic, and the Smithsonian in order to distinguish itself from "inauthentic" films such as Selig's *Hunting Big Game in Africa.*

Zukor (who founded the Famous Players Company in 1912, which eventually became Universal Pictures) understood that the novelty of films about inscrutable people with inscrutable customs in faraway lands would wear off quickly unless the films grafted familiar American characters and melodrama onto them. The distinctions between fiction and non-fiction and reality and fantasy did not matter nearly as much as making the strange familiar, so that the action, wherever it occurred—whether in an igloo, a yurt, or a tipi—shared the same core values as a middle-class citizen in Keokuk, Iowa. In 1912, this idea found its full

expression in the work of a pencil sharpener wholesaler from Chicago named Norman Bean, who created the ultimate American imperialist fantasy about Africa.

BEAN'S AFRICA

A pulp magazine called *All-Story Magazine* serialized Norman Bean's first story, "Under the Moons of Mars," in early 1912. Three months later, *All-Story Magazine* published another of his stories, "Tarzan of the Apes." Tarzan created such a stir that Bean started to use his real name—Edgar Rice Burroughs.

As the Lord of the Apes, Tarzan is the lord over the peoples, the animals, and the land itself. As Kenneth Cameron notes in *Africa on Film,* "he is the Lord of the Jungle, not because he is the strongest and the smartest . . . but because he is a Lord in England." Rather than a noble savage, Cameron notes, Tarzan is a savage noble.[9]

Tarzan derives his power as a dominator from nature and his innate ability to control it absolutely. His values are Western, and the plot ingredients in his stories are stock domestic boy-meets-girl melodramas. Burroughs also brought a dimension to the story that crossed the line between species. The loving relationship Tarzan has with his ape-mother, Kala, who "nursed her little waif" to adulthood in spite of her tribe's protests, intrigued audiences. They wanted more—a lot more—of it. Burroughs wrote twenty-four Tarzan novels during his career. Tarzan also became the most successful franchise in movie history, with eight silent films, forty sound features, and five television series, more than doubling the output of Ian Fleming's James Bond franchise.[10]

By 1913 Africa had become a cottage industry in the film business as studios started to pump out one-reel jungle melodramas with unlikely names such as *Thor, Lord of the Jungles* and *Wamba, a Child of the Jungle.* Alice Guy-Blaché, the first woman director in the motion picture industry, produced and directed one of the first jungle melodramas, *Beasts in the Jungle* (1913).[11] That same year, John Bray produced *Colonel Heeza Liar in Africa,* an animated cartoon that lampooned Roosevelt's exploits in Africa. ("Heeza Liar was his name / And Colonel was his handle. / He roamed the desert seeking fame / To snuff out T. R.'s candle.")[12] The character of the bumbling colonialist blasting his way through the jungle was a hit, and more titles quickly followed in 1914 such as *Colonel Heeza Liar, Explorer,* and *Colonel Heeza Liar, Naturalist,* and in 1915, *Colonel Heeza Liar, Nature Faker.* Bray produced a total of over sixty *Heeza Liar* adventures, making it the first commercially released cartoon series based upon a continuing character. Other jungle melodramas quickly followed.[13]

In 1914, J. S. Edwards and John Rounan established the E & R Jungle Film Company in Los Angeles on North Soto, two blocks from the Selig Zoo. "The Jungle Film Co., which started here several weeks ago with a small but complete jungle menagerie," noted *Moving Picture World*, "has just completed and run for the first time *Children of the Jungle,* a three-reel atmospheric picture, which abounds in realism of the wilds of the hot countries."[14] E & R Jungle Film's main claim to fame became the forty one-reel comedies that starred two chimps named Napoleon and Sally. Sally was already a celebrity because of her widely publicized talent for swilling beer. ("Of all the monkeys at the Zoo / There's none like Tippling SALLY. / She was the first who quenched her thirst / Quite al-co-hol-i-cally.")[15]

At the same time Sally and Napoleon were making their comedies, the Eclectic Film Company (Pathé) released the first episode of the serial melodrama *The Perils of Pauline.* Each week

the main character Pauline would begin the episode by escaping the clutches of one villain only to find herself in the clutches of another by the end of the final reel, creating the narrative technique known today as the "cliffhanger." The damsel in perpetual distress provided lots of opportunities for tearful deathbed scenes and thrilling saved-at-the-last moment rescues, including perhaps the most famous of all the melodramas: Pauline tied to the railroad tracks with an onrushing locomotive in the background. Film companies churned out over 800 episodes between 1912 and 1920 of more than sixty different series with such alliterative titles as *The Adventures of Dorothy Dare*, *The Hazards of Helen*, *The Exploits of Elaine*, and *Ruth of the Rockies*.[16] Collectively they became known as "Serial Queen" melodramas, and they helped to reshape the role of women (and consequently, men) in film narrative.

In January 1918, the National Film Corporation released *Tarzan of the Apes* starring an actor with fifty-two-inch-chest named Elmo Lincoln in the title role. Billed as "The Most Stupendous, Most Amazing, Most Thrilling Film Production in the History of the Screen," and shot "in the Wildest Jungles of Brazil—at a cost of $300,000" and with a cast of "1000s," the film promised "wild lions, tigers, elephants, apes, cannibals, etc."[17]

Tarzan's "fearless encounters with the jungle terrors, his slowly dawning realization that he is a man, his pathetic efforts to add to his knowledge are experiences that have been nowhere else been described with so absorbing interest," wrote the *Atlanta Constitution*. "When he meets other of his kind and is able to note the strange differences; when he see [*sic*] the woman who should be his mate but is separated by insurmountable difficulties from him, even greater trials are before him." People flocked to the theaters. The *Atlanta Constitution* reported, "Thousands upon thousands were turned away because the theater could not hold them."[18] *Tarzan of the Apes* became one of the first films to generate a $1 million in box office revenues. By October, Elmo Lincoln had reprised his role in an anemic sequel entitled *The Romance of Tarzan*.[19] The gold rush was on.

The visual discourse about Africa was bilateral during these years. The rising generation of documentary filmmakers that were making pictures abroad kept abreast of the commercial developments back home, and the commercial filmmakers in the States kept a sharp eye on the films that were coming from the far-flung jungles of Africa, Borneo, and the Amazon. While the liberal license afforded by creative freedom certainly did not hold commercial filmmakers to any meaningful standard of objective reality, they tapped into "documentary" footage in several ways: first, as a way of capitalizing on the curiosity of a public that was infatuated with jungle themes, and second, as a way to buy real footage of wild beasts in foreign lands in order to bolster the less than credible images that had been shot on jungle sets in places like Fort Lee, New Jersey, and Los Angeles.

As a result, Africa became increasingly Americanized, and the divergence between the real, the supposed, and the imagined continued to narrow as film domesticated the narrative of nature. The awkward alliance between showmanship, entertainment, moral values, history, politics, and education that had been brewing since the days of Wild Bill Cody's "First Scalp for Custer" began to normalize. And in the clutter of filmmakers who were jockeying for position to make a reputation or a fortune, one young man from Kansas gradually emerged as the heir apparent to Akeley, Kearton, and Hemment: Martin Johnson.

THE VOYAGE OF THE *SNARK*

A year after publishing *White Fang* in 1906, Jack London and his wife Charmian sailed beneath the Golden Gate Bridge on his custom-made $700,000 ketch, *Snark,* for a five-year cruise around the world. Their crew consisted of a captain, who was his wife's uncle and whom London later called "utterly, agedly helpless"; an engineer, a twenty-year-old footballer from Stanford University who knew nothing about engines; a cabin boy, who was London's Japanese American valet and had never been to sea; and Martin Johnson, a twenty-three-year-old cook from Lincoln, Kansas, who lacked credentials either as a cook or as an able-bodied seaman.[20] For the first week out of port, Johnson was so seasick he couldn't even step into the galley as the gaff-headed rig pounded its way toward Honolulu.

Martin Johnson was a young man eager for adventure. He'd read an open letter written by London in his mother's copy of the *Woman's Home Companion* that described the *Snark's* intended ports of call over the next five years. For any young man reading London's letter, the call to adventure would have been irresistible. Tongue in cheek, London had teased the editor with the claim that he would confine his reporting of the journey to topics of domestic concern for the *Woman's Home Companion* and not rile up his audience with audacious stories of adventure. "If we are boarded by pirates and fight it out till out deck becomes a shambles—I won't write the account of same for "The Woman's Home Companion," he wrote. "If we are wrecked at sea, and starve and eat one another, I shall not send you harrowing details of same. Nor will I send you any account, if we are all killed and eaten by cannibals."

London's plan was to sail "up the Seine to Paris, up the Thames to London, up the Danube from the Black Sea to Vienna; up the Amazon and other big South American rivers; and in the United States, up the Hudson . . . and down the Mississippi to the Gulf of Mexico." And then there were "the canals of China, a summer at Venice, a winter at Naples, and certainly a winter at St. Petersburg."[21]

The prospect of a high-seas adventure with Jack London was too much for Martin Johnson to resist. He wrote a six-page letter to London, offering himself for no pay in return for passage. Five months later, he found himself below decks in heaving seas on the first leg of a journey around the world.

Over the next eighteen months, the *Snark* careened from island to island westward toward Australia. By the time they reached the Solomon Islands, however, all aboard were suffering from acute cases of malaria, dysentery, and yaws, a painful bacterial infection that causes skin ulcers and bone lesions. Disenchanted, Jack and Charmian London jettisoned their dream of sailing around the world and departed on a steamer for Australia. They left Martin Johnson on the island of Malakula in the New Hebrides with the *Snark* and told him to await their instructions.

As Martin recovered from the yaws, he met three Pathé cameramen who had just come from Manila, where they'd filmed the arrival of Roosevelt's "Great White Fleet." Pathé had told the cameramen stop at the New Hebrides on their way home and film the cannibals that were said to be living in the interior of the island. When Johnson asked the men if they would teach him how to run a motion picture camera, they took the young Kansan under wing. Jack London had let Johnson shoot photographs during the trip with the four still cameras he had on board the *Snark,* so Martin had already developed some photographic skills. He was a good student and had a good eye.

In a fateful turn of events, all three of the Pathé cameramen came down with malaria. With the arrangements for a trip into the interior already made, Johnson offered to make the trip

for them. The physically exhausted Pathé cameramen gave Martin a camera and their bless-
ings. At the callow age of twenty-four, Martin Johnson stalked off into the jungles of the New
Hebrides in search of a tribe of men that, for all he knew, might decide to eat him.

Johnson found both his cannibals and his career.

DANCING CANNIBALS IN KANSAS

In 1909, the year Roosevelt left for Africa, Martin Johnson returned home to Kansas. He'd
been knocking around the Pacific for almost two years, and he had a boxful of photos and
some reels of film to show for it. As he stepped off the train onto the platform at Indepen-
dence, the town band struck up "Stars and Stripes Forever" to welcome home its itinerant
hero.[22] Wherever Martin went, people pressed him for stories about Jack London and the
South Seas cannibals.

Then the owner of Kerr's Drugstore hit upon an idea. The travelogue lecture was a staple
of the vaudeville circuit, and Charlie Kerr promised Martin that people would pay good
money to hear him talk about the strange people in strange places and to see his pictures and
the first motion picture ever shot of *real cannibals.* Charlie smelled a sure thing and put up his
own money to prove it.

Martin agreed to Kerr's proposition, and they dressed Kerr's Drug to look like the *Snark.*
Kerr bought the chairs and the projection equipment and soon was advertising Martin John-
son's trip to the Cannibal Isles. "Swaying rhythmically from side to side, as the story tellers
say the serpents do under the spell of the charmer's lute," the *Independence* (Kansas) reported
Johnson's performance in January 1910; "a young man sat with a shield, purchased from a sav-
age Solomon Islander, between his crossed legs, and as he swayed he scraped a wooden pestle
upon the shield continuously, energetically, earnestly. . . . Behind Martin as he worked lay a
grinning human skull [with] seaweed growing through the eyes and nose."[23]

The travelogue lecture was a smash in Independence, and soon Charlie Kerr opened
another theater which he called Snark #2, where Johnson met a high school student who
"embodied all that [Martin] wanted in a wife—beauty, charm, a sweet disposition, and a will-
ingness to take risks while cherishing wholesome home and hearth values." Martin Johnson
eloped with sixteen-year-old Osa Leighty a few weeks later. Hearing the news, Osa's father
warned Martin that if he ever met him, "I will kick your ass in so hard that your spine will
stick out of the top of your neck."[24]

But Martin Johnson's future looked bright; Jack London and the cannibals turned out to
be good business. Kerr built Snark #3, an 800-seat theater in Cherryvale, Kansas, as Martin
continued to elaborate his narrative, which now included over 500 lantern slides and still
photographs that he begged, borrowed, or bought from other travelers.[25] Gradually, his story
became an adventure about places he'd never been and things he'd never done. He even cre-
ated a "Men Only" version of his show that showed nudes while he talked about the "bizarre"
sexual practices of the South Sea Islanders. At one point Johnson even proposed returning
to the New Hebrides to find "ten or twelve" old cannibals to bring them to America so they
could "sing and dance" for his audiences.[26]

By the end of the summer of 1910, however, interest started to wane, and the enterprise
collapsed, forcing the Martin and his child-bride to join a traveling vaudeville show in order to

pay their debts. They knocked about the western United States and across Canada as Martin gave his travelogue as Osa sang "pseudo-Hawaiian" songs. "Life among the little known South Sea tribes, where white people seldom venture," the advertisement for their show ran in the *Lethbridge* (Alberta) *Daily Herald* in August 1911, "Cannibals, leprosy, animal life and the tidal wave, and customs of the savages fully illustrated in the acme of Motion Picture Photography." Their grueling schedule often included two matinees and two evening performances daily. Admission ranged from five cents to a quarter.[27] They scraped by.

Two years later, the subsequent appearances of Jack London's account of *The Cruise of the Snark* (1911) and *The Strange Adventures of Captain Quinton—Being a Truthful Record of and Experiences and Escapes of Robert Quinton During his Life Among the Cannibals of the South Seas as Set Down by Himself* (1912) helped reinvigorate the demand for London's South Sea adventures and stories about cannibals. Gradually, Martin Johnson polished his story as he learned the rhythms of exciting storytelling and the expectations of audience so that by the time their show opened in the Criterion Theater on Broadway in New York City on June 16, 1913, it contained over 6,000 feet of motion picture footage, most of it bought, and fifty hand-colored lantern slides with provocative titles such as *Cannibals, Their Wars, Worship and Tribal Life; Dances of the Head Hunters; Leprosy and Elephantiasis; Missionaries among the Cannibals;* and *Midgets of Borneo.* His show had always been billed as *Martin Johnson's Wonderful South Sea Island Travelogues,* but a New York promoter demanded Martin change the name to *Jack London's Adventures in the South Sea Islands,* in spite of the fact that Martin knew the Londons would be furious when they found out he was trading on Jack's name. "Jack London," Martin privately admitted to London in a letter in 1910, "is my only stock in trade."[28]

The show premiered well, but by summer the audiences dropped off, forcing the producers to close of the show. The Johnsons went back on the vaudeville circuit during the war years until finally, in 1917, a consortium of investors from Boston offered $7,000 to go back to the New Hebrides to get film footage of their cannibals.

It'd been nearly a decade since Martin had tramped around the jungles of the New Hebrides as a callow young man, but the delay would serve him well. Not only had his years on the vaudeville circuit taught him the intricacies of the entertainment business, but he also witnessed the revolution of narrative in film and was beginning to understand the potential for Osa to become a bigger attraction for him than Jack London ever was.

BLOOD AND THUNDER

Osa Johnson was a vision of middle-American innocence: she was blonde, petite, doe-eyed, with a face of an ingénue. In spite of her down-home looks, Osa was as adventurous as her husband. From the beginning of their marriage, she insisted upon making her husband's career journey with him, and together they barnstormed the country on the vaudeville circuit. During their travels, the Johnsons would have certainly seen Serial Queen melodramas such as *The Perils of Pauline.* Martin Johnson was a quick study, and he understood that the exaggerated emotional stakes of melodrama appealed to "lowbrow" audiences that were hungry for "blood and thunder" and who wanted to become emotionally involved with the character's dilemmas. Although one contemporary described the working-class audience for these melodramas as "gossipy shop girls with mouths full of gum, weasely young men with well-watered

hair and yellow suspenders embroidered with green shamrocks, and fat immigrants with respiratory problems," the primary audience for the serial melodrama was female.[29]

The presence of a beautiful, fashion-conscious female in the central role bridged spectacle and narrative. The title role character in *The Perils of Pauline* (played by Pearl White) was both someone to look at and someone to watch as the action of the melodrama pivoted around her. She was both liberated, as a woman who rejected the Victorian norms of behavior, and victimized, as the target of an endless series of sadistic men who conspired to destroy her. "The genre as a whole," writes Ben Singer, "is thus animated by an oscillation between contradictory extremes of female prowess and distress, empowerment and imperilment."[30] As such, the Serial Queen melodrama was an escapist fantasy of female resistance to the repressive regime of Victorianism, which had bound women to the hearth and the authority of men and denied them the right to participate in the democratic process of state. The serials tapped into a powerful feminist discourse for women's suffrage during the second decade of the century, and the heroines of the serials provided a hyperidealized model of a woman who was confident enough to reject society's traditional gender casting of her as a wife and a mother. For example, when a suitor presses Pauline to marry him, she demurs:

> No, that won't do. As an old, settled down, married woman I couldn't really do what I want. I must see life in its great moments. I must have thrills, adventures, see people, do daring things, watch battles. It might be best for me even to see someone killed if that were possible.[31]

Pauline broke out of the whalebone corset of Victorianism, and although her life was still decided by men, she made herself the center of action in her search of the world. She balanced strengths traditionally conceived as masculine (agility, strength, and expertise with a gun) with strengths traditionally conceived as feminine (charm, glamour, and moral virtue). "The serial-queen melodrama's investment in images of female power implies women's disenchantment with conventional definitions of gender," writes Ben Singer, "while at the same time it celebrates transformations in women's status after the turn of the century."[32]

There is no way to know whether Martin Johnson saw *Lady Mackenzie's Big Game Hunt Picture* (also known as *Heart of Africa*), which premiered at the Lyceum Theatre in New York in June 1915, but the image of the young, attractive, and well-coiffed Lady Grace Mackenzie tipping her pith helmet to the camera while kneeling between two dead male lions she had just shot ("One Morning's Bag") foreshadowed the emergence of women in roles that until then had been strictly confined to men.[33] Lady "Mac" (who was no more a titled aristocrat than Selig or Jones were colonels) "was hailed as the first woman ever to penetrate so far into the jungle and was said to have outdone Rainey or Roosevelt."[34]

More likely, however, the Johnsons saw D. W. Griffith's landmark work, *The Birth of a Nation*, when it first appeared that same year. Based upon the melodramas of a Baptist minister from North Carolina who was a vicious racist, *The Birth of a Nation* was as controversial as it was a seminal work in cinema.

One of the more racially inflammatory scenes in the film flirts with themes of interracial sex and marriage when a black Union sergeant named Gus (played by a white man in blackface) aggressively pursues the object of forbidden desire, Flora, the virginal daughter of a white plantation owner. Horrified by Gus's intentions, Flora runs away from the "renegade" only to find herself cornered on a rock ledge high above the valley. As Gus closes in on her, Flora edges closer and closer to the edge of the precipice rather than submit to his advances. "Stay away or I'll jump!" she threatens in the intertitle.

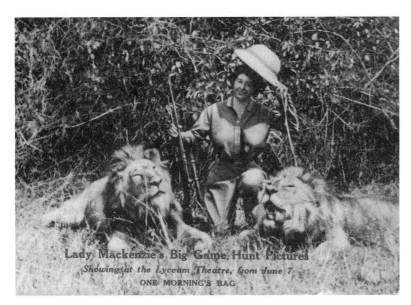

Lady Mackenzie's Big Game Hunt Pictures
Showing at the Lyceum Theatre, from June 7
ONE MORNING'S BAG

"Lady" Mackenzie's sham
Big Game Hunt, 1915

Inflamed by desire, Gus moves menacingly towards Flora. Preferring death to the implied alternative, Flora flings herself off the side of the cliff. Flora's brother exacts revenge from Gus by resurrecting the knights of the Ku Klux Klan to avenge the honor of white society by stamping out black men who lusted for white women.

Like Pauline (and Lady Mackenzie), Osa was adventurous and daring, unafraid of either beast or brute, and always concerned with her appearance. Like Flora in *The Birth of a Nation,* she retained a sense of youthful playfulness and innocence. Osa appealed to men as an object of desire and to her own sex as a woman who could do manly things without compromising her femininity.

When Martin and Osa Johnson sailed out of San Francisco harbor for the South Pacific in June 1917, Martin gave no indication he had any ideas of employing his wife as a white-woman-in-peril in a cannibal melodrama, but when he returned a year later, Osa had already settled into the film as its star.

On July 21, 1918, six months after the release of *Tarzan of the Apes,* Johnson premiered *Among the Cannibal Isles of the South Pacific* at the Rivoli Theater in New York. The film was an immediate critical and financial success.[35] The *New York Telegraph* applauded the film as an expert blend of education and entertainment, and the headline in the New York *Times* read "MOVIE MAN INVADES HOME OF CANNIBALS." "It would be unfair to the pictures," the review read breathlessly, "even if it were not impossible, to describe these scenes from the South Sea Islands."

The reviewer referred to the "devil-devil men" who still engaged in such barbaric practices as "burying useless old men and disposing of undesired children," savages who "Mr. Johnson says, are cannibals, and would have roasted him and his wife had not a British warship arrived in time to frighten them." The *Times* also acknowledged the value of Osa's screen presence in the film by noting that she added "an element of striking contrast, and it may be remarked that when she gets tired of following her husband into wild places she can probably get a mighty good job as a screen star."[36]

Among the Cannibal Isles of the South Pacific propelled the Johnsons into the ranks of the premier "documentary" filmmakers of their time. Even though they presented themselves and their stories as genuine, their work was an intoxicating blend of sensationalistic sex and

violence that exploited the imagined fears that Americans had toward the savage Other. They presented Melanesians as "fierce, filthy savages whose lives were governed by irrational violence and senseless customs."[37] They described them in simian terms, with toes like an ape and skin as black as a gorilla's, "nearer monkeys than men," wrote Martin Johnson, "the nearest thing to the missing link there is on earth."[38]

Even more alarming to American audiences, however, was the "Cannibal King's" infatuation with the beautiful, young white woman from Kansas.[39] "Apparently the whiteness of my skin puzzled the big black man," wrote Osa about her encounter with Chief Nagapate in her biography, *I Married Adventure,*

> With guttural grunts he first tried rubbing it off with his finger. This failing, he picked up a bit of rough cane and scraped my skin with it, and was astonished, apparently, when it turned pink. Shaking his head he then took off my hat and looked at my hair. It was yellow, and I suppose this also puzzled him. He parted it and peered down at my scalp, then he pulled it hard—then he turned me around, tilted my head forward and looked at the back of my neck.

Martin, fearful for his wife's safety, seized Nagapate's hand and shook it vigorously as he whispered to Osa to back away from the camp. "[Nagapate] caught me as I turned away," Osa continued, "He took my hand and shook it just as Martin had shaken his. . . . When I tried to withdraw my hand, he closed his fist hard upon it, and then began experimentally to pinch and prod my body."[40]

In Martin's cliffhanger version of the event, a British gunboat providentially appears, forcing the Cannibal King to back down from his unsavory intentions.

The film version of the encounter between the Cannibal King and Osa plays out differently. In *Among the Cannibal Isles of the South Pacific,* Johnson tells his narrative entirely through the title cards. "By this time we were literally scared stiff," he relates as the "Cannibal King" stares benignly into the lens of his camera, "and Nagapate's sarcastic laugh nearly paralyzed Mrs Johnson with fright." The visuals provide no action to support Johnson's narrative; it simply posits itself as the truth and then continues. "We packed our cameras and prepared to leave when Nagapate signaled his men. Each of us was seized, Nagapate himself holding Mrs Johnson, dislocating a wrist bone as she struggled." Meanwhile, Nagapate continues to gaze into the lens without showing any trace of ill will or madness.[41]

Nagapate wasn't a cannibal and likely his intentions weren't hostile. Even by Osa's account, he didn't dislocate her wrist. But Martin felt the need to create dramatic tension to carry the visuals, and so he exploited the developing trope of the black man (like Gus in *The Birth of a Nation*) who could not restrain his animal lust for a white woman. Just as importantly, Osa, for all her daintiness, held steady in the face of mortal danger. She never flinched or cowered, even when the cannibal murmured in wonder at her tender, white skin and golden hair.

Reviewers frequently mentioned Osa's appeal as a white beauty among the black beasts. One reviewer for the *New York Times* later wrote, "The strangeness of the savages is emphasized by the presence of Mrs. Johnson among them in many scenes. Looking as trim and easy as a girl out for everyday sport, she brings contrast interestingly into the pictures."[42] Her white, vulnerable presence amongst the dark savages supercharged the emotional and dramatic stakes of Martin's films.

Martin Johnson was perhaps the first nonfiction filmmaker to exploit taboos of abduction, cannibalism, and black/white rape at length. He wasn't as interested in understanding

the culture of the people he had traveled so far to visit as he was in making a film that would be a box-office success. It's hard to tell how much of Johnson's dread of savages was real or trumped up for his own purposes, although he later wrote in *Cannibal-Land* (1922) that the Melanesians were a threat only to people who intended to do them harm.[43] Certainly he was aware of the pressure on him to return to the United States with visual proof of his cannibals, and when that didn't materialize, he created a story within the written text of the title cards, based upon what he had learned about the power of melodrama he had seen in the movie houses of New York and Chicago.

His strategy worked because audiences were used to the conventions of the lecture film in which the images were of secondary importance to the verbal narrative. As a result his stories were more often insinuated than demonstrated visually. As narrative film matured and the lecture film faded away during the early decades of the twentieth century, however, audiences gradually expected the image and the narrative to reflect each other, without the substantial gaps that let Martin Johnson embroider his cannibal stories.

Nine months after *Among the Cannibal Isles of the South Pacific* opened in New York, the stockholders of the newly formed Martin Johnson Film Company sent Martin and Osa back to Melanesia to get, once and for, all unequivocal footage of "the real, raw cannibal savage." Such footage, Charmian London had convinced Martin, would be worth a fortune.[44]

For several months the Johnsons tramped through Melanesia in search of cannibals. He concocted a story about "monkey people" who lived their entire lives in trees, and he filmed elaborate ceremonies and rituals (such as the curing of human heads) but, alas, no cannibals.[45] Just as their hopes dimmed, they ran into local traders who told them about a tribe of cannibal *dwarfs* that lived on a neighboring island.

The Johnsons immediately set out for the interior of Espiritu Santo, the alleged home of the cannibal dwarfs. According to Osa, they hiked inland for three hours when they came across some "little people who might almost be classified as dwarfs" who were so terrified of their ruler that they begged Martin to kill him. "'He bad,' they explained agitatedly. 'He takem plenty pigs; he takem plenty women; he killem plenty men.'" After Martin "regretfully declined the task of executioner," he and Osa pushed on into the interior until they heard the sound of jungle drums and "caught a faintly sweet smell of roasting flesh."[46]

The Johnsons crept within view of the village and finally found the proof they'd been searching for: cannibals in the middle of a flesh feast. "I looked sharply toward the fire, and then I knew," wrote Osa. "Those pieces of meat spitted on long sticks were not the usual pork—they were parts of the body of a human being."

Martin filmed the cannibals as they sat around the fire, picking meat off the spit while others shuffled in a circle around them. As daylight dimmed, Martin gave a radium flare to one of the native boys with him and told him to sneak in among the cannibals and throw it in the fire.

The ignited flare terrified the natives and they scattered into the jungle but not before "snatch[ing] the meat from the fire as they ran." Martin ran toward the fire with his camera, hoping to film the body parts he had seen from the edge of the clearing, and much to his relief, he found a human head sitting in the embers of the fire. "There's proof nobody can get around!" he announced triumphantly as he filmed his charred prize.[47]

His triumph was short-lived. A cable from their distributor was already waiting for them as they exited the jungle: "The public is tired of savages," it read. "Get some animal pictures."[48] As it turned out, Edward Laemmle (the nephew of Carl Laemmle, a founder of Universal

Pictures) already had shot footage of "the real, raw cannibal savage." Laemmle's film, *Ship-wrecked Among Cannibals* (1920), premiered a full two years before Martin Johnson could edit and release *Head Hunters of the South Seas* (1922). By then the American public was weary of pictures about the strange ways that savages had for eating, loving, and smoking their dead.

Rather than go home, the Johnsons decided instead to spend the next several months in Borneo filming exotic animals in the Malaysian jungle, including some of the first footage ever shot in the wild of "The Elusive One," the orangutan. *Jungle Adventures* opened in New York in September 1921 and was an immediate financial and critical success, praised vigorously by the *New York Times* for its honesty and its deft ability to combine instruction with entertainment.[49] An advertisement in the *Times* billed it as "a fascinating tale of romance among the great ourang-outangs of the wilderness, the man-eating crocodiles, the denizens of primeval jungles, [and] herds of wild elephants."[50] A year later the Johnsons released *Head Hunters of the South Seas,* and, as predicted, it fared poorly at the box office, but Martin Johnson recut his footage into dozens of single reels that sold successfully to the education market.[51]

Unlike Roosevelt, Jones, or Rainey, who were less concerned with income potential than with advancing science or their own egos, Martin Johnson approached filmmaking practically rather than idealistically: either his films made money or he went out of business.[52] In order to attract investors, he developed a business model that included contracts, the distribution of stock, a schedule of deliverables, and a disbursement of profits. In addition, Martin's aesthetic skills as a filmmaker with a keen eye for lighting, composition, and editing were more sophisticated than Kearton's, Akeley's, or Hemment's. His years in vaudeville had also given him a knack for the theatrical and an innate understanding of story structure and pacing. More so than his predecessors, Johnson was interested in conflict and tension, and the need for the hero to triumph over nature's adversities, the very traits that made him an attractive prospect to those who were looking to cash in on America's newest animal fetish, the gorilla.

Adventures in Monkeyland

THE INTERRACIAL ABDUCTION FANTASY ABOUT APES (AND THE BLACK MEN WHO ACTED as their surrogates) had been simmering in Western society since the mid-nineteenth century, when a minor explorer from Louisiana by the name Paul du Chaillu showed up in London in 1861 with some gorillas skins and skulls that he'd collected in western equatorial Africa. It was the first time anyone had seen the fabled animal, and it sparked lively controversy in light of Darwin's revelations two years earlier with the publication of *On the Origin of Species*.[1]

Twenty years later, in 1881, *Ward's Nature Science Bulletin* published an anonymous poem entitled "The Missing Link" in which a gorilla king spurns a female chimpanzee in favor of a native woman, "a vision of beauty" such as he had never seen before. When the gorilla king confesses his love to her, the woman smiles at him, whereupon he sticks "his great prehensile toes" in her hair and carries her into the forest.[2]

The festishized abduction-rape fantasy subsequently rooted deeply in European and American culture. French sculptor Emmanuel Frémiet gave the fantasy physical form in 1887 when he created *Gorilla Carrying Off a Woman*, which replaced a "coarse" African woman with a "refined" European woman. Frémiet gave a copy of the bronze to the American Museum of Natural History, prompting Carl Akeley to remark that the captive woman indeed had "more of the earmarks of a Parisian model than of an African savage."[3]

There were no live gorillas in the United States when Roosevelt went to Africa in 1909.[4] Sporadic and ill-conceived attempts to capture adult gorillas had always ended in spectacular failure, and so the gorilla remained cloaked in mystique. Carl Akeley argued in 1921 that the gorilla was "more important than the study of any other African beast that has been the center of some many fables and superstitions" because of its close biological association with humans.

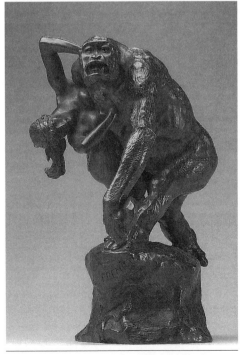

Emmanuel Frémiet's *Gorilla Carrying Off a Woman*, 1887

After the success of *Lassoing Wild Animals in Africa,* Buffalo Jones reprieved his performance in Africa in 1914 to search for gorillas. As he steamed toward Africa, he wrote his daughters, "I will soon be in Monkeyland and expect to rope a dozen or two [gorillas]."[5] Funded by an investor from Cleveland, Jones—now at the ripe age of seventy—tramped around the Congo with a foolproof plan for capturing them.

Based upon the "well-known fact that the gorilla is passionately fond of music and will not leave the vicinity of a camp as long as the music continues," Jones intended to capture gorillas by luring them into his camp with gramophones that played "the sweetest songs by women."

> It is also well-known that the gorilla is a greater fool than the old fool over women, and many native women have been carried off by him and kept for years in his den. This fondness for the frailer sex may prove the downfall of the gorilla, just as it has for many a man.[6]

After five months in the "cannibal-infested" Congo, Jones came down with a serious case of malaria followed by a heart attack that forced the aging man to return to the States.

The rest of the expedition stayed in Africa for another year and ultimately returned with a single monkey, a chimpanzee named Lindy, and three baby gorillas. "It would have been perilous to capture the mothers," the *Washington Post* explained, "so to get the baby gorillas, each several months old, it was necessary to shoot the mothers."[7] The baby gorillas died on their way to the States, and "Buffalo" Jones died four years later, chasing yet another farfetched dream.

The first serious attempt to film gorillas in the wild did not happen until 1921, when Akeley returned to Africa under the auspices of the American Museum of Natural History to collect specimens for the gorilla diorama in African Hall. Expedition member Mary Bradley put forth the rationalization of their mission: "Not one gorilla in any museum in the world was mounted by a man who had ever seen a wild gorilla, and not a specimen of the central or mountain gorilla was in any museum in America."[8]

On the upper slopes of Mt. Karisimbi in the Belgian Congo, Akeley shot the first film footage of mountain gorillas in their native habitat. He also shot three gorillas with a rifle, and Mary Bradley's husband, Herbert, killed the "Giant of Karisimbi," the large male that is currently on display in the AMNH diorama. In addition, the natives fatally speared an infant gorilla, which had become an orphan after Akeley had shot its mother. In light of the fact that Akeley himself estimated the total population of gorillas living on Mt. Mikeno and Mt. Karisimbi at between seventy-five and a hundred individuals, killing five of their number should have seemed like committing species genocide. Yet Akeley never gave an indication he was concerned about killing so many gorillas.[9]

He did weep over the death of those he had killed, however. "It took all one's scientific ardour to keep from feeling like a murderer," Akeley wrote in his biography, *In Brightest Africa.* "He was a magnificent creature with the face of an amiable giant who would do no harm except perhaps in self defense or in defense of his family." And yet Akeley's empathy didn't stop him from roasting and eating one of the gorillas so he could taste their flesh. He didn't like it.[10]

Akeley's sordid relationship with gorillas ended up with an even greater irony. Akeley was so profoundly affected by his experience that he spent the rest of his life lobbying for a gorilla sanctuary in the Belgian Congo. When he died, his body was buried on the slopes of Mt. Mikeno according to his wishes, so he could be amongst his brethren. Grave robbers later desecrated his grave. For decades, Akeley's grave has remained anonymous.

Nonetheless, Akeley did successfully complete the primary mission of the museum expedition. He did not consider himself a filmmaker, but rather as a technician who used the camera as a scientific instrument to record images for study and posterity. He only shot about 300 feet of film of the gorillas on Mr. Mikeno because he wanted to record his "first" encounter with them, not make a movie out of it.[11] News of his success whetted the public's appetite for gorillas, but few people have ever seen Akeley's moving images.

There are, however, still images of Akeley at work in his camp, skinning and decapitating the gorillas. Magazines published these unsettling images in the name of science, but in truth they are photos of trophy kills. Curiously, the first photographic images of gorillas to appear in public didn't show them in their natural habitat, but fallen and dismembered. However nobly the warrior Akeley praised his opponent's strengths, the moral of the tale was to celebrate dominion.

By 1923, the trickle of documentary films about Africa turned into a "flood." According to Kenneth Cameron in *Africa on Film,* seven documentaries premiered in 1923 and another seven in 1924, making those years "the two biggest years for nonfiction African films in the history of cinema," accounting for a quarter of all the African documentaries made in the twenty-year span between 1920 and 1940.[12] Some of the footage had been shot by amateurs who lacked the technical skills or the narrative polish to make successful films, such as F. Radcliffe Holmes, who wrote candidly about his filmmaking failures in *Through Wildest Africa* (1925).[13] Others who made documentaries were seasoned veterans such as Cherry Kearton (*On the Equator* and *Wild Life Across the World,* 1923) and A. Radclyffe Dugmore (*The Wonderland of Big Game, 1923* and *The Vast Sudan,* 1924), but they were often tired rehashes of work they had shot years before. (Kearton in particular reused footage of Buffalo Jones's *Lassoing Wild Animals in Africa* [1911] in several of his films.)

Meanwhile, Hollywood continued to churn out jungle melodramas, including three new Tarzan movies between 1920 and 1921. The idea of Africa as it had been created as a white American fantasy in the jungle melodramas bore little resemblance to the relict documentaries of a decade before. Audiences were losing interest in the expeditions of privileged elites like Roosevelt or Rainey; they wanted a film they could relate to in terms of their own experiences as blue-collar, working-class Americans, a film that reflected the virtues of virile, white American males and their families.

Then, in April 1923, Martin Johnson premiered *Trailing African Wild Animals.*

JOHNSON'S NEW AFRICA

The American Museum of Natural History had been mulling over the idea of producing films for the museum for years as a way to generate rather than expend income. Their sponsored expeditions to Africa were prohibitively expensive and required they mount constant subscription campaigns from donors in order to underwrite them. In addition, African Hall, which had been delayed by World War I, was still under construction, and the original construction estimate of a cost of $500,000 had doubled. "Naturally the first question that arises is how to obtain the million dollars," Carl Akeley wrote to Henry Osborn. "It is suggested that it is possible to secure this, in part at least, through motion pictures."

Akeley foresaw that motion pictures would complement the dioramas in African Hall. He proposed that the museum hire professional cameramen who could film "Africa in the broadest

and most comprehensive sense." Meanwhile, the critical and financial successes of Martin Johnson's *Among the Cannibal Isles of the South Pacific* and *Jungle Adventures* caught his eye.[14]

Early in 1921, Carl Akeley, the outgoing president of the Explorer's Club, invited Martin Johnson to join the ranks of prominent American explorers, the likes of Robert Peary, Roald Amundsen, and himself. (Osa was not invited to join because the club was exclusively male.) Akeley recruited the Johnsons to "make scientifically true motion picture records of the primitive tribes of Africa and its rapidly disappearing wildlife."[15]

Akeley had guaranteed President Osborn of the museum that any film made for him would be absolutely faithful to the facts and "contain nothing that can be criticized as to truthfulness."[16]

Akeley understood Osborn's disdain for common entertainment. He was a man of facts. He also understood that education did not depend the mere recitation of facts but the presentation of them in an engaging and empathetic way. Osborn's idealism notwithstanding, Akeley knew that Martin Johnson was good at *making* films. Akeley had already justified the inclusion of aesthetics in the dioramas for African Hall by arguing that the role of art was to serve science. He used the same argument when it came to putting entertainment into the service of education.

Martin Johnson's work was a stew made up of the raw and the cooked, the real and the imagined. The real came as images. Chief Nagapate of the Big Nambas on Malakula, the people who lived in the trees, and the human skull in the fire pit documented real events. To this day Martin Johnson's images of the people, their villages, and their ways of life remain important anthropological documents. Johnson's still and moving images of *rambaramp*—the life-sized wooden funeral effigies topped with the skull of the deceased—remain among the earliest and best ever taken.[17]

The fictions came as stories that were superimposed upon the visual facts. In Melanesia it had been about a Cannibal King who desired a beautiful white woman. The human skull Martin had photographed sitting atop a bed of coals in the fire pit at the center of the village on Espiritu Santo became part of a cannibal feast rather than a traditional Melanesian head-curing. Akeley understood that narratives were ephemeral and could be changed, but the images were genuine—*the things themselves*. So he recommended Martin Johnson without reservation to Osborn as the museum's resident filmmaker in Africa.

Interestingly, Johnson's contractual obligations to the museum were predicated upon his ability to generate major revenues. Johnson wrote a financial prospectus that laid out a timetable for production of two feature films, each of which he expected to net $100,000, and a "Big Animal" film that he called a "super feature" that "will be chock full of thrills, beautiful photography, comedy, and adventure." He predicted that this film "will be a very big money maker, certainly not less than $500,000 net." In his prospectus to the museum, Johnson wrote,

> My past training, my knowledge of showmanship, mixed with the scientific knowledge I have absorbed lately, the wonderful photographic equipment and especially the long focus lenses, the use of which I have perfected, make me certain that this Big Feature is going to be the biggest money maker ever placed on the market, as there is no doubt it will be the last big African Feature made, and it will be so big and spectacular that there will be no danger of another film of like nature competing with it. For these reasons it will produce an income as long as we live.

Convinced of the commercial viability of Johnson's plan, the museum committed $150,000 of venture capital, issued common and preferred stock to its investors, and then laid out a

profit-participation plan between the museum, its investors, and the newly formed Martin Johnson Expeditions Corporation.[18]

Two days after signing the contract with Johnson, Akeley and Osborn jointly signed a letter to George Eastman, the founder of Eastman Kodak and a major sponsor of the African Hall, to assuage his sudden doubts about investing in film production. Eastman had just seen a film sponsored by the Oakland Museum of Natural History called *Hunting Big Game in Africa with Gun and Camera* by H. A. and Sidney Snow. The *New York Times* called the film "the most complete, which means the most instructive and the most thrilling, motion picture of wild animal life ever made. . . . the last word, at least so far as animal life on the continent is concerned," but Eastman, as many others, were outraged by the film's patent fakery, which mixed African wildlife footage with bloody hunting scenes that were obviously staged.[19] Akeley and Osborn tried to distance themselves from the film, which was, in Akeley's words, "the last word in misrepresentation of fact in relation to Africa in general and its animal life in particular." Akeley and Osborn argued, perhaps a bit disingenuously, that Johnson's films would be "done without handicap of paying tribute to purely financial interests or of catering to the demands of [the exhibitors]" and that they would be "free from misleading titles, staging, misinterpretation, or any form of faking of sensationalism."[20]

Three months later, Martin and Osa arrived in Kenya. From the start, Martin and Osa created their own narrative about Africa. *Trailing African Wild Animals* (1923) was the first of the five feature length films and three lecture films they would make together in Africa before Martin died in a plane crash in 1937. *Trailing African Wild Animals* was built upon the pretense of looking for a lost lake in the sacred heart of Africa after Martin "discovered" the memoirs of an eighteenth-century Scottish minister in a dusty library in Nairobi that gave the directions to a land that existed "as in Abyssinia when the Pharaohs ruled, as it was in Canaan when Abraham came out of Ur." He and Osa put together "a caravan of camels, his 110 porters and thirty-six oxen, his three Ford cars and his twenty-four mules" and trekked into the wilderness for "thirty sundowns" beyond the pale of men and into a land of innocence "where pink lotus blossoms bloomed." There they found the Scottish minister's Lake Paradise.

"No longer Darkest Africa," wrote Helen Bullitt Lowry of the *New York Times,* "instead a glorious sun-cleansed Africa, fresh scented." In an article entitled "New Adam and Even Among Gentle Wild Beasts," Lowry described the new Africa, "as God made it."

> Not a dank equatorial jungle, fecund with crawling life, stinking with decayed vegetation. Instead, the high altitudes of wind-swept plateaus. Lands were a man and a woman can live together for two years without a day's sickness between them. No snarling wild beasts, slinking, devouring—a world of hatred and menacing dangers—as missionaries and move men alike have described it. Instead, an idyllic oasis, where nature is adjusted and where God is in His Heaven instead of the First Baptist Church, Topeka, Kan.[21]

Africa had not changed in the eleven years since Hemment had shot Rainey's film, but the American perception of it was undergoing a transformation that started with Hemment's pastoral views of wildlife. While the continent remained locked in a temporal vacuum, unable to achieve any real historical presence for Americans, the Africa that had so recently been described as inscrutable and threatening, now seemed not only hospitable but domestically familiar. "Wherever you look," wrote Helen Lowry, "animals dot the plain, grazing, galloping, as in a woodland pasture in Kentucky's Blue Grass region."[22]

The Johnsons built their home on the shores of Lake Paradise "like those of early American log cabins" hewn out of timber from the local forests. They led a biblical life, getting up with the sun and toiling until sun went down. The elephants stole sweet potatoes from their garden, and "silly" ostriches trotted about fussing over everything. "Zebra and oryx are always fighting," wrote Martin Johnson. "These idiots tear around after each other, kicking and snorting and fighting." In spite of their squabbles, however, the animals of Lake Paradise lived together peacefully. "They rub shoulders and all seem to be friends," Martin Johnson observed. "[W]e never even fired a rifle at Lake Paradise."

> Never was there a home happier than ours. There is no corner grocery store. The nearest telephone is 500 miles away. But we have sunshine and laughter and flowers the year round. In a sense, we are king and queen in our own right.[23]

And, much to the Johnsons' delight, they discovered that "the black boys were just as crazy as our own over the watermelons."

In New York, the film was an immediate hit and was "received with constant outbursts of applause." The good-looking couple from Kansas had homesteaded Paradise, where they lived as king and queen, Adam and Eve.

Martin Johnson made up the story about the Scottish missionary who had left behind the road map to Eden, just as he had embellished the story about the Cannibal King, Nagapate. Likely he modeled his Scot on the nineteenth-century Scottish missionary David Livingstone. Martin Johnson also invented Lake Paradise, which was already well known as Lake Rudolph just south of the Abyssinian border.[24]

The press raved about the film's authenticity and its deft ability to entwine entertainment and education. Many reviews made specific mention of Osa, who, in the words of the *New York World,* "appears not to have the slightest objection to the tickle of a lion's whiskers across her cheek." The beauty of Osa settled into an easy opposition to the beast. "Her distinctly feminine personality forms a striking contrast to the barbaric and quite evidently dangerous surroundings," the *World* noted.[25] But the grandest of praise came from Akeley himself, who pronounced the film "the finest thing in wildlife pictures that has come out of Africa, or any other place for that matter."[26]

Johnson's shining idyll distorted Africa just as much as David Livingstone's nightmarish vision of Africa "as the open sore of the Lord." The change in perception was at least partially the result of a change in the financial and spiritual values that Americans had assigned to Africa. Livingstone's book *Missionary Travels and Researches In South Africa* (1857) galvanized religious, political, and economic interests in Africa and helped to spark the British, French, German, and Portuguese scramble for control of Africa between 1869 and 1912. Perhaps the primary initial moral justification for an incursion into Africa was the charitable conversion of African heathens to Christianity.

Thomas Fowell Buxton, the leader of the antislavery movement in Great Britain, published *The African Slave Trade and Its Remedy* (1840), which presented Africa as "Bound in the chains of the grossest ignorance, [Africa] is prey to the most savage superstition. Christianity has made but feeble inroads on this kingdom of darkness."[27] Africa's "dark catalogue of crime" (which included slavery and cannibalism) "keep the African population in a state of callous barbarity, which can only be effectually counteracted by Christian civilization."[28]

As an institution with its own aims and practices, the missionary movement comprised the vanguard of political and economic interests in Africa. By creating and maintaining the myth

of Darkest Africa, the movement motivated contributors to advance and sustain the causes of Christianity and civilization. The missions in Africa established a beachhead for colonialism in Africa, "which affected processes of cultural change at the local level while offering suggestive insights into institutional changes at the macro-level."[29]

The conversion of the heathens was not just a spiritual enterprise but an economic one as well. Buxton portrayed Africa as the unfortunate victim of its own circumstances, a continent that begged for liberation so that its citizens would be free to engage in "legitimate commerce." In Buxton's words, Africa was "teeming with inhabitants who admire, and are desirous of possessing our manufactures."[30]

By 1914, seven European nations had fully divided Africa amongst themselves into fifty countries. Even though evangelical colonialism continued its mission to Christianize Africa, empire had taken firm root and the call to action became less pressing. The image of Darkest Africa began to lose its appeal; in its place grew the New Africa, brimming with light and hope, at least for the colonists. Martin Johnson tapped into this new vision of Africa as a "fresh scented" land of enchantment, a land that smacked of American progressive idealism.

Two years after he made *Trailing African Game Animals,* Martin Johnson made *The Wanderings of an Elephant* (1925), which was the purest natural history film of his career. For eighteen months, Martin and Osa followed elephants in eastern Africa and recorded their behaviors. Martin assembled the film so as to follow the hundred-year life-span of a single elephant. His motives for making this film are not clear; perhaps Martin Johnson wanted to live up to Akeley's and Osborn's expectations for a natural history film that was "free from misleading titles, staging, misinterpretation, or any form of faking of sensationalism."[31]

"My idea," Martin Johnson wrote to Terry Ramsaye, who edited the film in New York, "was to take a small elephant and follow it through its life until it was an old elephant . . . but I am now not so sure of this idea . . . for the reason that now that I see my film it seems monotonous . . . while I have photographed hundreds of elephants, they are all alike in the film, and there is not much action." *The Wanderings of an Elephant* went against his instincts as a storyteller and as someone who felt he had a finger on the pulse of commercial success. "It is a great elephant film," he wrote, "but from the public standpoint it has not enough thrills . . . no excitement to it, and I am enough of a showman to know that the public demands thrills and lots of them."[32]

The museum premiered *The Wanderings of an Elephant* for its members in late April 1925. Both showings were sold out; another 1,500 people were turned away at the door. "The whole thing 'went off big' with the house," the acting director of the museum, George Sherwood, wrote Johnson. In the next breath, however, Sherwood delivered the film's deathblow: "In your letter to me, you stated that the films are lacking in action. They are wonderful pictures, unquestionably the finest elephant pictures that have ever been taken, but, as you recognize, there is nothing in them to show the difficulties that you had to overcome to take such pictures."[33] *The Wanderings of an Elephant* never debuted in public. For Martin Johnson the museum's message was clear; in the end, commercialism trumped science. He wouldn't make the same mistake twice.

A PRESENTATION OF THE TRUE AFRICA

In January 1928, the Johnsons premiered *Simba, King of the Beasts* at the Earl Carroll Theatre in New York, which declared in an opening title that the film was "A Presentation of True Africa." With *Simba,* Martin Johnson freed himself from the tethers of the pure nature history

and returned to melodrama. He brought back Osa as his hero and then filmed her in a series of concocted close calls with death as she shoots a rampaging elephant, a charging rhino, and in the final sequence, a lion.[34]

Osa's role, which had already been defined by their experiences in the South Pacific, was to play the jaunty beauty among the sulking beasts, both animal and human. She was a refreshing figure for American audiences because she brought new dimensions into the discourse that helped define the new imaginary of Africa. Osa feminized a landscape that been dominated by white European males for over half a century. As a vessel of meaning, she expertly wove an ideological tapestry that contrasted Otherness between African and American, male and female, and white and black. These themes constituted the social dimension of Osa's character in the films.

One scene in *Simba* beautifully (and perhaps unintentionally) captures the contrast of Otherness between African and American, between male and female, and between white and black. The Johnsons have pitched their tent in a village that is in the midst of celebrating the end of a drought. On the left side of the frame, the villagers line up with their backs to the camera as they watch the main action in the village. Behind them, Osa stands inside the tent as she prepares to go on camera. The moment is intimate and feminine as Osa, arms akimbo, regards herself in the mirror. Expertly, she checks her makeup, pats her hair, and finally smoothes the wrinkles out of her chic safari suit before exiting the tent to join the festivities. She doesn't seem to be aware of the fact that she was being filmed and leaves the tent without glancing at the lens, which bolsters the idea of authenticity. In so doing, she resigns herself to the male gaze that shares her intimacy from afar.[35]

In the next scene, a black woman the title card condescendingly identifies as Osa's maid "gets what she thought was an idea" as sits at her makeup table and dabs white foundation powder on her face. The joke of a black woman in whiteface would have played well for the largely white audiences who were familiar with the white man in blackface that appeared regularly in vaudeville. Both representations control the essence of African-*ness:* their blackness. A white man in blackface displaces the blackness of the black man. A black woman in whiteface, however, does not deny a white woman her whiteness; rather, it reinforces her whiteness because it demonstrates that black women are so enamored with the ideal of white that they want to imitate it. The woman sitting at the makeup table is an effigy of racial loathing. Critics have often remarked how well the Johnsons treated the Africans as opposed to the repressive British colonials who bullied them. The Johnsons treated the "darkies" as if though they were *family.* Maybe not brothers and sisters but mute children, where men were "boys" and women occupied an uncertain sexual status.

Martin Johnson depicted African women as silly and vain, like the woman sitting at Osa's makeup table. They usually remained in the far background, on the verge of invisibility.

A third of the way through the film, Osa shoots dead a rogue bull elephant that charges Martin, who, according to the trope started by Cherry Kearton, steadfastly refuses to desert his camera.[36] "Tons of impending peril—maybe death!" screams the intertitle. "We had to stop the big bull!" the card claims self-defense. By counterposing Osa's prowess as a hunter against the paralytic black woman, Martin Johnson confirmed the status of the white woman in the racial hierarchy as not only above the African woman, but also above the African man, who were not the chiefs, wise men, or warriors of primal Africa that had so enamored Roosevelt and Akeley, but drones who work in service of their white masters.

Osa balances her manly skill with a lever-action Winchester with her feminine sense of

fashion. She has mastered both the beast and Africa, without surrendering her femininity. Most importantly, Osa keeps chaste her vulnerable white beauty.

In the next scene the Johnsons are in an African village. "The natives of our country were a pastoral race of half savage blacks," reads the title card. They walk through the village glimpsing African native life. "Man emerging from savagery," the title card reminds us. At the end of the scene two young African girls present themselves to the camera. They are bare-breasted and unself-conscious about their nudity. "Just a little black flapper," reads the title card, a double entendre that refers both to the chic white American flappers of the twenties, and a derogatory reference to the African woman's flaccid breasts.

Five minutes later in the film, Osa shoots another animal in self-defense, this time a "schizy" rhinoceros. Martin filmed her sitting astride the dead beast, the rhino's horn jutting up several feet between her legs. "Intermission" reads the next title card.

The second half of *Simba* repeats the same themes. The scene in the village that is celebrating the end of a drought in which Osa "makes up" herself inside the tent also contains a shot of two more young African women who have dressed ceremoniously for the event. "It takes only a few beads to glorify the African girl," reads the title card.

Intercut with these scenes Martin Johnson inserted a running gag about an old African man who can't figure out how to open a bottle of beer. The old man approaches the problem not by the logical process of trial and error, but by "monkeying" with the bottle, first inspecting it and then fussing with it until he finally gets the cap off and guzzles the beer.

The visual trope of the awkward savage trying to imitate civilized behavior or trying to grapple with modern technology became a staple of early ethnographic film. Robert Flaherty had already employed the technique to great effect in *Nanook of the North* (1922) when he set up a scene in which the title character examines a phonograph record, which is totally alien to him (and yet familiar to the audience) and then bites it three times as if trying to make sense of it. Martin Johnson admired *Nanook of the North* and reemployed Flaherty's techniques many times in his films. "This conceit of the indigenous person who does not understand Western technology allows for voyeuristic pleasure and reassures the viewer of the contrast between Primitive and the Modern," writes Fatimah Rony in *The Third Eye*.[37] The technique became a common racial trope in American fiction and nonfiction films about Africa, often played egregiously, as in *The Bushman* (1927), a film produced as a result of the Denver-African Expedition to Namibia in 1925, which contains a scene of the reaction of Bushmen to a portable phonograph that is playing an Al Jolson record song "containing the word 'Pickaninny' which the narrator explains with an exaggerated sense of irony is the only word carried over to American idiom by Africans."[38]

In the final scenes of *Simba,* a tribe of "Lumbwa" send out warrior hunters to kill a lion that had mauled the favorite ox of the king, which Johnson refers to as "His Darksome Highness." The scene is similar to the various Nandi lion hunts that Akeley, Roosevelt, and Rainey had arranged to film the warriors spearing a lion to death. Johnson didn't have enough footage to construct a full sequence, so he bought additional footage from American big game hunter Alfred J. Klein, who'd shot a similarly staged lion hunt in 1924 (*Equatorial Africa: Roosevelt's Hunting Grounds*). Just as he leased, bought, or borrowed footage and stills from others to put into his lecture shows about the Cannibal Isles of the South Seas, Johnson put aside what might or might not constitute the genuine for the dramatic needs of *Simba.*[39]

Johnson faked a narrative of the king's dead ox that was killed by one swipe of a lion's paw; he faked the village's dedication to revenge its death; and he willfully misrepresented the

purpose of the indigenous ceremonies that he filmed. In the film, the king sends a column of "priests" into the bush in order to assuage the rampaging lion; in fact, Johnson had recorded a mass circumcision ceremony of young men that obviously had nothing to do with lions.

As the Lumbwa encircle the enraged lion and close in for the kill, Johnson cuts to a close-up of the lion and then tells us that the lion is trying to decide whether to take his chances with the Lumbwa or with Osa, who holds her rifle at perpetual ready. "Nearer!" reads the title card. Johnson then cuts to Osa who steels herself for the lion's charge. Johnson milks the tension by delaying the action for a beat, and then in the matter of a few seconds, the lion charges Osa and without so much as flinching, she shoots the "roaring storm of fury." He drops to the ground, dead. Afterwards Osa stands around and jokes with the Lumbwa in order to suggest the African warrior hunters have accepted her as an equal.

Audiences of the time were not sophisticated enough to notice that Osa and the lion were never in the same shot together, and that Martin Johnson had filmed Osa separately (as cutaways) from the lion hunt and then constructed the story for the film. Although Osa had certainly killed lions during her years in Africa, she did not shoot the one in the film.

The final scene of *Simba* takes place back at the Johnsons' camp with Osa wearing a white apron as African children watch her roll out dough for an apple pie. Osa Johnson was the embodiment of the Roosevelt's frontier woman who lived her life in "the grinding toil and hardship of a life passed in the wilderness" but without sacrificing her "beauty and bloom." And whereas Roosevelt's frontier woman "was clad in a dingy gown and a hideous sunbonnet," Osa maintained perfect couture. Her pie and her apron affirmed the normalization of American domestic values and ideas in Africa. In the frame, black children stand beside her, waiting expectantly for their piece of American apple pie.

Simba, King of the Beasts (1928) made over $2 million, quadrupling Martin's prediction of "not less than $500,000 net" to the American Museum of Natural History in 1923.[40] Akeley and Osborn undoubtedly recognized *Simba* for what it was: a cinematic potboiler. The scientific rigor that Akeley had demanded initially of any film made for the museum lost its insistence, and as Johnson's techniques became more patently exploitive, the museum withdrew its endorsement of him.[41]

As America's darling adventurers and filmmakers in Africa, the Johnson became the primary manufacturer of images about the continent during the 1920s. *Simba* propelled the Johnsons into "the ranks of the superstars, and their names became household words across America."[42] The media doted on them the way it doted on Charles and Anne Morrow Lindberg. Their status as celebrities changed the focus of their work: from now on, their work would concentrate more on themselves than on the wildlife or people of Africa. They would dominate their films as the new archetype of the American adventurer-couple; as a result, Africa turns into something more like a playground than a testing ground, and the objects of their play become subjects of domination and derision.

THE TRUE-LIFE ADVENTURES OF KING KONG

America's fascination for great apes continued to gather momentum during the late 1920s. The Scopes "Monkey Trial" (*Tennessee v. John Scopes*) in 1925 brought sharp focus to Darwin, apes, and evolution when a high school biology teacher was charged with violating a

Tennessee statue that forbade the teaching of "any theory that denies the story of the Divine Creation of man as taught in the Bible, and to teach instead that man has descended from a lower order of animals."[43] That same year, a young African American boxer by the name of William "Gorilla" Jones stepped into the ring professionally as a middleweight.

The first documentary footage of gorillas wasn't shown publicly until 1926, when an adventurer-speculator named Ben Burbridge went to the Congo to capture live gorillas to sell to circuses and zoos. *Gorilla Hunt* (1926) documented the killing of three adult gorillas and the capture of several baby gorillas, which likely all died soon afterwards except for a four-year-old female that Burbridge brought back to the States and sold to Ringling Brothers, Barnum & Bailey's Circus."[44] "Congo" was the first live gorilla on public exhibit in the United States, and she piqued the public's fascination for great apes.[45] In the interests of science (and, no doubt, publicity), John Ringling let the pioneer primatologist Robert Yerkes conduct studies on "Congo" while she overwintered in Jacksonville, Florida, in early 1926. She died two years later with a diagnosis of colitis.[46]

Apes started showing up with increasing regularity in both fiction and nonfiction films. An anthropomorphized white gibbon named Bimbo stars as a central character in *Chang: A Drama of the Wilderness* (1927*),* a film that dramatizes the "eternal conflict of man and his implacable foe, the jungle, and the fierce beasts its dense foliage shelters."[47] Based upon the model of Flaherty's *Nanook,* the film is a hybrid of fiction and nonfiction. The film's producers, Merian Cooper and Ernest Shoedsack, cast native Laotians (whom they described as "a puckered jungle race") and directed them in a story—intercut with documentary footage—about a family determined to make its home in the jungle even as it is beset by pythons, tigers, leopards, and finally an elephant stampede that flattens their village and their home. Cooper and Shoedsack's frontier family stubbornly refuses to concede to nature and rebuilds.

Bimbo exhibits a full range of human emotions during the film. "The lighter side of the jungle life is depicted by Bingo, a simian, who is most comical in his expressions or curiosity, comfort, fright and anger," wrote Mordaunt Hall for the *New York Times.*[48] Bimbo's emotional reactions are more than just that of a monkey mimicking humans, however. He seems truly capable of those emotions partly because of his near-human size and partly because he has been integrated into the nuclear family.

Increasingly, safari-adventure films that featured Americans conquering, capturing, and taming the wild beasts and savage people who lived in far-flung Africa or Asia became part of movie matinee trade. In 1929, First Division Pictures concocted a hybrid documentary-melodrama titled *Up the Congo* that sensationalized the adventures of two women, Alice O'Brien and Grace Flandrau, who had journeyed (in the company of several men) into the Congo. Although much of the footage was indeed shot there, a features editor remembered only as "the Biggest Cutter in the Business" explained how First Division could commercialize the documentary footage so it would appeal to a larger audience. "All we gotta do," he formulated a success plan, "is graph the interest, redistribute the peaks, and potentialize the threat. We'll feature two ladies as having made the trip alone, run a title about the danger of exploration in the forest, show the tame elephants for wild, say that Teddy Roosevelt discovered the okapi, and play up the place where the Pygmies are shooting the party with poisoned arrows."[49]

The Wild Heart of Africa, which was released in 1929, was a rehash of footage of travel down the Nile from multiple sources. By early 1930, so many films about Africa were in circulation that a wag at *Variety* remarked that "so many people are going into woolly Africa with

cameras that the natives are not only losing their lens shyness but are rapidly nearing the stage where they will qualify for export to Hollywood."[50]

Many of the films that proliferated in the early 1930s that hybridized documentary footage from Africa and staged footage from Hollywood were largely as the result of the lack of supervision over content prior to the establishment of a movie industry code that defined what was ethically unacceptable to include within in a film. Even though the Motion Picture Association of America (MPAA) adopted such a code in 1930, lax enforcement until 1934 allowed some of the more unscrupulous producers to create films such as *Jango: Exposing the Terrors of Africa in the Land of Trader Horn* (1930, and rereleased a year later as *Jungle Hazards*), which turned into a scandal when Firpo Jacko, a janitor from Harlem, sued the production company for back wages that he had been promised for playing the role of a cannibal in the film.

Columbia Pictures also released *Africa Speaks* in 1930, which purported to follow the Colorado-Africa Expedition for 18,000 miles over fifteen months. Like many of its predecessors, *Africa Speaks* is a patch quilt of real and faked footage, including sequences staged and shot in Hollywood.[51] Nonetheless, Columbia Pictures billed the film as "an authentic and rare record of hitherto undiscovered monsters, disfigured folk, and customs of odd humans." *Africa Speaks* traded on bestial violence. "See Kiga, the king's son, torn to pieces by a lion in front the sound camera!" Curiously, the complaint filed against Columbia Pictures came from Talking Picture Epics, a company that distributed Martin and Osa Johnson's films, which alleged "that the big thrill in the Columbia picture, the scene showing a native being killed by a lion is fake, same being staged in the local Selig Zoo by the use of a Los Angeles darkey and a toothless lion from the zoo."[52]

In 1931 Ernest Shoedsack, one partner in the team that had made *Chang*, released *Rango*, a film shot in Sumatra that flirts with the relationship between humans and "their closest living relatives," orangutans, and Robert Flaherty released *Tabu*, a melodrama of the South Seas, which he directed with the German expressionist F. W. Murnau, the director of the vampire classic *Nosferatu, A Symphony of Horror* (1922)

Ubangi, also released in 1931, pirated footage from a Belgian medical expedition that had gone to the Congo in 1924 to investigate the origins and yellow fever and sleeping sickness. The Imperial Distributing Company then added a voice-over narrator who, much like Martin Johnson's fanciful story of the cannibal chief Nagapate, tells a story that bears no relation to the images. By 1931, however, viewing audiences were sophisticated enough to see through the narrative pretense when the main character of the film is gored to death by a wounded rhinoceros offscreen. "The photography in *Ubangi* is not tainted with any signs of professionalism," sighed *New York Times* movie critic Mordaunt Hall. "At no time is a really clear reflection thrown on the screen and many of the hazy scenes would be meaningless without the synchronized comment."[53]

In this clutter of films about cannibals and apes, one film overshadowed the others to such a degree that it sent them "winging into oblivion with a patronizing two-line review."[54] *Ingagi* (1930) claimed to record a two-year expedition to the Congo mounted by Sir Hubert Winstead of the Royal Geological Society. The film chronicles a tribe of Pygmies that offer a female virgin to a totemic gorilla of the forest and the offspring of the ape-woman union. Congo Pictures advertised the picture as "An authentic, incontestable celluloid document showing the sacrifice of a living woman to mammoth gorillas!" The lobby card in the Garrick Theater in Chicago showed an "erect" ape holding a topless African woman under his arm. His hand cups her breast, and the look on her face mixes surprise and desire. "Wild Women— Gorillas—Unbelievable!" the banner read.

The film was a fraud. Congo Pictures stole scenes of African wildlife from *Lady Mackenzie's Big Game Hunt* (1915) and then shot the story about the Pygmies in Luna Park and the Selig Zoo in Los Angeles. In spite of being panned by a few critics who found the film "not at all convincing" and "spoiled by extraordinarily bad photography," the public flocked to see a film that flaunted the taboo of sex between women and gorillas.[55]

In its review of *Blonde Captive* (1932), a hybridized film about a white woman who is abducted by Australian aboriginals in the Outback (and narrated by Lowell Thomas), *Variety* acknowledged sexual liaisons between the races in "number of known instances of white women who drift into the [Australian outback] just as white women consort with the Negro element in Harlem."[56]

Thomas Doherty writes in *Pre-Code Hollywood*,

> At the psychic core of the genre is the shiver of sexual attraction, the threat and promise of miscegenation. Forbidden by Jim Crow, desired darkly by the id, the dread and the allure of racial mixing, cultural and sexual, is the thread that binds together the divergent motion picture styles of the racial adventure film.[57]

The Federal Trade Commission filed a complaint against Congo Pictures not for its nudity or the suggestion of bestial sex, but for "false, fraudulent, deceptive, and misleading advertising." The FTC found after its protracted investigation that

> the so-called pygmies said to be shown in their native environment were not pygmies at all, but colored children of from five to ten years old, living in Los Angeles. The native woman represented as being sacrificed by her tribe to the gorillas was a Los Angeles colored woman, while the people represented as "strange creatures apparent half-human and half-ape" were actually colored people living in Los Angeles and made up for the purpose of the picture.[58]

Byron P. Mackenzie, the son Lady Mackenzie, sued Congo Pictures for pirating his mother's film and settled out of court for what was then the enormous sum of $150,000. Finally in 1933, the FTC issued a "cease and desist" order, which forced the distributor, RKO, to withdraw the film from exhibition. By then *Ingagi* had already grossed $4 million, making it one of the most profitable films of the Depression.[59] Encouraged by the box office receipts, the executives at RKO, on the verge of bankruptcy, decided to invest in another ape film that went into production less than a year later: *King Kong*.[60]

So many people have been nominated as the prototypes Carl Denham and Ann Darrow, two of the lead characters in Cooper and Shoedsack's *King Kong,* that it hardly makes sense to nominate two more, but the parallels between Martin and Osa Johnson and Carl Denham and Ann Darrow are worth noting because they represent a popular culture type that flourished during the 1930s.

Martin Johnson was a figurative prototype of the character of Carl Denham.[61] Both were relentlessly ambitious movie men who brought a blonde starlet into the jungle so they could get rich making a film about beauty and the beast. And like Carl Denham, Martin Johnson lived suspended between the business world of moviemaking and the dream/nightmare world of nature. When Denham knocks out Kong with gas bombs on Skull Island (proof of the power of technology to humble the greatest of the world's beasts), it might just as easily have been Martin Johnson who said "Why, the whole world will pay to see this!"

Osa Johnson was also a figurative prototype for Ann Darrow (played by Fay Wray) in the

film. Just as Ann Darrow makes the film for Denham, so Osa made films for her husband. Although both women were the stars of their films, they remained subordinated to the men's work that surrounded, protected, and even venerated her. Even though she was the star of Martin's films, Osa's femaleness kept her marginalized. "What counts," writes Budd Boetticher about the role of the female in the spectacle-narrative, "is what the heroine provokes, or rather what she represents: "She is the one, or rather the love or fear she inspires in the hero, or else the concern he feels for her, who makes him act the way he does. In herself the woman has not the slightest importance."[62]

In spite of her radiant cheerfulness and pluck in her husband's films, Osa grappled with chronic bouts of depression and alcoholism throughout her life as Mrs. Martin Johnson.[63]

CONGORILLA

The Johnsons returned from Africa in the fall of 1928 with *Across the World with Mr. And Mrs. Johnson* (1930), a travelogue that included everything from Boy Scouts to prominent product placement shots for Willys, which provided them with trucks, and Maxwell House Coffee, which provided the brew. The film was critically and financially successful, although a few critics began to sound sour notes, such as *Variety,* which called it "tiresome entertainment for the adult film addict."[64]

The Johnsons returned to Africa just days after the stock market crash in October 1929 with plans to make a film about the M'buti Pygmies of the Ituri forest of the Belgian Congo and the gorillas that lived on Mt. Mikeno, where Akeley had shot his footage almost ten years before. The Johnsons had been in the States during a critical period in the development of African gorilla films in 1929 and 1930, which likely affected Martin Johnson's decision to target both Pygmies and gorillas for his next film. They were aware of *Africa Speaks* (his distribution company had filed the complaint of fakery against the film) and that Hoefler had already been to the Ituri forest to film Pygmies.

The Johnsons returned to the United States in the summer of 1931 with enough footage to cut a lecture film, *Wonders of the Congo* (1931), which they took on a tour of major American cities. During that time, they likely saw *Ingagi* and perhaps several of the other African releases that were making the rounds on the screen.[65] In the summer of 1932, the Johnsons released *Congorilla: Adventures among the Big Apes and Little People of Central Africa,* a film about gorillas and Pygmies that exploited both purely for the sake of entertainment.

Congorilla abandons the pretense of the Garden of Eden and returns to the trope of Africa as a dark, savage place, where, an opening title card reads, "Peril and Death stalk amid primitive savages and primeval monsters." Twenty minutes into the film, the Johnsons encounter the M'buti Pygmies of the Ituri. They are an amiable bunch, which the Johnsons call "the happiest little savages on earth," who unwittingly offer themselves up as the butt of twenty minutes of racial pranks.

Racial bigotry was certainly not unique to the Johnsons or the majority of other white filmmakers of the time. Part of the imperial focus of African films from the time the black porter carries an overweight Roosevelt across the stream in *Roosevelt in Africa* (1909), Africans served as vehicles (both literal and metaphoric) to endorse white supremacy. The anonymous black faces that populated both the nonfiction and fiction films produced by Americans

between 1909 and *Congorilla* in 1932 are racial ciphers whose purpose it was to *increase* the distance between whites and people of color by proving the superiority of those who made and those who watched the films. While evidence of racism was common in all of the Johnson's films, the racism becomes more trenchant and mean-spirited in their later films. It had been twenty-eight years since the Pygmy Ota Benga had been put on display in the monkey house at the Bronx Zoo. Little had changed since then. "I found [the Pygmies] about the same size of a civilized baby when they are born," Martin Johnson relates in the voice-over, "and they grow until they are about ten years of age. Then all development seems to stop. An old pygmy seventy years of age is still a child of ten, both physically and mentally."[66]

Two conceits drive the sequences about the Pygmies. The first centers around two adult male Pygmies who ask Martin Johnson for cigars. "Yes, tobacco, that's all you do is beg," Martin says caustically as he hands them each a cigar. "Let's see you smoke it. Now smoke your heads off. I hope you get sick." For the next five minutes, the camera records the men trying to light their cigars with matches. Johnson then inserts an obviously contrived shot of at least fifty burned out matches on the ground. Finally Johnson steps into the frame, a white giant in comparison to the Pygmies. "Give me those

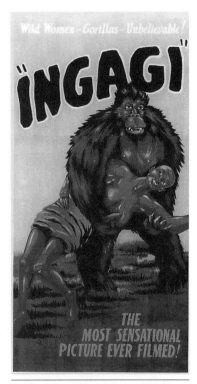

Movie poster for the sensationalistic *Ingagi* (1931), one of the most profitable films of the Depression

matches," he barks, "you give yourself a box of matches and you make my nice cigar look like cabbage." The cigars lit at last, the Pygmies puff contentedly. "There is nothing in town more hilarious than the efforts of two of the Pygmies to light the cigars," wrote the *New York Herald Tribune*. *Variety* agreed: "the business with the pygmies attempting to light cigars was good for a marathon of laughs."[67]

The Johnsons provided the audience with plenty of opportunities to laugh at the indigenous M'buti for their ignorance of such simple things as a bar of soap (which like the Inuit in *Nanook* who tries to chew a phonograph record, they try to eat) or a balloon, which an M'buti elder blows up until it explodes. "Perhaps it would not be too much to say that [*Congorilla*] forms a good model for the future for Mr. and Mrs. Johnson and all the rest of the camera and gun brigade," suggested the *New York Times*.[68]

The second conceit is built upon a Pygmy wedding that is staged as if children were play-acting an adult romance. Jungle drums announce the impending nuptials, and hundreds of Pygmies pour out of the forest to celebrate. The Johnsons decide to "host" the reception by providing a mountain of bananas and playing swing music on their phonograph, a marvel that the Pygmies accept "without curiosity as just another wonder of the white man."

The climax of *Congorilla* involves the capture of twin juvenile gorillas in the wild. "Absolutely authentic, true and hair raising," reported the *Hamilton* (Ohio) *Evening Journal* about a scene in which the Johnsons scramble to throw a net on the stranded juveniles, whose screams reminded Martin Johnson "of an hysterical woman."[69] At this point *Congorilla* perpetrates

many of the same crimes as its contemporaries. The capture sequence was staged and filmed in a fenced compound next to the Johnsons' house on the outskirts of Nairobi. They bought a third juvenile for $60 and then set up sequences around "camp" in which the gorillas drink beer, eat sugar, and then bathe before they are safely tucked in for the night.[70]

However cute or funny *Congorilla* might have been perceived to be, the film reflects the couple's weariness. Martin is cynical and scolding, and Osa at times seems defeated and her performance dazed. By the time they issued *Baboona: The Bride of the Beast* (1935), their work had become predictably formulaic. Only the novelty of filming Africa from the air kept the film fresh. "Their peripatetic cameras provide us with precious little of the blood-chilling jungle combats which enlivened the photographic safaris of other years even when their authenticity was open to grave doubts," wrote the *New York Times* film critic André Sennwald. "*Baboona* devotes an unconscionable sum of footage to the minor domestic activities of the Johnsons."[71]

Martin Johnson died in a commuter plane crash in 1937, and Osa continued their film career solo for several years. She never remarked on her husband's alcoholism and depression.

Whether in Africa, the South Seas, or the Amazon, the United States scattered the seeds of empire throughout the Third World and then watched them sprout. The American frontiersman and woman were stock characters in this environmental imaginary, reaffirming their racial and gender superiority under even the most hostile conditions. The discourse of conquest was monologic, allowing those who created it to exalt its power and reaffirm the Great Chain of Being with the United States at the top of all nations and the white male at the top of all races. The visual absolutism of the images developed during this time created an indisputable archive that rendered brute nature impotent by capturing it by net, gun, or camera. The chief agents of dominion became Winchester and Kodak, and their products—the taxidermic mount and the cinematic image—relegated nature to a purgatorial space, impossibly suspended between life, its referent, and death, its sign. As Roland Barthes phrased it, the taxidermic mount and the cinematic image provide "a live image of a dead animal." Physical death no longer provided an escape from tyranny.

The hunter and the photographer maintained the romantic pretense that foes of equal strength, courage, and determination were destined to meet on the field of battle, a distinctly imperial notion that was reflected in the poems of Kipling, the novels of Wister, the paintings of Remington, and the historical musings of Roosevelt. The deck was stacked, off course, and the outcome never in doubt.

In 1933 *King Kong* proclaimed a victory in the war between nature and humanity as Carl Denham and Ann Darrow humble the superbeast with the superior technology of modern warfare: gas bombs, machine guns, and airplanes. Three years later, when the American Museum of Natural History opened the doors to African Hall, Akeley's "Giant of Mikeno" rose up from the forest floor and beat his breast at the intruders who trespassed into his domain. And again, modern technology rendered his rage impotent.

In 1932, William "Gorilla" Jones won the undisputed middleweight championship of the world.

Nature, the Film

IN 1973, HAYDEN WHITE PUBLISHED *METAHISTORY,* A SYSTEMATIC STUDY OF A NEXUS of aesthetic constructs that underpin the historiographical text.[1] White contended that the historian, conditioned by preconceptual layers of historical consciousness, selected and organized "data from the unprocessed record" of the historical field into a "process of happening" with a beginning, middle, and an end "in the interest of rendering that record more comprehensible to an audience."[2] In other words, the historian, either consciously or unconsciously, unifies disparate elements within the historical field to create a rhetorically constructed prose narrative.

Roland Barthes had broached the idea twenty years earlier in "The Discourse of History" (1967), remarking that historical narratives were figurative representations—stories—created out of "a web of signifiers and signifieds projected onto a referent." White, however, proposed a more formal system—a grid—that contained the various elements that structured historical narratives. These *modes of explanation,* he ventured, "are embodied in the narrative techniques, the formal argumentation, and the ethical position developed in the historiographical discourse."[3]

White's ideas generated a firestorm of criticism, which prompted one pundit to remark that *Metahistory* is more famous for the debates it generated than for the ideas themselves.[4] But because natural history film developed as a hybrid form that conflated both historical and literary traditions, however, it occupies a middle ground between documentary and fictional narrative. On the one hand it assumes the posture of the documentary by claiming an *indexical bond,* a correspondence between the thing being represented and the thing itself. On the other hand, it employs traditional dramatic devices such as the development of structure (a beginning, a middle, and an end), character, and conflict. Putting aside the more contentious aspects of his theory of historical work, White's *modes of explanation* provides a viable method for examining the different ways in which films about nature encode cultural and political dogma within these dramatic narratives.

White divided the modes of explanation into three categories: *ideological representation, argument,* and *emplotment.* By conducting an archaeology of these modes of explanation, we can inquire how a historically situated set of social, technological, and visual practices constructed landscapes and the people and animals that live within them.

IDEOLOGICAL REPRESENTATION

The American discourse about the natural world purports to use the incontestable objectivity of science to discover the morality that is fundamental to nature. Such discourses, argues White, are laden with ideologies that reflect the historian's assumptions about how the past relates meaningfully to the present. "By the term 'ideology,'" White explains, "I mean a set of prescriptions for taking a position in the present world of social praxis and acting upon it (either to change the world or to maintain it in its current state)." Typically these prescriptions claim the authority of science or realism.[5]

African Hall in the American Museum of Natural History is deeply infused with social ideologies about race, family, and gender and political ideologies about strength, wealth, and power that instruct the roles nature has assigned to males and females, parents and children, and citizens of the state. These beliefs focus on social ideas that relate to racial segregation, gender, family, and physical exceptionalism. After 1936, films about nature embraced these same ideologies, where they remain largely in tact to this day.

The *segregation of species* in African Hall reinforced the atomization of nature by presenting animals in a biological periodic table of life with each species residing within its own nomenclature, within its own square juxtaposed to other squares.[6] Its celebration of Africa promotes taxonomy over taxidermy by separating the kingdom of nature into its racial components. Of the twenty-nine dioramas in African Hall, only four mingle species in a common space—*Libyan Desert*, *Upper Nile*, *Serengeti Plain*, and *Water Hole*—and even then the animals almost always mix with their own "kind." The diorama *Libyan Desert*, for example, combines two species of antelope with a gazelle. Other than a viper, which is half-buried in the sand, there are no other animals in the scene. Similarly, the animals that congregate around the tree in *Serengeti Plain* mix five species of antelope and gazelle with one species of zebra. No other animals appear in the frame.[7] In Akeley's Eden, animals keep to their biological selves.

Only three dioramas divide space equitably with different biological families: ostriches with warthogs; leopards with bush pigs; and hyenas and jackals with vultures.[8] The animals are always alarmed or threatened by the presence of the Other. The object lesson of African Hall is that safety depends upon maintaining a vigilant separation from others outside one's racial "family."

The hierarchy of order also applies to *gender*. In the nature created within African Hall, males are "naturally" superior to females. The chest-beating male silverback in *Mountain Gorilla* and the lead elephant bull in *African Elephants* act out the same gendered role as the dominant male in Akeley's *Muskrat Family Home*, a half-century earlier.[9]

Not only are the males usually larger or more colorful (a biological fact), they almost always preside within the frame by virtue of their physical placement within the visual composition. Males occupy the high ground, literally and figuratively, as in *Black Rhinoceros*, where the male stands at the center of the frame while the female reposes at his feet. *White Rhinoceros* contains a family of three: a bull, a cow, and a calf that line up in a clearly hierarchical order within the frame. The male takes the lead; the female stands a few steps behind the male; and the calf yet a few steps farther behind her. The male in *Greater Koodoo* towers above the female, as does the bull in *African Buffalo*. The females in *African Lion* lie prostrate before the male; the male giraffe in *Water Hole* turns a watchful eye while the female stoops to drink; and the females and juveniles in *Chimpanzee* and *Mandrill* all radiate from the male that dominates the frame. The ideology of gender concludes that the "natural" role of the male is to be alert, prepare for

danger, and when necessary defend his family, while his female(s) and juveniles huddle within his protective penumbra. It is an iteration of Roosevelt's West.

Coeval with gender is the ideology of *family*. When the African Hall opened in 1936, *Time* celebrated the social unity of family in the dioramas:

> In the damp uplands of the Belgian Congo a glowering male gorilla beats his breast, while the female leans placidly against a tree, watching her baby eat wild celery. At a waterhole a mother giraffe with widespread forelegs is bending down to drink. Beside her are the male, keeping watch, and the calf. Nearby a young Grévy's zebra is suckling its mother.[10]

The social core of African Hall is the family. Not counting birds or ornamental animals (such as a snake or squirrel) or animals used as foils for the main action, such as the porcupine that blocks the way in *White Rhinoceros* or the giant forest hog that distracts the antelopes in *Bongo*, there are 167 large mammals on display in African Hall. Of that total, seventy appear as mated pairs, and eighty-six appear within nuclear or extended families, which contain a mated male and female(s), and one or more juveniles.[11] Only eleven animals appear without mates.[12]

Lastly, African Hall is a showroom for the *physically exceptional*. There are no weak, wounded, old, or dead in this eugenic rendering of paradise.[13] Akeley only collected specimens he felt represented the physical zenith of the most dangerous, the most beautiful, and the most imposing of Africa's large vertebrates. Consonant with belief that masculine vigor was essential for a robust nation, these animals exemplified Roosevelt's "strenuous life," "the life of effort, of labor and strife; to preach that highest form of success which comes, not to the man who desires more easy peace, but to the man who does not shrink from danger, from hardship, or from bitter toil, and who out of these wins the splendid ultimate triumph."[14]

Akeley's specimens reflect the same ethic. "It would seem worth while," he wrote in *National Geographic* in 1912 during his search for the perfect elephant, "that the world's permanent record of elephant life should contain a specimen that illustrates the fullest development of the African species, the finest living representative of this race of animals."[15] For Akeley the ultimate measure of an elephant was size. His field notes are filled with measurements: *height at shoulder, height to top of head, circumference of fore foot, height above pelvis, spread of ears*, and, most importantly, the *weight* and *exposed length of tusks*. In April 1910, Akeley wrote to Henry Fairfield Osborn that a bull that had been killed in the Budongo Forest of Uganda had tusks that weighed 181.5 and 183 pounds.[16] "Of course I do not even dream of getting such a one," he lamented. (By comparison, the tusks of the lead bull in the elephant display in African Hall weigh about 83 pounds each.)

For Akeley, nature's standard was the apex of a species, which commanded respect because its size, its color, or its potential for violence. It either had wonderfully formed claws that ripped, teeth that tore, or antlers, horns, or tusks that gored. There was no place for deformed, stunted, scarred, or even ordinary animals in Eden. These animals were the masters of their race, the progenitors of empire.

In the diorama *Giant Eland*, the horns of the male spiral four feet above his head. A pendulous dewlap hangs from his jowls to his upper chest. He is striking animal weighing nearly a ton and almost nine feet long, with vertical white stripes against a chestnut coat. He glares at the viewer, his body tensed, while the female grazes beside him. They overwhelm their space with mass and vibrant color. Everything else in the frame is muted. On the wall adjacent the

diorama, a plaque lists the plants in the display by their botanical name and at the end of the list, the last entry reads, *Nightjar.*

The nightjar is a nocturnal bird with long wings and stubby legs. Because it nests on the ground, its plumage mimics leaves and bark and allows it to blend into the landscape. The nightjar in the diorama sits amongst the fallen leaves in the foreground not far from the hooves of the giant eland, and like the squirrel in the gorilla diorama, it takes a determined viewer to find it. Whereas the charismatic giant eland commands the viewer's attention, the nightjar deflects it. Its genius is to be invisible, but that genius also marginalizes it in the display. Compared to the dramatic giant eland, the nightjar serves no purpose other than to provide a piece of biological trivia neatly hidden away for those who take delight in discovering such detail. The dioramas promote the majestic over the mundane and the brash over the meek; in short, they draw a self-portrait of American national character.

These images of nature appear to make the social claim, *So as it is in nature, so must we make it in society.* Although this ideology reflects the American social and political culture of the early twentieth century, film continued to venerate its tradition even after replacing the natural history museum as the hegemonic source of images about nature. One need only compare the number of films made about lions to those made about nightjars to grasp the point. Although a growing feminist consciousness has loosened the grip of patriarchy, films about nature continue to valorize the same basic social and political ideologies of racial segregation, gender, family, and physical exceptionalism that remain on display in the natural history museum.

ARGUMENT

Argument consists of the rhetorical strategies that frame an historical field within a broader social context for deciding how life "ought" to be. Simply put, White writes, *argument* explains "the point of it all" by providing explanations "of what happens in the story by provoking principles of combinations which serve as putative laws of historical explanation."[17] The dramatic shift in representation that occurred when the imperial agent disappeared from the visual frame aggravated the angst society felt as a result of the deepening alienation between itself and nature. Under the imperial imaginary, the action precipitated around the colonizing agent *because* of him. He was the imperial hero, before whom both nature and the dark-skinned nations deferred.

In 1902, Lala Din Diyal photographed the British viceroy of India standing over a tiger he had just shot. *Their Excellencies Just After Shooting, Souvenir of the Visit of H(is) E(xcellency) Lord Curzon of Kelleston, Viceroy of India to H(is) H(ighness) the Nizam's Dominions* captures the essence of the imperial imaginary. In the foreground of the photograph, Lord Curzon, dressed formally in coat and tie, jodhpurs, and pith helmet, stands at a gentlemanly parade rest, his left hand tucked into his jacket pocket, Edwardian style, and his right hand propping up his rifle. His attentive wife, standing at his right a few paces behind him, is dressed in high Victorian style, casually rests her hand on the tree next to her. The viceroy and vicereine stand in a shining circle of light that envelopes them and the tiger. Their whiteness commands the viewer's attention.

The portrait, writes James Ryan in *Picturing Empire*, "is a striking photographic representation of the assertion of human and imperial power ritually enacted through the colonial

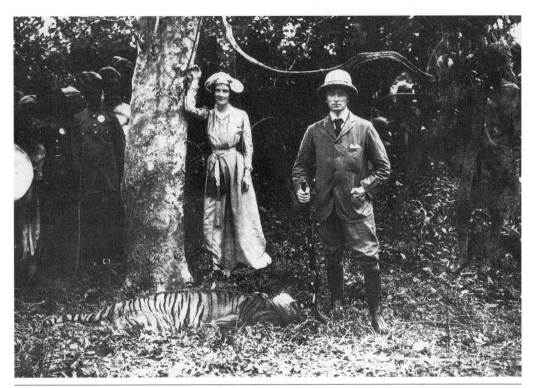

Lord and Lady Curzon, the viceroy and vicereine of India, pose imperially over a dead tiger after the hunt, 1902. Curzon's host, the Asaf Jahi ruler of Hyderabad, stands at the fringe on the right. His swarthy skin renders him virtually invisible, as are the bearers and beaters in the background.

hunt . . . [that] symbolizes British authority over India at the moment when Britain's Empire was at its zenith"[18] The viceroy's sphere of power engulfs everything and everyone. On his left, beyond the pale of light, stands Lord Curzon's host, His Highness, the Nizam—the title given to the Asaf Jahi ruler of the Hyderabad state in India. His swarthy skin renders him nearly invisible, like all the bearers and beaters who melt into the anonymity of the background.

By 1936, however, the imperial imaginary no longer cared to dote on visual proof of the conqueror. The death of Martin Johnson seven months after African Hall opened its doors marked the passing of the era of the visual celebration of the imperial hunter that had started with Roosevelt almost a half-century before in the Dakota Territory. The emerging generation of filmmakers cared less about the conqueror than the conquered, so rather than chronicle the process of conquest, the camera focused instead on its product—nature. The camera, whose prior purpose had been to record Lord Curzon's regency, now subsumed the missionary task of the white hunter-explorer. The camera replaces the gun as the instrument of sovereignty.

For fifteen years before his death in 1926, Carl Akeley labored to build the American scrapbook of Africa at the American Museum of Natural History.[19] His notes, often scrawled in the field after an exhaustive day of stalking the bush for his perfect specimen, lay out his ideas for African Hall.[20] His detailed sketches and models reflect his desire to dedicate the hall "entirely to Africa—to African scenes and African animals and African natives in their relation to the animals."[21]

At the center of the hall Akeley had envisioned a "panoramic" group of four elephants "treated in statuesque fashion," the trumpeting bull in the lead. Rhinoceros would flank the

elephants, and a bronze of an African warrior carrying a spear would greet the visitors at each entrance to the hall. Later, he replaced the idea of individual Africans for a band of Nandi lion hunters. Nonetheless, by the time the museum opened the doors to African Hall in May 1936, virtually every trace of human beings in the exhibits had disappeared.

Of the twenty-eight dioramas, the only evidence left of human beings in African Hall is a basket-like structure that sits high in the branches of an acacia tree that is painted in the background of *African Buffalo*. The museum explains that it removed the people from African Hall because it believed that the proper place for the display of Africans and their artifacts was in a separate hall dedicated to their traditional lifestyles and customs. This radical act of segregation not only exiled Africans from their homeland, but also emphatically confirmed the severance between humanity and nature.

The nature in African Hall contains no roads, telephone poles, or fences, no people picnicking on the grass or children skylarking in a playground, no cars, planes, or bicycles, no houses, restaurants, or factories. The new imaginary created the *wild frame* by "purifying" the image of nature so that it represents a time either before or beyond human beings.

The wild frame employs a rhetorical strategy that compounds its social and political power by removing obvious evidence of the author from the frame. As a result, writes media historian Wulf Kansteiner, "This impersonal style diverts attention from the limits of the specific textual perspective and produces the paradox that the historical fact which exists only as discourse is treated as a phenomenon of the non-discursive domain of the real."[22] In other words, the construct of nature—its image—usurps the claim of reality. Just as the American Museum of Natural History argued that looking at the lions behind the glass was an unmediated experience that was equivalent to looking at lions on the savannahs of East Africa, so the natural history film made the implicit claim that the viewer was, to paraphrase the nineteenth-century German historian Leopold von Ranke, witnessing reality *how it actually is*.

The wild frame is an *anachronistic space,* a term coined by Anne McClintock that circumscribes "the geographic space of the modern empire" by placing it in "a permanently anterior time." As a natural host for the modern fixation "with origins and genesis narratives," writes McClintock, the museum as "the modern fetish house of the archaic—became the exemplary institution for embodying the Victorian narrative of progress."[23] Whereas previous films had focused on the interactions between the hunter and the hunted, the wild frame removed evidence of the colonial agent from the frame and created a panoptic view of nature. The unseen hand of the creator retired like God to his heaven, made omniscient by his power to capture life through the lens. "Indeed," writes Neil Evernden, "objects gain credibility for us as the traces of our authorship are progressively eliminated."[24]

The wild frame creates a temporal and spatial paradox. While the viewer suffers a massive dislocation by not being present in either the actual time or space of the event, at the same time the wild frame makes a false claim for intimacy between the observer and the observed. The traces of reality encoded within the photographic and cinematographic image provide a level of access to nature no one had imagined possible as technical advancements in macro- and telephotography gave the camera the power to penetrate the intimate details of nature. "The need to bring things spatially and humanly 'nearer,'" wrote Walter Benjamin, "is almost an obsession today, as is the tendency to negate the unique or ephemeral quality of a given event by reproducing it photographically. There is an ever-growing compulsion to reproduce the object photographically, in close-up."[25] The viewer quickly came to believe there was no place a camera couldn't go and nothing it couldn't see.

However rare or elusive the animal, the camera is so privileged that it can reveal the most intimate details of its "secret" life, such as mating or giving birth. But their insubstantial presence is only a reiteration. "Although animals have always haunted the typology of human subjectivity," writes Akira Mizuta Lippit in *The Electric Animal,* "the nature of the animal has shifted in the modern era from a metaphysic to a phantasm; from a body to an image; from a living voice to a technical echo."[26] The image of nature, out of synch with the time and place of its referent, gradually supplanted material reality. Within filmic space, animals never disappear completely; rather, as Lippit points out, "they exist in a state of *perpetual vanishing . . .* lingering in the world *undead.*"[27]

By the 1930s, film reached into virtually every city and town in America, and with the advent of television, into virtually every household. As urbanization and industrialization pushed nature farther away from rapidly expanding urban centers, people increasingly accepted film as a readily accessible surrogate. Rather than close the gap between themselves and nature, however, film reinforced the feeling of alienation for two major reasons: first, because film treated its audience as tourists rather than citizens of the natural world, and second, because the animals they saw were not real but semiotic signs, biological wraiths trapped in an ideological netherworld. As a result, writes John Berger, "the life of a wild animal becomes an ideal, an ideal internalized as a feeling surrounding a repressed desire. The image of the wild animal becomes the starting-point of a daydream: a point from which the daydreamer departs with his back turned."[28]

The more the physical animal recedes into memory, the more tenaciously people cling to the belief that nature contains secret wisdom that is essential to understanding their humanity. Deeply rooted in the human psyche as "exemplary vehicles with which to mediate between the corporeality of the brain and the ideality of the mind," animals live among us, speak our language, and know our ways.[29] In his essay "Why Look at Animals?" John Berger argues, "What we are trying to define, because the experience is almost lost, is the universal use of animal-signs for chartering the experience of the world."[30] But manikins and painted or photographed images of nature fail to provide such an epiphany. They do, however, serve as a means for self-reflection. "The absorption of ourselves into Nature is simply the absorption of ourselves into ourselves," observes Neil Evernden, "or rather into our conception of how it 'ought' to be."[31]

EMPLOTMENT

White described his third mode of explanation as *emplotment,* which provided "the 'meaning' of the story by identifying the *kind of story* that has been told."[32] Just as the natural history film drew upon the ideological structure of the natural history diorama, so it also drew upon the literary structures of narrative cinema. These structures were not merely vessels in which meaning was reposed incidentally; rather, they participated as equal partners with ideology and argument in the creation of meaning. "The power to narrate," wrote Edward Said in *Culture and Imperialism,* "is very important to culture and imperialism, and constitutes one of the main connections between them." In fact, the necessity of connecting "the structures of a narrative to the ideas, concepts, experiences from which it draws support" is essential to the experience. For Said, imperialism was "unthinkable" without the "cultural artifact of

bourgeois society."[33] Indeed, as William Blake claimed in his annotations to Reynold's *Discourses,* "Empire follows Art and not vice versa as Englishmen suppose."[34]

Once motion pictures overcame the paralysis of motion and time that typified the stasis of the photograph and the diorama, it quickly appropriated the mainstays of narrative convention such as conflict, character, and plot. By the time Kearton premiered *Roosevelt in Africa* in 1910, the public was already impatient with shots of exotic animals grazing placidly in the distance. Instead, it expected dramatic conflict created by a protagonist who struggles to overcome difficulties set in his or her path by a wily antagonist; it expected narrative exposition rather than information; and it expected good to triumph over evil. The audience expected, as Roosevelt put it, *a good story well-told* and couched within a moral framework that reinforced American progressive liberalism.

The safari films of the 1920s and 1930s catered to the public's taste for violence, sex, and adventure by playing out an American Passion play about empire. The average person cared less about the "rhinoceros" or the "lion" as a species than as a character, and even though Roosevelt, Burroughs, and Osborn had all campaigned against anthropomorphism as unscientific, Roosevelt himself was as guilty as any of attributing human traits to the animals he portrayed in his writing of those he criticized. He admired the elephant for its intelligence and the lion for its strength and courage, for example, and he thought the giraffe suffered from a "tameness bordering on stupidity," that the rhino was "truculent and stupid," and he dismissed the hippo as just plain "stupid."[35] Roosevelt's animal melodramas were as much about pride and humility, patience and anger, sloth and diligence as they were about science, and even though he fumed over "nature fakers" who wrote stories about animals that were capable of thought or accomplished deeds that were unknown to science, his own prose implied many of the same value judgments as the fakers he vilified. In search of dramatic and comic foils worthy of the hero—the men and women of empire—the camera pressed animals into supporting roles as mock kings and cowards, beggars and thieves, reluctant maidens, self-sacrificing altruists, seers, soldiers, and fools. Once the new imaginary removed the imperial agent from the frame, however, the hero shifted its shape and became animal, reverting once again to a literary paradigm of the allegory.

As African Hall opened its doors, a group of men in a studio in Los Angeles were busily bringing nature to life in a way people had never experienced it before. The diorama, at its moment of deliverance, would be quickly overshadowed by a man named Walt Disney.

CHAPTER THIRTEEN

The World Scrubbed Clean

THE IMAGE OF NATURE IN THE CARTOONS, ANIMATED FILMS, AND DOCUMENTARIES produced by Walt Disney was revolutionary not only because of its progressive animated techniques but also because they couched nature within a uniquely American moral code. Their structural and thematic components coalesced a loose constellation of techniques and thinking about nature into a standard—one might even say a template—for fiction and nonfiction films about nature that would serve as the hegemonic Western model of representation for the rest of the twentieth century and beyond. Writing about the effect that Disney had on the way Americans perceived nature, media critic Richard Schickel wrote in 1968, "At this point all we know for certain is that Disney preempted the field in such a way that it will probably be a long time before anyone tries again and that if they do try, they will undoubtedly be tempted to imitate his proven formula."[1] Or as another pundit summed up Disney's influence, "The whole world is watching the United States and all the United States is watching Walt Disney."[2]

Disney developed into an unparalleled popular cultural force for many reasons. Foremost, perhaps, was his appeal to a huge swath of American grassroots society that had been crusading tirelessly against a perceived excess of immorality in the cinema. When the Ohio Industrial Commission petitioned the state to create a censorship board in 1915, the Mutual Film Corporation argued before the Supreme Court that films were entitled to the same constitutional protections of free speech that were guaranteed to the press and printed materials and therefore should be free from any sanction.

The Supreme Court disagreed. In *The Mutual Film Corporation v. Ohio Industrial Commission* the Court held unanimously that "the argument is wrong or strained which extends the guarantees of free opinion and speech" to the movies because "they may be used for evil." Movies were for better or worse "a business, pure and simple, originated and conducted for profit," and so were not entitled to the constitutional freedoms accorded to "the press of the country, or the organs of public opinion." The Court upheld the claim that some subjects were indeed unsuitable for "pictorial representation in public places." The decision cleared the way for state and federal censorship of the film industry.[3]

Moral crusaders such as William Sheafe Chase, the canon of the Christ Episcopal Church in Brooklyn, New York, took the floor in support of federal censorship. Chase spoke on behalf of many reformers when he addressed the question about what constituted appropriate content for the cinema, especially when it came to the responsibility for protecting the nation's children: "Who [does the filmmaking industry] propose ought to have control of this great invention? Who are going to be the people . . . who will educate the children of our land? A few motion-picture manufacturers, whose principal motive is making money?"[4]

By 1920 the motion picture industry had penetrated even the most barricaded community. The ease with which movies overran Protestant middle-class America challenged its religious and cultural hegemony. "Its command of public life was threatened," media critic Richard Maltby writes, "by the incursions of a modernist, metropolitan culture—a largely Jewish and Catholic culture—which the provincials regarded as alien."[5] The seemingly endless stream of murder, drugs, and sex scandals that flowed out of Hollywood only confirmed suspicions that Hollywood was a modern-day Sodom. Dashing men of the screen such as Rudolph Valentino (*The Sheik, Blood and Sand*) and Douglas Fairbanks (*Robin Hood, The Thief of Baghdad*) and "vamps" such as Gloria Swanson, Greta Garbo, Pola Negri, and Norma Talmadge engaged in flagrant behaviors that defied traditional views of marriage, sex, and social propriety. Betty Blythe, the star of *Queen of Sheba* (1921), reflected Hollywood permissiveness when she reported cavalierly, "I wear twenty-eight costumes and if I put them on all at once, I couldn't keep warm."[6] Feeling unjustly besieged by representations of values that didn't reflect its own, an increasingly alienated Protestant America reacted defensively.

In spite of several failed attempts to gather statistical data that proved movies were contributing to the delinquency of the nation's youth, the strongly held belief that the "immoral propaganda" of cinema was negatively affecting the moral composure of the young spurred activists to continue their campaign against indecency.[7] "Actors and actresses of the screen are teaching the public free love, adultery, murder, infidelity, and lust," exhorted Reverend Chase. "And too many of them naturally are practicing what they teach."[8] The "pest hole" Hollywood was a "vile corruptor of ideas" and "a threat to world civilization," and Chase and others appealed to the government to "rescue the motion pictures from the hands of the Devil and 500 un-Christian Jews" who were "offering a one-way ticket to hell for [a] nickel."[9]

By 1921 Ohio, Kansas, Maryland, Virginia, Florida, and Pennsylvania had established their own state censorship boards, and similar legislation was pending in thirty-one other states.[10] The censorship board in any town, city, county, and state was now free to decide what constituted indecency according to its own whims and prejudices. In Pennsylvania, a film was considered indecent if it showed an expectant mother knitting baby clothes, and in Topeka, Kansas, a kiss was deemed to be indecent if it lasted more than a few seconds.[11]

But the major studios weren't interested in assuaging the grumblings of a censorship board in Topeka, Kansas. From their point of view what people were *seeing* mattered more than what they were *saying*. Box office receipts spoke louder than any pulpit speech or censorship board. Indeed, the "dirt" in movies was pay dirt. Olga Martin, formerly the secretary to the director of the Production Code Administration, estimated in *Hollywood's Movie Commandments* that a quarter of all film production in the United States "was on the sensational smutty side," and that the profits from these films compensated "for the industry's losses on the clean 75 per cent which nobody seemed to support."[12] What America *wanted*, the producers concluded, was at sharp odds with what the reformers claimed America *needed*. So when Will Hays introduced the "Code to Govern the Making of Talking, Synchronized and Silent Motion Pictures" in 1930, Hollywood producers resisted its moral absolutism because they felt that such stringent morality would fatally jeopardize their profits.

At issue was the right to freedom of expression, however objectionable people might find it, and the right for the public to protect itself against what it regarded as the morally corrosive influence of an industry that cared more about profits than the health and welfare of its constituency. The showdown in the morality wars came in 1922 when legislators in Massachusetts launched a public referendum proposing the creation of a state censorship film board.

It was the first time the public was asked to voice its own opinion regarding censorship and in the privacy of the polling booth. When it was over, the citizens of Massachusetts handed the reformists such a thumping that it derailed the entire national crusade to enact federal legislation. The silent majority had spoken at last.

The morality wars brought Walt Disney to a crossroads. One road led to the Hollywood establishment, whose acceptance Disney had always craved. The name "Disney" was beginning to make headway in Los Angeles in the late 1920s, and important people were taking notice of what was coming out of the little workshop on Hyperion Avenue. The other road led east to the heart of Protestant America.

From a business point of view, Disney had little to lose by and everything to gain by going east. Perched on the edge of financial ruin, the economics of his business required he pay close attention to what was and wasn't working in the marketplace. The cartoon business seemed to be going nowhere. "The pictures were kicked out in a hurry and made to price. Money was the only object," recalled Disney. "[W]e saw that the medium was dying. You could feel rigor mortis setting in. I could feel it in myself. Yet with more money and time, I felt we could make better pictures and shake ourselves out of the rut."[13] By 1930 Disney was eager, if not desperate, to define himself and his work in ways that would allow him to shoulder his way through the pack of competing animators. What mattered to Disney was financial solvency and building a broad constituency of people who wanted his product. What mattered was the movie house owner in Baraboo, Wisconsin, who begged for movies that wouldn't offend his patrons.

At first Disney shied from the role of moralist. "We will not have worried one bit as to whether the picture will make the children better men and women or whether it will conform with the enlightened theories of child psychology," he wrote in an article for *Outland Monthly*. "It is not our job to teach, implant morals, or improve anything except our pictures."[14] But in 1931, when the public brought his marquee star, Mickey Mouse, up on morals charges, Disney suddenly found his future on trial in the court of public opinion.

On January 21, 1931 the *Atlantic City* (New Jersey) *Press* printed a letter by "A Child Lover" that decried the fact that even Mickey Mouse cartoons had become symptomatic of the moral bankruptcy of cinema. How could children resist the insidious influence of the movies, the writer asked, if they

> are constantly having presented before them on the screen such subjects as easy divorce and remarriage, indecency in dress, dancing and suggestiveness? Even in such would-be-innocent subjects as . . . Mickey Mouse comedies, they are beginning to inject these same undesirable qualities. To say nothing of the gross vulgarity and stupidity of so many of the short sketches so continuously being panned off on a long enduring public.[15]

Similar complaints flooded the press. Film critic and editor Terry Ramsaye, the same man who had edited Martin Johnson's film, summed up Walt's dilemma in the February 28, 1931, issue of the *Motion Picture Herald*: "Mickey Mouse, the artistic offspring of Walt Disney, has fallen afoul of the censors in a big way, largely because of his amazing success. Papas and mamas, especially mamas, have spoken vigorously to censor boards and elsewhere about what a devilish, naughty little mouse Mickey turned out to be." The public's verdict was emphatic: Mickey had to reform his wayward behavior. No more smoking, no more drinking, no more abusing the livestock, and no more dancing the tango with Minnie. "Mickey has been spanked," Ramsaye observed.

Although Disney's moral conversion was dictated more by his analysis of the marketplace and the realization that a long-standing disaffected segment of society had created a niche for his product than for his newfound sense of morality, he embraced the central tenet of the Production Code that "No picture shall be produced that will lower the moral standards of those who see it."[16] Henceforth, he decided, his works would embody the moral code that "evil is wrong" and "good is right."[17]

Disney rehabilitated his rogue mouse: no more drinking, carousing, smoking, or making untoward advances at Minnie.[18] No more impaling a cat through its anus with a broomstick (*The Barnyard Battle*, 1929), no more yanking a bull inside out, revealing its internal organs (*El Terrible Torreador*, 1929), and no more sexual suggestiveness as in *The Karnival Kid* (1929), in which Mickey chases down Minnie's runaway hot dog and spanks it. The rambunctious, violent humor that had been the hallmark of the studio's previous work swerved toward the conservative. In the process, Walt Disney invented *Walt Disney* as a simple man from humble beginnings who cared only about telling good stories to good people, a man of conviction who, like his neighbors, was troubled by the precipitous decline of moral standards in America. And so the callow young man who had been so enamored with fart jokes, cow udders, and billowing girl's bloomers began a lifelong process of transforming himself into a champion of American traditions and values.

Disney's appeal came from his native ability to speak in an uncomplicated and uniquely American idiom that people found both familiar and comforting. His stories were derived from their own experiences on the farm or in rural America rather than in far-flung places with strange animals and people. Mickey Mouse was not a hero in the conventional sense; he was populist Everyman. In Disney's words, he was just "a nice fellow who never does anybody any harm, who gets in scrapes through no fault of his own but always manages to come up grinning."[19]

Disney's chronic mistrust of highbrow culture also endeared him to the public. When quizzed about his artistic motives, he would roll out what Steven Watts calls his "aw, shucks" persona and then blast establishment intellectuals as "lost souls, sophisticates, who are so bored and turn their nose up at everything, they say it's childish. Well, what the hell's wrong with something being childish, you know? You can't have everything profound."[20] By distancing himself from aesthetes, Disney portrayed himself a man of the people.[21] "I've always had a nightmare," he told one journalist. "I dream that one of my pictures has ended up in an art theater. And I wake up shaking."[22]

Disney lacked the educational or intellectual pretentiousness of learned men of the eastern establishment, such as Roosevelt and Osborn; rather, he was what Lewis Mumford derisively defined as the kind of artist "whose education, whose mental bias, whose intellectual discipline, does not differ so much as the contents of a spelling book from the great body of readers who enjoy their work."[23] And yet, after the release of Disney's first animated feature-length film, *Snow White and Seven Dwarfs*, in 1938, the Christian community celebrated Disney as an "educator of the soul," a modern-day St. Francis who

> brings the soul of man nearer to the soul of the whole universe. For his world of birds and flowers and funny little bunnies is no unrelated fiction. The loving eye of the artist has noted the intricacies of life, the dip of the wing, the frisk of the tail, the droop or flourish of a petal. We are brought close to glowing nature and see that it is a thing of beauty. . . . He does all that St. Francis set out to do: to worship God in all His happy, glowing, stumbling creatures.[24]

Disney became a spiritual center of popular culture in America as religious, civic, and family groups embraced him as their moral educator. In 1952, the *St. Paul Pioneer Press* declared that Disney had "unmasked nature" to reveal "a sphere where God's master plan for the existence of the planet is dramatically enacted every second of the day." The consensus was unanimous, the *Pioneer Press* continued, that Disney's "genuine cinema art" instilled the viewer with "the wonders of creation and a deeper sense of awareness of the Creator who made them all and ordered their lives."[25]

Disney's mix of crafted selves resulted in an avuncular persona who confirmed the innate goodness of the world. He mixed narrative, largely by way of much-loved fairy tales and fables, with American middle-class values that celebrated virtue over evil, innocence over corruption, and providence over chance.

At first his heroes were clumsy, but endearing. Mickey, Goofy, Donald—even Pluto— were good-hearted and well-intentioned souls who did the best they could, stumbling along the way. Disney found himself attracted to a cast of heroes who were consonant with nature, such as *Snow White* (1938), *Bambi* (1942), *Cinderella* (1950), and *Sleeping Beauty* (1959) for example. This mystical, magical world of nature gushed forth from the experiences of a little boy who lived on a farm in central Missouri.

DEATH IN THE WOODS

Walt Disney was born in Chicago on December 5, 1901, less than three months after the assassination of McKinley and the inauguration of Theodore Roosevelt as president of the United States. In 1906, Disney's father moved the family out of the city to a hardscrabble farm in the hills of north central Missouri.

The Disney farm was rife with barnyard life. The cows had to be milked, the pigs had to be slopped, and the eggs had to be collected. For an impressionable boy of four years old who had grown up in a big city, life on the farm was a whirlwind of life filled with wonder, latent with violence, and underpinned by an implicit order. Walt watched the farm cat stalk the barn for the mice that lived under its boards, he watched the rooster politicking the hens, and he watched pigs jostling at the trough. The air was shrill with the restless lowing of cows, the cacophony of chickens, porcine grunts, and equine snorts. One did not live on a farm without witnessing the diurnal rhythms of bestial violence and lust, fraught with high drama and low comedy. The farm was also a very utilitarian place: cows that went out of milk became meat, as did the chickens that stopped laying eggs, and pigs were always destined to become bacon. For the Disney family, as for most Americans, farm animals were objects, devoid of subjective content. Their capacity to suffer was limited, and their duty in life was to serve.

Disney's barnyard humor provided the foundation for much of his early work. He relegated domesticated animals to the lowest echelon of life because he, like most Americans, considered them soulless husks, undeserving of moral consideration. Disney would no more have flinched at the sight of animal blood than at the sight of an oil leak on the farm tractor. Animals were foodstuffs.

Nature wasn't entirely one-dimensional for Disney, however. Sometimes Walt and his brother Roy would go for walks in the nearby woods next to the farm, where the regimented orderliness of the farm gave way to something mysterious. But appreciating the distinction

between the domesticated and the wild was not a lesson easily learned by a boy who'd gotten used to the idea of the human domination of animals.

During an outing into the woods by himself, Walt spotted an owl perched on a low-lying branch of a tree. He reached out to pet the owl, but it flew off. Walt chased it to another tree and when he tried to cup the bird in his hands, it clawed him. In a fit of juvenile rage, Disney hurled the owl to the ground and stomped it to death. According to his account, he buried the owl in a fit of remorse only to have its ghost return to him in dreams—and later in his work.

Disney replaced a Darwinian system with a moral code that doesn't reflect a recognizable biological reality, a system so bowdlerized that death itself becomes pornographic. Disney left behind the rancid chicken coop and the muddy pig wallow for a return to the Garden as it was before Death, a place free from the ravages of time and the corruptive influence of humans. Richard Schickel attributes Disney's sanitization of nature to his "lifelong rage to order, control and keep clean any environment he inhabited."

> All inner conflicts about the nature of the land were similarly resolved in Disney's . . . films; he always, and only, showed us a clean land. Indeed, the whole wide world was scrubbed clean when we saw it through his eyes.[26]

By 1936 Disney had produced almost 350 cartoon shorts, most of them drawn from the barnyard.[27] He was ready to explore the mysteries of the forest, but because cartoons were rarely longer than eight minutes, they were short on narrative and long on gags. Disney wanted to work in a longer form, but the industry thought of cartoons as throwaways, and the idea of a feature-length animated film seemed far-fetched because no one believed an audience would have the patience to sit through one. Intent on embracing what Steven Watts describes in *The Magic Kingdom: Walt Disney and the American Way of Life* as "the old American success story of the self-made man overcoming obstacles on the way to fame and fortune," Disney committed his company's resources at the height of the Depression in 1934 to make what became known by skeptics in the industry as "Disney's Folly," a feature-length animated program based upon the fairy tale that had been collected by the Jacob and Wilhelm Grimm in 1812 called *Little Snow-White (Sneewittchen)*.[28] The story had already appeared in film in 1902 and 1916, and once in a Betty Boop cartoon (1933).

Disney chose *Snow White* for a variety of reasons, the most compelling of which was the story's elegantly crafted narrative, which came with a compelling and attractive hero and heroine, a creepy villain, and dozens of human and animal familiars to supply poignancy and comic relief.[29] Walt Disney understood that the success of *Snow White* depended its ability to maintain a convincing narrative more than it did on his artistic or technical abilities. A compelling narrative, he concluded, was the only technique that could sustain feature-length animations. The most readily accessible and time-proven narratives were freely available in a limitless archive of European fairy tales and fables. As an adolescent, Disney had seen J. Searle Dawley's film version of *Snow White and the Seven Dwarfs* (1916), and Marguerite Clark's performance as the title character had made such an impression on him that he wanted to remake the tale for his first feature effort.[30]

In December 1936, a year before the opening of *Snow White and the Seven Dwarfs* and just a few months after the American Museum of Natural History had opened African Hall, Disney began work on what he intended to be his second animated feature, *Bambi*, based upon a novel published in Austria written by Felix Salten in 1923 called *Bambi, A Life in the Woods*.

An allegory about life in the forest, Salten's *Bambi* is a bloody rite-of-passage story about the loss of innocence to experience as a young forest deer that suffers a life of random violence, suffering, and death, much of it created by a disturbing all-powerful, God-like character called "Man" who wreaks existential havoc in their forest community by exacting indiscriminate blood sacrifices.[31]

Disney liked the idea of a story revolving around an innocent deer and his family in the forest, and he liked the strong cast of supporting characters Salten had created, but he rejected the violence and bloodshed and the internal struggle of a young male struggling to mature into a fully integrated adult citizen of his community who could cope with the unpredictable violence of life. Instead, Disney replaced Thanatos with Eros, and locked Bambi in a world of perpetual innocence.

Disney's *Bambi* serves as a valuable case study of the American moral view of nature because he coalesced various ideologies, arguments, and emplotments about nature that had already been percolating through American culture. A comparison of Salten's and Disney's texts reveals the ways each author tried to reconcile the central paradox of Bambi, which is the central paradox of the relationship between nature and culture: that humans are somehow situated both inside and outside nature. While sharing empathetically in the drama and comedy of the lives of the animals that live in the forest, human beings live outside its spiritual pale.

In Salten's novel, deer are the sovereign species by virtue of their evolved moral consciousness. While they are not intellectually disposed for normative discourse, they do have an intuitive understanding of the threat of history and its dire consequences. The bodies of mangled and dead animals litter the forest as the impressionable fawn witnesses rashes of random violence, suffering, death, and destruction that are the result of other animals, such as owls, ferrets, crows, and foxes, that prey upon the forest folk. At one point in the story, Bambi watches helplessly as Friend Hare's wife dangles her hind leg "lifelessly in the snow, dyeing it red and melting it with warm, oozing blood," and later, he encounters a mortally wounded fox that is in such agony that he "keeps biting the snow and the ground."[32] However gruesome, violence is part of the natural rhythm of nature. The violence wrought by Man, however, is not. As Friend Hare (Disney's "Thumper") dies at Bambi's feet after being shot by a hunter, he asks the piercing existential question Bambi cannot answer: "I don't understand—what have I ever done to Them?"

The animals in Disney's forest, on the other hand, are sentient, articulate creatures such as deer, squirrels, owls, foxes, and rabbits that live a leisurely life, free of violence save for the calamitous intrusions of Man. They consist of a cadre of small, warm-blooded animals such as rabbits, birds, squirrels, and a doughty old owl, who are well-behaved, polite, thoughtful citizens. Species that normally prey upon one another, such as the owl and the hare, for example, have reached a peaceful comity. A royal stag that the community collectively reveres as the Prince of the Forest assumes the highest position of power and authority as the forest's distant but ever-present patriarch, a role that Bambi is destined to achieve by virtue of his species, his sex, and his privilege as the stag's son.

The moral order of Disney's forest is absolute because like all myths, it is static. "Myth deprives the object of which it speaks of all History," Roland Barthes wrote in *Mythologies*. "All that is left for one to do is enjoy this beautiful object without wondering where it comes from. Or even better: it can only come from eternity; since the beginning of time, it has been made for bourgeois man."[33]

Erasing "all soiling trace of origin or choice" creates an unimpeachable social order that serves a powerful deterministic function for determining proper behavior, which is why the

stories of animals are usually told through the predictable constancy of the reproductive cycle. Disney makes this point emphatically at the end of the film when a sexually mature Bambi takes his father's place by stepping into his father's silhouette at the top of the crag overlooking the valley. He is no smaller and no larger than his father; he just reproduces his iconic pose as the Great Prince of the Valley. (In fact, Bambi's father doesn't die in a conventional sense; he just fades away.) Bambi is his father's doppelgänger, just as his own son will be his. (Disney repeated the formula in *The Lion King* [1994].)

Bambi's privileged life begins as a messianic birth in spring, announced by a bluebird. "Yessir, it isn't every day a Prince is born!" declares the wizened Owl. *Love is a song that never ends,* a tenor sings at the opening. *One single theme, repeating.* The strains of the melody waft over Bambi's birth. His purpose in life will not be simply to reproduce, but to reproduce a *son* who will replace him as he will replace his father.

Similarly, Bambi's mate, Faline, is confined to her role as a reproductive provider. "The role of women in such a society is the reproduction of men," writes David Payne in his essay on *Bambi.* "The role of the patriarch is to own the means of reproduction."[34] Bambi first discovers Faline at a pond while he is looking at his reflection in the water. The first time he looks down, he sees himself, but when he looks again, he sees his distal self next to him. Other than the fact that she has blue instead of brown eyes, Faline is, for all intents and purposes, a physical duplicate of Bambi. As his first cousin, she even shares blood with him. Like Narcissus, Bambi falls in love with himself, and like Echo, Faline can only repeat him.[35]

Like Eden, Disney's forest is an enclave that exists solely for and within itself and so does not seek anything outside itself. The forest symbolizes definitive fruition, a saccharine tautology that is threatened only by the ungainly intrusions of the Other, which threatens to violate the norms of the ideal. By usurping the role of the Serpent in the Garden, "Man" breaches the hermetic borders of purity in *Bambi* by disrupting the moral certainty of life in the forest, and like the Serpent, he brings the ruinous plagues of time and history.

The problem with Disney's altruistic world is that the bright light that illuminates the stage doesn't come from God or the sun but from a klieg light that has been hung overhead to shine on a morality play in which all its characters are well-behaved individuals who live in socially functional families within a perfectly mediated society. There are no shadows in this overlit world.

Disney's portrayal of nature reflects an intoxicative mix of spiritual idealism, self-loathing, and a longing for innocence, outlooks he shared with Americans as a result of a common ideological heritage. It is a subjective world of symbols, signs, and spirits camouflaged by the pretense of realism. "All too often, animal books are highly emotional, over-sentimental stories of creatures who act amazingly like humans," reads a Disney Educational Products record album of *Bambi,* "Although the animals in *Bambi* speak, they still retain their animal characters, and the portrayal of their way of life is scientifically true."[36]

A chorus of contemporary voices agreed. "The baby animals are overloaded with sentimentality," wrote Adrian Bailey in *Walt Disney's World of Fantasy,* "yet I judge their aim to be true . . . devoid of caricature and exaggeration."[37] Burroughs and his friend Roosevelt would have had a fit.

Disney devoted his career to achieving increasing levels of realism in his work. His work is a history of evolutions and revolutions: from stasis to motion; from matchstick figures to fully fleshed, articulated subjects; from silence to sound; from black and white to color; and from two-dimensions to the appearance of three. It is also a history of the search for realism; from

the surreal to the real; from the nonlinear to the linear; from the absurd to the plausible; and from nonsense to common sense. "When we do fantasy," Disney explained in a Fellini-esque way, "we must not lose sight of reality."[38]

Disney demanded pictorial realism in *Bambi*. He made his artists study animal anatomy and even shipped two live fawns to Los Angeles so they could draw directly from *nature*. "He might as well have gone out and taken pictures of real deer," said one worker, "that was the quality he was driving for in the animation."[39]

The idea of realism in animation contradicted the view of many that if the object of mainstream cinema was to imitate reality, then the object of animation should be to defy it. Animation was one of the few places left to imagination that owed no allegiance to the quotidian demands of reality. In the world of animation the laws of physics were disposable. People and objects didn't just defy gravity, they negated it. A reviewer for the *New York Times*, disgruntled with Disney's realism in *Bambi* typified the critical and public reaction to the film when it was released in 1942:

> Mr. Disney has again revealed a discouraging tendency to trespass beyond the bounds of cartoon fantasy into the tight naturalism of magazine illustration. His painted forest is hardly to be distinguished from the real forest. His central characters are a naturalistically drawn as possible. The free and whimsical cartoon caricatures have made way for a closer resemblance of life, which the camera can show better. Mr. Disney seems intent on moving from art to artiness . . . in trying to achieve a real-life naturalism [he] is faced with the necessity of meeting those standards, and if he does, *why have cartoons at all?*[40]

Disney's realism, however, was stylistic, not thematic. The depiction of nature in *Bambi*, however camouflaged as realism, is as surreal as any cartoon by Max Fleischer or Paul Terry. Similar to the way he created rubberized cartoon characters that suffer outrageous physical trauma and then snap back into their original shape without ill-effect (a technique known in the animation trade as "squash and recoil"), Disney created a model of nature that always springs back to its original form no matter how much it has been deformed.[41] In *Bambi*, the forest that is destroyed in the inferno during the fall is completely restored the following spring. The lesson of *Bambi* (and all of Disney's films) is that nature's elasticity is stronger than any threat "Man" can pose to it.

An architect who helped design Disneyland described Disney's peculiar brand of realism as a "Utopian in nature, where we carefully program out all the negative, unwanted elements and program in the positive elements. . . . We create a world they can escape to . . . to enjoy for a few brief moments . . . a world that is the way they would like to think it would be."[42] In other words, it was another way of saying, *Once upon a time . . .*

Between 1948 and 1960 Disney produced a series of documentary films about nature called the *True-Life Adventures* that drew upon the pseudorealism of *Bambi* to portray the natural world. At a time when the nation was struggling with the threat of a world destabilized by the threats of Communism, nuclear confrontation, the Korean War, and the birth of Red China, Disney turned to nature yet again as a rhetorical platform to celebrate the good society. Disney's consummate skill was to turn nature into a form of social narcissism by reversing the mirror so that instead of reflecting nature to society, he reflected society to itself. The ethics of representation did not matter to his audiences as much as their ability to feel connected to *their* nature, however artificially it was constructed. In "The Audience in the Wilderness,"

Margaret J. King writes, "This is nature but a very special kind: not an ecosystem, but an *ego-system*—one viewed through a self-referential human lens: anthropomorphized, sentimentalized, and moralized."[43]

After the traumatic violence of World War II, audiences were interested in healing and reintegrating the traditional middle-class American values that had been threatened by the social and political upheaval of the war years. Disney projected these emotional needs onto the peaceful natural landscape of the American wilderness in the *True-Life Adventures*. His celebration of the American Wonderland resonated deeply with viewers by revitalizing a belief in the value of the wilderness, whether the big open of the prairie (*The Vanishing Prairie*, 1954), the glacial fields of Alaska (*White Wilderness,* 1958); or the arid plains of the Sierra Nevada (*The Living Desert,* 1953), which tells a story "as big as America itself." Writes Angela Hawk in her essay "'Disney-fying' Mother Nature in the Atomic Era," Disney "embraced and promulgated the popular if highly idealized view that *American-ness* lay in the nation's historical connection with nature."[44]

Rather than depict animals as competitors or threats to humans, Disney recast them in patently human domestic terms so average Americans could identify with how animals fought for their share of the American Dream. He created stories that let people laugh at their foibles, cheer at the triumphs, and cry over the failures as they struggled against hunger, worked hard to try to get ahead, fell in love, and raised families. When it came to constructing narrative, Disney not only incorporated the progressive values that typified the natural history diorama, he also reverted to the brazen anthropomorphism of Long, Seton, and Roberts. "In approaching the problem of story telling" in *True-Life Adventures*, Disney explained, "once we have the basic footage, we use the same technique to be found in Disney cartoons. We look for personality, and we do this for a reason. If audiences can identify themselves with the seeming personality of an animal, they can sympathize with it and understand its problems better."[45] James Algar, the director of twelve of the thirteen original episodes of the *True-Life Adventures,* started with Disney as an animator on *Snow White and the Seven Dwarfs* (1937) and then as a sequence director for *Fantasia* (1940) and *Bambi* (1942). He knew virtually nothing about documentary filmmaking or about nature other than what he had learned about story structure and characterization as an apprentice in the Disney studios.

Algar disguised the Disney aesthetic and political agenda with the familiar claim of authenticity. "It is not permitted to disturb the completely detached inspection of animal and bird life in its free state," he claimed. "Animals are not even aware that they are being photographed."[46] Each episode began with the same title: "This is one of a series of TRUE-LIFE ADVENTURES presenting strange facts about the world we live in. These films are photographed in their natural settings and are completely authentic, unstaged and unrehearsed." And yet Algar's facile adherence to biological fact allowed him to retrofit nature so that it complied with the demands of narrative. *White Wilderness* (1958), for example, contains one of one of the most egregious fakes in natural history film, which spawned the urban legend that lemmings commit mass suicide by jumping over a cliff into the ocean when they feel overcrowded. Algar's crew built a "snow covered lazy-Susan style turntable" and spun the lemmings off the clip while the camera followed the action from below.[47] Producers routinely discarded authenticity in favor of narrative; the animals served story more than the story served the animals.

In spite of taking such frequent liberties with the biological truth, the *True-Life Adventures* became the chief cultural access point for seeing and knowing nature for the 78 million baby boomers. As schools started to install the series in their curricula, Disney produced a landslide

of educational materials to guide teachers in the classroom. In addition, the popularity of the movies created a tidal wave of merchandise, including everything from books, comics, and 45 records to ceramic figurines of the animals. The American cultural sponge soaked up Disney.

Disney's panoptic portraits of animals in the wild did not present nature either as hostile or inscrutable but as benign and comforting. Although he kept humans physically removed from the world of nature, he kept them emotionally invested. At once present and yet removed, the observer felt empowered by an oxymoronic sense of intimate distance. The farther away one was, the closer one felt to nature.

Disney's America shared the same ethic as Akeley's Africa: the less one interfered with nature, the more it remained pure and vulnerable and therefore needing of human protection. Many of the young people who grew up with Disney's nature in all its forms—cartoons, documentaries, animated features, and wildlife fantasies—became active members in preservationist and conservationist movements.[48] For many years conservationists backed Disney's efforts, believing that the *True-Life Adventures* "made wilderness available to the public without any threat of despoiling natural areas that environmentalists prized and wished to preserve from the onslaught of mass tourism and recreation."[49] In 1955, Ludlow Griscom, the curator of Harvard University's Museum of Comparative Zoology and the chairman of the board and honorary president of the National Audubon Society, awarded Disney the Audubon Medal for "individual achievement in the field of conservation and environmental protection." Griscom praised Disney and the *True-Life Adventures* for inspiring a generation of conservationists and preservationists who would "conserve [our] priceless natural assets forever."[50] Not until years later, when Disney proposed a ski resort in northern California that required an access road through the Sequoia National Park did environmentalists realize Disney's motives were commercial.[51]

The Disney studio paradigm trivialized nature by turning animal behaviors into theatrics. Much in the same way that Martin Johnson corrupted the quality of his visual imaginary with exploitative stories about imaginary cannibals, Disney took the beautiful imagery his cameramen had shot and turned nature into a human circus of spills, thrills, daredevils, and clowns that entertained audiences with their human-like antics.

In general, the press and the public perceived the images they were watching as a faithful representation of reality. In 1954, the *Los Angeles Times* announced in its review of *The Vanishing Prairie* that "Walt Disney, having captivated the world as the Master of Fantasy, now has become, by the greatest contradiction of the age, the Master of Reality."[52]

Others were less convinced. Later that same year, the cover story for *Time* criticized Disney's flippant treatment of nature. "Thus far, Disney seems afraid to trust the strength of his material," he wrote.

> He primps it with cute comment and dabs at is with flashy cosmetical touches of music. But no matter how hard he tries he can't make mother nature look like what he thinks the public wants: a Hollywood glamour girl. "Disney has a perverse way," sighs one observer, "of finding glorious pearls and then using them as marbles."[53]

The public shrugged off the criticism. Even though Disney was not interested in exploring nature as much as he was interested in exploiting it for "its believe-it-or-not freakishness or cheapening it by making it seem that animals are comically trying to imitate, in their little ways man's mastery of his environment," people found his work endearing, satisfying, curious, educational, and most of all, entertaining.[54]

LEAVING IT TO BEAVER

In 1950, James Algar produced the second *True-Life Adventure, In Beaver Valley,* a story about a settler family of beavers and their search for happiness and stability during troubled times. A model for virtually all the *True-Life Adventures* that would follow, the narrative of *In Beaver Valley* seems hopelessly artificial by contemporary standards. Like *Bambi,* however, the combination of discourse and dramatic narrative—or ideology and emplotment in Hayden White's terminology—provide an easy way to parse those mechanisms. They allow us to understand how Disney's natural history films distance people from nature rather than bring them closer in spite of an cinematic illusion of intimacy; we can see his reductionist, patronizing attitudes toward nature and toward human institutions ranging from industry to family; and we can see how he used nature as a shill to eulogize American social values.

In Beaver Valley opens with a kindly, paternal voice that informs us that "There was once a time when all of North America was a great green wilderness—nature's undisputed domain. . . . Where time is still measured by the passing seasons and only nature's law prevails." And in this nameless, timeless valley, where "Nature is at peace with herself," lives "a small but mighty builder of things . . . Nature's true pioneer," the beaver.[55] Its rhetoric reads like the caption for Carl Akeley's muskrats in his diorama for the Field Museum.

"The beaver is a solid citizen," the narrator continues, "and he builds a solid house." The phrase would have rung true to the American working-class man who in the years following the war wanted to build his own solid house in suburbia. He too was a hard worker, committed to providing a home for his family. The home was the inviolable foundation of the family and a source of masculine pride. "After all," the narrator reaffirms, "the beaver's home is his castle."

But a foreign menace lurks in the valley that threatens to undermine the peace, security, and stability of Beaver Valley. "All over beaver valley mothers are looking after their young, teaching them the art of self-preservation," the narrator warns. It seems a shifty coyote has "strayed a long ways from his native plains" in order to infiltrate Beaver Valley because it "should be easy pickings." But the community's "vigilance committee" raises an alarm, and the citizens take cover. "It seems that a coyote can't make a move these days without somebody giving the alarm," notes the narrator.

The danger quickly passes and the story then focuses on the domestic problems of a household of beavers that has become overcrowded "with so many babies nosing around the backyard or tied to the mother's apron strings." Feeling the strain on his family's resources, a young male "sets out to face the world, as an older brother should."

Reluctantly, he strikes out "by means of his father's canals" into the "unexplored wilderness." Uncertain and homesick, he forges ahead "into unknown waters" to see "what this new world has to offer." The answer is a beautiful female. "She's lovely," the narrator tells us. "And fastidious. Quite the charming little beaver that ever graced a riverbank. Or let herself be kissed in a quiet pool."

The female is not a maiden, it turns out, but a "young widow with a baby needing protecting," a clear reference to the American mothers who had lost their husbands to the war. The "bridegroom" accepts his responsibility without regret or hesitation: "So this is the way of the world. His first day away from home and he ends up with a family. But the honeymoon will have to wait. There's a dam to be built before this shallow stream will afford them protection." Summer fades while Mr. Beaver works tirelessly to build his home. "To stay on schedule, he

works the nightshift too." As fall arrives, he has no time to admire his handiwork, and "like many other anxious harvesters, he's worried about his feed pile. All he can see is the first thin film of ice."

But their domestic calm is shattered when "the gypsies of Beaver valley," a group of otter "hoodlums," threatens the peace and security of their home. Alarmed, Mrs. Beaver "hustles her baby to the refuge of the house," while "father drops his work and comes racing to protect the homestead." Fortunately, the gadabout otters get bored and continue their frolic elsewhere. Peace is restored, but Mr. Beaver, "a born worrier, always looking forward to the worst," goes back to work, as he diligently prepares "for the lean months ahead." The family works hard to prepare for the hardships that lie ahead, and even when it seems they are "overstocked with provisions, [the father] is determined to add one more tasty branch to his deep freeze."

In Beaver Valley closes with the family safely tucked away from the icy grip of winter. "Now safe and warm in his sturdy house, the beaver at last enjoys a well-earned rest," the narrator reassures his audience; "the seasons complete their cycle and close a True-Life Adventure in this hidden place called Beaver Valley."

"We were disappointed by the producer's patronizing attitude toward nature," wrote the nameless columnist for the *Talk of the Town* in the *New Yorker*. "But in Hollywood, nature is just a sort of dull play on a badly arranged set, the whole thing in need of clowning. So when the toad and the frog were introduced, swelling their throats in the passionate season, Disney dubbed in opera music to accent the notes and turn a fascinating sexual manifestation, seldom observed, into a ten-cent laugh."[56] Bosley Crowther, writing for the *New York Times,* was irritated by Disney's "playful disposition to edit and arrange certain scenes so that it appears the wild life in them is behaving in human and civilized ways" but resigned himself to the knowledge that his complaint would likely fall on deaf ears.[57] It did.

The industrious beaver, "Nature's engineer," promised progress and hope at a time when the American worker was struggling to find sense of stability in the uncertain labor market after the war threatened his dream of life in the middle class. But as inflation went up, the labor demand went down. Workers lost overtime; worse, they lost hours and sometimes their jobs. Workers went out on strike and demanded better wages and more hours. The politicians, the industrialists, and the ministers in their pulpits their congregations that American would return to its glory if America put its collective shoulder to the wheel.

The Beaver didn't shirk responsibility by complaining or wasting time on frivolity. Instead, he worked with whatever tools were at hand and he worked until the job was done. He was a man of action, not words. So when the *Boston Globe* reviewed *Beaver Valley* in 1950, it seemed natural to hear that "Nature is no sentimentalist, knows no pause in progress and development, attaches a curse on all inaction."[58] The *Pittsburgh Press* echoed the feeling. "These little animals really are workers [and] don't worry about hours or anything but getting the job done."[59] Perhaps the *Westporter Herald* (Westport, Connecticut) made the point most clearly. "For here is a creature who never heard of Five o'clock Lag, John L. Lewis or the cessation [of work] that should come with Sunday."[60] Statements like these were so embedded in the national discourse and its understanding of nature that it even convinced one of the nation's leading conservationist biologists, Olaus Murie, that *Beaver Valley* educated "not with propaganda, not with moralizing, or with any form of overt direction, but by association with interesting, entertaining adventures of nature, presented truthfully."[61]

Between 1948 and 1960, Algar made ten of the thirteen episodes of the *True-Life Adventures* on American soil. He compassed the nation from the Everglades to Alaska, from the

prairies of the heartland to the deserts of the Southwest. His films were nominated nine times for an Academy Award and won seven. Looking back over the last ten years of production, Disney continued to insist disingenuously that "we hired no actors. We wrote no story . . . Nature itself provided the drama."[62]

In 1885 Theodore Roosevelt had stood tall against the fierce charge of Old Ephraim in the rugged mountains of the American northwest. Seventy-five years later, the bear has become a happy citizen in the family of Disney's nature as the sow takes her cubs to school to teach them the "lessons" that they will need to know as they grow older, such as climbing trees or rooting for grubs. They play ("tag, wrestling . . . and [play] tricks on each other"), nap, eat a balanced diet of "meat, eggs, fish, fruits," and, of course, "sweets,' and when winter comes, settle in for "a peaceful winter's sleep."[63] The anthropomorphized beast, which had once been a symbol of the devouring Other, had changed its form into an idealized reflection of the self, as a domestic hero. Communists walked in a slavish lockstep with their centralized government; Americans, on the other hand, were fiercely individual and devoted to their families. The animals in Disney's wildscape held those same values of loyalty, industry, fidelity, and thrift dear. It was the American way.

PLEASURING GROUNDS

Just as the managers of national parks arbitrate nature by managing their environmental resources, so do the corporate giants that commission films about nature—Disney, Discovery, National Geographic, and the BBC being among the most well known—turn nature into landscapes of consumption. In *Imposing Wilderness,* Roderick Neumann describes Yellowstone National Park as the "quintessential landscape of consumption for modern society."[64] The wildness created for film reflect wildscapes of the imagination in which animals, plants, and people play out roles that have been created for them by wildlife managers, scientists, public relations officers, and interpretative centers. Philosophically Yellowstone shares the values of the philosophy of the father of American landscape architecture, Frederick Law Olmsted (1822–1903). Olmsted, who designed Central Park in New York, the grounds around the U.S. Capitol, and many other urban parks in Boston, Louisville, Chicago, Detroit, and Atlanta, for example, believed that properly created and tended landscapes refined society's bourgeois sensibilities. "The power of scenery to affect men," Olmsted declared, "is, in a large way, proportionate to the degree of their civilization and the degree in which their taste has been cultivated."[65]

When Congress created Yellowstone National Park in March 1872, it declared the core mission of Yellowstone to be "a public park or pleasuring ground for the benefit and enjoyment of the people."[66] The government's commitment to the "unimpaired" preservation of "the natural and cultural resources and values of the national park system for the enjoyment, education, and inspiration of this and future generations" constructs boundaries around boundless nature.[67] The scientific metrics that constantly redefine the ecological balance of the fauna and flora that live within the park must, within the imperatives of the park's mission, be translated within the park's prime missions: to *preserve* rather than *protect,* which encourages a static image of a balance of nature that must be maintained, and to construct nature ideologically as a useful product for human beings. The federal *pleasuring grounds* of Yellowstone are

not substantially unlike the corporate *pleasuring grounds* of other heterotopias of nature such as Disneyland. Both construct nature for human consumption; both endorse the values of promotion, rationality, and profit; and both, albeit in different ways, deny the role of human agency in the creation of nature. "Some forms of this popular modern idea of nature seem to me to depend on a suppression of the human history of labour," wrote Raymond Williams, "and the fact that they are often in conflict with what is seen as the exploitation or destruction of nature may in the end be less important than the no less certain fact that they often confuse us about what nature and the natural are and might be."[68]

The unsettled ecological status of our world has begun to force some of these issues into the open. As more and more people begin to accept that the causes of climate change are linked to human activity rather than the fickleness of nature, the social pretense that culture and nature are disconnected spheres of influence begins to collapse. The wild frame created by Akeley and Disney eighty years ago is gradually losing its appeal. In its place, however, the imperial hunter has returned to the frame in a new guise, dressed in the white lab coat and armed to the teeth with the newest weapons of science.

Roosevelt's hunter and the scientist share the same basic moral imperatives. The scientist continues to fight against nature (by curing disease), to control nature (by manipulating it), and to save nature from the anthropogenic forces that threaten to destroy it. Meanwhile, the camera continues to play its slavish role in the service of the ideologies that continue to rule it.

Notes

INTRODUCTION

1. Raymond Williams, *Keywords* (New York: Oxford University Press, 1983), 21.
2. Arthur O. Lovejoy and George Boas, *Primitivism and Related Ideas in Antiquity* (New York: Octagon, 1973), 109.
3. Friedrich von Bernhardi, *Germany and the Next War* (New York: Longmans, Green, 1914), 20.
4. C. S. Lewis, *Studies in Words,* 2nd ed. (Cambridge: Cambridge University Press, 1967), 61.
5. Francis Galton, *Hereditary Genius: An Inquiry into Its Laws and Consequences* (New York: D. Appleton, 1884), 14.
6. Alfred Russel Wallace, "A Review of *Hereditary Genius: An Inquiry into Its Laws and Consequences,*" *Nature* 17 (1870): 502–503.
7. Genesis 1:26, 29 and 9:3, KJV.
8. Thomas Aquinas, *Summa Theologica II and III,* Q64, article 1, 1273.
9. 56th Congress, 1st sess., *Congressional Record*, p. 704.
10. Roderick Nash, *Wilderness and the American Mind* (New Haven: Yale University Press, 1967), 24.
11. Ella Shohat, and Robert Stam, *Unthinking Eurocentrism: Multiculturalism and the Media* (New York: Routledge, 1994), 109.
12. Richard Peet and Michael Watts, *Liberation Ecologies: Environment, Development, Social Movements* (London: Routledge, 1996).
13. Peter A. Walker, "Political Ecology: Where is the Ecology," *Progress in Human Geography,* 29, no. 1 (2005): 78.
14. Carol Crumley, "Cultural Ecology: A Multidimensional Ecological Orientation," in *Historical Ecology: Cultural Knowledge and Changing Landscapes* (Santa Fe: SAR Press, 1994), 6.
15. G. Brown Goode, *The Museums of the Future* (Washington, DC: Government Printing Office, 1891), 427.
16. John Berger, *Ways of Seeing* (London: Penguin, 1972), 33.
17. Shohat and Stam, *Unthinking Eurocentrism,* 102.
18. Edmund Morris, *The Rise of Theodore Roosevelt* (New York: Random House, 2001), 106. Not everyone was a fan of Roosevelt. "Our people have adored this showy charlatan as perhaps no imposter of his brood his been adored since the Golden Calf," Mark Twain, an avowed anti-imperialist, groused in a letter to the *New York Times* on March 6, 1908.
19. Theodore P. Greene, *America's Heroes: The Changing Models of Success in American Magazines* (New York: Oxford University Press, 1970), 235.
20. "Theodore Roosevelt: The Picture Man." *Motion Picture World* 7 (October 22, 1910): 920.

CHAPTER ONE. TALES OF DOMINION

1. Richard Dawkins, *The God Delusion* (Boston: Houghton Mifflin, 2006), 132–133.

2. René Descartes, *Discourse on Method of Rightly Conducting the Reason and Seeking for Truth in the Sciences*, vol. 1 of *Philosophical Works*, ed. E. S. Haldane and G. R. T. Ross (New York: Dover, 1955), 119.

3. Raymond Williams, *Culture and Materialism* (London: Verso, 2005), 71.

4. Michel Foucault, *The Order of Things: An Archaeology of the Human Sciences* (New York: Vintage, 1970), 129.

5. Kenneth Varty, ed., *Reynard the Fox: Social Engagement and Cultural Metamorphoses in the Beast Epic from the Middle Ages to the Present*, vol. 1 of *Cultural Diversities and Intersections* (New York: Berghahn Books, 2000), 1–298.

6. Gesner's generation included naturalists such as Pierre Belon, Guillaume Rondelet, Carlo Ruini, Olaf Stor, and Giovanni Battista Ramusio.

7. Psalms 8:5 KJV.

8. Stephen Jay Gould, *The Flamingo's Smile: Reflections in Natural History* (New York: Norton, 1985), 282.

9. Leslie Fiedler, *Freaks: Myths & Images of the Secret Self* (New York: Touchstone, 1978), 152.

10. Hybridization could also occur by means other than sexual union, such as a result of witchcraft, eating certain plants, or by "'impression,' i.e., being frightened by animals during pregnancy or gazing at them at the moment of conception."

11. Other contemporaries of Paré include Jacob Rueff (*De conceptu et generatione hominis,* 1554), Conrad Lycosthenes (*Prodigiorum ac ostentorum chronicon,* 1557), Pierre Boiastuau (*Histoires prodigiueses,* 1560), and Edward Topsell (*The History of Four-footed Beasts and Serpents,* 1607).

12. Evelyn Fox Keller, *Reflections on Gender and Science* (New Haven: Yale University Press, 1985), 36.

13. Douglas M. Jesseph, "Galileo, Hobbes and the Book of Nature," *Perspectives on Science* 12, no. 2 (2004): 191.

14. Thomas Hobbes, "Of Darknesse from Vain Philosophy and Fabulous Traditions," in *Leviathan* (New York: E. P. Dutton, 1950), 591.

15. Neil Evernden, *The Social Creation of Nature* (Baltimore: Johns Hopkins University Press, 1992), 19.

16. John Berger, "Why Look at Animals?" in *About Looking* (New York: Vintage International, 1991), 12.

17. Roger Lewin, *Human Evolution: An Illustrated Introduction,* 5th ed. (Malden, MA: Blackwell, 2005), 4.

18. Paul Lawrence Farber, *Finding Order in Nature: The Naturalist Tradition from Linnaeus to E. O. Wilson* (Baltimore: Johns Hopkins University Press, 2000), 8–9.

19. Quoted in Paul Lawrence Farber, *Finding Order in Nature: The Naturalist Tradition from Linnaeus to E. O. Wilson* (Baltimore: Johns Hopkins University Press, 2000), 13.

20. Foucault, *The Order of Things* (New York: Vintage, 1973), 131. "The documents in this new history are not other words, texts or records," wrote Foucault of Linnaeus's enterprise, "but unencumbered spaces in which things are juxtaposed: herbariums, collections, gardens; the locus of this history is a non-temporal rectangle in which, stripped of all commentary, of all enveloping language, creatures present themselves one beside another, their surfaces visible, grouped according to their common features, and thus already virtually analysed, and bearers of nothing but their own individual names."

21. Louis Agassiz, "Essay on Classification," in *Contributions to the Natural History of the United States of America,* vol. 1 (New York: Arno Press, 1978), 135.

22. Francis Bacon, *The Works of Francis Bacon,* ed. James Spedding, Robert Leslie Ellis, and Douglas Denon Heath (New York: Hurd and Houghton, 1877), 1:350.

23. *Tikkun* is variously translated as "repair," "heal," 'restore," or perfect." *Tikkun olam* also resonates with Christianity (as Christ exhorted his followers to prepare for the Kingdom of Heaven through love, wakefulness, and charity) and Buddhism (as the Bodhisattva forswears final liberation until all people are free from suffering).

24. Strong's Number 7287. The Strong's number system identifies the Hebrew and Greek words from which the Bible was translated.

25. In the King James Version, the word *radah* appears a total of twenty-seven times. Its relative rarity seems to indicate a special emphasis, only no one can agree what that emphasis is. Nonetheless, the meaning of *radah* is critical to the understanding of God's charter and of humanity's relationship to nature.

26. Pico Della Mirandola, "Oration on the Dignity of Man," trans. Richard Hooker, 1998, http://wsu.edu:8080/~wldciv/world_civ_reader/world_civ_reader_1/pico.html (12 November 2009); emphasis added.

27. Robert Jamieson, Andrew Robert Fausset, and David Brown, *A Commentary, Critical and Explanatory, on the Old and New Testaments* (Hartford: S. S. Scranton, 1871), 1:18.

28. Adam Clarke, *The Holy Bible, Containing the Old and New Testaments, A Commentary and Critical Notes* (New York: T. Mason & G. Lane, 1837), 36.

29. Daniel Botkin, *Discordant Harmonies: A New Ecology for the Twenty-First Century* (New York: Oxford University Press, 1990), 85.

30. Adam Smith, *The Theory of Moral Sentiments,* ed. D. D. Raphael and A. L. Macfie (Oxford: Clarendon Press, 1976), 168.

31. Mathew 5:14, "Ye are the light of the world. A city that is set on a hill cannot be hid."

32. John Locke, *Two Treatises of Government,* ed. Peter Laslett (Cambridge: Cambridge University Press, 1988), 291.

33. Michael Wigglesworth, "God's Controversy with New England," *Proceedings of the Massachusetts Historical Society* 12 (1871–1873): 83. Wigglesworth alludes to Deuteronomy 32:10 (KJV): "He found [Moses] in a desert land, and in the waste howling wilderness; he led him about, he instructed him, he kept him as the apple of his eye."

34. Leo Marx, *The Machine and the Garden* (London : Oxford University Press, 1964), 76.

35. Anne McClintock, Aamir Mufti, and Ella Shohat, ed. *Dangerous Liaisons: Gender, Nation, and Postcolonial Perspectives* (Bloomington: University of Minnesota Press, 1997), 96.

36. Carolyn Merchant, *Reinventing Eden: The Fate of Nature in Western Culture* (New York: Routledge, 2003), 123.

37. J. Hector St. John de Crèvecoeur, *Letters from an American Farmer* (Oxford: Oxford University Press, 1997), 15.

38. Thomas Jefferson to John Banister Jr., Paris, October 15, 1785, in *Jefferson: Political Writings*, ed. Joyce Appleby and Terrence Ball (Cambridge: Cambridge University Press, 1999), 248.

39. Letter from Thomas Jefferson to G. K. van Hogendorp, Paris, dated October 13, 1785, in Everett E. Edwards, ed., "Part II: Selections from Jefferson's Writings," in *Jefferson and Agriculture* (New York: Arno Press, 1976), 25.

40. William Kennedy Laurie Dickson, Otto Latham, and Gray Latham premiered moving pictures on their collaborative invention, the Eidoloscope, on April 21, 1895, preceding the Lumières by some eight months.

41. Eric Barnouw, *Documentary: A History of Non-Fiction Film* (Oxford: Oxford University Press, 1974), 5. Edison's earliest extant film is *Edison's Kinetoscopic Record of a Sneeze,* also known as *Fred*

Ott's Sneeze, which was shot in January 1894. Edison's assistant, William Kennedy Laurie Dickson, the man most likely responsible for the actual development of the kinetoscope, deposited the first motion pictures made in the Black Maria at the Library of Congress in August 1893.

42. *Actualités* was one of several terms that were commonly used to describe these motion pictures. Others included "topicals," "interest films," and "documentaries," which obviously led to the term "documentary."

43. Woodrow Wilson, "The Ideals of America" *Atlantic Monthly* 90, no. 6 (1902): 721–734, http://www.theatlantic.com/issues/02dec/wilson.htm (30 December 2009).

44. *Das Boxende Kanguruh* (1895), *WildFilm History: Films: film clip,* http://www.wildfilmhistory.org/film/318/clip/439/Full+film.html (November 12, 2009). *Mr. Delaware and the Boxing Kangaroo* (1895) has also been cited as the first film with a "wild beast" in it, although the kangaroo was a circus animal.

45. *Children Playing with Lion Cubs* (1902), *AFI Catalog Feature Films,* http://www.afi.com/members/catalog/DetailView.aspx?s=&Movie=44341 (12 November 2009).

46. *Small Boy and Lion Cub, Hagenbeck's Circus* (1903), *AFI Catalog Feature Films,* http://www.afi.com/members/catalog/DetailView.aspx?s=&Movie=42644(12 November 2009).

47. *The Boxing Horse* (1899), *AFI Catalog Feature Films,* http://www.afi.com/members/catalog/DetailView.aspx?s=&Movie=30237 (12 November 2009).

48. Georg Wilhelm Friedrich Hegel, *The Hegel Reader,* ed. Stephen Houlgate (Oxford: Blackwell, 1998), 284.

49. *Hunting White Bear* (1903), *AFI Catalog Feature Films,* http://www.afi.com/members/catalog/DetailView.aspx?s=&Movie=42811 (November 12, 2009). A few films predate *Hunting the White Bear,* but they all depict elements of fox hunting. *Hunting the White Bear* is the first film that focuses on the beast.

50. Titles of silent films of the early period were generally indicative of their content, so, in spite of the fact that many of these films are lost to us, we can still discern their content by their titles.

51. *New York Commercial Advertiser,* January 5, 1903.

52. Interestingly, a "rogue" elephant named Mary was actually hanged in Erwin, Tennessee, on September 13, 1916, for killing her handler. Mary was hanged by a railroad derrick.

53. "Dogs Killed by Electricity," *New York Times,* July 20, 1887, 4; "Died for Science's Sake: A Dog Killed with the Electric Current," *New York Times,* July 31, 1888, 8; "More Experiments on Dogs" *New York Times,* August 4, 1888, 8; "Surer than the Rope: Demonstration of Capital Punishment by Electricity," *New York Times,* December 6, 1888, 5.

54. *New York Commercial Advertiser,* January 5, 1903.

55. Lisa Cartwright, *Screening the Body: Tracing Medicine's Visual Culture* (Minneapolis: University of Minnesota Press, 1995), 18.

56. Sometimes described as a "pumpkin."

CHAPTER TWO. THE PLOW AND THE GUN

1. Kerwin Lee Klein, *Frontiers of Historical Imagination: Narrating the European Conquest of Native America, 1890–1990* (Berkeley: University of California Press, 1999), 14.

2. The population of indigenous peoples in America had plummeted from an estimated 10 million at the time of Columbus to less than 300,000 by the time Turner published his thesis. In

effect, the Euro-American advance had already extinguished the Native American for all practical purposes.

3. Frederick Jackson Turner, *The Frontier in American History* (New York: Henry Holt, 1921), 219.

4. Theodore Roosevelt, "Ranch Life in the Far West: In the Cattle Country," *Century Illustrated Magazine* 35, no. 4 (1888): 495–510; Theodore Roosevelt, "The Home Ranch," *Century Illustrated Magazine* 35, no. 5 (1888): 655–669; Theodore Roosevelt, "The Round-Up," *Century Illustrated Magazine* 35, no. 6 (1888): 849–867; Theodore Roosevelt, "Frontier Types," *Century Illustrated Magazine* 36, no. 6 (1888): 831–843.

5. Karl Marx, *Grundrisse* (London: Penguin, 1993), 409.

6. Roderick Nash, *Wilderness and the American Mind*, 3rd ed. (New Haven: Yale University Press, 1982), 150.

7. Roosevelt shuttled regularly between the ranch and New York and stayed active in politics. In 1884 he served as the chairman of the Committee on Cities (New York) and was a delegate to the Republican National Convention; in 1886 he ran for mayor of New York City, and in 1889 President Harrison appointed TR as a commissioner for the U.S. Civil Service.

8. Roosevelt's history of the West effectively ends with General Anthony Wayne's victory over the Indians at the Battle of Fallen Timbers, Ohio, in 1794; although TR intended to continue his history, his political career overtook his ambitions as a historian by the time he finished the fourth volume.

9. H. W. Brands, *The Reckless Decade: America in the 1890s* (Chicago: University of Chicago Press, 2002), 24.

10. Theodore Roosevelt, *Thomas Hart Benton* (Boston: Houghton, Mifflin, 1887), 40. Roosevelt dashed off the book in five months while on the Maltese Cross ranch in the Dakota Territory. He had no access to research materials and later had to hire someone else to fill the particulars of Benton's life.

11. Ibid., 178. Roosevelt had a muddy definition of race. He applied the word to people of color, people of nations ("the American" and the "English" race) and even people of certain states, such as the Kentucky "race."

12. Ibid., 3.

13. Roosevelt, *The Winning of the West* (New York: G.P Putnam's Sons, 1917), 2:57.

14. Roosevelt, *Thomas Hart Benton,* 57.

15. For example, Roosevelt decried George Washington's secretary of war Henry Knox for having concluded peace treaties with Native American tribes.

16. Helen Hunt Jackson, *A Century of Dishonor: A Sketch of the United States Government's Dealings with Some of the Indian Tribes* (Norman: University of Oklahoma Press, 1995), xii.

17. Ibid., xiv.

18. Roosevelt, *Thomas Hart Benton,* 268.

19. Hermann Hagedorn, *Roosevelt in the Bad Lands* (Boston: Houghton Mifflin, 1921), 355; and Richard Hofstadter, *The American Political Tradition, and the Men Who Made It* (New York: Vintage, 1974), 274.

20. Ironically, when Benjamin Harrison appointed Roosevelt to the U.S. Civil Service as a commissioner, he found himself confronted with issues relating to Indian rights and abuses; as a result, he moderated his views towards Indians and eventually advocated assimilation.

21. Roosevelt, *Winning of the West,* 2:56.

22. Roosevelt, *Thomas Hart Benton,* 270.

23. Roosevelt, *Winning of the West,* 6:201.

24. George M. Beard, *A Practical Treatise on Nervous Exhaustion (Neurasthenia): Its Symptoms, Nature, Sequences, Treatment,* 5th ed., ed. A. D. Rockwell (New York: Kravs Reprint Co., 1971), 51–67.

25. Henry James, *The Bostonians* (London: Penguin, 2000), 260.

26. Edmund Morris, *The Rise of Theodore Roosevelt* (New York: Random House, 2001), 481. James was not a fan of Roosevelt's either and called him "the mere monstrous embodiment of unprecedented and resounding noise."

27. Nash, *Wilderness*, 3rd. ed., 153.

28. Renato Rosaldo, *Culture and Truth: The Remaking of Social Analysis* (Boston: Beacon Press, 1989) 70, 72.

29. Theodore Roosevelt, *African Game Trails* (New York: Charles Scribner's Sons, 1923), 1:15.

30. Paul Russell Cutright, *Theodore Roosevelt: The Naturalist* (New York: Harper & Brothers, 1956), 69.

31. Nash, *Wilderness*, 3rd. ed., 152.

32. *Report of the National Conservation Commission, Special Message from the President of the United States Transmitting a report of the National Conservation Commission, with accompanying papers,* February, 1909, http://memory.loc.gov/cgi-bin/query/r?ammem/consrv:@field(DOCID+@lit (amrvgvg38div5) (November 2006).

CHAPTER THREE. PICTURING THE WEST, 1883–1893

1. Theodore Roosevelt, "The Vigor of Life: The Second Installment of 'Chapters of a Possible Autobiography,'" *The Outlook*, March 22, 1913, 661.

2. Peggy Samuels and Harold Samuels, *Teddy Roosevelt at San Juan: The Making of a President* (College Station: Texas A&M University Press, 1997), 50, 53.

3. Sarah Watts, *Rough Rider in the White House: Theodore Roosevelt and the Politics of Desire* (Chicago: University of Chicago Press, 2003), 126.

4. Stefan Lorant, *The Life and Times of Theodore Roosevelt* (New York: Doubleday, 1959), 203.

5. TR to Henry Cabot Lodge, August 12, 1884, in *Selections from the Correspondence of Theodore Roosevelt and Henry Cabot Lodge, 1884–1918* (New York: Charles Scribner and Sons, 1925), 1:7.

6. Morris, *Rise of Theodore Roosevelt*, 283. The *New York Herald* (September 22, 1885) wrote about Roosevelt's monogrammed, forty-five-pound saddle, silver-inlaid bit and spurs, real angora chaps, a braided quirt, and an "exquisite pear-handled silver-mounted revolver" (Morris, 790).

7. Paul Schullery, *American Bears: Selections from the Writings of Theodore Roosevelt* (Boulder: Colorado Associated University Press, 1983), 7.

8. Watts, *Rough Rider,* 130.

9. Clay S. Jenkinson, *Theodore Roosevelt in the Dakota Badlands: An Historical Guide* (Dickinson, ND: Dickinson State University, 2006), 35–36.

10. William Henry Harbaugh, *Power and Responsibility: The Life and Times of Theodore Roosevelt* (New York: Collier, 1963), 78, 81.

11. The Pendleton Act of 1883, S. 133, 47th Cong., 2nd sess., *Congressional Record* 11 (December 4, 1882).

12. Morris, *Rise of Theodore Roosevelt,* 205.

13. Ibid., 549.

14. Other major artists of this early period include John W. Jarvis, Peter Rindisbacher, Arthur F. Tait,

Alfred Jacob Miller, Seth Eastman, John Mix Stanley, Paul Kane, William Jacob Hays, Samuel Colman, Fanny Palmer, and Newbold Trotter.

15. Watts, *Rough Rider,* 25.
16. Helen Cody Wetmore, *Last of the Great Scouts: The Life Story of Col. William F. Cody "Buffalo Bill" as told by his Sister, Helen Cody Wetmore* (Chicago: R. R. Donnelley & Sons, 1899), 208.
17. Ibid.
18. Ibid., 209.
19. Cody appeared on the stage for the last time in Denver in 1886 in *The Prairie Waif.*
20. Charles King, *Campaigning with Crook and Stories of Army Life* (New York: Harper & Bros., 1890), 42.
21. A more accurate historical version of the duel appears in Don Russell, *The Lives and Legends of Buffalo Bill* (Norman: University of Oklahoma Press, 1960).
22. His name was actually "Hay-o-wai," which translates as "Yellow Hair," based upon the woman's blonde scalplock he wore on his headdress.
23. Prentiss Ingraham, *Adventures of Buffalo Bill from Boyhood to Manhood. Deeds of Daring, Scenes of Thrilling, Peril, and Romantic Incidents In the Early Life of W. F. Cody, the Monarch of Bordermen.* Beadle's Boy's Library of Sport, Story and Adventure, vol. 1, no. 1 (New York: [Beadle and Adams], [1882?]. According to an eyewitness, Captain Charles King, the clash between Cody and Yellow Hand was "the work of a minute; the Indian has fired and missed. Cody's bullet tears through the rider's leg, into his pony's heart, and they tumble in confused heap on the prairie. The Cheyenne struggles to his feet for another shot, but Cody's second bullet crashes through his brain, and leaves the young chief, Yellow Hand, lifeless in his tracks.")
24. Paul L. Hedren, "The Contradictory Legacies of Buffalo Bill Cody's First Scalp for Custer," *Montana: The Magazine of Western History* 55, no. 1 (2005): 30.
25. Lester G. Moses, *Wild West Shows and the Images of American Indians 1883–1933* (Albuquerque: University of New Mexico Press, 1996), 30 and 137. See also Paul Reddin, *Wild West Shows* (Urbana: University of Illinois Press, 1999).
26. Nash, *Wilderness,* 3rd. ed., 27.
27. Randolph J. Cox, *The Dime Novel Companion: A Source Book* (Westport, CT: Greenwood Press, 2000), xiv–xxiv.
28. Hedren, "Contradictory Legacies," 21–22.
29. Dallas Stoudenmire, himself a gunman with a violent temper, created as much lawlessness in El Paso as he resolved, and his "reign of terror" provides an interesting insight into moral ambiguity of many "lawmen" in frontier cities. Stoudenmire was himself killed in a gunfight in El Paso in 1882.
30. In addition, President James Garfield was shot on July 2, less than four months after taking the oath of office. He died eleven weeks later.
31. Henry Nash Smith, *Virgin Land: The American West as Symbol and Myth* (Cambridge: Harvard University Press, 1978), 110.
32. "The Murderous Cowboys: How They Held a Court in Subjection in New Mexico," *New York Times,* February 16, 1886, 2.
33. Hermann Hagedorn in *Roosevelt in the Badlands* quotes Bill Sewall as saying that Pfaffenbach (whom he called a half-witted German named Wharfenberger) was "an oldish man who drank so much poor whiskey that he lost most of the manhood he never possessed."
34. Lorant, *Life and Times,* 224.
35. Ibid.

36. Theodore Roosevelt, *Ranch Life and the Hunting Trail* (New York: Century, 1888), 115.

37. Julian Ralph, *Our Great West: A Study of the Present Conditions and Future Possibilities of the New Commonwealths and Capitals of the United States* (New York: Harper & Brothers, 1893), 142.

38. Roosevelt, *Ranch Life,* 111.

39. Ibid., 101, 105, 107.

40. Ralph, *Our Great West,* 145 and 153.

41. Ibid., 153–154.

42. Ibid., 158.

43. Ibid., 159.

44. Francis Amasa Walker, *Political Economy,* 3rd ed. (London: Macmillan, 1892), 70.

45. TR to Cecil Arthur Spring Rice, December 27, 1904, in *The Letters of Theodore Roosevelt,* ed. Elting E. Morison (Cambridge: Harvard University Press, 1951–1954), 4:1084.

46. Theodore Roosevelt, *Hunting Trips of a Ranchman: Sketches of Sport on the Northern Cattle Plains* (New York: G. P. Putnam's Sons, The Knickerbocker Press, 1886), 191.

47. Michel Foucault, *The Birth of the Clinic* (New York: Pantheon, 1975), 107.

48. Ibid., 115.

49. Roosevelt, *Ranch Life,* 3, 13.

50. Theodore Roosevelt, *The Wilderness Hunter: Sketches of Sport on the Northern Cattle Plains* (New York: G. P. Putnam's Sons, 1893), 1:89.

51. "Hunting Trips of a Ranchman," review of *Hunting Trips of a Ranchman,* by Theodore Roosevelt, *Atlantic Monthly* 56, no. 336 (1885): 563.

52. Roosevelt, *The Wilderness Hunter,* 1:37.

53. Ibid., 1:vii.

54. September 12–17 and December 14–17, 1884.

55. "The Coming of Winter," *Century Illustrated Monthly Magazine,* 37, no. 2 (1888): 163.

56. Roosevelt, *The Wilderness Hunter,* 2:263.

57. Ibid.

58. Roosevelt, *Hunting Trips of a Ranchman,* 336.

59. Ibid., 338.

60. Roosevelt, "The Vigor of Life," 664. Because of his near-sightedness, Roosevelt was not a particularly good shot. He considered himself a member of a class of marksmen "of ordinary abilities who, if they choose resolutely to practice, can by sheer industry and judgment make themselves fair rifle shots."

61. However, in *The Wilderness Hunter* Roosevelt's prose succumbs to a heady rush when he has a close encounter with a grizzly bear in 1889. While hunting grouse near the headwaters of the Salmon and Snake rivers in Idaho, he "caught the loom of some large, dark object; and another glance showed me a big grisly [*sic*] walking slowly off with his head down." He shot and wounded the bear, which grunted and took off at a "heavy gallop." Roosevelt pursued and caught up to the bear in a thicket. "He turned his head stiffly towards me; scarlet strings of froth hung from his lips; his eyes burned like embers in the gloom." He fired again, this time "nicking" the bear's heart, but the animal "turned with a harsh roar of fury and challenge, blowing the bloody foam from his mouth so that I saw the gleam of his white fangs; and then he charged straight at me, crashing and bounding through the laurel bushes, so that it was hard to aim." Teddy shot the grizzly yet again, this time through the chest, but "he neither swerved nor flinched" as he rushed the gap between them so fast he barely had time to fire a fourth shot, which blew apart the bear's jaw. "I leaped to one side almost as I pulled trigger," he wrote, "and through the hanging smoke

the first thing I saw was his paw as he made a vicious side blow at me." The grizzly's momentum carried him past Roosevelt as he crashed headlong onto the ground, "but he recovered himself and made two or three jumps onwards" as Roosevelt desperately tried to reload. "Then he tried to pull up, but as he did so his muscles seemed suddenly to give way, his head drooped, and he rolled over and over like a shot rabbit."

62. TR to Anna Roosevelt, September 20, 1884, in *Letters of Theodore Roosevelt*, 1:82.
63. Theodore Roosevelt to Theodore Roosevelt Jr., April 20, 1905, in *Letters to His Children* (Charleston: BiblioBazaar, 2008), 78.
64. Carl Akeley, "Have a Heart: A Statement and Plea for Fair Game Sport in Africa," *The Mentor*, January 13, 1926, 47.
65. Roosevelt, *The Wilderness Hunter*, 44–46.
66. Ibid., 262.
67. Watts, *Rough Rider*, 180.

CHAPTER FOUR. AMERICAN IDOL, 1898

1. Jacob Riis, *How the Other Half Lives: Studies Among the Tenements of New York* (New York: Scribner's Sons, 1890).
2. William Henry Harbaugh, *Power and Responsibility: The Life and Times of Theodore Roosevelt* (New York: Collier, 1963), 93.
3. Eric Barnouw, *Documentary: A History of the Non-Fiction Film*, rev. ed. (Oxford: Oxford University Press, 1983), 23.
4. Albert E. Smith, *Two Reels and a Crank* (New York: Taylor & Francis, 1985), 148.
5. Also known under the title of *Theodore Roosevelt*, film No. 490 in the Edison catalogue. See *Theodore Roosevelt Leaving the White House* (1898), *The Library of Congress American Memory: Theodore Roosevelt on Film*, http://memory.loc.gov/cgi-bin/query/r?ammem/papr:@filreq%28@field%28NUMBER+@band%28trmp+4099%29%29+@field%28COLLID+roosevelt%29%29 (November 12, 2009).
6. TR to Cecil Spring-Rice, April 14, 1889, in *Letters of Theodore Roosevelt* (Cambridge: Harvard UP, 1951–1954), 1:157.
7. Lorant, *Life and Times*, 266.
8. Howard K. Beale, *Theodore Roosevelt and the Rise of America to World Power* (Baltimore: Johns Hopkins Press, 1956), 36.
9. Joseph Bucklin Bishop, "Theodore Roosevelt and His Time: Shown in His Own Letters," *Scribner's Magazine* 66, no. 5 (1919): 523.
10. Lorant, *Life and Times*, 283, 295.
11. Peggy Samuels and Harold Samuels, *Teddy Roosevelt at San Juan: The Making of a President* (College Station: Texas A&M University Press, 1997), 13.
12. TR to William Sturgis Bigelow, March 29, 1898, in *Letters of Theodore Roosevelt*, 2:802.
13. William D. Long, diary entry, April 25, 1898, in Lorant, *Life and Times*. After the war, Secretary Long admitted confidentially that "Roosevelt was right and we his friends were all wrong. His going into the army led straight to the Presidency."
14. Bernard DeVoto, ed., *Mark Twain in Eruption* (New York: Capricorn, 1968), 49.
15. Watts, *Rough Rider*, 26.

16. *New York Clipper*, April 9, 1898, 92.

17. Charles Musser, *The Emergence of Cinema: The American Screen to 1907* (New York: Charles Scribner's Sons, 1990), 247.

18. Watts, *Rough Rider*, 162.

19. Corinne Roosevelt Robinson, *My Brother, Theodore Roosevelt* (New York: Scribner's Sons, 1921), 150.

20. Theodore Roosevelt, *The Rough Riders* (New York: Charles Scribner's Sons, 1899), 15.

21. Ibid., 15, 19.

22. Ibid., 16, 25.

23. Ibid., 27.

24. Ibid., 37.

25. Ibid., 15.

26. Charles Herner, *The Arizona Rough Riders* (Tucson: University of Arizona Press, 1970), 84.

27. Edward Wagenknecht, *The Seven Worlds of Theodore Roosevelt* (Guilford, CT: Globe Pequot Press, 2009), 26.

28. Roosevelt, *The Rough Riders*, 20–21.

29. TR to Brooks Brothers, April 30, 1898, in Watts, *Rough Rider,* 169.

30. *Roosevelt and Officers of His Staff* (1898), *The Library of Congress American Memory: Early Motion Pictures 1897–1920*, http://memory.loc.gov/cgi-bin/query/D?papr:1:./temp/~ammem_cfoa:: (November 12, 2009). Also known as *President Roosevelt and the Rough Riders*, the film was shot in June 1898, three years before Roosevelt became president. According to the Library of Congress site, the film itself wasn't copyrighted until 1903 and likely received this title at that time.

31. *Col. Theodore Roosevelt and Officers of His Staff* (1898) was shot at Camp Wikoff, Montauk Point, Long Island, New York, a month after the war. See *AFI Catalog Feature Films*, http://www.afi .com/members/catalog/DetailView.aspx?s=&Movie=32128 (November 12, 2009).

32. Edison catalogue No. 642. Also see *Roosevelt's Rough Riders* (1898), *The Library of Congress American Memory: Theodore Roosevelt on Film*, n.d., http://memory.loc.gov/cgi-bin/query/h?ammem/ papr:@field(NUMBER+@band(sawmp+0318) (November 12, 2009).

33. Lorant, *Life and Time*, 297.

34. Theodore Roosevelt, "The Negro in America." *The Outlook*, June 4, 1910, 243.

35. Kathleen Dalton, *Theodore Roosevelt: A Strenuous Life* (New York: Knopf, 2002), 176.

36. John Hay's quotation of Sir Walter Scott, "One crowded hour of glorious life / is worth an age without a name."

37. Edward J. Renehan Jr., *The Lion's Pride: Theodore Roosevelt and His Family in Peace and War* (New York: Oxford University Press, 1998), 3. See also Harbaugh, *Power and Responsibility,* 105.

38. Roosevelt, *The Rough Riders*, 136.

39. Ibid., 132, 155.

40. Richard Harding Davis, *The Cuban and Porto Rican Campaigns* (New York: Charles Scribner's Sons, 1898), 217.

41. Jacob Riis, *Theodore Roosevelt: The Citizen* (New York: Macmillan, 1912), 168–169.

42. Davis, *Cuban and Porto Rican Campaigns,* 218–219.

43. In his farewell speech to the regiment on Montauk Point, Long Island, Roosevelt acknowledged the sacrifice that the black soldiers had made while fighting alongside the Rough Riders.

44. Watts, *Rough Rider,* 165.

45. Riis, *Theodore Roosevelt*, 169–170.

46. Nathaniel Philbrick, *The Last Stand* (New York: Viking, 2010), 47.

47. Paul Grondahl, *I Rose like a Rocket: The Political Education of Theodore Roosevelt* (New York: Free Press, 2004), 270.

48. Irving C. Norwood, "Exit—Roosevelt, the Dominant," *Outing Magazine* 53, no. 6 (1909): 722.

49. TR to Winthrop Chanler, March 23, 1899, in *Letters of Theodore Roosevelt*, 2:969.

50. TR to Henry Cabot Lodge, July 19, 1898, in *Letters of Theodore Roosevelt*, 2:853. In a letter to Henry Cabot Lodge, July 19, 1898, TR wrote, "Did I tell you that I killed a Spaniard with my own hand when I led the storm of the first redoubt? Probably I did."

51. Harbaugh, *Power and Responsibility*, 107.

52. Dalton, *Theodore Roosevelt*, 173.

53. Fitzhugh Lee, Joseph Wheeler, Theodore Roosevelt, and Richard Wainright, *Cuba's Struggle Against Spain with the Causes for American Intervention and a Full Account of the Spanish-American War, including Final Peace Negotiations* (New York: American Historical Press, 1899), 645.

54. Richard Slotkin, "Nostalgia and Progress: Theodore Roosevelt's Myth of the Frontier," *American Quarterly* 33 (1981): 611.

55. TR to Kermit Roosevelt, December 4, 1902, in *Letters of Theodore Roosevelt*, 3:389. Roosevelt had known Wood since 1897 and considered him his "playmate." "We put on heavily padded helmets, breastplates and gauntlets and wrap bath towels around our necks, and then we turn to and beat one another like carpets."

56. TR to Henry Cabot Lodge, July 10 and 19, 1898, in *Letters of Theodore Roosevelt*, 2:850–851.

57. Morris, *Rise of Theodore Roosevelt*, 875.

58. Milton Meltzer, *Mark Twain Himself: A Pictorial Biography* (Columbia: University of Missouri Press, 1960), 258.

59. TR to Henry Cabot Lodge, December 6, 1898, in *Letters of Theodore Roosevelt*, 2:892. TR got the honor he so sought in 2001, when President Clinton awarded the Medal of Honor to him "for conspicuous gallantry and intrepidity at the risk of his life above and beyond the call of duty."

60. TR to Henry Cabot Lodge, July 5, 1898, in *Letters of Theodore Roosevelt*, 2:849.

61. Dalton, *Theodore Roosevelt*, 175, 176, 186.

62. TR to Lodge, July 19, 1898, in *Letters of Theodore Roosevelt*, 2:851.

63. Slotkin, "Nostalgia and Progress," 37.

64. Watts, *Rough Rider*, 166.

65. Nathan Miller, *Theodore Roosevelt: A Life* (New York: William Morrow, 192), 314.

66. Owen Wister, *Roosevelt: The Story of a Friendship, 1880–1919* (New York: Macmillan, 1930), 6.

67. Edmund Morris, *Theodore Rex* (New York: Random House, 2001), 30.

68. Lorant, *Life and Times*, 344–345.

69. William H. Goetzmann and William N. Goetzmann, *The West of the Imagination* (New York: Norton, 1986), 303–304.

70. Dalton, *Theodore Roosevelt*, 178.

71. Charles Musser, "American Vitagraph: 1897–1901," *Cinema Journal* 22, no. 3 (1983): 12.

72. Ephraim Katz, *The Film Encyclopedia*, 4th ed. (New York: HarperResource, 2001), 136.

73. Benjamin B. Hampton, *History of the American Film Industry* (New York: Dovers, 1970), 22, 24.

74. It is not clear if *Tearing Down the Spanish Flag* and *Raising Old Glory over Morro Castle* are separate films. Charles Musser suggests they may be the same.

75. Robert Sklar, *Movie-Made America* (New York: Vintage, 1994), 22.

76. Raymond Fielding, *The American Newsreel 1911–1967* (Norman: University of Oklahoma Press, 1972), 29–45. Also see M. Paul Holsinger, ed., *War and American Popular Culture* (Westport, CT: Greenwood Press, 1999), 182.

77. Ana M. Lopez, "Early Cinema and Modernity in Latin America," *Cinema Journal* 40, no. 1 (2000): 76.

78. Edison films catalogue, no. 94, March 1900, p. 11. See *US Infantry supported by Rough Riders at El Caney* (1899), *The Library of Congress American Memory: The Spanish-American War in Motion Pictures,* http://memory.loc.gov/cgi-bin/query/r?ammem/papr:@filreq(+@FIELD(NUMBER+@band(sawmp+1916)+@field(COLLID+spanam) (November 12, 2009) and *Skirmish of Rough Riders* (1899), *The Library of Congress American Memory: The Spanish-American War in Motion Pictures,* http://memory.loc.gov/cgi-bin/query/r?ammem/papr:@filreq(+@FIELD(NUMBER+@band(sawmp+0959)+@field(COLLID+spanam) (November 12, 2009).

CHAPTER FIVE. THE END OF NATURE, 1903

1. Nash, *Wilderness*, 1st ed., 139.

2. Herbert K. Job, *Wild Wings: Adventures of a Camera-Hunter among the larger Wild Birds of North America on Sea and Land, With an Introductory Letter by Theodore Roosevelt* (London: Archibald Constable and Houghton Mifflin, 1905), xiii.

3. TR to Henry Cabot Lodge, May 15, 1909, in *Letters of Theodore Roosevelt*, 7:10.

4. *New York Evening Sun,* January 22, 1901.

5. Gerald Carson, "T.R. and the 'Nature Fakers.'" *American Heritage Magazine* 22, no. 2 (1971).

6. *New York Times,* December 17, 1908.

7. Theodore Roosevelt, *Through the Brazilian Wilderness* (New York: Charles Scribner's Sons, 1914), 120.

8. John Burroughs, "Real and Sham Natural History," *Atlantic Monthly* 91, no. 545 (1903): 298.

9. Ibid., 301.

10. TR to John Burroughs, June 11, 1903, in *Letters of Theodore Roosevelt,* 3:486.

11. Edward B. Clark, "Roosevelt on the Nature Fakirs," *Everybody's Magazine* 16 (1907): 771.

12. Ralph H. Lutts, ed., *The Wild Animal Story* (Philadelphia: Temple University Press, 1998), 173.

13. Jack London, "The Other Animals," *Collier's* 41, no. 24 (1908): 10–11, 25–26.

14. "Col. Roosevelt in Danger: Falls While Fleeing from a Wounded Bear, but his Companions Kill the Brute," *New York Times,* January 16, 1901, 1.

15. *New York Herald,* January 19, 1901. See also "Col. Roosevelt Was Treed: Attacked by a Number of Gray Wolves and Remained a Prisoner for Four Hours," *New York Times,* January 19, 1901, 1.

16. Theodore Roosevelt, "With the Cougar Hounds," *Scribner's* 30 (1901): 545–564.

17. TR to Frederick Courteney Selous, March 8, 1901, in *Letters of Theodore Roosevelt*, 3:6.

18. *New York Herald,* January 25 and 27, 1901.

19. Roosevelt, "With the Cougar Hounds," 535, 564.

20. TR to Theodore Roosevelt, Jr., January 14, 1901, in *Letters of Theodore Roosevelt*, 3:1.

21. Roosevelt, "With the Cougar Hounds," 548.

22. Donald Day, *The Hunting and Exploring Adventures of Theodore Roosevelt* (New York: Dial, 1955), 202.

23. Roosevelt, "With the Cougar Hounds," 564. World's record, personal correspondence with Jack Reneau, Boone and Crockett Club, August 4, 2007.

24. TR to Winthrop Chanler, March 8, 1901, in *Letters of Theodore Roosevelt,* 3:5.

25. Roosevelt, "With the Cougar Hounds," 417–435, 545–564. Many of the essays TR wrote

eventually appeared in book form as *Outdoor Pastimes of an American Hunter* (New York: Charles Scribner's Sons, 1905).

26. TR to Philip Bathell Stewart, April 6, 1901, in *Letters of Theodore Roosevelt,* 3:42.

27. "Glimpses of Strenuous Life in Colorado," *Literary Digest,* February 2, 1901.

28. *New York Journal Advertiser,* February 4, 1901.

29. Charles Musser, "The Early Cinema of Edwin Porter," *Cinema Journal* 18, no. 1 (1979): 6.

30. Edison catalogue, July 1901, p. 72. Also see Charles Musser, *Before the Nickelodeon* (Berkeley: University of California Press, 1991), 169; *Terrible Teddy, the grizzly king* (1901), *The Library of Congress American Memory: Theodore Roosevelt on Film,* http://memory.loc.gov/cgi-bin/query/ h?ammem/papr:@field(NUMBER+@band(edmp+1887) (November 12, 2009).

31. See "Colorado Bear Hunt," *Scribner's* 38 (1905): 387–408; "Wolf Hunt in Oklahoma," *Scribner's* 38 (1905): 513–532; and "In Louisiana Canebrakes," *Scribner's* 43 (1908): 47–60.

32. Morris, *Theodore Rex,* 172.

33. Ibid., 173.

34. This number is probably exaggerated. A more accurate number is 1,600 bears.

35. Morris, *Theodore Rex,* 173.

36. Ibid., 172.

37. Statistics provided by the Archives at Tuskegee Institute, February 1979, http://faculty.berea.edu/ browners/chesnutt/classroom/lynching_table_year.html (October 20, 2006).

38. William D. Crum, "A Negro in Politics," *Journal of Negro History* 53, no. 4 (1968): 301.

39. TR to Clifford Berryman, December 29, 1902, http://www.aaa.si.edu/exhibits/pastexhibits/ presidents/roosevelttberry.htm (January 5, 2010).

40. While Morris and Rose Michtom are frequently credited with inventing the teddy bear, the Stieff Company of Giengen, Germany, was simultaneously releasing a line of stuffed bears.

41. The story line of *The Teddy Bears* follows a virginal girl much like Goldilocks who stumbles upon a house occupied by seven (stuffed) teddy bears varying in size from Papa Bear to Baby Bear. Goldilocks peeks through the keyhole to the front door and watches three of the bears dance and frolic, which Porter animated by using stop-motion techniques. The scene and the tone then shift dramatically when the bears (who are now actors in teddy bear costume) discover Goldilocks spying on them and chase her into the wintry woods. A hunter, unmistakably Teddy Roosevelt, comes to Goldilocks's rescue by first shooting Papa Bear and then Mama Bear. He spares Baby Bear and presents it to Goldilocks on a chain presumably as a "new toy."

42. *A Compilation of the Messages and Speeches of Theodore Roosevelt, Supplemental,* ed. Alfred H. Lewis (Washington, DC: Bureau of National Literature and Art, 1906), 1:273.

43. Horace M. Albright and Frank J. Taylor, *Oh, Ranger! A Book about the National Parks* (Stanford: Stanford University Press, 1928), 1:15.

44. TR to Major John Pitcher, December 17, 1902, Heritage and Research Center, Yellowstone National Park. Also see Cutright, *Theodore Roosevelt,* 105.

45. John Pitcher to Theodore Roosevelt, March 2, 1903, Heritage and Research Center, Yellowstone National Park.

46. John Pitcher to Theodore Roosevelt, February 18, 1903, Heritage and Research Center, Yellowstone National Park.

47. John Pitcher to Theodore Roosevelt, March 26, 1903, Heritage and Research Center, Yellowstone National Park.

48. John Burroughs, *Camping and Tramping with Roosevelt* (New York: Houghton Mifflin Company, 1906), 6.

49. *Bozeman* (Montana) *Avant Courier*, May 1, 1903.

50. *Livingston Enterprise,* May 2, 1903.

51. "President Kills Lion in Yellowstone Park: Mr. Roosevelt Hunts in a Snowstorm and Gets Big Game" *New York Times,* April 12, 1903, 1.

52. Burroughs, *Camping and Tramping,* 67.

53. The park resumed killing mountain lions between 1914 and did not end its predator control program until 1935.

54. Carolyn Merchant, *Reinventing Eden: The Fate of Nature in Western Culture* (New York: Routledge, 2003), 2.

55. Ibid., 37.

56. George Perkins Marsh, *Man and Nature: Or, Physical Geography as Modified by Human Action,* ed. David Lowenthal (Cambridge: Belknap Press of Harvard University Press, 1864), 29.

57. Lewis Thomas, *The Lives of a Cell* (New York: Viking, 1974), 5.

58. James E. Lovelock, *Gaia: A New Look at Life on Earth* (New York: Oxford University Press, 1979), xii, 127.

59. Daniel B. Botkin, *Discordant Harmonies: A New Ecology for the Twenty-First Century* (New York: Oxford University Press, 1990), 42.

60. Crumley, "Cultural Ecology," 6.

61. A. Bernard Knapp and Wendy Ashmore, "Archaeological Landscapes: Constructed, Conceptualized, Ideational," in *Archaeologies of Landscape* (Malden, MA: Blackwell, 1999), 3, 10. See also S. Daniels and D. E. Cosgrove, "Introduction: Iconography and Landscape," in *The Iconography of Landscape: Essays on the Symbolic Representation, Design and Use of Past Environments* (Cambridge: Cambridge University Press, 1988), 1–10.

62. Knapp and Ashmore, *Archaeological Landscapes,* 15.

63. Theodore Roosevelt, *The Wilderness Hunter* (New York: Review of Reviews Company, 1910), 14.

64. Roosevelt, *Messages and Speeches,* 1:273.

65. Theodore Roosevelt, "In Cowboy Land: The Fourth Installment of 'Chapters of a Possible Autobiography,'" *Outlook* 104, no. 4 (1913): 148.

66. Donald Worster, "Seeing Beyond Culture," *Journal of American History* 76, no. 4 (1990): 1144. Donald Worster writes that "all landscapes are the result of *interactions* between nature and culture."

67. James Duncan and N. Duncan, "(Re)reading the Landscape," *Environment and Planning D: Society and Space* 6, no. 2 (1988): 117–126.

68. Roosevelt, *Messages and Speeches,* 1:273.

69. Denis E. Cosgrove, *The Palladian Landscape: Geographical Change and its Cultural Representations in Sixteenth-Century Italy* (University Park: Penn State University Press, 1993).

70. C. Barron McIntosh, "Use and Abuse of the Timber Culture Act," *Annals of the Association of American Geographers* 65, no. 3 (1975): 347–362.

71. Theodore Roosevelt, *Theodore Roosevelt: An Autobiography* (New York: Charles Scribner's Sons, 1924), 407.

72. *Forestry and Irrigation* 14, no. 6 (1908): 300. See also "The President Helps Lay a Cornerstone: He Makes an Address Laudatory of Yellowstone Park," *New York Times,* April 25, 1903, 1.

73. Clark, "Roosevelt on the Nature Fakirs," 774.

74. William Cronon, *Nature's Metropolis: Chicago and the Great West* (New York: Norton, 1991), 19.

75. *American Geologist* 32, no. 3 (1903): 199.

76. Jonathan Peter Spiro, *Defending the Master Race: Conservation, Eugenics, and the Legacy of Madison Grant* (Lebanon, NH: University Press of New England, 2009), 83.

77. William G. Beebe, Inness Hartley, and Paul G. Howes, *Tropical Wild Life in British Guiana: With an Introduction by Colonel Theodore Roosevelt* (New York: New York Zoological Society, 1917), ix.

78. Arnold Guyot, *Guyot's Physical Geography* (New York: Scribner, Armstrong, 1873), 121.

79. Carl Ritter, *Comparative Geography*, trans. William Gase (New York: American Book Company, 1864), 183.

80. Henry Thomas Buckle, *Introduction to the History of Civilization in England*, rev. ed. (London: Routledge and Sons, 1872).

81. Ellsworth Huntington, *Civilization and Climate,* 3rd ed. (New Haven: Yale University Press, 1924), 12.

82. Dalton, *Theodore Roosevelt*, 347.

83. Roosevelt also took a .30-caliber Springfield, a double-barreled .500-450 Holland, and several shotguns with him to Africa.

CHAPTER SIX. AFRICAN ROMANCE

1. Herman L. Fairchild, "Ward' Natural Science Establishment," *Scientific Monthly* 26, no. 5 (1928): 468.

2. Penelope Bodry-Sanders, *African Obsession: The Life and Legacy of Carl Akeley* (Jacksonville, FL: Batax Museum Press, 1998), 24.

3. James L. Haley, "The Colossus of his Kind: Jumbo," *American Heritage Magazine,* 1973, http://www.americanheritage.com/articles/magazine/ah/1973/5/1973_5_62.shtml (November 12, 2009).

4. TR to Frederick Courtney Selous, June 25, 1908, in *American Heritage* 58, no. 3, 93.

5. TR to Frederick Courtney Selous, February 15, 1898, in John Guille Millais, *The Life of Frederick Courtenay Selous, D.S.O., capt, 25th Royal Fusiliers* (London: Longmans, Green, 1919), 225.

6. Carl Georg Schillings, *Flashlights in the Jungle* (New York: Doubleday, Page, 1906), xv.

7. James R. Ryan, *Picturing Empire: Photography and the Visualization of the British Empire* (Chicago: University of Chicago Press, 1997), 197.

8. Theodore Roosevelt, *African Game Trails* (New York: Charles Scribner's Sons, 1910), 63.

9. *Harper's Weekly* 38 (March 24, 1894): 270.

10. John Henry Patterson, *The Man-Eaters of Tsavo and Other East African Adventures* (New York: St. Martin's Press, 1985).

11. The official reports of the death toll list only twenty-four victims, although the total was likely intentionally underreported.

12. Patterson sold the remains of the lions to the Field Museum, where they remain on display to this day.

13. Patterson, *The Man-Eaters of Tsavo,* x.

14. *The New Outlook* 95 (1910): 312. TR presented his idea of the "Biological Analogies in Histories" at Oxford University in 1910. Kipling wrote "White Man's Burden" in celebration of the American victory in Cuba.

15. Carl Akeley, *In Brightest Africa* (Garden City, NY: Doubleday, Page, 1923), 114.

16. TR to John Henry Patterson, March 20, 1908, in *Letters of Theodore Roosevelt*, 6:979.

17. Carl E. Akeley, "Theodore Roosevelt and Africa," *Natural History* 19, no. 1 (1919): 12. Roosevelt later claimed that the expedition was the suggestion of C. Hart Merriam. See Theodore Roosevelt, "Wild Man and Wild Beast in Africa," *National Geographic* 22, no. 1 (1911): 3.

18. Akeley, *In Brightest Africa,* 99–101.

19. Patricia O'Toole, *When Trumpets Call: Theodore Roosevelt After the White House* (New York: Simon and Schuster, 2005), 47. Roosevelt did not go wanting: he brought his own lamb's tongue, sardines, cod roe, pudding, eighteen pounds of chocolate, and ninety-two pounds of jams.

20. TR to Frederick Courteney Selous, August 19, 1908, in Cutright, *Theodore Roosevelt*, 191.

21. TR to Frederick Courteney Selous, September 12, 1908, in *American Heritage* 14, no. 3, April 1963.

22. Kenneth Cameron, *Into Africa: The Story of the East African Safari* (London: Constable and Company, 1990), 56.

23. Dalton, *Theodore Roosevelt*, 349.

24. H. W. Brands, *TR: The Last Romantic* (New York: Basic, 1997), 643.

25. "Returning from the Hunt," *New York Times,* March 2, 1910, 8.

26. Roosevelt's expedition cost in excess of $100,000. Paul Rainey's African Expedition two years later reportedly cost $250,000.

27. H. Paul Jeffers, *Roosevelt the Explorer* (New York: Taylor Trade Publishing, 2003), 145.

28. Grondahl, *I Rose like a Rocket*, 90.

29. *New York Evening Mail*, March 23, 1909.

30. Archie Butt, *The Letters of Archie Butt, Personal Aide to President Roosevelt* (New York: Doubleday, Page, 1924), 203.

31. Both Buxton and Schillings relied on the "flash-light" photographic techniques developed by George Shiras III, an American amateur photographer from Pittsburgh, who first pioneered those techniques in the 1890s. Shiras exhibited some of his photographs of American wild game at the Paris Exposition in 1900 and the Saint Louis Exposition in 1904, where they received gold medals. However, Shiras did not publish his work, *Hunting Wild Life with Camera and Flashlight: a Record of Sixty Five Years' Visits to the Woods and Waters of North America* until 1935. See also *National Geographic* 7, no. 7 (1906): 367–423.

32. Clark, "Nature Fakirs," 770–774.

33. Theodore Roosevelt, *Roosevelt's Writings: Selections from the Writings of Theodore Roosevelt,* ed. Maurice Garland Fulton (New York: Macmillan, 1920), 247.

34. Slotkin, "Nostalgia and Progress," 619.

35. Roosevelt, *African Game Trails*, vii.

36. Ibid.

37. Andrew Brodie Smith, *Shooting Cowboys and Indians: Silent Western Films, American Culture, and the Birth of Hollywood* (Boulder: University Press of Colorado, 2003), 11.

38. Cherry Kearton, "Photographing Wild Life the World Over," *Photographic Times* 46, no. 5 (1914): 198.

39. Kevin Brownlow, *The War, the West, and the Wilderness* (New York: Knopf, 1979), 437.

40. *Moving Picture World*, May 31, 1913, 884.

41. "Doe and Fawns," *Forest and Stream,* 38, no. 1 (1898): 1.

42. See Theodore Roosevelt, introduction to *Camera Shots at Big Game,* by A. G. Wallihan (New York: Doubleday, Page, 1901), 11. See also Theodore Roosevelt, "Camera Shots at Wild Animals," in *World's Work* (1901), 3:1545–1549.

43. Roosevelt, "Camera Shots," 3:1549.

44. Akeley, *In Brightest Africa*, 155.

45. Finis Dunaway, "Hunting with the Camera: Nature Photography, Manliness, and Modern Memory, 1890–1930," *Journal of American Studies* 34, no. 2 (2000): 217–218.

46. Roosevelt, *African Game Trails*, 260–261.

47. Ibid., 403.

48. Ibid., 309.

49. "The Smithsonian African Expedition," *Science* 37, no. 949 (1913): 364–365.

50. Roosevelt, *African Game Trails*, 468.

51. *National Geographic* published eleven of Dugmore's more dramatic photos in its May 1910 edition.

52. Roosevelt, *African Game Trails*, vii.

53. Charles Morris, *Battling for the Right: The Life Story of Theodore Roosevelt, including an account of the African Expedition* (n.p.: W. E. Scull, 1910), 184.

54. Rebuked by Roosevelt, *Collier's* sent an English hunter turned photographer, A. Radclyffe Dugmore, to British East Africa ahead of Roosevelt to send back pictures of Africa's game that the magazine published during 1909 ("Snapping Africa's Big Game, The Camera that Beat Roosevelt to the Jungle . . ."). In 1910, Dugmore published *Camera Adventures in the African Wilds: Being an Account of a Four Months' Expedition in British East Africa, for the Purpose of Securing Photographs of the Game from Life*, which preceded but did not overshadow Roosevelt's pictures.

55. Roosevelt, *African Game Trails*, 355.

56. TR to Frederick Selous, March 8, 1901, in *Letters of Theodore Roosevelt*, 3:7.

57. Roosevelt, *African Game Trails*, 64. In fact there was major disagreement among hunters of that time which game was the most dangerous, and Roosevelt discusses the "rankings" at length in *African Game Trails*.

58. Sir Alfred Pease, *The Book of the Lion* (New York: St. Martin's Press, 1986).

59. Roosevelt, *African Game Trails*, 355–356.

60. Ibid., 72. In a letter to Henry Cabot Lodge, May 15, 1909, three weeks into the trip, he reported he'd killed "four lions and two small ones" (Aida Donald, *Lion in the White House* [New York: Basic Books, 2007], 231).

61. Roosevelt, *African Game Trails*, 76.

62. Ibid., 42.

63. Because of an ability to reach terms for the conditions of a visit to the Vatican, TR would not meet with the pontiff.

64. Roosevelt, *African Game Trails*, 31; see also Millais, *Fredrick Courtenay Selous,* 267–272.

65. Roosevelt, *African Game Trails*, 31.

66. Ibid., 476.

67. Ibid., 217.

68. *Moving Picture World* 4 (May 29, 1909): 712.

69. Arnie Bernstein, *Hollywood on Lake Michigan: 100 Years of Chicago and the Movies* (Chicago: Lake Claremont Press, 1998), 46.

70. *Moving Picture World* 4 (May 29, 1909): 872.

71. *Moving Picture World* (May 31, 1913): 884.

72. *Moving Picture World* 5, no. 25 (1909): 884–885.

73. *Moving Picture World* 5, no. 25 (1909): 871.

74. *Moving Picture World* (May 14, 1910): 793.

75. *Moving Picture World* (April 30, 1910): 682.

76. *Moving Picture World* (December 18, 1909): 872.

77. The first photographic picture books of African wildlife were *With Flashlight and Rifle* by C. G. Shillings (1905) and *Camera Adventures in the African Wilds* by A. Radclyffe Dugmore,

which was published the same time as Kearton's film was in release. Dugmore (as did Schillings) would shine a flashlight on lions at night and then photograph them as they stared at the light.

78. Gregg Mitman, *Reel Nature: America's Romance with Wildlife on Film* (Cambridge: Harvard University Press, 1999), 7.

79. Louis Giannetti and Scott Eyman, *Flashback: A Brief History of Film*, 3rd ed. (Englewood Cliffs, NJ: Prentice Hall, 1996), 22.

80. Roosevelt, *Outdoor Pastimes*, 188. Roosevelt regarded his reputation as a naturalist dearly. Dr. C. Hart Merriam, Chief of the United States Biological Survey, noted that "[The] truthfulness of none of the field notes of Theodore Roosevelt has ever been doubted. Mr. Roosevelt's field methods clearly account for the accuracy of his writings, for he makes his notes on the spot. Weights and measurements are taken at once, and these, with other observations, are set down forthwith, in order that nothing may be left to the possible fickleness of memory."

81. F. A. Talbot, *Moving Pictures: How They Are Made and Worked* (London: Arno Press, 1970), 18.

CHAPTER SEVEN. THE DARK CONTINENT

1. Edward Said, *Culture and Imperialism* (New York: Vintage, 1994), 52. See also Wendy Ashmore and A. Bernard Knapp, eds., *Archaeologies of Landscape: Contemporary Perspectives* (Malden, MA.: Blackwell, 1999), 1.

2. Crumley, "Cultural Ecology," 15.

3. Said, *Culture and Imperialism,* 51.

4. Quoted in Said, *Culture and Imperialism,* 168.

5. Quoted in Said, *Culture and Imperialism*, 17. See also J. Kim Munholland, "The French Response to the Vietnamese Nationalist Movement, 1905–14," *Journal of Modern History* 47, no. 4 (1975): 655–675.

6. The competing theory of polygenism was even more racist, holding that whites and blacks were radically different species.

7. Quoted in Fiedler, *Freaks*, 240.

8. Thomas Dixon, *The Leopard's Spots* (New York: Doubleday, Page, 1902), 394.

9. Said, *Culture and Imperialism,* 77.

10. Degeneration in this sense does not include a devolution but a dislocation from the source of creation.

11. Henri de Blainville, "Sur une Femme de la Race Hottentote," *Bulletin de sciences par la Société philomatique de Paris* (Paris, 1815), 183.

12. William B. Cohen, *The French Encounter with Africans: White Response to Blacks, 1530–1880* (Bloomington: Indiana University Press, 1980), 241.

13. Patrick Brantlinger, "Victorians and Africans: The Genealogy of the Myth of the Dark Continent," in *Race, Writing, and Difference*, ed. Henry Louis Gates Jr. (Chicago: University of Chicago Press, 1985), 202.

14. Lucy Jarosz, *Constructing the Dark Continent: Metaphor as Geographic Representation of Africa,* Geografiska Annaler, 74 B (2): 105.

15. Edward Said, "Secular Criticism," in *The World, the Text, and the Critic* (Cambridge: Harvard University Press, 1983), 9.

16. Dorothy Hammond and Alta Jablow write in *The Africa that Never Was: Four Centuries of British*

Writing about Africa (New York: Twayne, 1970), 94, that "in the imperial period writers were far more addicted to tales of cannibalism than . . . Africans ever were to cannibalism."

17. Brantlinger, "Victorians and Africans," 217.

18. Stephen Jay Gould, *Ontogeny and Phylogeny* (Cambridge: Belknap Press of Harvard University Press, 1977), 127.

19. F. G. Crookshank, *The Mongol in our Midst* (London: Kegan Paul, Trench and Trubner, 1924).

20. Phillip V. Bradford and Harvey Blume, *Ota Benga: The Pygmy in the Zoo* (New York: St. Martins, 1992), 29.

21. Theodore Roosevelt, *The Works of Theodore Roosevelt*, ed., Hermann Hagedorn (New York: Charles Scribner's Sons, 1926), 11:316. Speech given at Louisiana Purchase Exposition, St. Louis, April 30, 1903.

22. Robert W. Rydell, "Souvenirs of Imperialism," in *Delivering Views: Distant Cultures in Early Postcards,* ed. Christraud M. Geary and Virginia-Lee Webb (Washington, DC: Smithsonian Institution Press, 1998), 50.

23. *St. Louis Republic*, March 6, 1904, 1.

24. *New York Times,* November 16, 1903, 1.

25. *St. Louis Republic,* March 6, 1904, 1; emphasis added.

26. Roosevelt, *African Game Trails,* viii.

27. W. J. McGee to S. P. Verner, October 21, 1903, in Bradford and Blume, *Ota Benga*, 241. Letter from W. J. McGee to S. P. Verner, dated October 21 (1903), in Bradford and Blume, *Ota Benga,* 241.

28. Bradford and Blume, *Ota Benga,* 97.

29. Ibid., 38. King Leopold II was quoted as saying, "I could cut off everything else, but not their hands. What else but their hands do I really need in the Congo?"

30. For an example, see Ernst Haeckel, *The History of Creation: Or the Development of the Earth and its inhabitants by the Action of Natural Causes,* trans. E. Ray Lankester (London: Henry S. King, 1876), 362–363.

31. *St. Louis Dispatch*, June 26, 1904, 6.

32. A. H. J. Keane, "Anthropological Curiosities," *Scientific American*, Supplement 64 (August 17,1907): 99.

33. *Scientific American* 92 (February 18, 1905): 107.

34. There was no way of determining their actual ages, so Verner estimated them.

35. *St. Louis Dispatch,* September 14, 1904, 6–7; emphasis added.

36. *St. Louis Dispatch,* September 14, 1904, 6–7.

37. Bradford and Blume, *Ota Benga*, 181.

38. *St. Louis Dispatch,* August 13, 1904, 8.

39. *St. Louis Dispatch,* September 14, 1904, 6–7.

40. Bradford and Blume, *Ota Benga*, 114. The question of whether or not Pygmies respond to pain is an unsettling echo of Figuier's experiments a century earlier.

41. Other headlines included "Negritos Captured Pole-Climbing Event and Patagonians Beat Syrians in Tug-Of-War" and "Pygmies in Mud Fight, Pelted Each Other Until One Side was Put to Rout."

42. *St. Louis Dispatch,* August 13, 1904, 8.

43. *Scientific American*, July 23, 1904. In 1902, H. H. Johnston published a study in the *Smithsonian Report* that Pygmies were in fact very adept in their own environment, but this study did not make its way into the public consciousness.

44. *St. Louis Republic*, August 6, 1904, 1.

45. "When the World Came to St. Louis," *1904 World's Fair in Forest Park* (July 2009), http://stlouis .missouri.org/citygov/parks/forestpark/history/fair.html (December 30, 2009).

46. Another version, printed in the *New York Evening Post* (September 10, 1906) claims Ota Benga's first wife was abducted by a tribe of "unneighborly savages."

47. Verner apparently abandoned Ota Benga to Hornaday; there is no evidence of his ever returning to New York.

48. "Man and Monkey Show Disapproved by Clergy: The Rev. Dr. MacArthur Thinks the Exhibition Degrading," *New York Times,* September 10, 1906, 1.

49. *New York Evening Post*, September 10, 1906, 5.

50. Bradford and Blume, *Ota Benga*, 224.

51. "Man and Monkey Show," *New York Times,* 1.

52. Ibid.

53. Ibid.

54. "Bushman Shares a Cage with Bronx Park Apes," *New York Times,* September 9, 1906, 17.

55. *New York Times,* September 10, 1906, 1.

56. Mitch Keller, "The Scandal at the Zoo," *New York Times*, August 6, 2006.

57. *New York Daily Tribune*, September 16, 1906, 1.

58. "The Mayor Won't Help to Free Caged Pygmy: He Refers Negro Ministers to the Zoological Society," *New York Times,* September 12, 1906, 9.

59. Bradford and Blume, *Ota Benga*, 217.

60. *New York Times*, July 16, 1916, 12.

61. Bradford and Blume, *Ota Benga*, 220.

62. Ibid., 228.

63. Sir Harry Johnston, "Where Roosevelt Will Hunt," *National Geographic* 20 (1909): 234.

64. Roosevelt, *African Game Trails*, 1:1.

65. Theodore Roosevelt, "Wild Man and Wild Beast in Africa," *National Geographic* 22, no. 1 (1911): 6.

66. Address delivered before the National Geographic Society, November 18, 1910, reprinted in ibid.

67. Ibid.

68. Roosevelt, *African Game Trails*, 1:81.

69. Ibid., 1:ix.

70. Ibid., 1:373. TR echoes Horatio Seymour's presidential campaign slogan of 1868, "This is a white man's country. Let white men rule."

71. Roosevelt, *Works of Theodore Roosevelt*, 2:325–326.

72. Roosevelt, *African Game Trails*, 1:354.

73. Address to the Republican Club of New York City, February 13, 1905, in Roosevelt, *Works of Theodore Roosevelt*, 16:346.

CHAPTER EIGHT. WHEN COWBOYS GO TO HEAVEN

1. Guy H. Scull, *Lassoing Wild Animals in Africa* (New York: Ridgway, 1911), xii.

2. Guy H. Scull, "Editor's Note: Lassoing Wild Animals in Africa," *Everybody's Magazine* 23, no. 3 (1910): 309.

3. Scull, *Lassoing Wild Animals*, 5.

4. Robert Easton and Mackenzie Brown, *Lord of the Beasts: The Saga of Buffalo Jones* (Lincoln: University of Nebraska Press, 1970), 17, 19.

5. Ibid., 17.

6. Ibid., 24.

7. Judith Hebbring Wood, "The Origin of Public Bison Herds in the United States," *Wicazo Sa Review: The Secular Past, the Mythic Past and the Impending Future* 15, no. 1 (2000): 169.

8. Roosevelt, *Works of Theodore Roosevelt*, 1:35.

9. Ibid., 1:349–350.

10. The Lacey Act of 1894, *U.S. Statutes at Large* 28 (1984): 73.

11. Wood, "Public Bison Herds," 171.

12. Martin S. Garretson, *The American Bison* (New York: New York Zoological Society, 1938), 197. Garretson reported that a New York millionaire had paid $1,500 for a bison head. For wage earnings of the average worker, see Asher Achinstein, review of *Earnings of Factory Workers, 1899 to 1927*, by Paul F. Brissenden, *Journal of the American Statistical Association* 25, no. 171 (1930): 371.

13. Margaret Mary Meagher, *The Bison of Yellowstone National Park* (Washington, DC: U.S. National Park Service, 1973), http://www.nps.gov/history/history/online_books/bison/chap3a.htm (November 12, 2009).

14. Easton and Brown, *Lord of the Beasts*, 125.

15. "Buffalo Jones Says Soldiers Lack Backbone," *New Haven Evening Register,* November 15, 1906.

16. Easton and Brown, *Lord of the Beasts*, 158.

17. Ibid., 159.

18. Scull, *Lassoing Wild Animals*, xvi.

19. Bird became a close friend to Roosevelt, and his family has subsequently denied that he ever had any political intent for underwriting Jones.

20. *New York Globe*, April 3, 1910.

21. Scull, *Lassoing Wild Animals*, 17–18.

22. Ibid., 65.

23. Ibid., 44.

24. Jane Tompkins, *West of Everything: The Inner Life of Westerns* (New York: Oxford University Press, 1992), 81.

25. Scull, "Editor's Note," 310.

26. "Lassoing Wild Animals, 'Buffalo' Jones's Roping Expedition Against the Big Game of Africa," *New York Times,* June 11, 1911, LS365.

27. Stephen Prince, *Movies and Meaning* (Needham Heights, MA: Allyn & Bacon, 1997), 244.

28. Miriam Hansen, *Babel & Babylon: Spectatorship in American Silent Film* (Cambridge: Harvard University Press, 1991), 78.

29. Scull, *Lassoing Wild Animals*, 311.

30. Richard Maltby and Ian Craven, *Hollywood Cinema* (Oxford: Blackwell, 1995), 117.

31. Even though Winchester commercially sponsored Roosevelt's safari, he still carried guns of English manufacture.

32. See Easton and Brown, *Lord of the Beasts,* 196–197. Lord Delmar's comment is an oblique criticism of Roosevelt's decision to send sixteen ships of the line—known as the "Great White Fleet"—around the world in 1907–1908 as a demonstration of American naval superiority. Comments like these continue to fuel speculation that Charles S. Bird did in fact intend to undermine Roosevelt's accomplishments through Jones.

33. Scull, *Lassoing Wild Animals*, v.

34. Ibid., 123.

35. "Topics of the Times: Abandoning Sport to the Dogs," *New York Times,* August 24, 1911, 6.

36. *Science*, n.s., 36, no. 914 (July 1912): 11. Also see *Science*, n.s., 35, no. 898 (March 1912): 411–412.

37. "Paul Rainey Going for a 3-Year Hunt," *New York Times,* February 1, 1911, 7. Rainey helped fund Carl Akeley's fourth expedition to Africa, which led to Carl Akeley's personal endorsement of Rainey.

38. *Science*, n.s., 36, no. 914 (July 1912): 11; also see *Science*, New Series, 35, no. 898 (March 1912): 411–412.

39. "Abandoning Sport to the Dogs," *New York Times,* August 24, 1911.

40. "Books and Authors: Notes of Forthcoming and Recent Publications," Saturday Review of Books and Art, *New York Times,* November 12, 1898, 760.

41. Pascal Imperato and Eleanor Imperato, *They Married Adventure: The Wandering Lives of Martin and Osa Johnson* (New Brunswick, NJ: Rutgers University Press, 1992), 96, 97. Hemment was the lead cinematographer. Rainey later hired a second cinematographer, Herbert K. "Pop" Binks, in Nairobi. Binks shot alongside Hemment and is rarely credited for his work. Hemment's finished film also included footage that was shot by Carl Akeley, who was "financially hard-pressed at the time."

42. *Moving Picture World* 12 (4 May 1912): 411.

43. *Montreal Morning Star*, April 19,1913, 27–28. Not so coincidentally, Rainey produced a second film in 1914, in which a "vicious African male lion" also charges the camera, which Rainey is operating this time. Again, the lion is shot at the very last second, which raises a question about the authenticity of the same scene in the earlier film.

44. *Moving Picture World* 12 (April 20, 1912): 214–215.

45. *Moving Picture World* 12 (May 4, 1912): 411; and *Moving Picture World* 12 (April 20, 1912): 214.

46. Gregg Mitman, *Reel Nature: America's Romance with Wildlife on Film* (Cambridge: Harvard University Press, 1999), 19.

47. *American Museum Journal* 12, no. 2 (1912): 118.

48. *Paul J. Rainey's African Hunt* opened at the Lyceum Theater in New York City on April 15, 1912. Less than sixty days later, on June 8, the film's distributor, Carl Laemmle, signed papers that merged his own company with three other studios to become Universal Pictures.

49. "The New African Hall Planned by Carl E. Akeley," *American Museum Journal* 14, no. 5 (1914): 175.

CHAPTER NINE. TRANSPLANTING AFRICA

1. John James Audubon, *The Original Water-Color Paintings by John James Audubon for the Birds of America* (New York: American Heritage / Bonanza Books, 1985), plate 76.

2. Stephen Bann, *The Clothing of Clio: A Study of the Representation of History in Nineteenth-Century Britain and France* (Cambridge: Cambridge University Press, 1984), 15.

3. Ibid., 26.

4. Ibid.

5. Ibid.

6. Ibid.

7. Ibid.

8. Michel Foucault, *The Order of Things: An Archaeology of the Human Sciences* (New York: Vintage, 1970), 135, 137; emphasis added.

9. Susan Sontag, *On Photography* (New York: Picador, 1977), 153.

10. Theodore Roosevelt, *The Memorial Edition of the Works of Theodore Roosevelt,* ed. Herman Hagedorn (New York: Scribners, 1926), 2:379–380.

11. Ibid., 4:476–477.

12. Donna Haraway, *The Haraway Reader* (New York: Routledge, 2004), 161.

13. Oliver Impey and Arthur MacGregor, eds., *The Origins of Museums: The Cabinet of Curiosities in Sixteenth and Seventeenth Century Europe* (Oxford: Oxford University Press, 1985), 1.

14. In addition to the fourteen imperial American eagles perched atop the turrets at both ends of the building on Seventy-seventh Street, the museum is surrounded by Theodore Roosevelt Park.

15. Privately printed, n.d. (c. 1940), AMNH archives 1270, folder (j), 1940.

16. TR to Charles Davenport, January 1, 1913, American Philosophical Society Library, Image 1242; emphasis added.

17. Franklin Kirkbride, "The Right to be Well-Born," *Eugenics Archive,* 1912, http://www.eugenics archive.org/html/eugenics/index2.html?tag=350 (December 23, 2009).

18. Erica Bicchieri Boudreau, "Yea, I have a Goodly Heritage: Health Versus Heredity in the Fitter Family Contests, 1920–1928," *Journal of Family History* 30 (2005): 367.

19. Psalms 16:6 (KJV): "The lines are fallen unto me in pleasant places; yea, I have a goodly heritage."

20. *Buck v Bell,* 274 U.S. 200 (1927).

21. *Buck v Bell,* 200.

22. Holmes's statement is a reiteration of Francis Galton, who argued that as physical traits are inherited, so are mental traits. Galton was Charles Darwin's nephew.

23. Haraway, *The Haraway Reader,* 190.

24. George N. Pindar, *The Theodore Roosevelt Memorial* (New York: American Museum Press, n.d.), 6.

25. Harry H. Laughlin, the managing director of the Eugenics Records Office in Cold Spring Harbor, New York, would later present an even more elaborate tracing of the Roosevelt family tree in "The Near-Kin of Theodore Roosevelt" as a biological study of "natural inheritance" at the Third International Eugenics Conference in 1932. In addition, Laughlin testified before the Virginia court in *Buck v. Bell* that the family of Carrie Buck—none of whom he'd ever met—was among "the shiftless, ignorant, and worthless class of anti-social whites of the South." Laughlin helped write and sponsor sterilization laws in the United States. Ironically, he was himself an epileptic, one of the criterion by which people were adjudged unfit for society.

26. The panel consists of five quotes from different sources, elided as a single statement. This pastiche of quotes is true for the other panels as well.

27. Carl E. Akeley, "African Hall: A Monument to Primitive Africa," *The Mentor,* January 1926, 14.

28. Haraway, *The Haraway Reader,* 157.

29. Akeley, "African Hall," 14.

30. Untitled pamphlet, American Museum of Natural History Archives, emphasis added.

31. Stephen C. Quinn, *Windows on Nature: The Great Habitat Dioramas of the American Museum of Natural History* (New York: Abrams, 2006), 27.

32. Donna Haraway, *Primate Visions: Gender, Race, and Nature in the World of Modern Science* (New York: Routledge, 1989), 29.

33. Haraway, *The Haraway Reader*, 175.

34. Steve Quinn, "History of the Diorama," *American Museum of Natural History: Dioramas—Transcript*, n.d., http://www.amnh.org/exhibitions/dioramas/behind/ (November 12, 2009); emphasis added.

35. Source?

36. Stewart E. White, "The Making of the Museum," *The Mentor*, January 1926, 6.

37. Haraway, *The Haraway Reader*, 186.

38. H. F. Osborn, *American Museum of Natural History: 54th Annual Report to the Trustees*, 2, American Museum of Natural History Archives.

39. Ibid. "Transcript: History of the Diorama. Transcript of interview with Steve Quinn, Senior Project Manager, American Museum of Natural History, about the history of the diorama," http://www.amnh.org/exhibitions/dioramas/behind/ (January 9, 10); emphasis added.

40. Quinn, *Windows on Nature*, 12.

41. Steven Quinn, "Audio History of the Diorama," American Museum of Natural History: Dioramas, n.d., http://www.amnh.org/exhibitions/dioramas/behind/ (December 10, 2010).

42. James L. Clark, "The Image of Africa," *Natural History*, January 1936, 70.

43. According to his first wife, Akeley had the idea for an African exhibit as early as 1908 while he was still at the Field Museum.

44. "Africa Transplanted," *Time*, June 1, 1936, 53.

45. American Museum of Natural History Archives.

46. "The New African Hall Planned by Carl E. Akeley," *American Museum Journal* 14, no. 5 (1914): 180.

47. Richard Maltby, *Hollywood Cinema* (Oxford: Blackwell, 1995), 117.

48. Carl Akeley, "Group of African Elephants in the American Museum," unpublished typescript, n.d., Mary Jobe Akeley Collection of the Papers of Carl Akeley, American Museum of Natural History Archives.

49. Haraway, *The Haraway Reader*, 187

50. Carl Akeley to Henry Fairfield Osborn, April 9–11, 1910, American Museum of Natural History Archives, Box 45.

51. "Adventure with An African Elephant," *American Museum Journal* 10, no. 6 (1910): 186.

52. Carl E. Akeley, "Theodore Roosevelt and Africa," *Natural History* 19, no 1 (1919): 12.

53. Ibid.

54. Accession tags #32728—32731, which fall between Kermit Roosevelt's calf and Theodore Roosevelt's cow, disclose no details about the specimens other than they were received as skulls. Therefore, it may be possible that one or two of those skulls might be Roosevelt's young cows.

55. H. E. Anthony, Associate Curator of Mammals of the Western Hemisphere, American Museum of Natural History, to Carl Akeley, August 26, 1924, and corrected in Akeley's hand and then returned to "Miss Percy" of the Department of Mammals, American Museum of Natural History Archives.

56. Bodry-Sanders, *African Obsession*, 151.

57. Carl Akeley to Herbert Lang, August 26, 1924, American Museum of Natural History Archives.

58. Photo no. 212596, American Museum of Natural History Archives. See also the photograph of Roosevelt's cow on page 47 of Akeley's *In Brightest Africa*. The caption reads, "the elephant was shot by Mr. Akeley's companions just after the picture was taken."

CHAPTER TEN. OF APE-MEN, SEX, AND CANNIBAL KINGS

1. Peet and Watts, *Liberation Ecologies*, 53.

2. Michel Foucault, *The Birth of the Clinic: An Archaeology of Medical Perception* (New York: Random House, 1975), xii.

3. Theodore Roosevelt, *Presidential Addresses and State Papers: January 16, 1907, to October 25, 1907* (New York: Review of Reviews Company, 1910), 6:1334,

4. *Guiseppe v. Walling*, 144 F.2d 608, 624 (2nd Cir. 1944).

5. Roland Barthes, *Mythologies* (New York: Hill and Wang, 1973), 108.

6. Louis Giannetti and Scott Eyman, *Flashback: A Brief History of Film* (New York: Prentice Hall, 200), 22.

7. Ibid., 24.

8. *Moving Picture World,* untitled advertisement, 5, no. 25 (1909): 884–885.

9. Kenneth M. Cameron, *Africa on Film: Beyond Black and White* (New York: Continuum, 1994), 34.

10. Bruce V. Edwards, "Tarzan Flicks," *Bad Cinema Diary*, n.d., http://www.cathuria.com/bcd/pages/BadCinema_Tarzan.pdf (September 9 2007).

11. Alison McMahan, *Alice Guy Blaché: Lost Visionary of the Cinema* (New York: Continuum, 2002), 159.

12. Leonard Maltin, *Of Mice and Magic: A History of American Animated Cartoons* (New York: McGraw Hill, 1980), 7.

13. Some titles of jungle melodramas for 1913 include *Alone in the Jungle*, *Terrors of the Jungle*, and *Voodoo Vengeance*.

14. *Moving Picture World,* December 12, 1914.

15. "Tippling Sally: A Song of Sorrow on Zoo Sunday," *Punch or The London Charivari*, October 17, 1891, 189.

16. Ben Singer, "Female Poser in the Serial-Queen Melodrama: The Etiology of an Anomaly," in *Silent Film* (New Brunswick, NJ: Rutgers University Press, 1996), 163.

17. "Strand: Tarzan of the Apes," *Washington Post,* May 19, 1918, SM6. In fact, most of the film was shot in Griffith Park and the Selig Zoo in Los Angeles and in Morgan City, Louisiana, where 300 black men were hired on as cannibal extras for $1.75 a day.

18. *Atlanta Constitution,* April 14, 1918, 14.

19. *Variety,* October 18, 1918. *Variety* panned *The Romance of Tarzan*. "Mr. Lincoln in his dress suit looked like a professional wrestler, and acted like one when in action. He gave the 'bull cry' of Tarzan's as though vainly trying to hit a top note, and no one could blame the beasts of the forest when he returned to Africa for walking out on him. A caption said he wasn't the Tarzan they had known, and he wasn't."

20. Johnson told London that he had spent six months as a "second cook" in a Kansas City "restaurant" but "Did not cook any fancy dishes—all plain food; for the customers were all laboring men."

21. Jack London, "A Preliminary Letter from Jack London Who Is Going Round the World for the Woman's Home Companion," *Woman's Home Companion* 33, no. 11 (1906): 19.

22. Osa Johnson, *I Married Adventure: The Lives and Adventures of Martin and Osa Johnson* (Philadelphia: J. B. Lippincott, 1940), 63.

23. *Indianapolis Star,* January 16, 1910, 1.

24. Imperato and Imperato, *They Married Adventure*, 55–56.

25. Ibid., 53.

26. Martin Johnson to Jack and Charmian London, Independence, Kansas, November 25 1909, in Imperato and Imperato, *They Married Adventure,* 54.

27. *Letheridge Daily Herald,* August 10, 1911, 4–6.

28. Martin Johnson to Jack and Charmian London, Independence, Kansas, 21 July 1910, in Imperato and Imperato, *They Married Adventure,* 53.

29. Singer, "Female Poser," 163.

30. Ibid., 164.

31. Charles Goddard, "The Perils of Pauline," *Project Gutenberg eBooks,* 2004, http://www.gutenberg .org/files/6065/6065.txt (November 12, 2009).

32. Singer, "Female Poser," 175–176.

33. The film went by several titles, among them *Heart of Africa, Lady Mackenzie's Big Game Adventures,* and *Lady Mackenzie's Pictures.*

34. Erik Barnouw, *Media, Lost and Found* (New York: Fordham University Press, 2001) 42. Barnouw states that Arthur "Snitch" Sintzenich, a major cinematographer in Hollywood for many decades, was the cameraman for Lady Mackenzie. "Lady Mac," as Sintzenich's diary calls her, was "backed by American investors and . . . the purpose of the safari is the motion footage he is to take, which is expected to yield a handsome profit from theatre showings" (42).

35. *Among the Cannibal Islands of the South Pacific* was actually the name given to the silent lecture film and the feature; however, the feature was divided into two parts—*Cannibals of the South Seas* and *Captured by Cannibals*—which has caused some confusion about the actual name of the film. See *Among the Cannibal Isles of the South Pacific* (1918), *AFI Catalog Feature Films,* http://www .afi.com/members/catalog/AbbrView.aspx?s=&Movie=14806 (12 November 2009).

36. "Movie Man Invades Home of Cannibals: Martin E. Johnson Shows Thrilling Pictures Taken in South Sea Islands," *New York Times,* July 22, 1918, 9.

37. Imperato and Imperato, *They Married Adventure,* 80–81.

38. Ibid., 81.

39. Martin Johnson, *Cannibal-Land: Adventures with a Camera in the New Hebrides* (Boston: Houghton Mifflin, 1922), 134.

40. Johnson, *I Married Adventure,* 121.

41. Fatimah Tobing Rony, *The Third Eye: Race, Cinema, and Ethnographic Spectacle* (Durham: Duke University Press, 1994), 89.

42. "The Screen: More Adventuring," *New York Times,* January 9, 1923, 27.

43. Imperato and Imperato, *They Married Adventure,* 80.

44. Charmian London to Martin Johnson, Glen Ellen, California, March 27, 1918, in Imperato and Imperato, *They Married Adventure,* 80.

45. Imperato and Imperato, *They Married Adventure,* 803.To a modern anthropologist, however, those same images document a head-curing ceremony in early twentieth-century Melanesia. Chief Nagapate of the Big Nambas on Malakula, the people who lived in the trees, and the human skull in the fire were visual documents of real events. Martin Johnson's images of the people, their villages, their ways of life, including the how they cured human heads, remain important anthropological documents. In fact, Johnson's still and moving images of *rambaramp*—life-sized wooden funeral effigies topped with the skull of the deceased—remain among the earliest and best ever taken.

46. Johnson, *I Married Adventure,* 159–161.

47. Martin Johnson claimed that the "human parts" roasting on the fire were a human foot and a

human spleen. One can't help but wonder how it is possible to recognize a roasted human spleen from a distance.

48. Brownlow, *War, West, and Wilderness*, 468.
49. "The Screen," *New York Times*, September 12, 1921, 20.
50. "Display Ad 79," *New York Times*, September 12, 1921, 20.
51. Imperato and Imperato, *They Married Adventure*, 90.
52. According to Pascal and Eleanor Imperato, Johnson admired Rainey as a "bold and resourceful innovator whose perseverance and risk-taking had been rewarded by both public acclaim and commercial success" (ibid., 98).

CHAPTER ELEVEN. ADVENTURES IN MONKEYLAND

1. Stuart McCook, "'It may be Truth, but it is not Evidence': Paul du Chaillu and the Legitimation of Evidence in the Field Sciences," *Osiris*, 2nd ser., 11 (1996): 177. See also Tamara Giles-Vernick and Stephanie Rupp, "Visions of Apes, Reflections on Change: Telling Tales of Great Apes in Equatorial Africa," *African Studies Review* 49, no. 1 (2006): 51–73. Vernick and Rupp point out that Paul du Chaillu reported "curious stories" told in Gabon including one of an "immense gorilla" who carried off a woman into the forest and "forced her to submit to [his] desires."
2. Jeannette Eileen Jones, "'Gorilla Trails in Paradise': Carl Akeley, Mary Bradley, and the American Search for the Missing Link," *Journal of American Culture* 29, no. 3 (2006): 321.
3. Jeanette Eileen Jones, "Gorilla Trails in Paradise: Carl Akeley, Mary Bradley, and the American Search for the Missing Link," *Journal of American Culture* 29, no. 3 (2006), 429–436.
4. Robert M. Yerkes, "Gorilla Census and Study," *Journal of Mammalogy* 32, no. 4 (1951): 429–431. Many so-called gorillas on display in the United States, such as the one exhibited by Ringling Brothers Barnum and Bailey in the late 1890s ("Johanna") were really either chimpanzees or baboons. The primatologist Robert M. Yerkes estimated in 1951 that "prior to this century, it seems improbable that more than a score had reached America alive." 430–431.
5. Easton and Brown, *Lord of the Beasts*, 206.
6. Ibid., 204.
7. "Gorilla Hunters Return: Woman Tamed One Baby Animal After Its Capture in Africa," *Washington Post*, July 2, 1915, 6.
8. Mary Bradley, "In Africa with Akeley," *Natural History* 27, no. 2 (1927): 161.
9. Akeley, *In Brightest Africa*, 235.
10. Ibid., 229–230.
11. Jones, "Gorilla Trails in Paradise," 328.
12. Cameron, *Into Africa*, 46.
13. S.B., "Reviewed Work(s): Through Wildest Africa by E. Ratcliffe Holmes," *Journal of the Royal African Society* 26, no. 104 (1927): 409.
14. *Head Hunters of the South Seas* would not release until January 1923.
15. Jeanette Eileen Jones, "'In Brightest Africa': Naturalistic Constructions of Africa in the American Museum of Natural History, 1910—1936," in *Images of Africa: Stereotypes & Realities,* ed. Daniel M. Mengara (Trenton, NJ: Africa World Press, 2001), 198.
16. Carl Akeley to Henry Fairfield Osborn, American Museum of Natural History, A342: Box 1, Folder 7, Correspondence.

17. Imperato and Imperato, *They Married Adventure,* 83.

18. Prospectus of the Martin Johnson Expeditions Corporation, July 24, 1923, American Museum of Natural History Archives.

19. "The Screen: Wild Animal Thrills," *New York Times,* January 9, 1923, 27.

20. Carl E. Akeley and Henry Fairfield to George Eastman, July 26, 1923, American Museum of Natural History archives.

21. Helen Bullitt Lowry, "New Adam and Eve Among the Gentle Wild Beasts," *New York Times,* April 29, 1923, SM8.

22. Ibid.

23. Martin Johnson, "Camera-Hunts in the Jungles of Africa," *New York Times,* July 17, 1927, SM4.

24. Imperato and Imperato, *They Married Adventure,* 105.

25. "Beauty and the Beast," *New York World,* May 21, 1923.

26. Imperato and Imperato, *They Married Adventure,* 112.

27. Thomas Fowell Buxton, *The African Slave Trade and Its Remedy* (London: Cass, 1967), 10–11. See also Brantlinger, "Victorians and Africans."

28. Buxton, *The African Slave Trade,* 244.

29. Frank A. Salamone, "Review: Colonial Evangelism," *African Studies Review* 27, no. 1 (1984): 132.

30. Buxton, *The African Slave Trade,* 342.

31. Carl E. Akeley and Henry Fairfield Osborn to George Eastman, July 26, 1923, American Museum of Natural History Archives.

32. Martin Johnson to Terry Ramsaye, December 19, 1925, American Museum of Natural History Archives.

33. George Sherwood to Martin Johnson, May 3, 1926, American Museum of Natural History Archives.

34. In *They Married Adventure* Imperato and Imperato suggest that Martin Johnson did not appear as the hero of his own films because he was self-conscious about his facial tic.

35. It is an erotic gaze, similar to that of the bald, aging Monsieur Hire as he watches a young woman live her life in an apartment across the courtyard from his in Georges Simenon's novel *Les Fian-çailles de Monsieur Hire* (1933).

36. The visual trope of the hunter who shoots dead the fierce animal that is about to kill the camera-man" started with John Hemment (*Paul J. Rainey's African Hunt* and its sequel, *Rainey's African Hunt*) and then was used by the Snows (*Hunting Big Game in Africa with Gun and Camera*), and the Johnsons in most of their features.

37. Rony, *The Third Eye,* 112–113.

38. *The American Film Institute Catalogue of Motion Pictures Produced in the United States: Feature Films, 1921–1930,* F2.0701.

39. The title of the film is misleading. "Simba," which means "lion" in Ki-Swahili, takes only up twelve minutes of the eighty-six-minute film.

40. Mitman, *Reel Nature,* 31.

41. According to Mitman (*Reel Nature,* 35), the AMNH severed its relationship with Johnson after he "falsely used the name of the American Museum to secure a gorilla-collecting permit from the Belgian government."

42. Imperato and Imperato, *They Married Adventure,* 146.

43. Public Acts of the State of Tennessee (1925), 27, House Bill no. 185.

44. *New York Times,* December 14, 1926.

45. David P Willoughby, *All About Gorillas* (Cranbury, NJ: A. S. Barnes, 1978), 174–175. As many as four gorillas may have preceded "Congo" to the United States, although there is some confusion

about whether at least two of them were chimpanzees mistaken for gorillas. The first gorilla in America arrived in Boston in 1897 and lived only five days. A second gorilla arrived at the Bronx Zoo in 1911 and lived twelve days. A third, named Dinah, also arrived in New York and lived for eleven months at the Bronx Zoo between 1914 and 1915, and a fourth, named John Daniel, appeared in the Ringling Brothers circus for one month in 1921.

46. Yerkes, "Gorilla Census and Study," 434; and Robert M. Yerkes and Margaret Sykes Child, "Anthropoid Behavior," *Quarterly Review of Biology* 2, no. 1 (1927): 43.

47. "Thrills of Making Jungle Film: Intrepid Producers Reveal Some of the Dangers of Picturing Scenes in Area North of Siam Infested by Man-Eating Tigers," *New York Times,* April 10, 1927, X7.

48. *New York Times,* April 30, 1927.

49. Eileen Manning Michels, "Alice O'Brien: Volunteer and Philanthropist," in *Women of Minnesota: Selected Biographical Essays,* ed. Barbara Stuhler and Gretchen Kreuter (St. Paul: Minnesota Historical Press, 1977), 147.

50. *Variety*, January 1930.

51. Mitman, *Reel Nature,* 53.

52. Thomas Doherty, *Pre-Code Hollywood: Sex, Immorality and Insurrection in American Cinema 1930–1934* (New York: Columbia University Press, 1999), 240.

53. *New York Times*, June 1, 1931.

54. Brownlow, *War, West, and Wilderness*, 403.

55. Mordaunt Hall, "The Screen: In the Jungle," *New York Times*, March 17, 1931, 37.

56. *Variety*, March 1, 1932, 21. See also Geoffrey Gray, "Looking for Neanderthal Man, Finding a Captive Woman: The Story of a Documentary Film," *Health and History* 8, no. 2 (2006): 69–90.

57. Doherty, *Pre-Code Hollywood,* 254.

58. Ibid., 241. Doherty gives an excellent account of the legal difficulties *Ingagi* had with the FTC and the newly formed Hays Office, whose job it was to develop and promote standards of decency in the cinema.

59. Andrew Erish, "Illegitimate Dad of King Kong," *Los Angeles Times*, January 8, 2006.

60. Cynthia Erb, *Tracking King Kong* (Detroit: Wayne State University Press, 1998), 37.

61. Rony, *The Third Eye,* 171. According to Rony, the characters of Denham, Driscoll, and Wray were composites of adventurer filmmakers Douglas and Katherine Burden, Merian Cooper and Ernest B. Schoedsack, and Ruth Rose, Schoedsack's wife, who was one of the three writers of *King Kong*. Others, such as the gorilla hunter Ben Burbridge, have also been cited as the inspiration for Denham's character.

62. Jon Tuska, *The American West in Film: Critical Approaches to the Western* (Santa Barbara: Greenwood Press, 1985), 224.

63. Imperato and Imperato, *They Married Adventure,* 164.

64. Ibid., 151.

65. The Johnsons named the twin juvenile gorillas they captured "Congo" and "Ingagi," thus acknowledging that they were at least aware of the presence of the film *Ingagi*.

66. *Congorilla*, 1932, dir. Martin Johnson.

67. *New York Herald Tribune,* July 22, 1932. See also *Variety*, July 6, 1932.

68. *New York Times,* July 22, 1932.

69. *Hamilton* (Ohio) *Evening Journal,* November 17, 1932, 15.

70. Imperato and Imperato, *They Married Adventure,* 163, 167.

71. André Sennwald, "The Screen: Aerial Safari in Africa with Mr. and Mrs. Martin Johnson in 'Baboona,' at the Rialto," *New York Times*, January 23, 1935, 21.

CHAPTER TWELVE. *NATURE,* THE FILM

1. Hayden White, *Metahistory: The Historical Imagination in Nineteenth-Century Europe* (Baltimore: Johns Hopkins Press, 1973). See also, Wulf Kansteiner, "Hayden White's Critique of the Writing of History," *History and Theory* 32, no. 3 (1993): 277.
2. White, *Metahistory,* 5.
3. Ibid.
4. Ewa Domanska, "Hayden White: Beyond Irony," *History and Theory* 37, no. 2 (1998): 174.
5. White, *Metahistory,* 22.
6. Foucault, *The Order of Things,* 131. "The locus of this history," noted Foucault, "is a non-temporal rectangle in which, stripped of all commentary, of all enveloping language, creatures present themselves one beside another, their surfaces visible, grouped according to their common features, and thus already virtually analyzed, and bearers of nothing but their own individual names.
7. I refer only to the physical animals in the dioramas. The painted backgrounds sometimes contain other animals, such as the ungulates in the distance in *African Lion.*
8. The exception is *Upper Nile,* in which a hippopotamus and a shoebill share the diorama rather awkwardly with four different species of ungulates. Similarly, the giant forest hog in the *Bongo* diorama appears at the extreme edge of the frame, obscured by vegetation. The appearance of small mammals, birds, and reptiles in other dioramas is incidental and often hard to spot.
9. Donna Haraway, "Teddy Bear Patriarchy: Taxidermy in the Garden of Eden, New York City, 1908–1936," in *The Haraway Reader.* Haraway's deconstruction of gender in *The Giant of Karisimbi* exposes the biases inherent in the composition.
10. "Africa Transplanted," *Time,* June 1, 1936, 53.
11. The lion and the bongo live in harems.
12. Animals that appear singly are a hippopotamus in *Upper Nile,* a hyena in *Hyaena—Jackal—Vultures* and nine species of the family *bovidae,* including an oryx, dama, eland, topi, hartebeest, sitatunga (marshbuck), roan, waterbuck, blesbok, and roan antelope.
13. The only exception is a dead zebra that appears in *Hyaena—Jackal—Vulture.*
14. Theodore Roosevelt, *The Strenuous Life* (New York: Century, 1905), 1.
15. Carl E. Akeley, "Elephant Hunting in Equatorial Africa with Rifle and Camera," *National Geographic Magazine* 23 (1912): 810.
16. Carl E. Akeley to Henry Fairfield Osborn, April 9, 1910, American Museum Natural History Archives.
17. White, *Metahistory,* 11.
18. James R. Ryan, *Picturing Empire: Photography and the Visualization of the British Empire* (Chicago: University of Chicago Press, 1997), 103.
19. Akeley, "African Hall," 10–11. Akeley conceived of African Hall in 1911 and presented the idea to Henry Fairfield Osborn and the directors of the museum in 1912. Work began on the hall in 1914.
20. American Museum of Natural History Archives, Ms. A-344.
21. "The New African Hall Planned by Carl E. Akeley," *American Museum Journal* 14, no. 5 (1914): 180.
22. Wulf Kasteiner, "Hayden White's Critique of the Writing of History," *History and Theory* 32, no. 3 (1993), 284.
23. Anne McClintock, *Imperial Leather: Race, Gender and Sexuality in the Colonial Contest* (London: Routledge, 1995), 14, 40. McClintock specifically relates anachronistic space to marginalized women, colonized people or the working class, rather than to animals or nature. The full quote

reads, "Colonized people—like women and working class in the metropolis—do not inhabit history proper but exist in a permanently anterior time within the geographic space of the modern empire as anachronistic humans, atavistic, irrational, bereft of human agency."

24. Evernden, *Social Creation of Nature,* 99.
25. Sontag, *On Photography*, 191.
26. Akira Mizuta Lippit, *Electric Animal: Toward a Rhetoric of Wildlife* (Minneapolis: University of Minnesota Press, 2000), 21.
27. Ibid., 1.
28. John Berger, *About Seeing* (New York: Vintage, 1991), 17.
29. Lippit, *Electric Animal,* 6.
30. Berger, *About Seeing,* 8.
31. Evernden, *Social Creation of Nature,* 99.
32. White, *Metahistory,* 7.
33. Said, *Culture and Imperialism,* xiii, 67, 71.
34. Ibid., 13.
35. Roosevelt, *African Game Trails,* 173, ix, 223.

CHAPTER THIRTEEN. THE WORLD SCRUBBED CLEAN

1. Richard Schickel, *The Disney Version: The Life, Times, Art and Commerce of Walt Disney,* 3rd ed. (Chicago: Elephant Paperbacks, 1997), 291.
2. Ralph H. Lutts, "The Trouble with Bambi: Walt Disney's Bambi and the American Vision of Nature," *Forest & Conservation History* 36, no. 4 (1992): 160.
3. Gregory D. Black, *Hollywood Censored: Morality Codes, Catholics and the Movies* (Cambridge: Cambridge University Press, 1994), 17. The decision would not be reversed until 1952, in *Joseph Burstyn, Inc. v. Wilson,* when a unanimous Court decided that motion pictures were entitled to the guarantees of the First Amendment.
4. Ruth Vasey, *The World According to Hollywood: 1918–1930* (Madison: University of Wisconsin Press, 1997), 25.
5. Richard Maltby, "More Sinned Against than Sinning: The Fabrications of Pre-Code Cinema," http://www.sensesofcinema.com/contents/03/29/pre_code_cinema.html.
6. Black, *Hollywood Censored,* 29.
7. Olga Martin, *Hollywood's Movie Commandments* (New York: H. W. Wilson, 1937), 24. See also Garth Jowett, Ian Jarvie, and Kathryn Fuller, *Children and the Movies: Media Influence and the Payne Fund Controversy* (Cambridge: Cambridge University Press, 1996). In 1928, a philanthropic organization in Cleveland, the Payne Fund, awarded $200,000—a huge sum in those days—to Reverend William H. Short's Motion Picture Research Council for the purpose of funding a scientific study that would provide hard evidence that movies were indeed a corruptive influence on the nation's youth. Reverend Short hired educators, psychologists, and social scientists from Yale, Ohio State, NYU, Penn State, and the University of Chicago to conduct formal studies on such topics as "Boys, Movies, and City Streets," "Getting Ideas from the Movies," and "The Social Conduct and Attitudes of Movie Fans." According to film historian Robert Sklar, Reverend Short was out to "get the goods on the movies, [and] nail them to the wall." The Payne studies failed to provide any convincing evidence for the reformers' argument.

8. *Gary* (Indiana) *Post-Tribune*, "Hollywood Must be Purified by U.S. Government," February 10, 1922, quoted in J. J. Maloney, "The Crime Film," *Crime Magazine: An Encyclopedia of Crime*, n.d., http://www.crimemagazine.com/crimefilm.htm (December 27, 2009). See also Bruce Long, ed., "'The Humor of a Hollywood Murder,' Part 6: Evil Hollywood," *Taylorology: Exploration of the Life and Death of William Desmond Taylor*, September 1993, http://www.public.asu.edu/~ialong/Taylor09.txt (December 27, 2009). See also Black, *Hollywood Censored*, 167–189.

9. Gaines M. Foster, *Moral Reconstruction: Christian Lobbyists and the Federal Legislation of Morality, 1865–1920* (Chapel Hill: University of North Carolina Press, 2002), 5.

10. Vasey, *World According to Hollywood*, 17. See also Richard Maltby, "The Motion Picture Code as Published 31 March 1930," in *Hollywood Cinema*, 2nd ed. (Malden, MA: Wiley-Blackwell, 2003), 593–597.

11. Black, *Hollywood Censored*, 15.

12. Martin, *Hollywood's Movie Commandments*, 30.

13. Maltin, *Of Mice and Magic*, 33.

14. Walt Disney, "The Cartoon's Contribution to Children," *Overland Monthly and Out West Magazine* 91, no. 8 (1933): 138.

15. Steven Watts, *The Magic Kingdom: Walt Disney and the American Way of Life* (Columbia: University of Missouri Press, 1997), 35.

16. The original Motion Picture Code of 1930 was convoluted and verbose; as a consequence, the document was quickly reissued in a more succinct form as "Particular Applications of the Code and the Reasons Therefore [Addenda to 1930 Code]," which is quoted here.

17. Black, *Hollywood Censored*, 40.

18. Mickey was not only sexually suggestive but sexually aggressive. In *Plane Crazy* (1928) Minnie jumps out of Mickey's plane in midair in order to escape his persistent advances, and in *The Plow Boy* (1929) she slugs Mickey when he tries to get too familiar with her.

19. Bob Thomas, *Walt Disney: An American Original* (New York: Disney Editions, 2002), 108. Disney drew a parallel between his Mouse and Charlie Chaplin, whom he described as another "little fellow trying to do the best he could."

20. Watts, *The Magic Kingdom*, 81, 401.

21. Ibid., 241. Disney was anything but a man of the people. Among other things, Disney aggressively and illegally resisted unionization of his company in the early 1940s, he condoned unfair labor practices, and he was the founding vice president of the ultraconservative Motion Picture Alliance for the Preservation of American Ideals, which, according to Steven Watts, was "the bulwark of anticommunism in Hollywood well up into the 1950s" (241). The manifesto of the MPA, which was written by Ayn Rand and called the "Screen Guide for Americans," held among its principles that loyal Americans didn't "smear" "industrialists, the profit motive and wealth, [or] the success ethic" nor "glorify failure, depravity, or the common man."

22. Schickel, *The Disney Version*, 39.

23. Lewis Mumford, "Ex-Libris," *Freeman* 7 (April 18, 1923): 143, quoted in Frederick J. Hoffman, "Philistine and Puritan in the 1920s," *American Quarterly* 1, no. 3 (1949): 255–256.

24. Charles W. Brahares, "Walt Disney as Theologian," *Christian Century*, August 10, 1938, 968–969.

25. "Walt Disney Unmasks Nature," *St. Paul Pioneer Press*, August 10, 1952. See also "Disney's Contribution to Genuine Cinema Art," *Los Angeles Tidings*, June 20, 1952. Also in Watts, *The Magic Kingdom*, 307.

26. Thomas, *Walt Disney*, 130.

27. Russell Merritt and J. B. Kaufman, *Walt in Wonderland: The Silent Films of Walt Disney* (Baltimore: Johns Hopkins University Press, 1993).

28. Watts, *The Magic Kingdom*, 42. See also Dave Smith and Steven Clark, *Disney, The First 100 Years* (New York: Disney Editions, 2002), 36.

29. Thomas, *Walt Disney*, 130.

30. Schickel, *The Disney Version*, 60.

31. Felix Salten, *Bambi: A Life in the Woods* (New York: Simon and Schuster, 1928).

32. Ibid., 142.

33. Roland Barthes, *A Barthes Reader*, ed. Susan Sontag (New York: Hill and Wang, 1982), 140.

34. David Payne, "Bambi," in *From Mouse to Mermaid: The Politics of Film, Gender and Culture*, ed. Elizabeth Bell, Lynda Haas, and Laura Sells (Bloomington: Indiana University Press, 1995), 144.

35. The argument could also be made that Bambi and Faline represent the anima and animus of the Jungian aspect of the psyche.

36. Lutts, "The Trouble with Bambi," 164.

37. Adrian Bailey, *Walt Disney's World of Fantasy* (New York: Everest House, 1982), 152–153.

38. Schickel, *The Disney Version*, 200.

39. Ibid., 201.

40. Ibid., 267–268; emphasis added.

41. The clearest visual statement of this principle can be found in Disney's cartoon *The Old Mill* (1937), an animated tone poem about a short, violent summer storm that passes by a windmill. Disney dismissed the piece as "just a poetic thing," but it won an Academy Award.

42. Alfred Russel Wallace, "A review of Hereditary Genius, An Inquiry into Its Laws and Consequences," *Nature* 17 (1870): 137.

43. Margaret J. King, "The Audience in the Wilderness." *Journal of Popular Film & Television* 24, no. 2 (1996): 60–69; emphasis added.

44. Angela Hawk, "'Disney-fying' Mother Nature in the Atomic Era: How Disneyland's Portrayals of Nature Reflected Post-War Ideals of Family, Child-Rearing, and the Home, 1955–1966," *Explorations: An Undergraduate Research Journal*, 2004, http://undergraduatestudies.ucdavis.edu/explorations/2004/hawk.pdf (November 12, 2009).

45. Nick Sammond, *Babes in Tomorrowland: Walt Disney and the Making of the American Child, 1930–1960* (Durham: Duke University Press, 2005), 239.

46. Ibid., 238.

47. W Riley Woodford, "Lemming Suicide Myth Disney Film Faked Bogus Behavior," *Alaska Fish & Wildlife News*, 2003, http://www.wildlifenews.alaska.gov/index.cfm?adfg=wildlife_news.view_article&articles_id=56&issue_id=6 (November 12, 2009).

48. The True-Life Fantasies were filmed fictionalized versions of True-Life Adventures that included titles such as *Perri* (1957), *Chico, the Misunderstood Coyote* (1961), *Sammy, the Way Out Seal* (1962) and *Charlie, the Lonesome Cougar* (1967).

49. Gregg Mitman, *Reel Nature: America's Romance with Wildlife on Film* (Cambridge: Harvard University Press, 1999), 124.

50. Hawk, "Disney-fying Mother Nature," 20.

51. Mitman, *Reel Nature*, 124.

52. Ed Ainsworth, "Disney Creating New Era of Realism," *Los Angeles Times*, November 29, 1954.

53. "Father Goose," *Time*, December 27, 1954, 46.

54. Schickel, *The Disney Version*, 290.

55. *Walt Disney's True-Life Adventure: Beaver Valley*, Dell Nature Classic no. 625 (New York: Dell, 1955).

56. Olaus Murie, "The World We Live In," *Living Wilderness* 37 (Summer 1951): 17–18.

57. Bosley Crowther, "The Screen: Two Pictures Have Premieres," *New York Times*, November 10, 1953, 38. Also in Sammond, *Babes in Tomorrowland*, 240.

58. "Nature, On Celluloid," *Boston Globe*, August 8, 1950.

59. *Pittsburgh Press*, February 10, 1951.

60. Howard Munce, "Mr. Eager Never Stops," *Westporter Herald*, Westport, CT, October 1950.

61. *The Living Wilderness*, the publication of the Wilderness Society.

62. *Walt Disney's True-Life Adventures* (New York: Golden Press, 1958), 7.

63. Ibid., 41–67.

64. Roderick P. Neumann, *Imposing Wilderness: Struggles over Livelihood and Nature Preservation in Africa* (Berkeley: University of California Press, 1998), 24.

65. Nash, *Wilderness*, 3rd ed., 106.

66. The so-called National Park Service Organic Act (16 U.S. Code 1, 2, 3, and 4), establishing the National Park Service on August 25, 1916, states that it "shall promote and regulate the use of Federal areas known as national parks, monuments and reservations . . . by such means and measures as conform to the fundamental purpose of the said parks, monuments and reservations, which purpose is to conserve the scenery and the natural and historic objects and the wild life therein and to provide for the enjoyment of the same in such manner and by such means as will leave them unimpaired for the enjoyment of future generations."

67. National Park Service, "The National Park System Caring for the American Legacy," *National Park Service*, n.d., http://www.nps.gov/legacy/mission.html (November 12, 2009).

68. Raymond Williams, *Problems in Materialism and Culture* (London: NLB, 1980), 78.

Bibliography

"Abandoning Sport to the Dogs." *New York Times,* August 24, 1911.

Achinstein, Asher. Review of *Earnings of Factory Workers, 1899 to 1927,* by Paul F. Brissenden. *Journal of the American Statistical Association* 25, no. 171 (1930): 371.

"Adventure with an African Elephant." *American Museum Journal* 10, no. 6 (1910): 186.

"Africa Transplanted." *Time,* June 1, 1936, 53.

Agassiz, Louis. "Essay on Classification." In *Contributions to the Natural History of the United States of America,* vol. 1. New York: Arno Press, 1978.

Ainsworth, Ed. "Disney Creating New Era of Realism." *Los Angeles Times,* November 29, 1954.

Akeley, Carl E. "African Hall, A Monument to Primitive Africa." *The Mentor,* January 1926, 10–11.

———. "Elephant Hunting in Equatorial Africa with Rifle and Camera." *National Geographic Magazine* 23 (1912): 810.

———. "Gorilla Trails in Paradise: Carl Akeley, Mary Bradley, and the American Search for the Missing Link." *Journal of American Culture* 29, no. 3 (2006): 429–436.

———. "Have a Heart: A Statement and Plea for Fair Game Sport in Africa." *The Mentor,* January 13, 1926, 47.

———. *In Brightest Africa.* Garden City, NY: Doubleday, Page, 1923.

———. "Theodore Roosevelt and Africa." *Natural History* 19, no. 1 (1919): 12.

———. *The Wilderness Lives Again.* New York: Dodd & Mead, 1943.

Albright, Horace M., and Frank J. Taylor. *Oh, Ranger! A Book about the National Parks.* Stanford: Stanford University Press, 1928.

Among the Cannibal Isles of the South Pacific. Martin Johnson Film Co. 1918. *AFI Catalog Feature Films,* http://www.afi.com/members/catalog/AbbrView.aspx?s=&Movie=14806 (November 12, 2009).

Appleby, Joyce, and Terrence Ball. *Jefferson: Political Writings.* Cambridge: Cambridge University Press, 1999.

Aquinas, Thomas. *Summa Theologica,* vol. 3, pt. 2, 2nd sec. New York: Cosimo, 2007.

Audubon, John James. *The Original Water-Color Paintings by John James Audubon for the Birds of America.* New York: American Heritage / Bonanza Books, 1985.

Bacon, Francis. *The Works of Francis Bacon.* Edited by James Spedding, Robert Leslie Ellis, and Douglas Denon Heath. New York: Hurd and Houghton, 1877.

Bailey, Adrian. *Walt Disney's World of Fantasy.* New York: Everest House, 1982.

Bann, Stephen. *The Clothing of Clio: A Study of the Representation of History in Nineteenth-Century Britain and France.* Cambridge: Cambridge University Press, 1984.

Barnouw, Eric. *Documentary: A History of the Non-Fiction Film.* Rev. ed. Oxford: Oxford University Press, 1983.

———. *Media, Lost and Found.* New York: Fordham University Press, 2001.

Barthes, Roland. *A Barthes Reader.* Edited by Susan Sontag. New York: Hill and Wang, 1982.

———. *Mythologies.* New York: Hill and Wang, 1973.

Beale, Howard K. *Theodore Roosevelt and the Rise of America to World Power.* Baltimore: Johns Hopkins Press, 1956.

Beard, George M. *A Practical Treatise on Nervous Exhaustion (Neurasthenia): Its Symptoms, Nature, Sequences, Treatment.* 5th ed. Edited by A. D. Rockwell. New York: Kravs Reprint Co., 1971.

"Beauty and the Beast." *New York World,* May 21, 1923.

Beebe, William, G. Inness Hartley, and Paul G. Howes. *Tropical Wild Life in British Guiana: With an Introduction by Colonel Theodore Roosevelt.* New York: New York Zoological Society, 1917. Berger, John. *About Seeing.* New York: Vintage, 1991.

———. *Ways of Seeing.* London: Penguin, 1972.

———. "Why Look at Animals?" In *About Looking.* New York: Vintage International, 1991.

Bernstein, Arnie. *Hollywood on Lake Michigan: 100 Years of Chicago and the Movies.* Chicago: Lake Claremont Press, 1998.

Bishop, Joseph Bucklin. "Theodore Roosevelt and His Time: Shown in His Own Letters." *Scribner's* 66, no. 5 (1919): 523.

Black, Gregory D. *Hollywood Censored: Morality Codes, Catholics and the Movies.* Cambridge: Cambridge University Press, 1994.

Bodry-Sanders, Penelope. *African Obsession: The Life and Legacy of Carl Akeley.* Jacksonville, FL: Batax Museum Press, 1998.

"Books and Authors: Notes of Forthcoming and Recent Publications." *New York Times,* November 12, 1898, 760.

Botkin, Daniel B. *Discordant Harmonies: A New Ecology for the Twenty-First Century.* New York: Oxford University Press, 1990.

Boudreau, Erica Bicchieri. "Yea, I have a Goodly Heritage: Health Versus Heredity in the Fitter Family Contests, 1920–1928." *Journal of Family History* 30 (2005): 367.

Das Boxende Kanguruh. 1895. *WildFilm History: Films: film clip,* http://www.wildfilmhistory.org/film/318/clip/439/Full+film.html (November 12, 2009).

The Boxing Horse. 1899. *AFI Catalog Feature Films,* http://www.afi.com/members/catalog/DetailView.aspx?s=&Movie=30237 (November 12, 2009).

Bradford, Phillip V., and Harvey Blume. *Ota Benga: The Pygmy in the Zoo.* New York: St. Martins, 1992.

Bradley, Mary. "In Africa with Akeley." *Natural History* 27, no. 2 (1927): 161.

Brahares, Charles W. "Walt Disney as Theologian." *Christian Century,* August 10, 1938, 968–969.

Brands, H. W. *TR: The Last Romantic.* New York: Basic Books, 1997.

———. *The Reckless Decade: America in the 1890s.* Chicago: University of Chicago Press, 2002.

Brantlinger, Patrick. "Victorians and Africans: The Genealogy of the Myth of the Dark Continent." In *Race, Writing, and Difference,* edited by Henry Louis Gates Jr. Chicago: University of Chicago Press, 1985.

Brownlow, Kevin. *The War, the West, and the Wilderness.* New York: Knopf, 1979.

Buckle, Henry Thomas. *Introduction to the History of Civilization in England.* Rev. ed. London: Routledge and Sons, 1872.

"Buffalo Jones Says Soldiers Lack Backbone." *New Haven Evening Register,* November 15, 1906.

Burroughs, John. *Camping and Tramping with Roosevelt.* New York: Houghton Mifflin, 1906.

———. "Real and Sham Natural History." *Atlantic Monthly* 91, no. 545 (1903): 298.

"Bushman Shares a Cage with Bronx Park Apes." *New York Times,* September 9, 1906, 17.

Butt, Archie. *The Letters of Archie Butt, Personal Aide to President Roosevelt.* New York: Doubleday, Page, 1924.

Buxton, Thomas Fowell. *The African Slave Trade and Its Remedy.* London: Frank Cass, 1967.

Cameron, Kenneth M. *Africa on Film: Beyond Black and White.* New York: Continuum, 1994.

———. *Into Africa: The Story of the East African Safari.* London: Constable and Company, 1990.

Carson, Gerald. "T.R. and the 'Nature Fakers.'" *American Heritage Magazine* 22, no. 2 (1971).

Cartwright, Lisa. *Screening the Body: Tracing Medicine's Visual Culture.* Minneapolis: University of Minnesota Press, 1995.

Children Playing with Lion Cubs. American Mutoscope and Biograph Co. 1902. *AFI Catalog Feature Films,* http://www.afi.com/members/catalog/DetailView.aspx?s=&Movie=44341 November 12, 2009).

Clark, Edward B. "Roosevelt on the Nature Fakirs." *Everybody's Magazine* 16 (1907): 770–774.

Clark, James L. "The Image of Africa." *Natural History,* January 1936, 70.

Clarke, Adam. *The Holy Bible, Containing the Old and New Testaments, A Commentary and Critical Notes.* New York: T. Mason & G. Lane, 1837.

Cohen, William B. *The French Encounter with Africans: White Response to Blacks, 1530–1880.* Bloomington: Indiana University Press, 1980.

"Colorado Bear Hunt." *Scribner's* 38 (1905): 387–408.

"Col. Roosevelt in Danger: Falls While Fleeing from a Wounded Bear, but his Companions Kill the Brute." *New York Times,* January 16, 1901, 1.

"Col. Roosevelt Was Treed: Attacked by a Number of Gray Wolves and Remained a Prisoner for Four Hours." *New York Times,* January 19, 1901, 1.

Col. Theodore Roosevelt and Officers of His Staff. American Mutoscope Company. 1898. *AFI Catalog Feature Films,* http://www.afi.com/members/catalog/DetailView.aspx?s=&Movie=32128 (November 12, 2009).

"The Coming of Winter." *Century Illustrated Monthly Magazine* 37, no. 2 (1888): 163.

Cosgrove, Denis E. *The Palladian Landscape: Geographical Change and Its Cultural Representations in Sixteenth-Century Italy.* University Park: Penn State University Press, 1993.

Cox, Randolph J. *The Dime Novel Companion: A Source Book.* Westport, CT: Greenwood Press, 2000.

Cronon, William. *Nature's Metropolis: Chicago and the Great West.* New York: Norton, 1991.

Crookshank, F. G. *The Mongol in our Midst.* London: Kegan Paul, Trench and Trubner, 1924.

Crevècoeur, J. Hector St. John de. *Letters from an American Farmer.* Oxford: Oxford University Press, 1997.

Crowther, Bosley. "The Screen: Two Pictures Have Premieres." *New York Times,* November 10, 1953, 38.

Crum, William D. "A Negro in Politics." *Journal of Negro History* 53, no. 4 (1968): 301.

Crumley, Carol. "Cultural Ecology: A Multidimensional Ecological Orientation." In *Historical Ecology: Cultural Knowledge and Changing Landscapes.* Santa Fe: SAR Press, 1994.

Cutright, Paul Russell. *Theodore Roosevelt: The Naturalist.* New York: Harper & Brothers, 1956.

Dalton, Kathleen. *Theodore Roosevelt: A Strenuous Life.* New York: Knopf, 2002.

Daniels, S. and D. E. Cosgrove. "Introduction: Iconography and Landscape." In *The Iconography of Landscape: Essays on the Symbolic Representation, Design and Use of Past Environments.* Cambridge: Cambridge University Press, 1988.

Davis, Richard Harding. *The Cuban and Porto Rican Campaigns.* New York: Charles Scribner's Sons, 1898.

Dawkins, Richard. *The God Delusion.* Boston: Houghton Mifflin, 2006.

de Blainville, Henri. "Sur une Femme de la Race Hottentote." *Bulletin de sciences par la Société philomatique de Paris* (1815): 183.

Descartes, René. *Discourse on Method of Rightly Conducting the Reason and Seeking for Truth in the Sciences.* Vol. 1 of *Philosophical Works.* Edited by E. S. Haldane and G. R. T. Ross. New York: Dover, 1955.

DeVoto, Bernard, ed. *Mark Twain in Eruption.* New York: Capricorn, 1968.

"Died for Science's Sake: A Dog Killed with the Electric Current." *New York Times,* July 31, 1888, 8.

Disney, Walt. "The Cartoon's Contribution to Children." *Overland Monthly and Out West Magazine* 91, no. 8 (1933): 138.

"Disney's Contribution to Genuine Cinema Art." *Los Angeles Tidings,* June 20, 1952.

"Display Ad 79." *New York Times,* September 12, 1921, 20.

Dixon, Thomas. *The Leopard's Spots.* New York: Doubleday, Page, 1902.

"Doe and Fawns." *Forest and Stream* 38, no. 1 (1898): 1.

"Dogs Killed by Electricity." *New York Times,* July 20, 1887, 4.

Doherty, Thomas. *Pre-Code Hollywood: Sex, Immorality and Insurrection in American Cinema 1930– 1934.* New York: Columbia University Press, 1999.

Domanska, Ewa. "Hayden White: Beyond Irony." *History and Theory* 37, no. 2 (1998): 174.

Douthwaite, Julie. "Rewriting the Savage: The Extraordinary Fictions of the 'Wild Girl of Champagne.'" *Eighteenth Century Studies* 28, no. 2 (1994–1995): 178.

Dunaway, Finis. "Hunting with the Camera: Nature Photography, Manliness, and Modern Memory, 1890–1930." *Journal of American Studies* 34, no. 2 (2000): 217–218.

Duncan, James, and N. Duncan. "(Re)reading the Landscape." *Environment and Planning D: Society and Space* 6, no. 2 (1988): 117–126.

Easton, Robert, and Mackenzie Brown. *Lord of the Beasts: The Saga of Buffalo Jones.* Lincoln: University of Nebraska Press, 1970.

Edwards, Bruce V. "Tarzan Flicks." *Bad Cinema Diary,* n.d., http://www.cathuria.com/bcd/pages/Bad Cinema_Tarzan.pdf (September 9, 2007).

Edwards, Everett E., ed., "Part II: Selections from Jefferson's Writings." In *Jefferson and Agriculture.* New York: Arno Press, 1976.

Erb, Cynthia. *Tracking King Kong.* Detroit: Wayne State University Press, 1998.

Erish, Andrew. "Illegitimate Dad of King Kong." *Los Angeles Times,* January 8, 2006.

Evernden, Neil. *The Social Creation of Nature.* Baltimore: Johns Hopkins University Press, 1992.

Fairchild, Herman L. "Ward Natural Science Establishment." *Scientific Monthly* 26, no. 5 (1928): 468.

Farber, Paul Lawrence. *Finding Order in Nature: The Naturalist Tradition from Linnaeus to E. O. Wilson.* Baltimore: Johns Hopkins University Press, 2000.

"Father Goose." *Time,* December 27, 1954, 46.

Fiedler, Leslie. *Freaks: Myths & Images of the Secret Self.* New York: Touchstone, 1978.

Fielding, Raymond. *The American Newsreel 1911–1967.* Norman: University of Oklahoma Press, 1972.

Forestry and Irrigation 14, no. 6 (1908): 300.

Foster, Gaines M. *Moral Reconstruction: Christian Lobbyists and the Federal Legislation of Morality, 1865–1920.* Chapel Hill: University of North Carolina Press, 2002.

Foucault, Michel. *The Birth of the Clinic.* New York: Pantheon, 1975.

———. *The Birth of the Clinic: An Archaeology of Medical Perception.* New York: Random House, 1975.

———. "Of Other Spaces." *Diacritics* 16, no. 1 (1986): 26.

———. *The Order of Things: An Archaeology of the Human Sciences.* New York: Vintage, 1970.

Galton, Francis. *Hereditary Genius: An Inquiry into Its Laws and Consequences.* New York: D. Appleton, 1884.

Garretson, Martin S. *The American Bison.* New York: New York Zoological Society, 1938.

Gates, Henry Louis, Jr., ed., "Victorians and Africans: The Genealogy of the Myth of the Dark Continent." In *Race, Writing, and Difference,* edited by Henry Louis Gates Jr. Chicago: University of Chicago Press, 1985.

Giannetti, Louis, and Scott Eyman. *Flashback: A Brief History of Film.* 3rd ed. Englewood Cliffs, NJ: Prentice Hall, 1996.

Giles-Vernick, Tamara, and Stephanie Rupp. "Visions of Apes, Reflections on Change: Telling Tales of Great Apes in Equatorial Africa." *African Studies Review* 49, no. 1 (2006): 51–73.

"Glimpses of Strenuous Life in Colorado." *Literary Digest,* February 2, 1901.

Goddard, Charles. "The Perils of Pauline." *Project Gutenberg eBooks,* 2004, http://www.gutenberg.org/files/6065/6065.txt (November 12, 2009).

Goetzmann, William H., and William N. Goetzmann. *The West of the Imagination.* New York: Norton, 1986.

Goode, G. Brown. *The Museums of the Future.* Washington, DC: Government Printing Office, 1891.

"Gorilla Hunters Return: Woman Tamed One Baby Animal After Its Capture in Africa." *Washington Post,* July 2, 1915, 6.

Gould, Stephen Jay. *The Flamingo's Smile: Reflections in Natural History.* New York: Norton, 1985.

———. *Ontogeny and Phylogeny.* Cambridge: Belknap Press of Harvard University Press, 1977.

Gray, Geoffrey. "Looking for Neanderthal Man, Finding a Captive Woman: The Story of a Documentary Film." *Health and History* 8, no. 2 (2006): 69–90.

Greene, Theodore P. *America's Heroes: The Changing Models of Success in American Magazines.* New York: Oxford University Press, 1970.

Grondahl, Paul. *I Rose Like a Rocket: The Political Education of Theodore Roosevelt.* New York: Free Press, 2004.

Guyot, Arnold. *Guyot's Physical Geography.* New York: Scribner, Armstrong, 1873.

Haeckel, Ernst. *The History of Creation: Or the Development of the Earth and Its Inhabitants by the Action of Natural Causes.* Translated by E. Ray Lankester. London: Henry S. King, 1876.

Hagedorn, Hermann. *Roosevelt in the Bad Lands.* Boston: Houghton Mifflin, 1921.

Haley, James L. "The Colossus of his Kind: Jumbo." *American Heritage Magazine,* August 1973, http://www.americanheritage.com/articles/magazine/ah/1973/5/1973_5_62.shtml (November 12, 2009).

Hall, Mordaunt. "The Screen: In the Jungle." *New York Times,* March 17, 1931, 37.

Hammond, Dorothy, and Alta Jablow. *The Africa that Never Was: Four Centuries of British Writing about Africa.* New York: Twayne, 1970.

Hampton, Benjamin B. *History of the American Film Industry.* New York: Dover Publications, 1970.

Hansen, Miriam. *Babel & Babylon: Spectatorship in American Silent Film.* Cambridge: Harvard University Press, 1991.

Haraway, Donna. *The Haraway Reader.* New York: Routledge, 2004.

———. *Primate Visions: Gender, Race, and Nature in the World of Modern Science.* New York: Routledge, 1989.

———. "Teddy Bear Patriarchy: Taxidermy in the Garden of Eden, New York City, 1908–1936." In *The Haraway Reader.* New York: Routledge, 2004.

Harbaugh, William Henry. *Power and Responsibility: The Life and Times of Theodore Roosevelt.* New York: Collier, 1963.

Hawk, Angela. "'Disney-fying' Mother Nature in the Atomic Era: How Disneyland's Portrayals of Nature Reflected Post-War Ideals of Family, Child-Rearing, and the Home, 1955–1966." *Explorations: An Undergraduate Research Journal,* 2004, http://undergraduatestudies.ucdavis.edu/explorations/2004/hawk.pdf (November 12, 2009).

Hedren, Paul L. "The Contradictory Legacies of Buffalo Bill Cody's First Scalp for Custer." *Montana: The Magazine of Western History* 55, no. 1 (2005): 30.

Hegel, Georg Wilhelm Friedrich. *The Hegel Reader.* Edited by Stephen Houlgate. Oxford: Blackwell, 1998.

Herner, Charles. *The Arizona Rough Riders.* Tucson: University of Arizona Press, 1970.

Hobbes, Thomas. "Of Darknesse from Vain Philosophy and Fabulous Traditions." In *Leviathan.* New York: E. P. Dutton, 1950.

Hoffman, Frederick J. "Philistine and Puritan in the 1920s." *American Quarterly* 1, no. 3 (1949): 255–256.

Hofstadter, Richard. *The American Political Tradition, and the Men Who Made It.* New York: Vintage, 1974.

Holsinger, M. Paul, ed., *War and American Popular Culture.* Westport, CT: Greenwood Press, 1999.

"Hunting Trips of a Ranchman." Review of *Hunting Trips of a Ranchman,* by Theodore Roosevelt. *Atlantic Monthly* 56, no. 336 (1885): 563.

Hunting White Bear. Pathé Frères. 1903. *AFI Catalog Feature Films,* http://www.afi.com/members/catalog/DetailView.aspx?s=&Movie=42811 (November 12, 2009).

Huntington, Ellsworth. *Civilization and Climate.* 3rd ed. New Haven: Yale University Press, 1924.

Imperato, Pascal, and Eleanor Imperato. *They Married Adventure: The Wandering Lives of Martin and Osa Johnson.* New Brunswick, NJ: Rutgers University Press, 1992.

Impey, Oliver, and Arthur MacGregor, eds. *The Origins of Museums: The Cabinet of Curiosities in Sixteenth and Seventeenth Century Europe.* Oxford: Oxford University Press, 1985.

"In Louisiana Canebrakes." *Scribner's* 43 (1908): 47–60.

Ingraham, Prentiss. *Adventures of Buffalo Bill from Boyhood to Manhood: Deeds of Daring, Scenes of Thrilling, Peril, and Romantic Incidents In the Early Life of W. F. Cody, the Monarch of Bordermen.* Beadle's Boy's Library of Sport, Story and Adventure, vol. 1, no. 1. New York: [Beadle and Adams], [1882?].

Jackson, Helen Hunt. *A Century of Dishonor: A Sketch of the United States Government's Dealings with Some of the Indian Tribes.* Norman: University of Oklahoma Press, 1995.

James, Henry. *The Bostonians.* London: Penguin, 2000.

Jamieson, Robert, Andrew Robert Fausset, and David Brown. *A Commentary, Critical and Explanatory, on the Old and New Testaments.* Hartford: S. S. Scranton, 1871.

Jarosz, Lucy. *Constructing the Dark Continent: Metaphor as Geographic Representation of Africa, Geografiska Annaler* (1992) 74 B (2): 105.

Jeffers, H. Paul. *Roosevelt the Explorer.* New York: Taylor Trade Publishing, 2003.

Jenkinson, Clay S. *Theodore Roosevelt in the Dakota Badlands: An Historical Guide.* Dickinson, ND: Dickinson State University, 2006.

Jesseph, Douglas M. "Galileo, Hobbes and the Book of Nature." *Perspectives on Science* 12, no. 2 (2004): 191.

Job, Herbert K. *Wild Wings: Adventures of a Camera-Hunter among the larger Wild Birds of North America on Sea and Land, With an Introductory Letter by Theodore Roosevelt.* London: Archibald Constable and Houghton Mifflin, 1905.

Johnson, Martin. "Camera-Hunts in the Jungles of Africa." *New York Times,* July 17, 1927, SM4.

———. *Cannibal-Land: Adventures with a Camera in the New Hebrides.* Boston: Houghton Mifflin, 1922.

Johnson, Osa. *I Married Adventure: The Lives and Adventures of Martin and Osa Johnson.* Philadelphia: J. B. Lippincott, 1940.

Johnston, Sir Harry. "Where Roosevelt Will Hunt." *National Geographic* 20 (1909): 234.

Jones, Jeanette Eileen. "'Gorilla Trails in Paradise': Carl Akeley, Mary Bradley, and the American Search for the Missing Link." *Journal of American Culture* 29, no. 3 (2006): 321.

———. "'In Brightest Africa': Naturalistic Constructions of Africa in the American Museum of Natural

History, 1910—1936." In *Images of Africa: Stereotypes & Realities.* Edited by Daniel M. Mengara. Trenton, NJ: Africa World Press, 2001.

Jowett, Garth, Ian Jarvie, and Kathryn Fuller. *Children and the Movies: Media Influence and the Payne Fund Controversy.* Cambridge: Cambridge University Press, 1996.

Kansteiner, Wulf. "Hayden White's Critique of the Writing of History." *History and Theory* 32, no. 3 (1993): 277.

Katz, Ephraim. *The Film Encyclopedia.* 4th ed. New York: HarperResource, 2001.

Keane, A. H. J. "Anthropological Curiosities." *Scientific American,* Supplement 64 (August 17, 1907): 99.

Kearton, Cherry. "Photographing Wild Life the World Over." *Photographic Times* 46, no. 5 (1914): 198.

Keller, Evelyn Fox. *Reflections on Gender and Science.* New Haven: Yale University Press, 1985.

Keller, Mitch. "The Scandal at the Zoo." *New York Times,* August 6, 2006.

King, Charles. *Campaigning with Crook and Stories of Army Life.* New York: Harper & Bros., 1890.

King, Margaret J. "The Audience in the Wilderness." *Journal of Popular Film & Television* 24, no. 2 (1996): 60–69.

Kirkbride, Franklin. "The Right to be Well-Born." *Eugenics Archive,* 1912, http://www.eugenics archive.org/html/eugenics/index2.html?tag=350 (December 23, 2009).

Klein, Kerwin Lee. *Frontiers of Historical Imagination: Narrating the European Conquest of Native America, 1890–1990.* Berkeley: University of California Press, 1999.

Knapp, A. Bernard, and Wendy Ashmore. "Archaeological Landscapes: Constructed, Conceptualized, Ideational." In *Archaeologies of Landscape.* Malden, MA: Blackwell, 1999.

"Lassoing Wild Animals, 'Buffalo' Jones's Roping Expedition Against the Big Game of Africa." *New York Times,* June 11, 1911, LS365.

Lee, Fitzhugh, Joseph Wheeler, Theodore Roosevelt, and Richard Wainright. *Cuba's Struggle Against Spain with the Causes for American Intervention and a Full Account of the Spanish-American War, including Final Peace Negotiations.* New York: American Historical Press, 1899.

Lewin, Roger. *Human Evolution: An Illustrated Introduction.* 5th ed. Malden, MA: Blackwell, 2005.

Lewis, C. S. *Studies in Words.* 2nd ed. Cambridge: Cambridge University Press, 1967.

Lippit, Akira Mizuta. *Electric Animal: Toward a Rhetoric of Wildlife.* Minneapolis: University of Minnesota Press, 2000.

Locke, John. *Two Treatises of Government.* Edited by Peter Laslett. Cambridge: Cambridge University Press, 1988.

London, Jack. "The Other Animals." *Collier's* 41, no. 24 (1908): 10–11, 25–26.

———. "A Preliminary Letter from Jack London Who Is Going Round the World for the Woman's Home Companion." *Woman's Home Companion,* November 1906, 19.

Long, Bruce, ed. "'The Humor of a Hollywood Murder,' Part 6: Evil Hollywood." In *Taylorology: Exploration of the Life and Death of William Desmond Taylor,* September 1993, http://www.public .asu.edu/~ialong/Taylor09.txt (December 27, 2009).

Lopez, Ana M. "Early Cinema and Modernity in Latin America." *Cinema Journal* 40, no. 1 (2000): 76.

Lorant, Stefan. *The Life and Times of Theodore Roosevelt.* New York: Doubleday, 1959.

Lovejoy, Arthur O., and George Boas. *Primitivism and Related Ideas in Antiquity.* New York: Octagon, 1973.

Lovelock, James E. *Gaia: A New Look at Life on Earth.* New York: Oxford University Press, 1979.

Lowry, Helen Bullitt. "New Adam and Eve Among the Gentle Wild Beasts." *New York Times*, April 29, 1923, SM8.

Lutts, Ralph H. "The Trouble with Bambi: Walt Disney's Bambi and the American Vision of Nature." *Forest & Conservation History* 36, no. 4 (1992): 160.

————. *The Wild Animal Story.* Philadelphia: Temple University Press, 1998.

Maloney, J. J. "The Crime Film." *Crime Magazine: An Encyclopedia of Crime,* n.d., http://www.crime magazine.com/crimefilm.htm (December 27, 2009).

Maltby, Richard. *Hollywood Cinema.* Oxford: Blackwell, 1995.

————. *Hollywood Cinema.* 2nd ed. Malden, MA: Wiley-Blackwell, 2003.

————. "More Sinned Against than Sinning: The Fabrications of Pre-Code Cinema." *Senses of Cinema,* 2003. http://www.sensesofcinema.com/contents/02/29/pre_code_cinema.html (January 13, 2010).

Maltin, Leonard. *Of Mice and Magic: A History of American Animated Cartoons.* New York: McGraw Hill, 1980.

"Man and Monkey Show Disapproved by Clergy: The Rev. Dr. MacArthur Thinks the Exhibition Degrading." *New York Times,* September 10, 1906, 1.

Marsh, George Perkins. *Man and Nature: Or, Physical Geography as Modified by Human Action.* Edited by David Lowenthal. Cambridge: Belknap Press of Harvard University Press, 1864.

Martin, Olga. *Hollywood's Movie Commandments.* New York: H. W. Wilson, 1937.

Marx, Karl. *Grundrisse.* London: Penguin, 1993.

Marx, Leo. *The Machine and the Garden.* London: Oxford University Press, 1964.

"The Mayor Won't Help to Free Caged Pygmy: He Refers Negro Ministers to the Zoological Society." *New York Times,* September 12, 1906, 9.

McClintock, Anne. *Imperial Leather: Race, Gender and Sexuality in the Colonial Contest.* London: Routledge, 1995.

McClintock, Anne, Aamir Mufti, and Ella Shohat, eds., *Dangerous Liaisons: Gender, Nation, and Postcolonial Perspectives.* Bloomington: University of Minnesota Press, 1997.

McCook, Stuart. "'It may be Truth, but it is not Evidence': Paul du Chaillu and the Legitimation of Evidence in the Field Sciences." *Osiris,* 2nd ser., 11 (1996): 177.

McIntosh, C. Barron. "Use and Abuse of the Timber Culture Act." *Annals of the Association of American Geographers* 65, no. 3 (1975): 347–362.

McMahan Alison. *Alice Guy Blaché: Lost Visionary of the Cinema.* New York: Continuum, 2002.

Meagher, Margaret Mary. *The Bison of Yellowstone National Park.* Washington, DC: U.S. National Park Service, 1973. http://www.nps.gov/history/history/online_books/bison/chap3a.htm (November 12, 2009).

Meltzer, Milton. *Mark Twain Himself: A Pictorial Biography.* Columbia: University of Missouri Press, 1960.

Merchant, Carolyn. *Reinventing Eden: The Fate of Nature in Western Culture.* New York: Routledge, 2003.

Merritt, Russell, and J. B. Kaufman. *Walt in Wonderland.* Baltimore: Johns Hopkins Press, 1993.

Michels, Eileen Manning. "Alice O'Brien: Volunteer and Philanthropist." In *Women of Minnesota: Selected Biographical Essays*, edited by Barbara Stuhler and Gretchen Kreuter. St. Paul: Minnesota Historical Press, 1977.

Millais, John Guille. *The Life of Frederick Courtenay Selous, D.S.O., capt, 25th Royal Fusiliers.* London: Longmans, Green, 1919.

Miller, Nathan. *Theodore Roosevelt: A Life.* New York: William Morrow, 1992.

Mitman, Gregg. *Reel Nature: America's Romance with Wildlife on Film.* Cambridge: Harvard University Press, 1999.

"More Experiments on Dogs." *New York Times,* August 4, 1888, 8.

Morris, Charles. *Battling for the Right: The Life Story of Theodore Roosevelt, including an account of the African Expedition.* n.p.: W. E. Scull, 1910.

Morris, Edmund. *The Rise of Theodore Roosevelt.* New York: Random House, 2001.

———. *Theodore Rex.* New York: Random House, 2001.

Moses, Lester G. *Wild West Shows and the Images of American Indians 1883–1933.* Albuquerque: University of New Mexico Press, 1996.

"Movie Man Invades Home of Cannibals: Martin E. Johnson Shows Thrilling Pictures Taken in South Sea Islands." *New York Times,* July 22, 1918, 9.

Munce, Howard. "Mr. Eager Never Stops." *Westporter Herald,* October 1950.

Munholland, J. Kim. "The French Response to the Vietnamese Nationalist Movement, 1905–14." *Journal of Modern History* 47, no. 4 (1975): 655–675.

"The Murderous Cowboys: How They Held a Court in Subjection in New Mexico." *New York Times,* February 16, 1886, 2.

Murie, Olaus. "The World We Live In." *Living Wilderness* 37 (Summer 1951): 17–18.

Musser, Charles. "American Vitagraph: 1897–1901." *Cinema Journal* 22, no. 3 (1983): 12.

———. *Before the Nickelodeon.* Berkeley: University of California Press, 1991.

———. "The Early Cinema of Edwin Porter." *Cinema Journal* 18, no. 1 (1979): 6.

———. *The Emergence of Cinema: The American Screen to 1907.* New York: Charles Scribner's Sons, 1990.

Nash, Roderick. *Wilderness and the American Mind.* New Haven: Yale University Press, 1967.

———. *Wilderness and the American Mind.* 3rd. ed. New Haven: Yale University Press, 1982.

National Park Service. "The National Park System Caring for the American Legacy." *National Park Service,* n.d., http://www.nps.gov/legacy/mission.html (November 12, 2009).

"Nature, on Celluloid." *Boston Globe,* August 8, 1950.

Neumann, Roderick P. *Imposing Wilderness: Struggles over Livelihood and Nature Preservation in Africa.* Berkeley: University of California Press, 1998."The New African Hall Planned by Carl E. Akeley." *American Museum Journal* 14, no. 5 (1914): 180.

Norwood, Irving C. "Exit—Roosevelt, the Dominant." *Outing Magazine* 53, no. 6 (1909): 722.

O'Toole, Patricia. *When Trumpets Call: Theodore Roosevelt After the White House.* New York: Simon and Schuster, 2005.

Patterson, John Henry. *The Man-Eaters of Tsavo and Other East African Adventures.* New York: St. Martin's Press, 1985.

"Paul Rainey Going for a 3-Year Hunt." *New York Times,* February 1, 1911, 7.1

Payne, David. "Bambi." In *From Mouse to Mermaid: The Politics of Film, Gender and Culture,* edited by Elizabeth Bell, Lynda Haas, and Laura Sells. Bloomington: Indiana University Press, 1995.

Pease, Sir Alfred. *The Book of the Lion.* New York: St. Martin's Press, 1986.

Peet, Richard, and Michael Watts. *Liberation Ecologies: Environment, Development, Social Movements.* London: Routledge, 1996.

Pico della Mirandola, Giovanni. "Oration on the Dignity of Man." Translated by Richard Hooker, 1998, http://wsu.edu:8080/~wldciv/world_civ_reader/world_civ_reader_1/pico.html (November 12, 2009).

Pindar, George N. *The Theodore Roosevelt Memorial.* New York: American Museum Press, n.d.

"The President Helps Lay a Cornerstone: He Makes an Address Laudatory of Yellowstone Park." *New York Times,* April 25, 1903, 1.

"President Kills Lion in Yellowstone Park: Mr. Roosevelt Hunts in a Snowstorm and Gets Big Game." *New York Times,* April 12, 1903, 1.

President Roosevelt and the Rough Riders. 1898. *Library of Congress American Memory: Early Motion Pictures 1897–1920,* http://memory.loc.gov/cgi-bin/query/D?papr:1:./temp/~ammem_cfoa:: (November 12, 2009).

Prince, Stephen. *Movies and Meaning.* Needham Heights, MA: Allyn & Bacon, 1997.

Quinn, Stephen C. "Audio History of the Diorama." *American Museum of Natural History: Dioramas,* n.d., http://www.amnh.org/exhibitions/dioramas/behind/ (November 12, 2009).

———. "History of the Diorama." *American Museum of Natural History: Dioramas—Transcript,* n.d., http://www.amnh.org/exhibitions/dioramas/behind/ (November 12, 2009).

———. *Windows on Nature: The Great Habitat Dioramas of the American Museum of Natural History.* New York: Abrams, 2006.

Ralph, Julian. *Our Great West: A Study of the Present Conditions and Future Possibilities of the New Commonwealths and Capitals of the United States.* New York: Harper & Brothers, 1893.

Reddin, Paul. *Wild West Shows.* Urbana: University of Illinois Press, 1999.

Renehan, Edward J., Jr. *The Lion's Pride: Theodore Roosevelt and His Family in Peace and War.* New York: Oxford University Press, 1998.

"Returning from the Hunt." *New York Times,* March 2, 1910, 8.

Riis, Jacob. *How the Other Half Lives: Studies Among the Tenements of New York.* New York: Scribner's Sons, 1890.

———. *Theodore Roosevelt: The Citizen.* New York: Macmillan, 1912.

Ritter, Carl. *Comparative Geography.* Translated by William Gase. New York: American Book Company, 1864.

Robinson, Corinne Roosevelt. *My Brother, Theodore Roosevelt.* New York: Scribner's Sons, 1921.

Rony, Fatimah Tobing. *The Third Eye: Race, Cinema, and Ethnographic Spectacle.* Durham: Duke University Press, 1994.

Roosevelt, Theodore. *African Game Trails.* New York: Charles Scribner's Sons, 1923.

———. "Camera Shots at Wild Animals." *World's Work* (1901).

———. "Frontier Types." *Century Illustrated Magazine* 36, no. 6 (1888): 831–843.

———. "The Home Ranch." *Century Illustrated Magazine* 35, no. 5 (1888): 655–669.

———. *Hunting Trips of a Ranchman: Sketches of Sport on the Northern Cattle Plains.* New York: G. P. Putnam's Sons, The Knickerbocker Press, 1886.

———. "In Cowboy Land: The Fourth Installment of 'Chapters of a Possible Autobiography.'" *Outlook* 104, no. 4 (1913): 148.

———. Introduction to *Camera Shots at Big Game,* by A. G. Wallihan. New York: Doubleday, Page, 1901.

———. *The Letters of Theodore Roosevelt.* Edited by Elting E. Morison. Cambridge: Harvard University Press, 1951–1954.

———. *Letters to His Children.* Charleston: BiblioBazaar, 2008.

———. *The Memorial Edition of the Works of Theodore Roosevelt.* Edited by Herman Hagedorn. New York: Scribners, 1926.

———. *A Compilation of the Messages and Speeches of Theodore Roosevelt, Supplemental.* Edited by Alfred H. Lewis. Washington, DC: Bureau of National Literature and Art, 1906.

———. "The Negro in America." *Outlook,* June 4, 1910, 243.

———. *Outdoor Pastimes of an American Hunter.* New York: Charles Scribner's Sons, 1905.

———. *Presidential Addresses and State Papers: January 16, 1907, to October 25, 1907.* Homeward Bound Edition. New York: Review of Reviews Company, 1910.

———. *Ranch Life and the Hunting Trail.* New York: Century, 1888.

———. "Ranch Life in the Far West: In the Cattle Country." *Century Illustrated Magazine* 35, no. 4 (1888): 495–510.

———. *Roosevelt's Writings: Selections from the Writings of Theodore Roosevelt.* Edited by Maurice Garland Fulton. New York: Macmillan, 1920.

———. *The Rough Riders.* New York: Charles Scribner's Sons, 1899.

———. "The Round-Up." *Century Illustrated Magazine* 35, no. 6 (1888): 849–867.

———. *Selections from the Correspondence of Theodore Roosevelt and Henry Cabot Lodge, 1884–1918.* New York: Charles Scribner and Sons, 1925.

———. *The Strenuous Life.* New York: Century, 1905.

———. *Theodore Roosevelt: An Autobiography.* New York: Charles Scribner's Sons, 1924.

———. *Thomas Hart Benton.* Boston: Houghton, Mifflin, 1887.

———. *Through the Brazilian Wilderness.* New York: Charles Scribner's Sons, 1914.

———. "The Vigor of Life: The Second Installment of 'Chapters of a Possible Autobiography.'" *Outlook,* March 22, 1913, 661.

———. "Wild Man and Wild Beast in Africa." *National Geographic* 22, no. 1 (1911): 3.

———. *The Wilderness Hunter.* New York: Review of Reviews Company, 1910.

———. *The Wilderness Hunter: Sketches of Sport on the Northern Cattle Plains.* New York: G. P. Putnam's Sons, 1893.

———. *The Winning of the West.* New Knickerbocker Edition. New York: G. P. Putnam's Sons, 1917.

———. "With the Cougar Hounds." *Scribner's* 30 (1901): 545–564.

———. *The Works of Theodore Roosevelt.* Edited by Hermann Hagedorn. New York: Charles Scribner's Sons, 1926.

Roosevelt's Rough Riders. 1898. *The Library of Congress American Memory: Theodore Roosevelt on Film,* http://memory.loc.gov/cgi-bin/query/h?ammem/papr:@field(NUMBER+@band(sawmp+0318) (November 12, 2009).

Rosaldo, Renato. *Culture and Truth: The Remaking of Social Analysis.* Boston: Beacon Press, 1989.

Russell, Don. *The Lives and Legends of Buffalo Bill.* Norman: University of Oklahoma Press, 1960.

Ryan, James R. *Picturing Empire: Photography and the Visualization of the British Empire.* Chicago: University of Chicago Press, 1997.

Rydell, Robert W. "Souvenirs of Imperialism." In *Delivering Views: Distant Cultures in Early Postcards,* edited by Christraud M. Geary and Virginia-Lee Webb. Washington, DC: Smithsonian Institution Press, 1998.

S.B. "Reviewed Work(s): Through Wildest Africa by E. Ratcliffe Holmes." *Journal of the Royal African Society* 26, no. 104 (1927): 409.

Said, Edward. "Secular Criticism." In *The World, the Text, and the Critic.* Cambridge: Harvard University Press, 1983.

———. *Culture and Imperialism.* New York: Vintage, 1994.

Salamone, Frank A. "Review: Colonial Evangelism." *African Studies Review* 27, no. 1 (1984): 132.

Salten, Felix. *Bambi: A Life in the Woods.* New York: Simon and Schuster, 1928.

Sammond, Nick. *Babes in Tomorrowland: Walt Disney and the Making of the American Child, 1930–1960.* Durham: Duke University Press, 2005.

Samuels, Peggy, and Harold Samuels. *Teddy Roosevelt at San Juan: The Making of a President.* College Station: Texas A&M University Press, 1997.

Schickel, Richard. *The Disney Version: The Life, Times, Art and Commerce of Walt Disney.* 3rd ed. Chicago: Elephant Paperbacks, 1997.

Schillings, Carl Georg. *Flashlights in the Jungle.* New York: Doubleday, Page, 1906.

Schullery, Paul. *American Bears: Selections from the Writings of Theodore Roosevelt.* Boulder: Colorado Associated University Press, 1983.

"The Screen." *New York Times,* September 12, 1921, 20.

"The Screen: More Adventuring." *New York Times,* January 9, 1923, 27.

"The Screen: Wild Animal Thrills." *New York Times,* January 9, 1923, 27.

Scull, Guy H. "Editor's Note: Lassoing Wild Animals in Africa." *Everybody's Magazine* 23, no. 3 (1910): 309.

———. *Lassoing Wild Animals in Africa.* New York: Ridgway, 1911.

Sennwald, André. "The Screen: Aerial Safari in Africa with Mr. and Mrs. Martin Johnson in 'Baboona,' at the Rialto." *New York Times*, January 23, 1935, 21.

Shohat, Ella, and Robert Stam. *Unthinking Eurocentrism: Multiculturalism and the Media.* New York: Routledge, 1994.

Singer, Ben. "Female Poser in the Serial-Queen Melodrama: The Etiology of an Anomaly." In *Silent Film.* New Brunswick, NJ: Rutgers University Press, 1996.

Skirmish of Rough Riders. 1899. *The Library of Congress American Memory: The Spanish-American War in Motion Pictures,* http://memory.loc.gov/cgi-bin/query/r?ammem/papr:@filreq(+@FIELD (NUMBER+@band(sawmp+0959)+@field(COLLID+spanam) (November 12, 2009).

Sklar, Robert. *Movie-Made American.* New York: Vintage, 1994.

Slotkin, Richard. "Nostalgia and Progress: Theodore Roosevelt's Myth of the Frontier." *American Quarterly* 33 (1981): 611.

Small Boy and Lion Cub, Hagenbeck's Circus. 1903. *AFI Catalog Feature Films,* http://www.afi.com/ members/catalog/DetailView.aspx?s=&Movie=42644 (November 12, 2009).

Smith, Adam. *The Theory of Moral Sentiments.* Edited by D. D. Raphael and A. L. Macfie. Oxford: Clarendon Press, 1976.

Smith, Albert E. *Two Reels and a Crank.* New York: Taylor & Francis, 1985.

Smith, Andrew Brodie. *Shooting Cowboys and Indians: Silent Western Films, American Culture, and the Birth of Hollywood.* Boulder: University Press of Colorado, 2003.

Smith, Dave, and Steven Clark Disney. *The First 100 Years.* New York: Disney Editions, 2002.

Smith, Henry Nash. *Virgin Land: The American West as Symbol and Myth.* Cambridge: Harvard University Press, 1978.

"The Smithsonian African Expedition." *Science* 37, no. 949 (1913): 364–365.

Sontag, Susan. *On Photography.* New York: Picador, 1977.

Spiro, Jonathan Peter. *Defending the Master Race: Conservation, Eugenics, and the Legacy of Madison Grant.* Lebanon, NH: University Press of New England, 2009.

"Strand: Tarzan of the Apes." *Washington Post,* May 19, 1918, SM6.

Talbot, F. A. *Moving Pictures: How They Are Made and Worked.* London: Arno Press, 1970.

Terrible Teddy, the grizzly king. 1901. *The Library of Congress American Memory: Theodore Roosevelt on Film,* http://memory.loc.gov/cgi-bin/query/h?ammem/papr:@field(NUMBER+@band(edmp +1887) (November 12, 2009).

"Theodore Roosevelt: The Picture Man." *Motion Picture World* 7 (October 22, 1910): 920.

Theodore Roosevelt Leaving the White House. 1898. *The Library of Congress American Memory: Theodore Roosevelt on Film,* http://memory.loc.gov/cgi-bin/query/r?ammem/papr:@filreq%28@field%28NUM BER+@band%28trmp+4099%29%29+@field%28COLLID+roosevelt%29%29 (November 12, 2009).

Thomas, Bob. *Walt Disney: An American Original.* New York: Disney Editions, 2002.

Thomas, Lewis. *The Lives of a Cell.* New York: Viking, 1974.

"Thrills of Making Jungle Film: Intrepid Producers Reveal Some of the Dangers of Picturing Scenes in Area North of Siam Infested by Man-Eating Tigers." *New York Times,* April 10, 1927, X7.

"Tippling Sally: A Song of Sorrow on Zoo Sunday." *Punch or The London Charivari,* 17 October 1891, 189.

Tompkins, Jane. *West of Everything: The Inner Life of Westerns.* New York: Oxford University Press, 1992.

"Topics of the Times: Abandoning Sport to the Dogs." *New York Times,* August 24, 1911, 6.

Turner, Frederick Jackson. *The Frontier in American History.* New York: Henry Holt, 1921.

US Infantry supported by Rough Riders at El Caney. 1899. *The Library of Congress American Memory: The Spanish-American War in Motion Pictures,* http://memory.loc.gov/cgi-bin/query/r?ammem/papr:@filreq(+@FIELD(NUMBER+@band(sawmp+1916)+@field(COLLID+spanam) (November 12, 2009).

Varty, Kenneth, ed., *Reynard the Fox: Social Engagement and Cultural Metamorphoses in the Beast Epic from the Middle Ages to the Present.* Vol. 1 of *Cultural Diversities and Intersections.* New York: Berghahn Books, 2000.

Vasey, Ruth. *The World According to Hollywood: 1918–1930.* Madison: University of Wisconsin Press, 1997.

von Bernhardi, Friedrich. *Germany and the Next War.* New York: Longmans, Green, 1914.

Wagenknecht, Edward. *The Seven Worlds of Theodore Roosevelt.* Guilford, CT: Globe Pequot Press, 2009.

Walker, Francis Amasa. *Political Economy.* 3rd ed. London: Macmillan, 1892.

Walker, Peter A. "Political Ecology: Where is the Ecology." *Progress in Human Geography,* 29, no. 1 (2005): 78.

Wallace, Alfred Russel. "A Review of Hereditary Genius, An Inquiry into Its Laws and Consequences." *Nature* 17 (1870): 137.

"Walt Disney Unmasks Nature." *St. Paul Pioneer Press,* August 10, 1952.

Walt Disney's True-Life Adventures. New York: Golden Press, 1958.

Walt Disney's True-Life Adventure: Beaver Valley. Dell Nature Classic no. 625. New York: Dell, 1955.

Watts, Sarah. *Rough Rider in the White House: Theodore Roosevelt and the Politics of Desire.* Chicago: University of Chicago Press, 2003.

Watts, Steven. *The Magic Kingdom: Walt Disney and the American Way of Life.* Columbia: University of Missouri Press, 1997.

Wetmore, Helen Cody. *Last of the Great Scouts: The Life Story of Col. William F. Cody "Buffalo Bill" as told by his Sister, Helen Cody Wetmore.* Chicago: R. R. Donnelley & Sons, 1899.

"When the World Came to St. Louis." *1904 World's Fair in Forest Park,* July 2009, http://stlouis.missouri.org/citygov/parks/forestpark/history/fair.html (December 30, 2009).

White, Hayden. *Metahistory: The Historical Imagination in Nineteenth-Century Europe.* Baltimore: Johns Hopkins Press, 1973.

White, Stewart E. "The Making of the Museum." *The Mentor,* January 1926, 6.

Wigglesworth, Michael. "God's Controversy with New England." *Proceedings of the Massachusetts Historical Society* 12 (1871–1873): 83.

Williams, Raymond. *Culture and Materialism.* London: Verso, 2005.

———. *Keywords.* New York: Oxford University Press, 1983.

———. *Problems in Materialism and Culture.* London: NLB, 1980.

Willoughby, David P. *All About Gorillas.* Cranbury, NJ: A. S. Barnes, 1978.

Wilson, Woodrow. "The Ideals of America." *Atlantic Monthly* 90, no. 6 (1902): 721–734, http://www.theatlantic.com/issues/02dec/wilson.htm (December 30, 2009).

Wister, Owen. *Roosevelt: The Story of a Friendship, 1880–1919.* New York: Macmillan, 1930.

"Wolf Hunt in Oklahoma." *Scribner's* 38 (1905): 513–532.

Wood, Judith Hebbring. "The Origin of Public Bison Herds in the United States." *Wicazo Sa Review: The Secular Past, the Mythic Past and the Impending Future* 15, no. 1 (2000): 169.

Woodford, W. Riley. "Lemming Suicide Myth Disney Film Faked Bogus Behavior." *Alaska Fish &*

Wildlife News, 2003, http://www.wildlifenews.alaska.gov/index.cfm?adfg=wildlife_news.view _article&articles_id=56&issue_id=6 (November 12, 2009).

Worster, Donald. "Seeing Beyond Culture." *Journal of American History* 76, no. 4 (1990): 1144.

Yerkes, Robert M. "Gorilla Census and Study." *Journal of Mammalogy* 32, no. 4 (1951): 430–431.

Yerkes, Robert M., and Margaret Sykes Child. "Anthropoid Behavior." *Quarterly Review of Biology* 2, no. 1 (1927): 43.

Index

abduction rape fantasy, 157

Abernathy, Jack, 46, 87

actualités, 13, 100–101

Adam and Eve, 76

Africa: and film, 90; as American Eden, 161–162; as American West, 98–99; big game hunting in, 84–89, 94; images of, 119

Africa on Film (Cameron), 147

Africa Speaks (film, 1930), 168, 170

African Game Trails (Roosevelt), 95–96, 100, 112

African Pygmy, 106–110

Agassiz, Louis, 6

Akeley, Carl, 46–47, 83–87, 96, 127, 130, 133, 137–144, 157–162, 166, 177

Akeley camera, 143

Aldrovandi, Ulisse, 4

Algar, James, 190, 192–193

America, visions of, 9

American exceptionalism, 12, 57

American Museum of Natural History, 99, 123, 127, 129, 131, 133–146, 158–160, 166, 174–178

American Nervousness (Beard), 25

Among the Cannibal Isles of the South Pacific (1918), 153–154

anachronistic space, 178

animals, as subjects of the camera, 10–11

anthropomorphism, 180

apes, 157–159, 166–170

Aquinas, Thomas, xi; the Great Chain of Being, 3, 4

Argument (White), 173–179

art as science, 139

Audubon, John James, 129

Baartman, Saritje, 104

Baboona: The Bride of the Beast (1935), 172

Bacon, Francis, 5; repairing the world, 7

balance of nature, 75–78, 80–81

Bambi (1942), 185, 188–189, 192

Bambi, A Life in the Woods (1923), 186–187

Barnum, P. T., 83–84

Barnyard Battle, The (1929), 184

Barthes, Roland, 145, 173, 187

Battle of Santiago Bay, The (1898), 63

Battleship Maine, 51

Bean, Norman, 147

Bear Hunt in Russia (1909), 14

Bear Hunt in the Rockies (1910), 14

Bear Jumping Hurdles (1899), 13

Beard, George, 25

Benga, Ota, 108–111, 171

Benjamin, Walter, 178

Benton, Thomas Hart, 25

Berger, John, 5, 179

Berryman, Clifford, 70–71

bestiality, 4

Beveridge, Albert J., xii

Beverly, Robert, 9

Bill of Rights, The, 104

Bingo, Otto, 111

Bird, Charles Sumner, 118, 121–122

Birth of a Nation, The (1915), 152–154

Birth of the Clinic, The (Foucault), 42

bison, hunting of, 116–117

black bear, hunting of, in Mississippi, 70

"Black Maria," 10

Blackton, James Stuart, 62

Blainville, Henri de, 104

Blumenbach, Johann Friederich, 104–105, 110

Boas, George, xi

Book of the Lion (Pease), 96

Boone and Crockett Club, 27

boosterism, 40

border melodramas, 33–35

Boxing Cats (1898), 13

Boxing Dogs (1899), 13

Boxing Horses, Luna Park (1904), 13

Boxing Horses, The (1899), 13

Bray, John, 147

Broca, Paul, 104

Bronco Buster (Remington), 60

Buck, Carrie, 135

Buck v. Bell (1927), 135

Buckle, Henry Thomas, 81

"Buffalo Bill's Duel with Yellowhand," 36

Buffon, Georges Louis Leclerc de, 5, 6, 8, 132

Bumpus, Hermon, 141

Buntline, Ned, 33
Burial of the "Maine" Victims, 53
Burroughs, Edgar Rice, 147
Burroughs, John, 66, 75
Buxton, Edward North, 89

camera: in Africa, 101; as a sporting device, 92–94;
 still, 33
Cameron, Kenneth, 88, 147, 159
Cannibal-Land (1922), 155
cannibals, 150–151, 153–156, 168
Cartwright, Lisa, 16
censorship, 181–183
Century of Dishonor, A (Jackson), 24
chain of being, 12
Chang: A Drama of the Wilderness (1927), 167
Charge of the Rough Riders at San Juan Hill, The (Rem-
 ington), 56
Chase, William Sheafe, 181–182
cheetah, 124, 126
Children Playing with Lion Cubs (1902), 13
Cinderella (1950), 185
cinématographe, 10
Civilization and Climate (Huntington), 81
Clarke, Adam, 8
classic static stability, 77
Cody, William Frederick "Buffalo Bill," 33–37, 40, 41
Collier, Holt, 70
Collier's, 94
Colonel Heeza Liar in Africa (1913), 147
Col. Theodore Roosevelt and Officers of His Staff (1898),
 54
Coney Island (Luna Park), 14–16
*Congorilla: Adventures Among the Big Apes and Little
 People of Central Africa* (1932), 170–172
Cooper, Merian, 169
cowboy safari, 115
Crevecoeur, J. Hector St. John de, 9
Cronon, William, 79
Crumley, Carole, 77, 103
Cuban and Porto Rican Campaigns, The (Davis), 56
Cuban Refugees Waiting for Rations (1898), 53
Cunningham, C. H., 94
Cuvier, Georges, 104–105
cyborgs, 138

*Daniel Boone Escorting Settlers Through the Cumberland
 Gap* (1851–1852), 32
Dark Continent, 103–109, 112, 146, 162–163
Davenport, Homer, 89
Davis, Richard Harding, 55–57
*De Generis Humani Varietate Nativa (On the Natural
 Variety of Mankind)*, 104
Declaration of the Rights of Man and Citizen, 104

Delmar, Lord, 121
determinism, 5
dime novels, 36
diorama, 129–145, 174–178, 180
Disney, Roy, 185
Disney, Walt, 181–195
Disney childhood, 185–186
dominion, 8, 9, 11, 14, 16, 78, 96, 105, 112, 115,
 120, 122, 131; scriptural, 7
"Double-Jumbo," 84
Drama of Civilization, The (Cody), 36
Drawing the Line in Mississippi (Berryman), 70–71
du Chaillu, Paul, 157
Dugmore, A. Radclyffe, 159
Dundy, Elmer "Skip," 15

E & R Jungle Film Company, 147
Eastman, George, xiv, 161
economic depression of 1893, 22
Edenic myth, 103
Edison, Thomas, 15
education and entertainment, 126, 146, 183–185,
 189–191
electricity, development of, 15
elephant, 141–142
Elephant Hunting in Cambodge [sic] (1909), 14
Elephants Shooting the Chutes, Luna Park Coney Island
 (1904), 16
*Elephants Shooting the Chutes, Luna Park Coney Island
 #2* (1904), 16
elk in Yellowstone National Park, 72, 75, 80
emerging cinematic narrative, 100
eminent domain, 25
emplotment (White), 173, 179
Endangered Species Act (1973), 80
Enlightenment, 1
environment, 79
environmental determinism, 21, 81
environmental ethic, 78
environmental imaginary, 9, 26, 28, 36, 41, 77–78,
 81, 112–113, 145, 178
Equatorial Africa: Roosevelt's Hunting Ground (1924),
 165
"erotics of ravishment, the," 9
eugenics, 134–135, 141
Evans, Robley "Fighting Bob," 121
Evernden, Neil, 179
Explorer's Club, 160

"fair, manly hunting," 47
Feeding the Doves (1896), 13
Feeding the Hippopotamus (1903), 14
Feeding the Russian Bear (1903), 14
Feeding the Swans (1895), 13–14

Field Museum (Chicago), 83, 86, 129
Fighting With Our Boys In Cuba (1898), 62
Figuier, Louis, 104–105
film, in Cuba, 53, 62
"Fitter Families for Future Fireside," 134
Flaherty, Robert, 165
Flandrau, Grace, 167
Flashlights in the Jungle (1906), 89–90
Forest Management Act of 1897, 79
Forest Reserve Act (1891), 27, 79
Foucault, Michel, 42, 131
Four Seasons, The (Akeley), 83
fox, 1–3
frontier thesis, 19–22
frontiersman, 116
Gaia hypothesis, 77
Galileo, 5
Galton, Francis, xii
Garden of Eden, 76, 103, 127, 170, 188
Gertie the Dinosaur, 16
Gesner, Conrad, 2
Goff, John, 73
Goode, George Brown, xiv
Gordon, James H., 111
Gould, Stephen Jay, 106
Goyathlay (Geronimo), 61–62
Great Chain of Being, The, 3, 4, 8
Great Train Robbery, The, (1903), 16
"Great White Fleet," 121, 149
great white hunter, 84, 86–89, 95, 97
Grey, Zane, 117
Grinnell, William Bird, 27, 92
grizzly bear, 45
Guy-Blaché, Alice, 147
Guyot, Arnold, 81, 90, 99
Guyot's Physical Geography (1873), 81

Hall of African Mammals (American Museum of
 Natural History), 136–141, 144–146, 158–160,
 174–178
Hanna, Mark, 61
Haraway, Donna, 132–133, 137–138, 141
Harmand, Jules, 103
Harrison, Benjamin, 32
Hays, Will, 182
Head Hunters of the South Seas (1922), 156
Hearst, William Randolph, 53, 68
"heart of darkness," 90
Hemment, John C., 124–127
Hereditary Genius (Galton), xii
heterotopia, 131, 195
Hickok, William "Wild Bill," 34
hierarchy of races, 103–113, 117, 119, 133–135, 174
Hist! See Who's Coming! (Davenport), 89

Hobbes, Thomas, 5
Holmes, Oliver Wendell, Jr., 135
Hornaday, William T., 110–111, 116
Hottentot Venus, 104
Humorous Phases of Funny Faces (1906), 63
Hunting Bats in Sumatra (1910), 14
Hunting Big Game in Africa (1909), 99, 146
Hunting Big Game in Africa with Gun and Camera
 (1922), 161
Hunting Buffalo in Indo-China (1908), 14
Hunting Sea Lions in Tasmania (1910), 14
Hunting the White Bear (1904), 14
*Hunting Trips of a Ranchman: Sketches of Sport on the
 Northern Cattle Plains* (1885), 23, 29–30, 42–45
Huntington, Ellsworth, 81

I Married Adventure (Johnson), 154
"Ideals of America, The" 11
ideological representation, 173–176
image, hegemony of, xiv
images of Africa, 89
images of nature, 41, 81
images of the West, 32–33, 36–37, 40, 43
imperial imaginary, 8, 85, 98, 103–106, 111–113,
 118–121, 126–127, 167, 172, 179–180, 195
imperialist nostalgia (Rosaldo), 26
Imposing Wilderness (Neumann), 194
In Beaver Valley (1950), 192–193
indexical bond, 173
Ingagi (1930), 168–169
Ingraham, Prentiss, 35, 95
Into Africa: The Story of the East Africa Safari, 88

Jack London's Adventures in the South Sea Islands
 (1913), 151
Jackson, Helen Hunt, 24
Jackson, William Henry, 33
James, Henry, 25
Jamieson, Robert, 8
*Jango: Exposing the Terrors of Africa in the Land of
 Trader Horn* (1930), 168
Jefferson, Thomas, 9
Johnson, Harry, 112
Johnson, Martin, 148–156, 159–172, 177
Johnson, Osa, 150–156, 160–166, 169–170, 172
Jones, Charles Jessie "Buffalo," 74, 115–126, 158–159
Jumbo, 83

Karnival Kid, The (1924), 184
Kearton, Cherry, 89–91, 99–101, 112, 119, 122, 125,
 127, 146, 159
Kearton, Richard, 91
Kent, William, 26, 119
Kettle Hill, 55

Kinetograph, 10
Kinetoscope, 100
King, Margaret J., 190
King Kong (1933), 166, 169, 172
Kirkbride, Franklin, 134

Lady MacKenzie's Big Game Hunt Picture (1915), 152–153, 169
land use reform, 79
landscape, 103; of consumption, 78
Lang, Herbert, 143
Lassoing Wild Animals in Africa (1911), 14, 120–122, 126, 159
Leatherstocking Tales, 30
lebensraum, 20
lemmings, 190
leopard, 86–87
Lewis, C. S., xii
Liberation Ecologies (Peet and Watts), xiii
Liceti, Fortunio, 4
Linnaeus, Carl, 6, 132
lion, 96–97, 99, 112, 118–119, 121–122, 124–125; hunting of, in Africa, 112
Lippit, Akira Mizuta, 179
Little Bighorn, 35
Living Desert, The (1953), 190
Lodge, Henry Cabot, 29
London, Jack, 66–67, 149–151
Long, John D., 52
Long, William J., 66
Longino, Andrew, 70
Louisiana Purchase Exposition (1903), 106–110, 113
Lovejoy, Arthur, xi
Loveless, Marshall, 119–121

MacArthur, R. S., 111
manifest destiny, xiii
Marsh, George Perkins, 76
Marx, Karl, productive life, 21–22
masculinity, 25, 29
McCay, Winsor, 16
McClintock, Anne, 9, 178
McGee, W. J., 106–109
McKinley, William, 50–51, 61
Means, Ambrose, 119–121
Merchant, Carolyn, 76
Merriam, C. Hart, 68, 75, 90
Metahistory (White), 173
Mickey Mouse, 183–184
Minot, Henry David, 90
Mirandola, Giovanni Pico della, 7
modes of explanation (White), 173
Monkey Bicyclist, The (1904), 13
Moose Hunt in Canada, A (1906), 14
Morris, Charles, 95

motion picture, 182
motion picture camera: in Cuba, 53–55; as transformative power, 12, 122, 124–127, 129, 146, 178–179, 195
mountain lion: hunting of, in Colorado, 67–68; hunting of, in Yellowstone National Park, 72–75, 80
Muir, John, 65
Mumford, Lewis, 184
museums of natural history, 129–139
Muskrats at Home (Akeley), 130, 132
Mutual Film Corporation, 181
Mutual Film Corporation v. Ohio Industrial Commission, 181
"myth ideological system," 58–59, 62–63

Nagapate, 162, 168
Nandi, 96, 112–113
Nanook of the North (1922), 165
narrative, 129, 131–133, 140–141, 144, 146–148, 152–156, 160–161, 165–166, 170, 180–181, 184–185, 188–190
Nash, Roderick, xiii
Nast, Thomas, 32
National Audubon Society, 191
National Geographic, 146
Native Americans, attitudes toward, 19–20, 115
nature: as an economic model, 26; as environment, 28; as a mechanical system, 5; relation to dominion, 5; as social norm, xi; subjectivity in, 1
"nature fakers," 66–67, 116, 145
nature's continent, 81
neurasthenia, 25
New York Zoological Society, 110–111, 113, 123–124, 146
Newmann, Roderick, 194
nickelodeon, 100, 146

Oakland Natural History Museum, 129
O'Brien, Alice, 167
Old Ephraim, 45
Olmstead, Frederick Law, 194
Omohundro, "Texas Jack," 33
On the Equator and Wild Life Across the World (1925), 159
O'Neill, Bucky, 53, 58
Orientalism (Said), 105
Osborn, Henry Fairfield, 126, 134–135, 138–140, 142, 144, 159–161, 166
O'Sullivan, Timothy, 33

Paine, Thomas, xii
Panther Hunting on the Isle of Java (1909), 14
Paradoxa (Linnaeus), 6
Paré, Ambroise, 4
pastoral Africa, 125–127

Patterson, John Henry, 85, 93
Paul J. Rainey's African Hunt (1912), 124–127
Pease, Alfred, 96–97
Peet, Richard, xiii
Perils of Pauline, The (1914), 147–148, 151–153
Philadelphia City Troop and a Company of Roosevelt's Rough Riders (1898), 62
pictorial journalism, 33
Picture Man, xv
Picturing Empire (Ryan), 176
"pigskin library," 88
Pitcher, John, 73–74, 117
Pocock's Legion of Frontiersmen, 91
Polar Bear Hunt, A (1906), 14
Porter, Edwin S., 14–16, 69, 72, 100
Porter, Robert P., 19
President Roosevelt at the Army-Navy Game (1901), 101
President Roosevelt at the Dedication Ceremonies, St. Louis Exposition (1903), 101
press, 67–69
Primitivism and Related Ideas in Antiquity, xi
production code, 168–169, 184
Production Code Administration, 182
Professor Welton's Boxing Cats (1894), 13

Rainey, Paul, 123–126
Rainey African expedition, 123–126
Raising Old Glory over Morro Castle (1898), 62
Ralph, Julian, 40–41
rambaramp, 160
Ramsaye, Terry, 163, 183
Ranch Life and the Hunting Trail (1886), 23, 31, 37, 39–40
Rango (1931), 168
Ratzel, Friedrich, xi, 20–21
Read, W. H., 56
"Real and Sham Natural History," 66
realism, 188–189, 191
Recovery Narrative, 76
Remington, Frederic, 39, 55, 60
repairing the world, 7
rhinoceros, 121
Right Red Hand, The (Cody), 35
Riis, Jacob, 49, 55, 57
Ritter, Carl, 81
Rock, William "Pop," 62
Rogers, Will, 62
Rony, Fatimah, 165
Roosevelt, Kermit, 88–89, 93, 97, 142
Roosevelt, Theodore "Teddy," Jr.: Africa, 65, 84, 86, 111; preparations for Africa, 87; American West, 23–24; as author, 23, 31; Boone and Crockett Club, 27; Colorado Hunt, 67; in Cuba, 55–58; Dakota Territory, 29–31, 38; as environmental activist, 28, 79–80; foreign relations, 51; game

butcher, 65, 70, 88; Governor of New York, 61; images of, 30–31, 39, 45, 50–51, 54, 58, 60, 68, 95, 97, 100–101, 120, 122, 135–136; as lawgiver, 37–38; as lion, 97; Medal of Honor, 59; and motion picture camera, 49–51; naturalist, 42–43; treatment of Native Americans, 24–25, 40; on usurpation of native land, 24; nature, 25, 41; as police commissioner, 49; political life of, 29, 31; end of presidency, 84; race relations, 32, 70–71, 85, 112; as reformer, 32, 49; agitates against Spain, 51; his 'Spaniard,' 58; sport hunter, 26–27, 29–30, 43–47, 65–70, 73–74, 81, 84, 86–89, 91, 93–94, 97–99, 142; "the strenuous life," 29–30, 44, 67, 112; as vigilante hero, 38–39; attraction to violence, 58; as war lover, 52; as writer, 41, 43; Yellowstone, 65, 72–75, 78
Roosevelt in Africa (1910), 100–101, 112–113, 170
Roosevelt Memorial, 136
"Roosevelt Party Crossing a Stream, The" (1910), 113
Roosevelt's "old cow" (1903), 141–144
Roosevelt's Rough Riders, 54
Roosevelt's Rough Riders Embarking for Santiago (1898), 54
Root, Elihu, 73–74
Rough Riders, 53–63
"Rough Riders Charge up San Juan Hill," 56
Ruini, Carlo, 3
Russell, Charlie, 36
Ryan, James, 176

Said, Edward, 103, 105, 179
Salten, Felix, 186–187
San Juan Hill, 55
Schickel, Richard, 181, 186
Schilling, C. G., 89
science, as theology, 6
Scopes "Monkey Trial," The, 166
Scouts of the Prairie, The (Buntline), 33
Scribner's Magazine, 95
Scull, Guy, 119–120
Second International Congress on Eugenics, 135
Selig, William, 90–91, 99–100
Selig Polyscope Company, 91
Selous, Frederick Courtney, 84–85, 87, 96–97
Serial Queen melodrama, 147–148, 151–152, 170
Seton, Ernest Thompson, 66, 116
settling the West, 32, 36
Shipwrecked Among Cannibals (1920), 156
Shoedsack, Ernest, 168–169
Shohat, Ella, xiii–xiv
Shooting Captured Insurgents (1898), 62
Simba, King of the Beasts (1928), 163–166
Singer, Ben, 152
Sitting Bull, 37
Skirmish of Rough Riders (1899), 63

Sleeping Beauty (1959), 185
Slotkin, Richard, 90
Small Boy and Bear, Hagenbeck's Circus (1903), 13
Smith, Adam, 8
Smith, Albert E., 50
"Smithsonian African Expedition," 88–91, 94, 100
Smithsonian Institution, The, 88, 101, 116, 123, 129, 146
Snark, 149–150
Snow, H. A., 161
Snow White and the Seven Dwarfs (1938), 184–186
social Darwinism, 106–112
Spanish-American War (Cuban War for Independence) 12, 51–59, 62
"squash and recoil," 189
St. Augustine, 1
Stam, Robert, xiii–xiv
Starr, Frederick, 106, 109
static equilibrium, 76
Storming of San Juan Hill, The (West), 56
Stoudenmire, Marshall Dallas, 37
"Summer Birds of the Adirondacks in Franklin County, N.Y., The," 90

Taft, Howard, 84
"Tarzan of the Apes," 147–148, 159
taxidermy, 129
taxonomy, 6
Tearing Down the Spanish Flag (1898), 62
technology, xiii
teddy bear, 71–72
"Teddy" Bears, The, 72
TR's Arrival in Africa (1909), 89
Terrible Teddy, the Grizzly King (1901), 69
Terrible Torreador, El (1929), 184
Theodore Roosevelt Leaving the White House (1898), 101
theology, Christian, 1
Thomistic doctrine, xii
Thompson, Frederic, 15
Through Wildest Africa (1925), 159
tikkun olam, 7
Timber Culture Act of 1873, 79
Time Machine, The (1895), 112
Topsy, 15–16, 69
Trailing African Wild Animals (1923), 159, 161
True-Life Adventures (Disney), 189–194
Tsavo, lions of, 85, 93, 96
Turner, Frederick Jackson, 19–22, 81
Twain, Mark, 52, 59
Two African Trips with Notes and Suggestions on Big Game Preservation (1902), 89

Ubangi (1931), 168
Unthinking Eurocentrism, xiii
Up the Congo (1929), 167
U.S. Infantry Supported by Rough Riders at El Caney (1899), 63

Vanishing Prairie, The (1954), 190
Vardaman, James K., 71
Vast Sudan, The (1924), 159
Verner, Samuel P., 107–108, 111
visions of nature, 42
Voltaire, 104
von Bernhardi, xi–xii
von Ranke, Leopold, 178

Walker, Francis Amasa, 41
Wanderings of an Elephant, The (1925), 163
Warbonnet Creek, 35
Ward's Natural Science Establishment, 83–84
Watts, Michael, xiii
Watts, Sarah, 47
Watts, Steven, 186
Wells, H. G., 112
West, the American, 9
West, William H., 56
Westinghouse, George, 15
Westward the Course of Empire Takes its Way (Leutze), 32
White, Hayden, 173
White, Stewart Edward, 138
White, William Allen, xv
"White Man's Burden," 85, 106
White Wilderness (1958), 190
"Why Look at Animals?" (Berger), 179
wild frame (1903), 178–179, 195
Wild Heart of Africa, The (1929), 167
Wild West show, 36–37
Wilderness and the American Mind (Nash), xiii
Wilderness Hunter, The (1893), 23, 31, 43, 45
Williams, Raymond, xi, 1, 195
Wilson, Woodrow, 11, 12
Winchester Arms, 82
Wister, Owen, 30
Wonderland of Big Game, The (1923), 159
Wonders of the Congo (1931), 170
world machine, 5
Wreck of the Battleship "Maine" (1898), 53

Yellow Hand, 35
Yellowstone Game Protection Act (1894), 27
Yellowstone National Park, 72–81, 117, 194

Zukor, Adolph, 146